Science fiction audiences

Why are *Star Trek* and *Doctor Who* so popular? These two science fiction series have both survived cancellation and continue to attract a huge community of fans and followers. *Doctor Who* has appeared in eight different TV and film guises and *Star Trek* is now approaching its fourth television incarnation. *Science Fiction Audiences* examines the continuing popularity of two television 'institutions' of our time.

Through dialogue with fans and followers of *Star Trek* and *Doctor Who* in the US, Britain and Australia, John Tulloch and Henry Jenkins ask what it is about the two series that elicits such strong and active responses from their audiences. Is it their particular intervention into the SF genre? Their expression of peculiarly 'American' and 'British' national cultures? Their ideologies and visions of the future, or their conceptions of science and technology? None of these works in isolation, because, as the plentiful interviews with fans and followers illustrate, audiences actively play with their entertainment according to complex and shifting categories of recognition, competence and pleasure.

Science Fiction Audiences responds to a rich fan culture which encompasses debates about fan aesthetics, teenage attitudes to science fiction, queers and *Star Trek*, and ideology and pleasure in *Doctor Who*. It is a book both for fans of the two series, who will be able to continue their debates in its pages, and for students of media and cultural studies, offering a historial overview of audience theory in a fascinating synthesis of text, context and audience study.

John Tulloch is Professor of Cultural Studies at Charles Sturt University and is the author of nine books, including *Doctor Who: The Unfolding Text* and *Television Drama: Agency, Audience and Myth*. **Henry Jenkins** is Director of Film and Media Studies at MIT and is the author of *Textual Poachers: Television Fans and Participatory Culture* and *What Made Pistachio Nuts? Early Sound Comedy and the Vaudeville Aesthetic*.

Popular Fiction Series
Series editors:
Tony Bennett
Professor, School of Humanities, Griffith University

Graham Martin
Professor of English Literature, Open University

Science fiction audiences

Watching *Doctor Who* and *Star Trek*

John Tulloch and Henry Jenkins

London and New York

First published 1995
by Routledge
11 New Fetter Lane, London EC4P 4EE

Simultaneously published in the USA and Canada
by Routledge
29 West 35th Street, New York, NY 10001

© 1995 John Tulloch and Henry Jenkins

Phototypeset in Times by Intype, London

Printed and bound in Great Britain by
TJ Press (Padstow) Ltd, Padstow, Cornwall

British Library Cataloguing in Publication Data
A catalogue record for this book is available from the British Library

Library of Congress Cataloging in Publication Data
Tulloch, John.
 Science fiction audiences : Doctor Who, Star Trek, and their fans /
John Tulloch and Henry Jenkins
 p. cm. – (Popular fiction series)
 Includes bibliographical references and index.
 1. Doctor Who (Television program) 2. Star Trek (Television
program) I. Jenkins, Henry, 1958– . II. Title. III. Series.
PN1992.77.D6273T85 1995
791.45′72—dc20 94–29962
 CIP

ISBN 0–415–06140–7
 0–415–06141–5 (pbk)

Contents

About the cover

The challenge of visually representing science fiction audiences proves vexing. Stereotypes abound – pimple-faced nerds in rubber Vulcan ears or wrapped in multi-coloured scarfs, overweight women clutching collectables and dolls. Such images of the science fiction audience surface throughout the popular press, bringing with them familiar assumptions that these fans and followers are obsessed with trivia and gadgetry, unable to separate fiction from reality, incapable of fitting within mainstream society, and incapable of resisting the latest programme-related merchandise. The persistence of these stereotypes has more to do with the limited background (and imagination) of more casual viewers than with the reality of active fan experience. Since this book challenges those stereotypes, we hoped to avoid reproducing them on the book's cover. Yet, the designers also had to face the problem of evoking the programmes and their audiences for readers who may have a limited range of images and associations with *Star Trek* and *Doctor Who*. The current design represents a compromise between these two goals, one debated among those involved in preparing this book.

If the cover still risks reproducing stereotypes of fans as consumers and collectors, it hopes to represent a different relationship between audiences and programme materials. The aura of supersaturated colours evokes the glow of the television screen and the immediacy of our experience of popular texts. As this book argues, fans and followers are not so much transfixed by these images as engaged by them, both fascinated and frustrated by their potentials. The figures here – the machine, the hero, the alien and the female companion/counsellor – are archetypes central to the science fiction genre, though different audiences will place different emphasis upon their meaning and importance to their appreciation of the programmes. These images are diffused, unfocused, incomplete, depending always on the acts of perception and interpretation to give them meaning. The absence of background details runs counter to the fan's desire to master fully the programme universe but suggests the degree that various audiences contextualize these images in different ways, reading them within different interpretive frameworks. The cover thus suggests through abstraction and simplification the protean nature of these programme characters and their availability to diverse and multiple science fiction audiences.

Series editors' preface

There are many good reasons for studying popular fiction. The best, though, is that it matters. In the many and varied forms in which they are produced and circulated – by the cinema, broadcasting institutions, and the publishing industry – popular fictions saturate the rhythms of everyday life. In doing so, they help to define our sense of ourselves, shaping our desires, fantasies, imagined pasts, and projected futures. An understanding of such fictions – of how they are produced and circulated, organized and received – is thus central to an understanding of ourselves; of how those selves have been shaped and of how they might be changed.

This series is intended to contribute to such an understanding by providing a context in which different traditions and directions in the study of popular fiction might be brought into contact so as to interanimate one another. It will thus range across the institutions of cinema, broadcasting and publishing, seeking to illuminate their respective specificities, as well as the relations between them, with a view to identifying the ways in which popular film, television, and writing interact as parts of developed cultural technologies for the formation of subjectivities. Consideration of the generic properties of popular fictions will thus be situated within an analysis of their historical and institutional conditions of production and reception.

Similarly, the series will represent, and coordinate, a debate between the diverse political perspectives through which the study of popular fiction has been shaped and defined in recent years: feminist studies of the part popular fictions play in the production of gendered subjectivities and relations; Marxist perspectives on the relations between popular fictions and class formations; popular fiction as a site for the reproduction and contestation of subordinate racial and national identities. In encompassing contributions from these often sharply contrasting traditions of thought the series will explore the complex and intertwining web of political relations in which the production and reception of popular fictions are involved.

It should be clear, though, that in all of this our aim is not to transform popular fiction into something else – into literature, say, or art cinema. If the study of popular fiction matters it is because what is ultimately at stake in such analysis is the production of a better popular fiction as well as of better, politically more productive, ways of reading it.

Tony Bennett
Graham Martin

Acknowledgements

The writing and publishing of this book is itself the stuff of science fiction. The two writers, one living in the United States, the other in Australia, never met face to face or spoke by telephone until the first draft of the manuscript was completed. The book, in turn, was edited and published in Great Britain. Great distances were bridged through e-mail, fax and overnight express mail. Any errors remaining in the current volume are probably the result of a fax being sent to the wrong office.

Henry Jenkins would like to express his appreciation to Cynthia Jenkins for her active intellectual collaboration and seventeen years of shared enthusiasm for *Star Trek* and its fans; to Henry Jenkins, IV, who increasingly contributes thoughts and insights to my research; to John Campbell and Greg Dancer, who helped to facilitate many of the interviews and who have promising futures as scholars of popular culture; Briony Keith, Chris Pomiecko, Eve Diana and Janet Sahlstrom for their tireless administrative support; *Strange Bedfellows*, ACAFEN-L, and the Narrative Intelligence Reading Group, for offering me a sounding board for my emerging thoughts on fandom; the Gaylaxians for their cooperation with this research; many academic friends who share my enthusiasm for *Star Trek* (Martin Marks, Martin Roberts, Lee Heller, Shoshoanna Green, Marc Davis, Taylor Harrison, Peter Chvany, Mary Fuller, Shoggy Waryn, Amy Bruckman, Les Perelman, Janet Murray and Warren Sacks) and academic friends who provide advice regardless of their cultural preferences (Jane Shattuc, Ben Singer, Eithne Johnson, Eric Schaffer, Laura Wilson, Aniko Bodgroghkozy, Tara McPherson, Lynn Spigel, Kristine Karnack, David Thorburn, Ed Turk, Peter Donaldson, Ruth Peary, David Halperin, Harriet Ritvo, Phil Khoury, Sherry Turkle, and many others); and John Fiske who brought the two writers together even when they were miles apart.

Henry Jenkins would like to dedicate his sections of *Science Fiction Audiences* to H. G. Jenkins Jr, who first introduced him to the pleasures of *Star Trek*. While he often claims that he could throw away his television

set without any loss or regret, he still watches the series every week. My father, his moral commitments and personal character seem far more heroic to me than the exploits of Kirk, Picard and Cisco. He is a man who builds things but who has come to understand a son who thinks things.

John Tulloch would like to dedicate this book to the memory of his parents. It was on their TV set, in the hospitality of their home, that he watched *Doctor Who* for very many Saturdays, starting in 1963. He would like to thank the many *Doctor Who* fans he has met and mingled with at conventions over the last fifteen years; and also the many audience groups of *Doctor Who* fans and followers who have given their time to the research for this book. Anne Davies, Director of the Communication/ Law Centre at the University of New South Wales, and Elizabeth Christopher, lecturer in the Commerce Faculty at Charles Sturt University, were, in earlier days, meticulous and enthusiatic research assistants on the *Doctor Who* audience project and deserve special thanks; as does Jennifer Newton who typed and retyped the manuscript in its various versions. Thanks are also due to Tracy Meszaros for compiling the index, and to Janice Lamb for later-stage secretarial work. Finally, Tony Bennett has been a scrupulously intelligent and helpful editor; it has been a pleasure working for his series.

Both writers would like to acknowledge all of the science fiction fans and followers who cooperated in the book's research. As a policy, the writers have changed the names of programme followers, especially where the sources desired to be anonymous, while preserving the names and giving recognition to the expertise and creativity of the active fans.

We would both also like to thank Tony Bennett and Rebecca Barden for their patience and commitment to producing an excellent book, no matter how long it took.

Introduction

This book comes out of a number of years' work that John Tulloch and Henry Jenkins have done with fans and followers of *Doctor Who* and *Star Trek* respectively. Especially in the case of the *Doctor Who* fans and followers, the audience research spans a period in which the key questions that audience theorists have asked have themselves changed, as methods and theories about 'reading' the text have altered. So, too, have fans changed their views during this period. Consequently, the book inevitably covers two kinds of historical process.

The first is a shift in fans themselves: for example, Kate Orman, of the *Doctor Who* fan club of Australasia, spoke in June 1993 of being part of 'what we now think of as the "Third Wave" of *Who* fandom Down Under'. This third wave, she feels, is much less didactic than earlier fans, less elitist, more pluralistic and tolerant. 'Earlier, the Australasian club held strong views, and often dictated them to its members: the club was "officially" opposed to the production team in 1984, and held its own letter-writing campaign to have the producer . . . sacked.'

The greater diversity of fan views which Kate Orman believes the third wave has released may well have led to changes – in part at least – to the 'fans as reading formation' phenomenon which is described in this book. But that phenomenon was an important one historically (just as the didactic academic critiques of popular science fiction were important historically); and Orman argues that a major preoccupation of the current club magazine is to 'repair some of the damage done by the club in its more didactic phase earlier in the 80's'. After reading the manuscript of this book, her feeling is that the current fans are 'more po-mo', more diverse, more ironic, more able to laugh at themselves than those a decade earlier; but the earlier legacy certainly continues, and it was very evident during the research for this book.

The second shift recorded in this book is in some ways a parallel one, as media academics have moved from often doctrinaire critiques of science fiction (which we examine in Chapter 2) to more open and tolerant accounts of both television texts and the audiences that watch

them. Inevitably, as with fans like Kate Orman, as academics we have been involved in and influenced by our own history, and it is well at some points to be reflexive about the way in which it has impacted on the research for this book. Thus, for instance, in Chapter 8 we look at the influence of the academic interviewer on fans' and followers' interpretations of science fiction texts. For students of media this is an important question; but for many fans, they may be more interested in contacting Kate Orman and her colleagues in the USA and UK, asking them to be reflexive about *Star Trek* and *Doctor Who* fan clubs, and the relationship over time of the open and closed attitudes that Orman describes.

These fans will continue to circulate fanzines that also reflect on questions that have exercised us in this book – the politics, ideology, sexual preferences and aesthetics of these television series. As Kate Orman says, a 'recent topic for debate has been why so many *Who* fans are gay – perhaps because fandom can be more accepting than the "real world"?' This sense of being 'more accepting' is why it is important for us to go beyond doctrinaire analysis – either by a fan elite reading formation, or by high culture inclined academic critics.

We hope to do the same in this book; but, like the fans, we won't always succeed. As we have individually named our chapters (while both of us have either worked on or commented on all chapters), we hope that the failures in this regard will be brought back to us – by fans and followers as much as by academic critics. Meanwhile, we want to bring back to fans' notice that many of the high culture prejudices maintained by academic critics seem to be reproduced by the fans themselves. As the chapters of this book proceed, a number of examples of high culture put-downs of *Star Trek* by British and Australian *Doctor Who* fans will emerge. We should note these just as forcefully as we note the MIT students' put-down of *Doctor Who* for its poverty of special effects. One thing of interest here is that whereas the British and Australian fans and followers of *Doctor Who* often tend to lump together series like *Star Trek*, *Battlestar Galactica* and *Buck Rogers* as 'plastic' and 'sensationalist' 'American-style superhero stuff', the American MIT fans distinguish between 'real science fiction series' like *Star Trek* and 'junk' like *Buck Rogers* and *Battlestar Galactica*. What 'real science fiction' is is a question that is asked often in the following pages. Both academic critics and fans/ followers need to be aware of the many varying answers to that question; and perhaps to ask themselves whether it needs to be asked at all.

Finally, the TV programmes themselves and/or their fandoms continue. Kate Orman notes that 'like *Star Trek*, *Doctor Who* has survived its cancellation – partly due to a vigorous fandom'. *Doctor Who* fans currently talk (some with hope, and others saying 'if it's going to be American it's bad') of Steven Spielberg contracting to make the series; while *Star Trek*, of course, is now running its third-generation series, and the

fourth series is being planned. At the level of textual production, as well as among fans, diversity seems assured.

John Tulloch, Charles Sturt University
Henry Jenkins, Massachusetts Institute of Technology
March 1994

Part I

Chapter 1

Beyond the *Star Trek* phenomenon
Reconceptualizing the science fiction audience

Henry Jenkins and John Tulloch

Nineteen-ninety-one was a landmark year in the history of what popular journalists call 'the *Star Trek* phenomenon'. Twenty-five years after its initial airing on 8 September 1966, *Star Trek* still commanded the covers of major magazines and was the focus of a two-hour television documentary.[1] The first five feature films had earned a total of $398 million in box office revenues. Thirty-five different *Star Trek* novels have commanded a spot on the *New York Times* paperback bestseller list and Pocket Book's long-standing series had grown to more than a hundred titles. Widely syndicated, the original *Star Trek* episodes were still being shown 200 times a day in the United States and were all available for rent or purchase on videotape. *Star Trek: The Next Generation* was America's highest rated syndicated drama, seen by more than 17 million viewers every week.

Countless writers have struggled to understand *Star Trek*'s success; one recent bibliography listed more than 1,300 English-language articles examining every conceivable aspect of the programme, its producer and stars, its exploitation and its reception.[2] Much of this coverage displays curiosity about *Star Trek*'s hardcore audience. Most often, however, that audience is constructed as exotic, unknowable and irrational. *Entertainment Weekly*'s cover story, '*Star Trek* at 25', opens with a typically alien representation of stereotypical fans:

> The *Enterprise* has assumed orbit around a Class M planet inhabited by the oddest race of creatures we've ever encountered. They call themselves 'Trekkies' – some insist on the word 'Trekkers' – and their entire civilization seems to be based on an ancient TV show about a band of space-age pioneers. They worship in hives called 'conventions', where they don silly velour uniforms and plastic pointy ears. Mr. Spock says these strange beings are harmless, but I'm not so sure.[3]

Elsewhere, the magazine listed 'a pretty good Trekkie starter kit', some $2,600 worth of collectors' items, bumper stickers, buttons, T-shirts, bubble-gum cards, mugs, toys, and of course the ever-present rubber

Spock ears and stuffed tribbles. The fan as extraterrestrial; the fan as excessive consumer; the fan as cultist; the fan as dangerous *fan*atic – these images of the science fiction audience have a long history.[4]

What was interesting about the coverage of *Star Trek*'s twenty-fifth anniversary, however, was not that the press continually evoked these same stereotypes but rather that many of the reports offered a different and somewhat more sympathetic representation of the science fiction audience. Journalists began to adopt the fans' own preferred term, 'Trekkers', over the derogatory 'Trekkies'.[5] Many reporters cautiously confessed their own long-standing interest in the series and its characters. The reporters were not alone. One survey, cited on a television documentary about the programme's anniversary, showed that 53 per cent of the American public classified themselves as '*Star Trek* fans'. *New Scientist* ran a story discussing how important the series had been in the recruitment and development of a new generation of American researchers and technicians: 'MIT students, NASA engineers and other technical people find the programme compelling. *Star Trek* is confirmation that what they are doing is worthwhile, that science is not an unnatural, sinister art that will lead to our destruction, but something that will allow us to become richer, fuller humans.'[6] Such stories constitute a reconceptualization of the science fiction fan within popular discourse: the writers' acceptance of the fan as Self rather than Other, as 'NASA scientists, MIT students' and 'liberal humanists' rather than 'overweight women' in velour uniforms and pimple-faced geeks with toy phasers.

There are limits to this new conceptualization: textual meaning still holds privilege over readers' meanings; fan activities are still defined primarily through relations of consumption and spectatorship rather than production or participation. The twenty-fifth anniversary documentary, for example, showed fans waiting in autograph lines or browsing through dealers' rooms, examining commercially produced merchandise; it did not offer interviews with fan writers, publishers, artists, composers, performers or videomakers.

These images model an ideal audience – an audience that buys what the producers have to offer and respects the studio's creative control over the series development. As one male *Trek* fan explains on the programme, 'I think anything with *Star Trek* on it will draw me to it like a magnet!' These images stand in stark contrast to the resistant and creative audience that has emerged in several recent academic accounts of this same subculture.[7] Academic writers have turned to fans as emblematic examples of audience resistance, of the appropriation and rearticulation of programme materials, of 'poaching'. Journalists, on the other hand, now turn to fans as a justification of their own interest in the media, as symbols of the responsiveness of the marketplace to popular demand, as advocates for the merits and meaningfulness of network

programming during a period of increased challenge from cable competition.

As they focus attention on the science fiction audience, academic writers do not venture into a space 'where no one has gone before'. Rather, scholars move into a space already heavily colonized by other discursive constructs, mapped by popular journalism and preconceived by the reading public. This chapter offers a brief history of the different ways that producers, journalists, critics and audience-members have conceptualized the *Star Trek* audience(s). The focus on *Star Trek*, here, will allow consistency and clarity; it is worth recognizing, however, that many of these same images and debates have surfaced in response to the audiences for *Doctor Who* and many other science fiction series.[8]

THE MAKING OF STAR TREK

> We suspected there was an intelligent life form on the other side of the tube. We planned to use our show to signal some thoughts to them. Never in our wildest imaginings did we expect the volume and intensity of the replies that we received.
>
> (Gene Roddenberry)[9]

Stephen E. Whitfield and Gene Roddenberry's *The Making of Star Trek*, published in September 1968 as the NBC television series entered its third and final season, remains a central document within the *Star Trek* fan culture – a myth about origins and the creative process, an ur-text for information about the characters and their universe. For early fans of the series, this book provided a common background for discussions and speculations, during a time when the episodes themselves could not be re-read, except through the fans' homemade audiotapes. Early fans recall quizzing each other on its contents to demonstrate their mastery over the programme material. Apart from backgrounding the fictional universe of *Star Trek*, the book reproduces sections from the original series proposal, inhouse memos, letters, documenting the laborious process by which the aired programme materialized from Roddenberry's initial concepts. The book presents its history of 'The Making of *Star Trek*' as the story of a creative producer's heroic struggle against network mediocrity:

> The television writer-producer faces an almost impossible task when he attempts to create and produce a quality TV series. Assuming he conceived a program of such meaning and importance that it could ultimately change the face of America, he probably could not get it on the air or keep it there! [10]

Gene Roddenberry, we are told, came to American television with a diverse background: retired airline pilot, retired cop, longtime reader of

pulp science fiction. He moved swiftly from a writer for programmes like *The Naked City, Have Gun Will Travel* and *Dr Kildare* to produce a short-lived serviceman drama, *The Lieutenant.* Roddenberry was asked by MGM to submit a proposal for a new series, and in 1963 he pitched *Star Trek* to the network executives as a '*Wagon Train* to the Stars'. His proposed programme would be a weekly science fiction series with recurring characters 'who travel to other worlds and meet jeopardy and adventure'.[11] *Star Trek* was rejected by MGM, only to be embraced by Desilu studios, eager to expand its productions beyond its familiar sitcoms. The series was pitched to CBS and rejected; NBC commissioned first one and then a second pilot before finally committing to the programme, after rejecting most of the initial characters, adopting a new cast and protesting loudly against the inclusion of Spock. Despite network indecision, poor time slots and mediocre ratings, *Star Trek* remained on the air for a three-year run and was then cancelled.

The Making of Star Trek is preoccupied with the production process. Empirical audiences play only a limited role here, yet the book often frames its account in terms of two very different conceptions of the television audience: the network's insistence on appealing to the lowest common denominator and the producer's faith in the existence of an intelligent and discriminating audience. Consider, for example, this passage:

> A number of people [network executives] expressed concern that the viewer might reject the concept of different races, particularly Negro and white, working side by side. . . . Gene stood his ground, gambling on his belief in the television audience, determined to carry out his plan of presenting subject matter and situations on *Star Trek* that would challenge and stimulate the thinking of the viewer.[12]

Network constraints are consistently ascribed to a low estimation of the viewership (the first pilot was described as 'too cerebral' for television; the plan for a female second-in-command was rejected as too controversial), while Roddenberry's creative vision is vindicated by appeals to the programme's audience support:

> a devoted fan-following of topflight scientists, engineers, and educators who recognized the ingenuity and foresight behind the fictional facade; science-fiction buffs who for the first time could see in concrete form much that they had been reading about for years; and of course a whole new generation of young people to whom possible futures were a reality rather than a dream.[13]

Roddenberry's statements at the time the programme was being produced offer a more complex and contradictory picture of the series' perceived audience. On the one hand, Roddenberry clearly operated with a perception of the mass audience as essentially passive and distracted:

We will be competing with other television series for a mass audience on an adventure-drama-action basis. That audience will sit out there as ever, with a hand poised over the control knob, beer, potato chips and a dozen other distractions around them.

He therefore stressed the need for the series to follow established television conventions wherever possible, rather than moving into less familiar generic territory:

Perhaps the fact that we are 'science fiction' and therefore somewhat suspect, we may need even more than average attention to a story which starts fast, poses growing peril to highly identifiable people, with identifiable problems, and with more than the average number of 'hooks' at act breaks.

As his discussion continued, however, Roddenberry evoked an image of a heterogeneous audience which might be captured through manipulation of diverse generic traditions within science fiction:

This need not invite bad writing since science fiction (as all sf classics indicate) permits an enormous range of audiences – the child, the housewife, and the truck driver can enjoy the colorful peril of Amazons wielding swords (or even muscled romance) while, at the same time, the underlying comment on man and society can be equally interesting and entertaining to a college professor.[14]

Here, Roddenberry evokes notions of socially situated viewers and polysemic texts. Roddenberry was apparently torn between his suspicions of the intellectual rigour of the mass audience and his recognition of the particular cultural competencies that different segments of his potential viewership might bring to bear upon the programme.

The distinctions between elite and mass viewers in *The Making of Star Trek* are familiar ones to students of 1960s American television and the shift from the 1950s 'Golden Age' of live television to the 1960s 'Vast Wasteland'. Roddenberry evoked these categories even more explicitly in his notes to programme writers, 'Our Aim? *Television*. But we don't intend to play down to television any more than our writers did on *Chrysler Theatre*, *Naked City*, *Kaiser Aluminum Hour* or *The Lieutenant*.'[15] Roddenberry's ideal *Star Trek* audience was, at heart, the mythic urban, educated viewer of the 1950s anthology dramas, such as *Chrysler Theatre*, as well as the socially relevant dramas of the early 1960s, such as *Naked City* or his own *The Lieutenant*. Roddenberry's narrative of the series development reflects both a desire to reach a mass viewership and a desire to address the burning social issues of the day. Science fiction allowed him to say what he was no longer able to say in contemporary

drama and reach an audience intelligent enough to comprehend his thinly-veiled allegories.

Missing here is an acknowledgement that *Star Trek* itself reflected many of the moves that were redefining network television during the 1960s. Vance Kepley has summarized the changes NBC underwent in the late 1950s and early 1960s:

> The company shifted from live programs to predominantly telefilms; it abandoned a schedule noted largely for its specials to implement one characterized by the routines of series programming; it established a policy of acquiring its shows from a stable set of outside program suppliers.[16]

Kepley traces a reorientation of the network's management, which led from Pat Weaver's 'Operation Frontal Lobes' of the 1950s with its commitment to public service programming and intellectually challenging drama, towards the more entertainment-focused approach taken by David Sarnoff and Robert Kintner from 1956–65. Weaver's programming strategy had played an important role in building an audience for early television, attracting urban and affluent viewers with 'caviar' and getting them to stay around for 'the bread and butter'. Sarnoff and Kintner's focus on building viewer loyalty for 'least objectional' series programming was important in stabilizing NBC's audience, broadening its base and ensuring consistent advertising revenue. The network embraced genre series, such as *Wagon Train* or, for that matter, *Star Trek*, that could ensure a high commitment from viewers. NBC had gone from a focus on audience quality under Weaver to a focus on audience quantity and consistency under Kintner. The paradox of *Star Trek* was that the programme itself reflected the strategies of the Kintner era (a genre series, filmed rather than live, produced by an outside contractor who regularly supplied network programming, foregrounding entertainment rather than education, modelled after *Wagon Train*) while its producer still spoke of it in terms of the ideals of the Weaver era and targeted it at an audience demographic that was seen as increasingly unattractive within the network's overall marketing strategies. As a result, *Star Trek* stood in constant danger of cancellation and Roddenberry depended on science fiction fans for support.

THE *STAR TREK* CAMPAIGN

> *Star Trek* fans seem to have been born with a roll of stamps in one hand and a typewriter in the other.
>
> (Gene Roddenberry)[17]

Roddenberry's ideal *Star Trek* viewer (familiar with the traditions of science fiction, attentive to the nuances of the programme's social com-

mentary, committed to its optimistic vision of the future) rematerializes as a viewer activist, ready to challenge the networks and lobby on behalf of the 'creative producer':

> As the rumor of impending cancellation spread among fans of the show, a ground swell of protests began to rise. During the months of January and February that ground swell assumed the proportions of a tidal wave. A highly articulate and passionately loyal viewing audience participated in what is probably the most massive anti-network programming campaign in television history.[18]

A network press release, reprinted in *The Making of Star Trek*, claims that NBC received more than 114,667 letters protesting their plans to cancel the series. (Others have estimated that the eventual number of letters could have been as high as one million, though NBC's official count has never reached more than 500,000.) Both the producer and the networks argue that this 'grass-roots' campaign and NBC's subsequent decision to renew the series reflected commercial responsiveness to public taste. Whitfield and Roddenberry explain, '[the "Save *Star Trek*" campaign] serves as a graphic reminder to the networks that people like to believe they have a voice in affairs that concern them, and will express that voice, sometimes in staggering proportions'.[19] As Bjo Trimble, a key organizer of the campaign, proclaimed: 'And so a major triumph of the consumer public over the network and over the stupid Nielsen ratings was accomplished through advocacy letter-writing.'[20]

Popular accounts of this letter-writing campaign face a central contradiction. Their focus on the intensity of the audience's commitment to the programme displaces the established mechanisms by which NBC and the other networks measured audience response: the Nielsen Ratings. The networks' position has always been that television programming reflects audience taste as measured by ratings shares. As Eileen Meehan, a critic of the Nielsen system, summarizes this argument, 'Perhaps we may not like *Alf*, *Murder She Wrote*, or *Wheel of Fortune*, but millions of people do.'[21] In other words, the audience gets the programmes it both desires and deserves and the networks' low standards reflect marketplace demand. Meehan's work demonstrates, however, that ratings methods are selected less on the basis of their social scientific reliability (which is minimal) but rather on their ability to construct an 'audience commodity' that can be sold to advertisers. Distrust of the Nielsen system (and of social science research methods generally) is a long-standing strain in American popular rhetoric, even as the networks appeal to the system to bolster them from complaints about their monopolization of broadcasting. (As early as 1961, in the famous 'Vast Wasteland' address to the National Association of Broadcasters, FCC director Newton Minnow challenged the validity of making network policy on the basis of the Nielsens, calling

for programme decisions which reflect 'the people's good sense and good taste'.)[22] Sharing Minnow's position, Roddenberry and Whitfield represent the network's reliance on the Nielsen Ratings as simply one more example of their underestimation of the viewing public.

Far from a spontaneous uprising of average television viewers, many of the key leaders in this campaign had a long history in American science fiction fandom. Roddenberry had actively courted this group, screening the programme's pilot episodes at a World Science Fiction Convention before the series was even aired. The producer provided fans with a steady flow of programme-related materials and occasionally allowed fan leaders access to the set. A long-time reader of *Astounding Stories* and other pulp science fiction magazines, Roddenberry recognized the important role that fandom played in the reception of genre-related texts and had, perhaps, anticipated that this group would provide powerful allies in his struggle with the network executives. Long-time fans speak of the letter-writing campaign as a founding moment for *Star Trek* fandom. The letter-writing campaign proved an important tactic in successful fan efforts throughout the 1970s to see *Star Trek* returned as a television series or a feature film and in their efforts to get NASA to name the first space shuttle after the *Enterprise*. The campaign has also provided a model for more recent attempts at viewer activism, such as campaigns to save *Cagney and Lacey*, *Beauty and the Beast* and *Twin Peaks*, as well as for groups such as Viewers for Quality Television.[23] Roddenberry built upon this institutional base of support as a potential market for spin-off merchandise through the creation of a mail-order company, Star Trek Enterprises (later re-named Lincoln Enterprises). Fans organized the *Star Trek* Welcommittee, in 1972, as a central information clearing-house for information on fan activities and news about the programme. Fan writers began to write and publish their own zines while the programme was still on the air and that activity intensified following its cancellation. By the decade's end, the infrastructure was in place for the massive proliferation of fan activity and the new public attention to *Star Trek* that would emerge throughout the 1970s.

FROM '*STAR TREK* LIVES!' TO 'GET A LIFE!'

> *Star Trek* fans . . . Turn on your TV sets and see the TV show that would not die!
>
> (*Star Trek Lives!*, 1975)[24]

If, in the late 1960s, *Star Trek* appeared to be the property of a few die-hard fans, who had not yet come to grips with the programme's demise, *Star Trek* and its audience gained new visibility in the early 1970s. In February 1972, the first *Star Trek* convention was held in New York's Statler-Hilton Hotel; organizers had anticipated a few hundred fans, but

actual attendance exceeded 3,000. The convention attracted national attention with cover stories in *Variety* and *TV Guide*. The following year, 6,000 people attended the New York *Star Trek* convention, which by that point was being widely imitated in other regions. Attendance peaked at the 1974 convention which attracted 15,000 registrants and was forced to turn away another 6,000 who sought admission at the door. The audience for *Star Trek* had grown dramatically as a consequence of its widespread syndication in the early 1970s; children raced home from school to watch it in afternoon slots, while college students discovered it through late-night reruns.[25]

The 1970s saw, as well, a flurry of publications surrounding the programme. A surprisingly high number of these early books focused as much attention on the *Star Trek* audience as upon the series itself. David Gerrold's *The World of Star Trek* (1973) included an extensive discussion of *Star Trek* fans and their activities with a particular focus on Bjo Trimble and her letter-writing campaign. Gerrold, a former science fiction fan turned television writer, adopts a sneering tone when he writes about the series fans. His stance reflects growing tensions between the active *Star Trek* fans (who were largely female) and the male establishment of literary science fiction fandom:

> In order for a subculture to be viable, it has to be rich enough in structure and detail to be consistent. Otherwise, it's not a subculture at all; it's a fetish, a compulsion, an obsession. Science fiction has long since demonstrated its viability as a subculture. . . . Unfortunately, this distinction seems to have escaped some of the more fanatic Trekkies, some of the organizers of fanzines. Because *Star Trek* appeared to take place within a viable and consistent culture, some hardcore Trekkies believe that a permanent fandom can be engendered simply by adopting the *Star Trek* culture – or as much of it as was shown and implied – wholeheartedly. . . . These are people who have forgotten that *Star Trek* was only a TV show. They've so immersed themselves in it that they've lost touch with reality.[26]

Gerrold consistently refers to female fans as 'Trekkies', making the link to 'Groupies' explicit at several points; he treats their writing activity as simply another symptom of their fanaticism. Gerrold respects the utilitarian approach to fanzine publishing within literary fandom, where amateur writing and publishing is seen as a training ground for professional work. He feels, however, that *Star Trek* fan-writing is 'of limited interest – except, of course, to those who are *Star Trek* fans';[27] these writers, Gerrold insists, are wasting their time since they will have 'no hope of ever having them published'.[28] (Marion Zimmer Bradley notes in a more recent essay that *Star Trek* fan-writing provided a support network for women who had found the old male establishment of literary fandom

closed to them and cites many professional writers who emerged from its ranks.)[29] More importantly, however, Gerrold discounts the possibility that such writings could be important and valid as contributions within the subculture without having commercial viability within a larger marketplace.

The female media fans received far more sympathetic treatment in *Star Trek Lives!* (1975), written by three active fans, Jacqueline Lichtenberg, Sondra Marshak and Joan Winston. An eclectic book, *Star Trek Lives!* was a collection of 'personal notes and anecdotes' about the series and its following. The book's tone is often breathlessly worshipful towards the original series:

> There has never been anything like the response to *Star Trek*. Something in *Star Trek* moved people profoundly, far beyond the normal impact of a television series. What was that 'something?' Will future scholars find *Star Trek* such a bright vision that it actually inspired people to create a brighter world? Will they conclude that the dream was father to the fact?[30]

Lichtenberg, Marshak and Winston consistently treat the *Star Trek* audience as a 'movement' which went beyond simply a lobbying effort on behalf of the show or a marketplace for consumer goods, a 'movement' that had been galvanized by Roddenberry's utopian vision of the future. Reading the book today, one senses the fans' exhilaration (signalled by the exclamation point in the title): 'Fans who had been all alone, thinking that they were the last of the true fans left, suddenly realized that there was somebody out there like them. Thousands of somebodies. Tens of thousands. Millions.'[31]

Perhaps the book's most important contribution was to focus attention onto the activity of fan writing and publishing, 'Do-It-Yourself *Star Trek*'. The book's closing chapter examined the amateur publishing that surrounded the series, giving detailed descriptions and extensive quotes of individual stories, encouraging new writers to try their hands at fan fiction, and reading zine-publishing as a female-centred activity: 'People have become so entranced with that world that they simply cannot bear to let it die and will recreate it themselves if they have to – or if given half a chance.'[32] This account, and the book's reprinting of the address for the *Star Trek* Welcommittee, attracted many new fans, even if the writers sometimes adopted an enclavish tone in their treatment of their 'movement'. Many of the cited stories, which had appeared in small circulated publications, were reprinted to much larger readerships in the wake of the book's publication. Following *Star Trek Lives!*, Marshak co-edited, with Myrna Culbreath, two commercial volumes of fan fiction, *Star Trek: The New Voyages* (1976) and *Star Trek: New Voyages II* (1977).[33] Published by Bantam Books with an introduction by Gene Roddenberry and

with commentary on the individual stories by the series stars, *New Voyages* bridged the gap between media professional and fan.

These 1970s' accounts of fandom display a fervent loyalty to the programme's producer and a profound distrust of the network, attitudes that emerged from the 1960s 'Save *Star Trek*' campaign. *Star Trek* is consistently described as 'the show the network could not kill!'[34] As Bjo Trimble writes, 'NBC has still never contacted us or shown one iota of interest in why we ran such a campaign to save one TV show.'[35] Roddenberry had. As a result, these fans owed their prestige within the 'movement' to their close accessibility to him. Generally, the stories published in *The New Voyages* reflect a commitment to preserving and extending the original without posing any direct challenge to its basic ideological assumptions.

Whatever personal motivations he might have had, Roddenberry's embrace of that community reflects fandom's importance during this period as a resource for rallying support for his future activities and as an increasingly lucrative market for commercial spin-off products. (A mid-1970s vintage catalogue for Lincoln Enterprises, for example, shows Roddenberry's company not simply marketing *Star Trek*-related goods, scripts, stationery, photographs, but also promoting his current efforts, such as *Genesis II*, *Spectre* and *Questor*.) A greater distance between producer and fans would emerge in the late 1970s and early 1980s; fans would remain an important secondary audience for *Star Trek* but the series' core audience included many who were not active members of the fan subculture. The box-office success for *Star Wars* (1977), *Close Encounters of the Third Kind* (1977) and *ET* (1980) signalled the existence of a science fiction and fantasy audience that was larger than anyone had previously suspected; the value of *Star Trek* for Paramount gained new recognition and the studio moved to exploit its 'franchise' through the feature films and, subsequently, through a second live-action series, *Star Trek: The Next Generation*.[36] Roddenberry's personal contact with the fans was displaced in the 1980s by the glossy publications of the official *Star Trek* fan club and by official fan liaisons, such as Richard Arnold. While Roddenberry's statements were taken as canonical by the fan community, Arnold, himself a former fan who had been a participant in the 'Save *Star Trek*' letter-writing campaign, often antagonized fans with his disrespect for the community's traditions and his attempts to impose his own readings of the series. The cottage industry of Lincoln Enterprises was joined by the profit-minded Creation Cons and the mass-market *Starlog* magazine.

Ironically, if fans saw this commercial expansion as a vindication of their long-standing commitment to media science fiction, popular accounts ridiculed fans as abnormal in their obsessive interest in what was, after all, 'only a television series'. The more successful fans were in broadening the market for the series, the more marginal they became to its overall

reception. What emerged from this tension was the stereotype of the 'Trekkie', a grotesque embodiment of everything that critics feared about mass culture – blind consumerism, obsessive commitment to the trivial, a loss of dignity and respect, a retreat from reality into the world of the 'boob tube'. Early fans recount a long history of confused reporters who could not quite understand the programme's popularity or the fans' behaviour:

> When some of us were being interviewed by a well-known snotty local news commentator/movie reviewer . . . we were asked about our 'passions' concerning *Star Trek*. That puzzled us. We like the show, of course, but none of the fans present could have really said they were 'passionate' about *Star Trek*. The interviewer kept at this theme until finally the cameraman decided to help out by asking, 'Don't you think it's pretty *abnormal* for grown people to run around in costumes and be able to quote every word Mr. Spock ever said?'[37]

Bjo Trimble's story ends with a crafty fan turning the tables on the cameraman and questioning him about his own detailed knowledge of baseball statistics; the threatened journalist retreats, 'No! Baseball is *normal*; this stuff isn't.'

Trimble's anecdote suggests the thinly drawn yet sharply policed boundaries between normal and abnormal audience behaviour, appropriate and inappropriate ways of relating to mass culture (both within fandom and in the culture at large). The 'Trekkie' caricature, a distortion of actual fan behaviour and practices, marks that boundary, separating the cultural practices of the Other from the writer's own relationship to the media.

Despite long-standing stories about befuddled and biased reporting of *Star Trek* conventions, one can trace a dramatic shift from relatively sympathetic, if often inaccurate, coverage in the 1970s to more overtly condescending and patronizing representations in the 1980s. Contrast, for example, the way that *TV Guide* covered the first New York convention in 1972 with the way *Newsweek* covered *Star Trek*'s twentieth anniversary in 1986:

> All over the country today, people are wearing '*Star Trek* Lives' T-shirts, pasting *Star Trek* bumper stickers on their cars. . . . *Star Trek*'s fans, loyal as always and more numerous than ever, easily filled and overfilled an entire floor of New York's Statler-Hilton Hotel. . . . The conventioneers were an ecumenical group, a thoroughly mixed bag of blacks, whites, Puerto Ricans and Oriental, old and young, men and women, in suits and in rags.[38]

> Hang on: You are being beamed to one of those *Star Trek* conventions, where grownups greet each other with the Vulcan salute and offer in

reverent tones to pay $100 for the autobiography of Leonard Nimoy.... [*Star Trek* fans consist] of a lot of overweight women, a lot of divorced and single women.... Kooks.[39]

Negative representations of fandom offered 'mundane' or non-fan readers extreme versions of the 'Trekkie' stereotype as reassurance of the normality of their own media consumption habits. Most people only watch *Star Trek*; Trekkies inhabited a world totally dominated by *Star Trek*. Such reassurances became necessary precisely at the moment when *Star Trek* moved from a cult phenomenon into a national pastime.

Fans actively resisted such portrayals. A button, visible in the late 1970s, expressed their refusal of such labelling: 'We are Trekkers, not Trekkies.' The term 'Trekkie' represented an identity imposed upon the group from the outside while 'Trekker' came to refer to the group's self-constructed and more affirmative identity. The widespread use of the term, Trekker, in the twenty-fifth anniversary coverage represented a victory in fans' long-standing attempts to redefine their public representation; the portrayal of fans as 'NASA Scientists, MIT students' constituted, in some ways, a return to Roddenberry's late 1960s rhetoric about 'intelligent life' at the receiving end of the broadcast signal or the *TV Guide* descriptions of fans as an 'ecumenical group'.

STAR FLEET ACADEMY

Science fiction is an addiction (or habit) so reasonable in any teenager who can read (and many who can't very well, in this age of *Star Trek* and *Star Wars*) that it is superficially a curiosity that it doesn't always last.... The science fiction drug is available everywhere to kids, in superhero comics, on TV, in the movies, in books and magazines. It is impossible to avoid exposure, to avoid the least hint of excitement at Marvel Comics superheroes and *Star Trek* reruns and *Star Wars*, impossible not to become habituated even before kindergarten to the language, cliches, basic concepts of science fiction. Children's culture in the contemporary U.S. is a supersaturated SF environment.

(David G. Hartwell)[40]

So far, this discussion has had little to say about academic interest in the *Star Trek* audience – for good reason. Scholars, such as Robert Jewett and John S. Lawrence or Harvey Greenberg, lent their academic authority to the pathologization of *Star Trek* fandom. Lawrence and Jewett describe 'Trekkies' as inarticulate cultists and zealots, comparing them to the Manson Family in their obsessive interest in an otherwise banal text.[41] Greenberg, a psychologist of adolescence, offers a more sympathetic explanation for why teenage girls, his image of *Trek* fans, are so preoccupied with the character of Mr Spock: 'He embodies the central virtues

and dilemmas of the pubertal years. His noble, flawed figure recapitulates in outer space many a Terran youngster's search for a viable identity.'[42]

For the most part, however, academic writers focused their attention onto the text, exploring its popularity through a close analysis of individual episodes, rather than venturing into the unfamiliar terrain of fandom.[43] The academy's isolation from the science fiction audience almost certainly skewed their research since these critics displayed an unnerving ability to focus on texts ('Who Mourns for Adonis?', 'The Apple', 'Spock's Brain', 'Let This Be Your Last Battlefield', 'Omega Glory') which are marginal to fan interest in the series and often regarded as among the worst moments of the series.[44] Such episodes represented *Star Trek* reduced to its most generic elements, displaying its ideology in its crudest form, which accounts for why they proved such easy game for ideological critics and so distasteful to the programme's followers.

If some critics were drawn to the mythic qualities of the series, many more cite *Star Trek* as representing some of the most banal and trivial aspects of media science fiction. In so far as science fiction had gained serious attention within the academy, it had done so by distancing itself from the 'shoot it if it moves' space opera and promoting its philosophical discussion of alternative societal orders. Teresa Ebert, in fact, argues for three distinct 'streams' in modern science fiction: Parascience Fiction (*Star Trek*); Mimetic Science Fiction (*Stranger in a Strange Land*); Metascience Fiction (*Dhalgren*).[45] Reflecting a typical and still current debate among academics, Ebert's interest in postmodern fiction leads her to privilege meta-SF (embodying 'a self-reflexive discourse acutely aware of its own aesthetic status and artificiality') over 'traditional' SF (employing the 'mimetic conventions of the bourgeois novel with its preoccupations with socio-psychological realism and its commitment to a causal interpretation of the universe').[46] Very much in third and last place is para science fiction, 'an adaption and updating of the old-fashioned space-genre type of science fiction for the tastes of middle-class consumers whose passion for gadgets is inexhaustible'.[47] Her disdain for this form of science fiction (which 'has a tendency to leave the literary domain altogether and move into TV serials, films and comic strips') is unmistakable.[48]

Her condescension is shared by other critics, such as Lester Del Rey, Brian Aldiss and David Hartwell, who view media science fiction as an infantilized version of the serious literary genre. For them, media fans are subliterate.[49] Hartwell treats media science fiction as part of young fans' initiation into the genre with later interest in such programmes seen as signs of an arrested development:

> Most often, a kid freezes at the gosh-wow tv/comics/movies stage and carries an infatuation with fantastic and absurd adventure into later life. But sometimes, usually by the age of twelve, a kid progresses to

reading science fiction in paperback, in magazines, book club selections – wherever he can find it, because written SF offers more concentrated excitement.[50]

Much like David Gerrold, these critics reflect the tensions which separated literary and media science fiction fans in the late 1960s. The consequence of this widespread dismissal of media science fiction has been a neglect of the media science fiction audience, at least until recently.

Scholarly writers may make sweeping generalizations about that audience, generalizations that have become the common currency within critical studies at least since the Frankfurt School, but they do so in the absence of any direct engagement with science fiction followers and their interests. Bernard Sharratt, for example, calls the 'expertise' and 'intimacy' which television fans have in the detailed mythology of their favourite shows 'pseudo-knowledge'. Such trivia displaces 'real' knowledge (i.e. knowledge of the social and economic structures which position and exploit them). Television, Sharratt asserts, 'provides us all with both a common knowledge and an instant expertise'.[51] But it is an expertise about individual personalities, not about social structure: 'history is seen as made by actual men (and even, occasionally, women) but history (and art and science) is thereby reduced to biography and anecdote'.[52] What this indicates, Sharratt argues, is a 'structure of experience' where television viewers (particularly working-class TV viewers) are left seeking the 'semi-pretence or semi-fantasy' of control of their world, when in fact they have neither the knowledge nor the economic resources to control it.[53] They are in a situation of extreme vulnerability as regards continuing employment and they have a considerable ignorance of the economic forces behind that condition. The popularity of certain cultural forms, Sharratt says, may well be related to this 'displacement of knowledge' with the added dimension that the violence and horror in horror movies or science fiction are much worse than the conditions suffered by the viewers. This manufactured horror acts

> to *enhance* the reassuring, solid presence of the surrounding sitting room once the programme moves on or clicks off. . . . As we watch the violence and horrors of the world 'outside' brought 'inside' the home by the screen, the quiet and safety of that home becomes simultaneously an almost impossible ideal and an actual reality.[54]

Sharratt's argument, of course, presumes the right of academics to determine what kinds of knowledge and politics matter. Fans are often accused by such writers with an obsession with trivia. If we see trivia, however, as decontextualized knowledge, then fans do not engage with trivia at all. For fans, information about the programme, its characters, its production, etc., is information which fits within a very precise context and is used to

make sense of an even more complex narrative universe. Similarly, fan politics is often concerned with the local rather than with the global, yet it defies academic attempts to define Bosnia as somehow more political than the interpersonal relations between men and women. Several decades of feminist thought would argue otherwise. We might, however, be able to redefine trivia not as useless or decontextualized knowledge but rather as unauthorized knowledge, as knowledge which certain authorities (including the academy) have decided does not count and does not matter. The politics that stems from trivia may be thought of as a politics of the local, of the everyday. Such a politics is no less real, no less vital, to those who engage with it than the sorts of politics which Sharratt embraces. The point, in any case, is that we can come to no real understanding of that alternative system of knowledge, of that other politics, if we simply theorize fans rather than engaging directly with their culture and their lived experience.

RETHINKING THE SCIENCE FICTION AUDIENCE

Much like popular journalism's 'Trekkies', these representations of subliterate, infantilized or politically duped audiences allow writers to speak about fans while allowing no possibility for fans to speak back. Such accounts disallow that ethnographic moment which, as Tony Giddens rightly argues, should be central in social theory, the process of 'getting to know what actors already know, and have to know, to "go on" in the daily activities of social life'.[55] We cannot, as Giddens says, adequately describe social activity at all 'without knowing what its constituent actors know, tacitly as well as discursively'.[56]

Over the past few years, several scholars, most notably Constance Penley, Camille Bacon-Smith and Henry Jenkins, have sought to open such a dialogue with the fan community. Writing ethnographic accounts of fandom in the 1980s and 1990s, these writers have discovered a very different community than the 'movement' that Gerrold or Marshak, Lichtenberg and Winston described in the 1970s: *Star Trek*'s centrality to media fandom could no longer be assumed and the programme had taken its place alongside many other series, such as *Blake's 7*, *Beauty and the Beast* or *The Professionals*; fandom no longer functioned as a support group for Roddenberry and the stars but rather as an autonomous (and predominantly female) subculture working to define its own social identity and cultural practices; fan-writing now welcomed much bolder breaks with the series concept. Each of these changes had occurred only in the face of heated debate within the fan community and represented a dividing issue between original and newer fans of the series. The more resistant or subversive aspects of fandom became the primary focus of these academics' interests (and, as a result, these academics have tended

to focus attention onto and side with newer fans). Their studies reflect the general movement within cultural studies towards a reconsideration of the media audience, a methodological shift which was initially felt in relation to so-called women's genres (notably soap opera and romance) and the news (the discourse of male authority) but has now spread to other popular forms (such as science fiction or popular music).

Older scholars, particularly those committed to critical perspectives on mass culture, respond with some discomfort to these newer approaches. Tania Modleski, the American writer who has most pointedly attacked audience research, summarizes her concerns:

> If the problem with some of the work of the Frankfurt School was that its members were too far outside the culture they examined, critics today seem to have the opposite problem: immersed in their culture, half in love with their subject, they sometimes seem unable to achieve the proper critical distance from it. As a result, they may unwittingly wind up writing apologias for mass culture and embracing its ideology.[57]

Modleski, thus, expresses her reservations about a general reorientation from critical distance towards greater proximity with both popular audiences and popular texts. She sees this shift as ultimately coopting in that it allows no space for critiquing and exposing the ideological construction of mass culture.

Without accepting her somewhat puritanical critique of the seductive power of popular culture, one must acknowledge the importance of her reservations and of the distinction between distance and proximity as alternative positions from which to discuss popular culture. The best ethnography, as Tony Giddens suggests, is characterized by a fluid movement between 'critical distance' from and 'mutual knowledge' with the reception community: distance facilitates understandings that may not be fully recognizable by participants within a culture while proximity or 'mutual knowledge' allows for a recognition of pleasures and meanings central to the participant's cultural experience.

Ethnographic accounts of the science fiction audience have negotiated this tension in various ways. Camille Bacon-Smith's *Enterprising Women* adopts a more traditional and distanced anthropological perspective; she positions herself as 'The Ethnographer', an objective outsider who must be initiated into the practices and beliefs of the fan community. Constance Penley, on the other hand, describes herself as 'gaga' about 'Slash' fandom, adopting a confessional tone to describe what she, as a feminist, learned from her interaction with the female fan-writing community. A long-time fan, Jenkins adopts practices of feminist ethnography that involve an exchange of manuscripts with his research participants and allows an active collaboration in the creation of his account.

These attempts to achieve a middle ground between critical distance

and mutual knowledge embody larger movements within the social sciences. Modern ethnographers, unlike their nineteenth-century predecessors, no longer come to the task of studying cultural practices as total outsiders and can no longer speak from a comfortable position of 'objective knowledge'. Their own pre-existing knowledge and understanding, their own cultural commitments, become central components of the research process. As Renato Rosaldo explains:

> The truth of objectivism – absolute, universal, and time-less – has lost its monopoly status. It now competes, on more nearly equal terms, with the truths of case studies that are embedded in local contexts, shaped by local interests, and colored by local perceptions. . . . Such terms as *objectivity*, *neutrality* and *impartiality* refer to subject positions once endowed with great institutional authority, but they are arguably neither more nor less valid than those of more engaged, yet equally perceptive, knowledgeable social actors. Social analysis must now grapple with the realization that its objects of analysis are also analyzing subjects who critically interrogate ethnographers – their writings, their ethics and their politics.[58]

Rosaldo concludes that there may be no ideal perspective from which to write ethnography. Each vantage point – proximate or distant, participant or observer – brings certain insights to bear upon the community, yet also brings with it certain blind spots.

TOWARDS A NEW APPROACH

While acknowledging that its own understanding(s) of the science fiction audience are constructions, reflecting the different methods that are brought to bear upon this subject matter, this book addresses the question of ethnographic authority in a different way. Its authors adopt a range of different research methods which encapsulate the history of academic attempts to conceptualize the television audience, opening a dialogue between alternative scholarly traditions.

Henry Jenkins writes here, as in *Textual Poachers*, from the position of both an academic and a fan. The history of *Star Trek* fandom in the United States, outlined above, recapitulates his own relationship to the series. Although he did not watch it when it was first aired or participate in the initial letter-writing campaigns, Jenkins discovered *Star Trek* in syndicated reruns in the early 1970s, mastered the arcane lore in *The Making of Star Trek* and treasured the James Blish novelizations of the original series episodes. He learned of fandom through *Star Trek Lives!* and *The World of Star Trek*. He ventured to his first convention as a reporter for his college newspaper and wrote an article ripe with many of the 'Trekkie' stereotypes he now critiques. His own active participation

within the community coincided with the release of *Star Trek: The Wrath of Khan*, during a period of fandom's revitalization.

Henry Jenkins had been raised by conservative Republican parents, taught in racially segregated schools, and came of age within a city still struggling to resolve the civil rights conflicts of the 1950s and 1960s. He first saw *Star Trek: The Wrath of Khan* while living in Cobb County, Georgia, a conservative district which was the national headquarters for the anti-communist John Birch Society and was represented by Larry MacDonald, who wanted to reinstate the House UnAmerican Activity Committee. *Star Trek* and its fandom offered him a 'utopian' vision of a world which accepted a broader range of cultural diversity than he encountered in his everyday life. Viewed in that context, he experienced *Star Trek* as a progressive text which played a crucial role in shaping his political commitments to feminism, homosexual rights, racial justice and multi-cultural education. Like many fans, he has become progressively more critical of the programme's ability to live up to those ideals as he has developed a broader political context for understanding its ideological compromises. Fandom offered him a model of a grassroots media activism as well as a space where one could engage in political and aesthetic debates about gender, sexuality and popular culture. If these experiences led him to reject ideological accounts of *Star Trek* which ascribe to it an unambiguously conservative influence on its audiences, he is also suspicious of accounts of audience resistance which deny the basic problems of media access and media ownership, and the ideological complexity of both textual and audience discourses.

Increasingly frustrated with the dominant top-down paradigm of subject position theory, Jenkins was one of a generation of young American cultural studies scholars strongly influenced by the powerful mentorship of John Fiske. Fiske's focus on ethnographic audience study as an alternative means of understanding mass culture allowed Jenkins a way of making sense of his own history as a fan and his own experience of the ideological complexity of *Star Trek*. At the same time, Jenkins's experience of growing dissatisfaction with *Star Trek* and frustration with its inability to keep pace with the political growth of its audiences pushed him against the easy optimism that sometimes characterizes Fiske's work. Semiotic resistance was not always enough to offset the producer's refusal to represent certain groups and concepts within the primary text; the primary text retained an authority, an aura which could not be successfully met by the home-made secondary texts which circulated around it. Local forms of grassroots cultural production at the site of consumption were not substitutes for getting access to the mainstream media which continues to be the most powerful story-telling mechanism in contemporary life.

Like many other writers of his generation, he rejects an either – or portrayal of 'mass culture' in favour of approaches which look at the

contradictory ideological impulses within popular texts and which focus on particularity rather than generalization. He applies to this research practices that situate audience interest in *Star Trek* within the viewers' larger social and cultural experience. His essays do not so much celebrate audience resistance as try to document and uncover the complex discursive resources popular audiences bring to bear on the reception of popular texts, the myriad of often contradictory purposes those programme materials play in their lives. He focuses in this book on three different groups that have defined their identities at least in part through their interaction with *Star Trek* – the mostly male members of MIT's technoculture, the mostly female participants within the fanzine community, and the gay, bisexual and lesbian members of the Gaylaxians. He has personal ties to all three of these groups which have allowed him access and insight into their activities. He thus continues here the exploration begun in *Textual Poachers* of the value of proximate knowledge.

John Tulloch, a keen follower of science fiction films, comics and novels in his childhood, watched *Doctor Who* from its very first episode in December 1963, and continued to follow each episode for the next twenty-five years. Aware of changes in his own life, especially his politicization during 1968 as a sociology student at the University of Sussex, he was curious about the continuing hold the series had on him. Seeing himself as a very different audience member in 1963 (as a conservative, empiricist History undergraduate at Cambridge University, as compared with the more radical Sussex 'critical realist' after 1968), he began to consider the different narratives of *Doctor Who* that had been able to interpellate these different audiences in his personal experience. This self-examination led to his researching and writing (with Manuel Alvarado) *Doctor Who: The Unfolding Text*, a book that focused on the different production signatures and generic inflections of the series in different eras. Researching the book brought him into close contact with other followers and fans of the series, and he became aware for the first time of the passionate likes and dislikes British and Australian fans had for particular production eras (such as the fan distaste for the 1976–8 'send-up' era under producer Graham Williams and 'star' Tom Baker). Yet it was this period that was most enjoyed by his university students who followed the series! What had begun as curiosity about his own changing subject positions in relation to *Doctor Who* became an interest in the more broadly – socially and institutionally – constituted science fiction audience.

His work on the fans and followers of *Doctor Who* was conducted over a period of twelve years and, as a result, his analysis inevitably inscribes the recent history of audience research. Early stages of the *Doctor Who* audience study, for example, focused on differential decoding of political and ideological forms in 'The Monster of Peladon', developing the kind of approach advanced by David Morley in his *Nationwide Audience* book.

Later, Tulloch drew on Morley's own critique of this early work, emphasizing issues of genre and cultural competence. This study needed further grounding in theories of reading formation (Bennett and Woollacott) and societal and institutional orders of discourse (Fairclough) where institutionalized contexts for reading and audience research were given more serious attention. Finally, he drew on recent ethnographic approaches (Giddens) emphasizing both mutual knowledge with, and critical distance from, fans, though still in the context of reading formation and orders of discourse.

As collaborators, then, we have had, to some extent, different intellectual trajectories (for instance, the early importance to Jenkins of Fiske's account of the polysemic address of popular culture, in contrast to the more sociological approach shared by Morley and Tulloch); and as a consequence, this book will centre as much on alternative ways of understanding, and alternative research methodologies, as it will upon *Star Trek*, *Doctor Who* or their audiences. However, we both share the same goal: to bring together understanding of the complex discursive resources of audiences with due recognition of the constraining power of institutions and ideology.

What can such a book tell its readers about the science fiction audience, given the sheer tonnage of writing about the *Star Trek* fan community that has preceded it? What can readers find here that was not already in Jenkins's *Textual Poachers* or Tulloch and Alvarado's *Doctor Who: The Unfolding Text*?

First, the book examines not simply active media fans, the female writing community that has been the centre of most previous research, but the wider audiences that are drawn to *Star Trek* and *Doctor Who*. This broader viewership is constituted as much by the conditions and consequences of the institution of television itself (as it constructs 'bedrock' and 'bonus' audiences) as by the agency of fandom. If more than 50 per cent of all Americans now regard themselves as fans of *Star Trek*, we need to move beyond a specific focus on fandom as a subcultural community to a consideration of what it means for these more casual audience members to identify themselves as 'fans'. This book will, therefore, adopt a distinction between fans, active participants within fandom as a social, cultural and interpretive institution, and followers, audience members who regularly watch and enjoy media science fiction programmes but who claim no larger social identity on the basis of this consumption. Fans and followers are conceived as two specific segments of the larger science fiction audience, though the boundary between the two groups remains fluid and ultimately somewhat arbitrary. This study assumes as well that there is not one but rather multiple fan communities which are drawn to these programmes for different reasons and adopt different reading formations for their reception.

Second, this book will examine the relationship between these more broadly defined science fiction audience(s) and representations of science within science fiction, a question largely ignored by previous ethnographic treatments of media fandom. How does the media organize the images and explanations of science and science fiction in the symbolic sphere? To what extent do dominant ideologies of scientism determine audience readings of *Star Trek* and *Doctor Who*? A particular focus will be on the ways that science fiction fits within a more broadly defined techno-culture which viewers as much as producers inhabit.

Third, this book will begin to provide a cross-cultural analysis of the audiences for *Star Trek* and *Doctor Who*. Some of the analysis considering how the two programmes re-inscribe particular conceptions of national identity has been omitted for lack of space. But there is evidence here (for example in the MIT chapter on *Star Trek* fans, and in the analysis of Australian *Doctor Who* fans' debate over the 'decline' in British institutions) about how audiences define their tastes and distastes for these programmes in relation to their identification with 'imaginary social communities'. What do *Star Trek* and other American science fiction series mean to British or Australian fans and followers of *Doctor Who*? What do *Doctor Who* and other British science fiction series mean to American fans and followers of *Star Trek*? How does the insertion of these programmes within specific national broadcasting contexts shape their reception and alter their meaning?

Finally, the book will address a question which David Morley has posed in relation to his own audience research, when he asks whether a 'preferred reading' is 'a property of the text, the analyst or the audience'. The writers seek here a more complex understanding of the interplay between these three terms – between the text's position within the shifting history of national imaginaries, the analyst's position within the recent history of audience research, and the changing constituencies of science fiction fans and followers. Ultimately, we are searching for a way by which audience research may be coupled with alternative approaches to textual analysis and historical perspectives on the production process. In that way, cultural study's discovery of the audience will enlarge rather than displace its traditional areas of interest.

Chapter 2

Positioning the SF audience
Star Trek, Doctor Who and the texts of science fiction

John Tulloch

> The primary question for the sociologist of SF should be: how is social order communicated in SF and how does this symbolic act relate to the structure and function of social action? Who are the heroes, villains and fools of the social order, and in the name of what principles do they act?
>
> (Charles Elkins)[1]

In this chapter we will focus on the more textually based approaches to the analyses of *Star Trek* and other popular science fiction. In doing so we will relate our arguments to the contrast that Tania Modleski draws between Frankfurt School-style critics who 'were too far outside the culture they examined' and the more recent fan-oriented critics, whom she sees as 'immersed in their culture, half in love with their subject, sometimes . . . unable to achieve the proper critical distance from it'.

As we will quickly find, lack of critical distance is not a feature of most of the analyses surveyed in this chapter. Rather than being half in love with their subject, the standard textual accounts emphasize the conservative and socially controlling nature of popular science fiction, particularly in the context of scientism and social order. Although later in the chapter we will refer to feminist work which does see progressive, socially liberating possibilities in *Star Trek*, most of the textual accounts of popular science fiction are embedded in the tradition of the Frankfurt School (Adorno, Horkheimer, Marcuse, Habermas, etc.), with their pessimistic stress on popular culture's tendency to communicate the 'common sense' of social order rather than 'fantasies' of social change.

As David Buxton points out in his analysis of *Star Trek* and popular culture, this opposition between 'social control' and 'social change' has been a long-lasting one within critical cultural theory.

> For Horkheimer and Adorno, the social meaning of the cultural product under capitalism was entirely determined by its commodity status, which functioned to produce a homogenous, uncritical consciousness. For Walter Benjamin, on the other hand, the technology of the mass media (mechanical reproduction on a vast scale) produced a collective

meaning, opening up the possibility for cultural struggle over this meaning, even within the framework of the capitalist cultural industries.[2]

Though Buxton goes on to a more nuanced account of the Frankfurt School, he is right to point to problems with both these positions. The Frankfurt theorists' 'negative critique' of popular culture as commodity production often implies a critique of the audience as well, seen as 'slumped bodies massed, and hours accumulated, in front of the screen',[3] so that we are left with a feeling of fatalism and passivity. In this view, popular television seems hardly recuperable for citizenship. On the other hand, Benjamin's position 'can easily lead to an exaggerated optimism attached to symbolic readings which evacuate the relations of production',[4] thus replacing analysis of power, social structure and the economic, political and technological determinants of popular culture with a simplistic 'active audience' populism.[5]

Most of the textual analyses of *Star Trek* and science fiction that we examine in this chapter draw on the first of these traditions. Basically, this approach has emphasized popular television's power to suppress alternative perspectives by denying audiences knowledge of systematic contradictions and exploitations within the social order. Jay Goulding's critique of *Star Trek* in *Empire, Aliens and Conquest* is typical of this tradition. Goulding argues:

> Advanced industrial societies produce all sorts of material class related contradictions which have their counterparts at the cultural or ideational level. These societies preach equality of opportunity and produce inequality; they speak in the name of peace and continue to stack up nuclear weapons; they plan strategies to expand space through world development and produce further dependent colonization; they forward philosophies of freedom and continue to operate through domination; they speak in the name of the free market and act in the name of corporate monopoly and privileged access.[6]

For Goulding, *Star Trek* becomes part of this larger culture of deception, helping to rationalize inconsistencies in the social order and to bolster the control of the ruling class by 'perpetuating distortions of consciousness'.

This tradition tends to emphasize the monopolistic power of the ruling class and the culture industries, as well as the 'dupe'-like nature of the mass audience. Thus on the one hand, Goulding points to the immense economic and cultural power of NBC, the network which first aired *Star Trek*. NBC is a wholly-owned subsidiary of RCA which has not only 'an incredible monopoly on communication systems through the world' but also makes aviation and navigational equipment, radar systems, military and space electronics, early warning ballistic missile systems, the US

Navy's AEGIS air defence system,[7] and controls record and book companies, frozen foods and a host of other consumer industries. On the other hand, Goulding speaks of the audience being 'duped' and 'brainwashed' through their leisure pursuits.

> We are numbed by the bombardment of mass media 'pluggings' of these space sagas. . . . *Star Trek* and *Star Wars* are very much part of a culture industry. Our daily lives are saturated and permeated with these mythologies. The complex of shared meanings that defines culture has become massified and depersonalized in a way that takes away our individuality, itself negating the ideals of democracy.[8]

Drawing directly on Adorno's theory, Goulding argues that while *Star Trek* and *Star Wars* glorify the power of individual cunning and action, the programme actually embraces a type of ' "pseudo-individualism" . . . founded on standardization'. The series preserves a 'halo of free choice' within 'rigid rules and structured inequalities'. Kirk becomes a 'swash-buckling maverick' who nevertheless operates within and upholds 'the rules of the Federation'.[9] These rules, in Goulding's analysis, are fundamentally those of male authority and sexism (deference to command figures on the starship bridge), capitalism (the setting-up and protecting of mining colonies throughout the galaxy), possessive individualism and the Darwinian ethic.

To illustrate his thesis Goulding examines episodes in *Star Trek* where Captain Kirk violates the Prime Directive of non-interference in other cultures. In 'This Side of Paradise' the *Enterprise* encounters a planet whose inhabitants live in a state of drugged euphoria (the result of a spore-producing plant), producing only what they need to survive and spending the rest of their time at play. The episode, Goulding argues, rejects any possibility of 'full and free development outside of capitalist enterprise'. Rather, the protagonists endorse capitalist values and assumptions. 'The Trekkers are appalled that these people . . . are not producing surplus for the Federation and are not engaged in commercial enterprises.' The episode, for Goulding, is 'a clear jab at utopian socialism'. Although many of the crew members succumb to the planet's charms, Kirk resists, telling Bones, 'Maybe we don't belong in Paradise. . . . Maybe we're meant to fight every inch of the way. Maybe we can't stroll to the sound of lutes, Bones – we must march to the sound of drums.' Similarly, in the *Star Trek* episode 'The Way to Eden', a band of space hippies (whose civil disobediences are modelled after the 1960s youth movements) are 'intolerable for the orderly, command attitude of the Trekkers'.[10]

In Goulding's view, *Star Trek*'s violation of the Prime Directive replicates the US government's military interventions in Latin America.

Non-interference means that Kirk and the *Enterprise* can intervene in

any society that does not appear to be democratic. Communist societies, socialist societies, hippy societies, women's societies, utopian societies are favourite targets for the Trekkers as they were for the US in the 1960's. . . . Behind the friendly helpful hand of the Federation with its statutes of full and free development we have two major forms of domination: a cultural domination which leads Kirk and friends to teach aliens how to be American; and a political domination based on devastating firepower.[11]

Thus, Goulding argues, *Star Trek* is a text for its time, translating the 1960s contradictions of the United States' internal and external dilemmas into myth. Focusing on the Federation's great enemies, Goulding argues that the Klingons' social character and physical appearance encode a Cold War ideology, contributing 'a doubly packed punch at both mainland China and Russia'. Such a myth could have a direct impact on the way that young Americans understood their cultural Others: 'we can imagine teenage boys watching these episodes and then going to Viet Nam to fight the Klingons'.[12] In this way, Goulding argues, *Star Trek* became a 'diversion from the reality of American imperial domination', inviting viewers to escape into a future which avoids the contradictions of the present.[13]

In Goulding's analysis, then, *Star Trek* is primarily about the 'reaffirmation of social control'.[14] The audience is conceived as one which is duped into 'sublimation with fictional characters' and their suspect ideals: 'struggle, capital accumulation (power centralization), ruthless competition, the ability to follow orders, daredevil fervour, wit and cunning'.[15] Deprived of rationality, the science fiction audience is locked into 'instrumental reason', the logic governing industrial societies. Here decision-making – both at work and in leisure time – 'revolves round means to an end and the end is defined by the authority figures'.[16]

At the audience level, the condition of popular myth is one of continuous repetition of a drug-like fix. '*Star Trek* and *Star Wars* continually promise freedom, equality and self-actualization but never deliver the goods. This is a fundamental law of mythology – a never ending repetition.'[17] Goulding imagines the audience as composed of 'mindless' perfect consumers who 'wait religiously, anxiously, desperately for the next installment of *Star Wars* or *Star Trek*'.[18] Such consumption deadens the popular intellect, foreclosing any meaningful resistance. 'Not only do we consume the culture industry but it consumes us. It represses and blinds, deprives and distorts our mental faculty of the ability to step back and reflect.'[19]

This highly pessimistic view of popular science fiction has a number of key points of focus: on the relationship between instrumental reason, authority figures and characterization; on the relationship between charac-

terization and myth; on myth as narrative; and on the 'grand narrative' of scientism. We will now look at these different points of 'mass culture' critique in relation to *Star Trek* and *Doctor Who*.

SF CHARACTERIZATION, INSTRUMENTAL REASON AND AUDIENCES

Instrumental reason – where decision-making is based on instrumental means to an end, and that end is defined by authority figures – is, in Goulding's view, the paramount logic of industrial societies. Industrial capitalism must compete and expand; hence its logic is imperialistic. Above all, popular science fiction populates its 'out there' with authoritative and expansionist decision-makers. 'Ideationally,' Goulding argues, 'Kirk's role model is ideal for American imperialist mentalities.'[20]

Given the emphasis in critical theory on the textual positioning of the viewer via role modelling and sublimation, audience analysis in this tradition is integrally related to the characterization of decision-makers in the text – to, as Elkins puts it, the 'heroes, villains and fools of the social order'. Goulding suggests that 'Most viewers within the television series ... will be deferential to command figures.'[21] In *Star Trek* these command figures are constructed in precise ways.

> On the one hand, Spock with his calculable logic tells us the odds, tells us how possible or impossible it is to do something. He represents the head, the mind, rationality – a systematic body of knowledge. On the other hand, McCoy tells us his feelings, his intuitions, his near divine revelations, his faith in God, goodness and justice. He represents the heart, the soul, irrationality, a bundle of unbridled inconsistencies. Together, the head and the heart portray both what is machine-like (technology) and what is emotional (human) in mankind. . . . These two vocations of science and religion are resolved in a political framework. Science can tell us how to do something but not necessarily why; religion can tell us why to do something but not necessarily how. Science can logic itself into inaction while religion can self-destruct because of emotional bindings. Politics is left to lead the way, to culminate the knowledge of both science and religion. . . . Politics is forever in the command seat. Captain Kirk can never show weakness.[22]

This is why, in Goulding's analysis, it is Kirk's pragmatism and militarism that the narrative privileges over McCoy's talk of paradise. The dominant political role is carried by a meta-narrative which synthesizes reason and spirituality in violent action on behalf of 'democracy'. This is what, in Goulding's view, makes Kirk an ideal role model 'for American imperialist mentalities'. But, as we will see in the next section, other science

fiction theorists like Elkins see the characters signifying beyond current social contradictions to establish a myth of capitalism itself.

SCIENCE FICTION AS SOCIAL ORDER AND MYTH

As the quotation from Charles Elkins at the head of this chapter indicates, Jay Goulding's emphasis on the relationship between the myths of science fiction, role models of action and 'social order' is a familiar one in the recent analysis of popular culture. Will Wright, for example, asks similar questions about Western films when he analyses 'myth as a conceptual response to the requirements of human action in a social situation. . . . Myths reconcile deep social conflicts through models of action'.[23] And John Fiske, talking about *Doctor Who*, discusses how the text works as myth 'by a careful structuring of heroes, villains and discourses'.[24]

The general agreement among these theorists is that popular cultural genres like SF and the Western operate as modern myths. Like Goulding, David Buxton sees the significance of *Star Trek* (and also the Western) in the 1960s in terms of the social contradictions of the time: 'their insistent moralising within the framework of a pure, pre-consumption epoch of capitalism (the Western) or a post-consumption stage (*Star Trek*) betrayed widespread anxiety over the breakdown of social discipline'.[25] According to these critical theorists, popular myths like the Western and science fiction inserted 'heroes, villains and fools' into systematic patterns of social action, obviating social contradictions and so positioning audiences within 'preferred', 'dominant' or 'official' understandings of the industrial world. Thus not simply a particular stage of US imperialism was at stake here (as in Goulding's analysis of Kirk in relation to the Vietnam War); but rather the entire stage of capitalism (as in Wright's analysis of the Western and monopoly capitalism), or even capitalism itself (in contrast to feudalism, as in Elkin's analysis).

To flesh out this more general perspective of the 'mass culture' critique, we will discuss one episode of *Doctor Who* ('The Monster of Peladon') which was used in our audience research. In 'The Monster of Peladon', the Doctor returns to a planet which he has helped (in the earlier 'Curse of Peladon') to take the first steps out of backwardness and obscurity by joining a galactic federation. Peladon has been a feudal society, ruled by a king and a high priest dedicated to the 'ancient ways'. But the planet is also rich in tricilicate, a rare mineral hitherto found in only one other place in the galaxy. By encouraging the King to join the Federation the Doctor is promoting modern entrepreneurial action which will have the effect of establishing a new kind of social order. The tricilicate must be mined in huge quantities, with a consequent growth and specialization of Peladon's working class: and the sharing of Peladon's new wealth must be managed, requiring new functions of the state. Furthermore, Peladon,

with its 'one crop' economy and total lack of science and technology, risks military or economic exploitation by the Federation as one of the galaxy's 'Third World' planets.

The patterns and potential contradictions of this new and expansive capitalist order are played out in 'The Monster of Peladon' as a drama of 'heroes, villains and fools'. By the time that the Doctor returns to Peladon, several years have passed, and the young king has died, leaving only a daughter. Peladon is a stridently patriarchal society, and 'as only a girl' the young Queen rules in the shadow of her chancellor who is still dedicated to idol worship and the 'ancient ways'. Gender power is thus one marker of the divide between the feudal and the modern in 'The Monster of Peladon'. Class power is another marker: the miners are on the point of armed rebellion against the chancellor Ortron and his aristocratic cronies who are keeping Peladon's new wealth for themselves. Further, Eckersley (an engineer sent from Earth to bring Peladon up to date with laser mining technology) has his own plans to corner the mineral wealth of the planet. He is working in collusion with Martian Ice Warriors (posing as a Federation peace force) to monopolize the tricilicate. Since Mars is the only other planet in the galaxy which possesses this mineral, control of Peladon will give the Martians economic power in the Federation, and will also bring great personal wealth to Eckersley who plans to use it in his quest for power on Earth. So, as well as potentially promoting new areas of gender and class conflict, Peladon's movement into the 'modern' universe carries with it all the perils of international (or inter-planetary) racial conflict and the 'development of underdevelopment'.

The narrative of this six-part episode of *Doctor Who* is a complex one, based on both internal and external structures of power. Initially Ortron appears to be the 'villain', but as workers, nobles and Queen band together for the good of Peladon against the Martian invaders, he becomes less a 'villain' than a 'fool', whose mistake was not to support the 'natural' development to the consensus of state capitalism. That path is articulated in class terms by the Doctor, who tells the Queen:

> That the miners are on the point of armed rebellion ... and that [the miners' leader] Gebek is your only hope. Civil war is the last thing that he wants. ... Etis [a radical miner] has scored a considerable success with that attack of his on the armoury – now all the young hotheads are keen to follow him. ... Send for Gebek at once, your Majesty, promise him a better way of life for his miners, and see that they get it. That will cut the ground from under Etis's feet. You've got to convince your people that joining the Federation means a better way of life for everybody, not just for a few nobles at court.

This 'modern' path is also articulated in gender terms by the Doctor's female assistant, Sarah-Jane Smith:

> Women's liberation, your Majesty – on Earth it means we women don't let men push us around. . . . There's nothing 'only' about being a girl your Majesty. Never mind why they made you a queen, the fact is you *are* the Queen, so just you jolly well let them know it!

And finally the modern is articulated in terms of the 'nation' – again by Sarah, who (believing the Ice Warriors to be a genuine Federation 'security' force) calls for the restoring of inter-class harmony on Peladon to 'get rid of the troops as soon as possible'.

Written and transmitted in 1974 (the year of the British miners' strikes against the Heath Conservative government), and several years before the Falklands jingoism of Mrs Thatcher, 'The Monster of Peladon' speaks in the name of very clear principles of social order. 'Modernity' is measured in terms of entrepreneurial activity and productivity – there will be new wealth created from natural resources. Modernity will be fair and democratic as well as competitive – 'a better way of life for everybody'. It will be liberating for women as well as men – a gift from Earth (England) 1974, which is where Sarah-Jane comes from. And it will embody the nationalism of consensus – organized by the state against aliens and foreigners.

Inevitably, then, *Doctor Who*, like *Star Trek*, speaks to a very particular historical moment. Evidence from Australian responses to this episode indicate quite how particular: in this case re-reading 'The Monster of Peladon' in terms of the 1975 sacking of the Whitlam Labor Government by the Queen's representative in Australia, the Governor-General.[26]

Yet, if we follow Elkins, this SF storyline about the problematic transition from a feudal to a state capitalist social order also imparts a much more universal and generic meaning. For Elkins the crucial principle is 'pragmatic, bourgeois individualist'.

> That most SF heroes personify this aspect of the bourgeois explains why one finds many of them 'liberating' static, isolated, feudal societies and opening them up to the rest of the Galactic empire. As Marx pointed out, the overthrowing of feudal society was the historical mission of the bourgeois. The spaceship of the famous *Star Trek* crew, '*The Enterprise*' is appropriately named.[27]

Elkins's 'liberating' science fiction hero is an agent in what Clyde Taylor calls the master narrative of western civilization: 'the struggle of capitalist rationality to overcome nature and less instrumentally rationalistic cultures'.[28] Because of this emphasis on entrepreneurial rationality, Elkins suggests that traditional SF reconstructs the bourgeois social order *at its most radical moment*. The origins of capitalism are represented ritually

and repeatedly by its 'liberation' of feudal society. At the same time, as Buxton notes, the enemy is also frequently represented as feudal. Buxton sees *Star Trek* as structured around

> a reworking in space of colonialism, capitalist accumulation and super-power rivalry against the Klingon Empire (Chinese) and the Romulan Empire (Russians) both marked by an extreme aggressivity and rigid, feudal-like military hierarchies which set them apart from the republican 'Federation' (Free World).[29]

To deny current contradictions, then, science fiction frequently goes *back* in time in order to re-tell the known tale of capitalism's victory over feudalism. In this ritual of reaffirmation the representation of the *science* in science fiction is crucial, as we will see in the next two sections of the chapter.

SCIENCE FICTION AS NARRATIVE

It is, of course, technology and science that signify the modernity of capitalism in the myths of science fiction. Yet, as John Fiske points out in his analysis of *Doctor Who*, science is not unproblematic in popular SF – and it is here that science fiction narrative plays a crucial ideological role.

> Of the discourses of knowledge in this narrative, the first, and most obvious, is that of science: but science is not the value-free, objective discourse it claims to be in society. . . . Pure science is finally totalitarian – it allows no alternative, no oppositional view. In story after story in *Dr Who*, 'pure' or 'cold' science is used to maintain or establish a totalitarian political order. Science is a means of power in an intergalactic version of feudal society. The Doctor typically defeats a totalitarian, scientific antagonist and replaces him or her with a liberal democratic humane scientist to take over and bring justice and freedom to the oppressed serf class.[30]

Again, then, the emphasis is on popular heroes 'liberating' a feudal society; but in this analysis, science (like gender or class) is implicated in 'good' and 'bad' social relations in the struggle for modernity. A central textual contradiction is that the 'objectivist' (anti-individualist) and empiricist *quality* of modern science is coded here as 'authoritarian' (feudal). As Fiske notes, 'the objectivity of empiricism distrusts the individual in any role other than that of observer, analyst or computer. Value-laden scales such as morality or politics are anathema to it.'[31] An alternative 'democratic' and socially caring version of science must therefore be found. Elkins's simple social drama of 'heroes, villains and fools' becomes in Fiske a multi-layered narrative struggle of 'heroes, villains

and discourses'; and 'good' science (the science of morality) distinguishes the capitalist order not only from the feudal order it has replaced, but also from the system that *currently* threatens its order – communism.

On the one hand, Fiske argues, 'the onward syntagmatic flow of the narrative serves to restrict the potential range of the discourses, and thus the range of positions from which the reading subject can make sense of the text'.[32] But on the other hand, the narrative is composed of layer upon layer of discourses; discourses of politics, economics, individualism, science and morality. As Fiske argues, this 'play' of discourses has a definite hierarchy: because of our complete identification with the morality of the scientist/hero, the 'ideological closure of the moral discourse is more final and complete than it can be of the political and economic discourses which would on their own admit of radically opposed or negotiated readings'.[33] It is the nature of popular texts, Fiske argues, to operate within the high consensus areas of a discourse (e.g. good Doctor scientist versus evil feudal ruler) and then to 'extend this assumed and unquestioned consensus to more controversial areas',[34] such as the 'anti-individualism' of science, the politics of capitalism or the economics of free trade. In Fiske's view then it is the discourse of scientific morality which is more important than the political discourse (emphasized by Goulding) in establishing dominant textual meanings. Though this is not actually contradictory of Goulding's analysis (since Kirk's 'political' synthesis of Spock's rationalism and McCoy's spiritualism is indeed a scientific morality), it does put greater emphasis on the science in science fiction – an emphasis which other theorists take further.

INSTRUMENTAL RATIONALISM AND THE IDEOLOGY OF SCIENTISM

Robert Dunn takes Fiske's argument about science fiction, the 'authoritarianism' of science and the compensatory myths of capitalism much further (and with much less optimism about the 'active reader'). Dunn, like Goulding, draws on Habermas and critical theory to argue that the ideology of 'scientism' has extended 'technical control as a principle' to all the major institutions of modern capitalist society. Science and technology, he argues, have become central tools of economic, military and state power, and as a consequence new conceptions of science emerge. 'Displacing reason and subjecthood, mastery and technical control resulted in a science based primarily on the narrow goals of material progress, usually defined as increased productivity and profitability.'[35]

Despite the emphasis on a 'good' and 'moral' science in science fiction, science in modern capitalist society in fact works transparently in the service of productivity – as in the case of the laser gun in 'The Monster of Peladon' (except when it is used 'badly', i.e. against the social order, by

the radical miners). Further (and again, as in 'The Monster of Peladon') 'positivist science can be seen emerging as a major ideological force justifying the corporate liberal State'.[36] As the practical problems of politics are converted into technical problems of administration, any conception of politics as the means to achieving the 'good society' is left behind. Scientism – where the technical 'management of things' justifies the domination of people – is a closed discourse entirely in the hands of a technocratic elite.

The technical approach to social problems, as Wright argues in his analysis of the Western, *becomes* the new legitimating ideology, with social values shaped through 'intense and calculated exposure to news, advertising, and drama' to conform with 'the technical needs of the economic system'. Consumers surrender discussion of goals and means to the 'technocrats who purport to understand the objective functioning of the system'.[37] Thus Wright's Westerns and Dunn's popular science fiction series are populated with specialized professionals who work together for a common administrative goal. Dunn argues that in TV drama the 'eccentric scientist' has been displaced by 'a professional or expert, serving in a bureaucratic organization, frequently as a member of a team'. These experts owe their primary loyalty to the 'established authorities', reflecting the shifting status of science within the modern state. 'Whereas science previously operated at the illegitimate or fantastic fringes of society, today television portrays science as fully integrated into contemporary social reality, defined by and embodied in official agencies of protection and control.'[38]

Certainly it is the case that, beginning in 1970, the 'eccentric scientist' in *Doctor Who was* replaced by a much more 'establishment' Doctor (played by Jon Pertwee) as he worked with a United Nations peace-keeping organization as its official scientist, phoned up heads of state, and told queens how to deal with their industrial problems. He was also the most 'Bondian' of the Doctors in his reliance on technology and gadgetry. Similarly, Dunn says of *Star Trek*:

> First the setting was a thoroughly technologized existence: an immense space ship whose crew were completely reliant for their survival on familiar apparatuses of science fiction. Second, traditional political, moral and emotional issues were posed and resolved within a technological framework.... In *Star Trek*, science and technology were employed to extend the status quo into the realm of the future, thus preserving the dominant values.[39]

As in the analyses of Goulding, Elkins and Fiske, Dunn sees the fictional representation of science in TV drama as a mythical force resolving societal contradictions, resulting in 'a religious/magical belief in technical mastery over evil forces'.[40] Like Goulding, Dunn argues that the particular

societal contradictions which the myth of scientism resolves operate especially forcefully at the psychological level.

> Such themes are an ideal prescription for viewers routinely suffering from feelings of alienation, powerlessness and confusion. In particular, as a vehicle of 'tension-management' and 'conflict-resolution' scientism has addressed a set of needs generated by a decade of social and political crises. In a society ridden with anxieties and hostilities, torn by conflict, and desperately needing institutional controls, portrayals of technological and bureaucratic domination can be very reassuring.[41]

In Dunn's view, the emergence of 'scientism' in the themes of popular television during the 1960s also had more specific historical reasons than the broad shift from market to managed capitalism which Wright sees behind the rise of the professional Western during the same period. Warfare (both domestic, during the protest movements of the 1960s, and overseas, in Vietnam) together with growing public fear about the national crime rate led to 'an intensification of the collective need for protection and security' by the decade's end. Dunn suggests that the popular appeal of 'social control and protection' shows responded to 'an audience need for psychological compensation for institutional instability, a growing crisis of legitimation, and a widespread sense of powerlessness'.[42]

FEMINIST SCIENCE FICTION: 'PARTIAL UTOPIAS'

Dunn's analysis of the ideology of scientism is an extreme case of the notion of TV drama manipulating and positioning the audience:

> scientism has reproduced and reinforced the powerlessness to which it has been a response. By reaffirming bureaucratic authority and technical control, and by providing *artificial* experiences of mastery and control, the symbols of scientism attempt to further weaken opposition to the system of authority and to promote acceptance of the established social reality.[43]

What feminist science fiction writer Joanna Russ calls 'SF and Technology as Mystification' is, in this kind of analysis, seen as an addictive pattern, establishing a surrogate sense of audience power and self-purpose in the face of real public powerlessness and alienation.

As Russ sees it, 'Talk about technology is cognitive addiction.'[44] Much as physiological addiction creates physical needs, cultural addictions provoke emotional needs. *Star Wars* triggers a need for 'self-worth and pleasure' which is satisfied through 'sexism, racism, heterosexism, competition and macho privilege'. Such a response, however, ignores the fact that these same forms of privilege produce 'a world in which most of the

viewers of *Star Wars* do not have the self-worth and the access to excitement and pleasure that they need'.[45]

Russ's critique of scientism and male-dominated technology is typical of recent feminist science fiction's central challenge to the 'grand narrative' of science. As feminist theorist, Robin Roberts argues in her recent book on gender and science in science fiction:

> science's grand narrative has been used to justify the oppression of subordinate groups, including women. Because science wields power as a source of legitimacy for ideology, women need to pay attention to the discourse of science. . . . Using the tropes of science fiction, feminist writers reconstruct science to provide a critique of and an imaginative alternative to real-life science, a field still inhospitable to women. . . . Women cannot control scientific narratives because, although they are frequently its subject, they are largely excluded from the practice of science. Through feminist science fiction, however, women can write narratives about science. With its imaginative possibilities, science fiction provides women opportunities denied them in the real world.[46]

Roberts emphasizes key positions adopted by feminist science fiction: whereas male-dominated science fiction values scientific accuracy, plausibility and 'hard science', feminist science fiction focuses on magic, art and 'soft science'; while male-dominated science fiction 'emphasizes how technology develops', feminist science fiction 'contains characters who change over time'[47] via communal relations which are taken as models for an ideal society. Feminist science fiction is thus centrally concerned with harnessing alternative sciences (telekinesis, telepathy, teleportation, psionics) to social change. As Roberts says, 'While male scientists . . . explore unknown continents, women explore the world of the mind. As a result, women discover mental powers that seem magical and mysterious from the perspective of traditional science.'[48]

The feminist science fiction writers that Robin Roberts discusses do not reject the negative-critique of the Frankfurt School tradition. Rather, they work out of ideology-critique to provide a much less pessimistic view of popular culture. Through focusing on 'magical' or 'fantasy' mental powers they seek social change at the very heart of instrumental rationalism – by liberating women and men from cognitive addiction. It is precisely because the grand narrative of formal science is male-dominated that popular science fiction matters to feminists. It is there that Joanna Russ can find utopian societies that are 'classless, without government, ecologically minded . . . sexually permissive'.[49] As Roberts shows, feminist utopian writing and science fiction restore to women's own use many of the values which patriarchal culture had used to control women: for instance, the association of women with motherhood, with the home

and with nature. In feminist science fiction, motherhood, reproduction and nature become new sources of female power; and the home and family are re-elevated as models for moral community.

It is from the basis of this feminist SF discourse that Russ can make a distinction (missing in the male theorists discussed earlier in this chapter) between the 'cognitive addiction in technology' of *Star Wars* and the 'partial utopia' of *Star Trek*. Unlike Elkins, Russ does not see *Star Trek* as simply a myth of capitalist enterprise; nor, unlike Dunn, simply as an example of 'scientism' being used to extend the status quo into the future.

> In *Star Trek* the need is for a community and morality; the means offered to achieve these ends are self-control and adherence to a fairly simple established morality. . . . *Star Trek* is a very muddled and partial utopia. Yet it is utopian and I believe that if anything lifts the show out of the class of purely addictive culture, it is the series' utopian longing and the consequent sense of profound tragedy that hovers just under the surface of that longing.[50]

Star Trek, in Joanna Russ's view, *restores* 'political realities' (i.e. Wright's questions of human value and 'the good life') to a society preoccupied with technophilia and to a government hitherto perceived as no more than the successful administration of technical problems. Russ writes:

> *Star Trek* addresses itself to different desires . . . : worthwhile goals, a clear conscience, peers whom one can respect, love, and be loyal to, a chance to exercise one's skills, self-respect, a code of conduct which can be followed without disaster – *and* excitement and self-importance.[51]

If, as Norman Fairclough says in *Language and Power*, in our current instrumentalist society 'People's involvement in politics is less and less as citizens and more and more as consumers',[52] then in Russ's view *Star Trek* addresses the citizen, *Star Wars* the consumer. But how does she account for this difference in two roughly concurrent, commercial US science fiction products?

TEXTUAL POACHERS: THE *STAR TREK* AUDIENCE

> Let us for a moment compare *Star Wars* with *Star Trek*. The latter has certainly generated an immense paraphernalia around itself, but the minor industry around *Star Wars* is part of a commercial advertising campaign; that around *Star Trek* originated in the audience itself and commercial exploitation of the paraphernalia came later.
>
> (Joanna Russ)[53]

Russ's sense of the utopian values of *Star Trek* 'originating in the audience itself' begins a train of thought which has been taken much further by

Henry Jenkins, whose work emphasizes the utopian vision of the 'small scale communities' of science fiction, the fans. However, Jenkins would strongly disagree with Russ over her distinction between *Star Wars* and *Star Trek*. Jenkins insists that we retain a healthy scepticism about the sharp contrast between the social control of *Star Wars* and the utopianism of *Star Trek*. For critics like Russ, *Star Wars* becomes the ideological equivalent of 'para-science fiction', the bad object against which they can make their more progressive claims for *Star Trek*. In practice, though, *Star Wars* provoked a tremendous amount of fan-writing, rivalling for a time the more closely studied work of *Star Trek* fans, and adopting many of the same utopian themes. A fan-reading of *Star Wars* would stress the film's heroic treatment of resistance to totalitarian authority and the need to form alliances across multiple planetary cultures, races and genders. This focus on resistance led many American *Star Wars* fans to embrace the British series, *Blake's 7*, even before it was introduced commercially into the American market, finding many of the same themes there that emerged from their reading of the Lucas films. The friendship between Luke Skywalker and Han Solo was read as containing some of the same utopian possibilities which critics and fans find within the intense homo-social bonds that link Kirk and Spock. And Princess Leia emerged as a powerful female character capable of exercising the autonomy denied women within the aired *Star Trek* episodes, a figure comparable to *The Avengers'* Emma Peel or *Aliens'* Ripley. This reception history argues against the sharp ideological distinctions which text-based critics make between *Star Trek* and *Star Wars*, pointing to the ways that the utopianism of science fiction may emerge as much from the audience as from the producers.

So Jenkins argues that audience activism and cultural production realizes the utopian potential of a wide array of popular culture texts, *Star Wars* as well as *Star Trek*, as they are read through the community's own traditions and in relation to its own emotional needs:

> Fan culture finds that utopian dimensions within popular culture are a site for constructing an alternative culture. Its society is responsive to the needs that draw its members to commercial entertainment, most especially the desire for affiliation, friendship, community.... The characters in these programmes devote their lives to goals worth pursuing and share their hours with friends who care for them more than life itself. The fans are drawn to these shows precisely because of the vividness and intensity of those relationships; those characters remain the central focus of their critical interpretations and artworks.[54]

Jenkins notes, for example, how filk music, the folk music of science fiction fandom, builds upon the genre's traditional roots in technological

utopianism to frame songs in support of the American space programme. These songs operated according to basic ideological oppositions:

> These choices are posed in different ways: for instance, the choice between apathetic acceptance of man's decline and a forward movement to better worlds of tomorrow; for others, the choice between missiles and rockets, war and peaceful exploration. One side, that most often attributed to the mundanes [non-fans], represents postmodern cynicism and complacency; the other embodies the fan's passionate faith in human progress.[55]

Jenkins argues that like many concepts that circulate within the fan community, the fans' support of the space programme is 'ideologically impure, combining concepts of enlightenment philosophy with a radical critique of consumer capitalism and military expansionism'. Such a conception of technological progress provides fans with a basis for criticizing the militarism of the Reagan-Bush 'Star Wars' weapon programme as 'a fundamental betrayal' of the high ideals of the space 'mission'. 'It is a corruption of the "final frontier"; it holds no faith in the future and substitutes destructive bombs for utopian spaceships.'[56]

Drawing on de Certeau, Jenkins writes of the 'textual poaching' by these 'discriminating' SF fans. He suggests that fan activity reflects both a fascination with media content (which leads them to continue to work with and upon the original programme material) and a frustration with the producer's inability to tell the kinds of stories they wish to see (which results in their progressive rewriting of the programme ideology as the characters and situations become the basis for their own subcultural activity). In contrast to Russ's notion of 'emotional addiction', Jenkins offers a more empowering audience psychology – of 'emotional realism', as shown, for example, by the 'military wife who approved of the new *Star Trek* policy of "taking the family along". "Sure, there may be danger, but I'd rather face them with my mate instead of waiting safely planetside." '[57] Here, Jenkins says, the 'interpolation of the personal and the experiential into the realm of the fictional helps to cement the close identification many fans feel with series characters and their world'.[58] As with the critical theorists discussed earlier, there is an emphasis here on audience identification with *Star Trek* characters. But this time the stress is on the 'lived experience' of the audience, who are no longer seen to be in a 'drug-like' state; and, as in feminist science fiction, the home and family are seen as models for community feeling.

This type of 'emotional realism' stands, Jenkins argues 'at the point of intersection between textually-preferred meanings and larger social ideologies',[59] so that *Star Trek* originator Gene Roddenberry's 'much touted utopian vision' of the future offers fans a way of thinking about their own social experiences, giving them

a basis for making critical judgments about their own social situations, for recognizing earthly injustices which might be unacceptable in the realm of Starfleet, for proposing new ways of structuring gender relations based more fully upon notions of equality and acceptance of difference.[60]

This degree of emotional play between the values of the text and a fan's own social experience can lead to the ironic situation, Jenkins notes, where a series text like *Star Trek* which in many cases gave them their initial exposure to abstract notions of justice, equality, cultural difference and human progress, is criticized by fans for not being responsive to their changing beliefs about sexism, racism and so on. In this way, fans can become increasingly critical of the producer's failure to conform to their understanding of the series' ideological commitments. This ideological revisionism surfaces, for example, in the fan novels of Jane Land, whose reconsideration of *Star Trek*'s sexual politics is a focus of Chapter 10.

So, if Goulding, Elkins, Dunn and Fiske are primarily concerned with the *subject positioning of SF audiences*, Jenkins's emphasis on the *fan-made* 'poaching' and refashioning of texts, raises questions about SF audiences themselves and about the potential for empowering discourses among them. How then can we reconcile these two views of the *Star Trek* audience: Goulding's compulsive consumers 'like drug addicts' and Jenkins's empowered citizen-'utopians'? We will examine that question in terms of different audiences later in the book, but will look first at textual theories which suggest that the texts of *Star Trek* actually *invite* this contradiction.

IDEOLOGY AS UTOPIA: 'THE OBJECTIVELY AMBIGUOUS TEXT'

Buxton notes that the Adorno/Benjamin opposition has also influenced the distinctions made *between* popular cultural forms, so that 'for the 1960's counter-culture rock and television were invested with oppositions between "active" and "passive" consumption, "true" and "false" needs'.[61] In contrast to the adult TV audience, their 'minds closed to new ideas and feelings, their bodies slumped in front of the television', music commentators spoke of the young rock music generation 'not only consuming it but creating it'.[62] The distinction here between 'false' and 'authentic' popular culture is similar to Russ's contrast of *Star Wars* and *Star Trek*. But none of these critics (including Russ) has a theory as to how a mass commercial marketplace for rock music or science fiction can *remain* 'authentic' or 'utopian' – Russ simply talks of the industry around *Star Trek* 'originating in the audience itself and commercial exploitation . . . came later'.[63] The fact is that the TV texts of *Star Trek* were always highly

commercial; yet (in Russ's and Jenkins's view) were always also utopian. As Jenkins argues, the texts of *Star Trek* helped to awaken fans to the politics of equality and acceptance embodied within the programmes' IDIC philosophy ('Infinite diversity in infinite combinations') and Prime Directive (Starfleet's non-interference clause). How can we displace this *Star Wars* versus *Star Trek* formulation in a way that is neither totally preoccupied with the structural positioning of the passive viewer by the text, nor opts simplistically for an 'active audience' position which to all extents and purposes implies a subject independent of the text?

Terry Lovell has argued that popular television inevitably carries, as well as the dominant class interests of its producers, use-values which its mass audience seeks in its entertainment. 'Among the latter will be those expressing the hopes and aspirations of the dominated which are thwarted under capitalism and patriarchy.'[64] Buxton takes this point further:

> By virtue of the fact that it must rally a mass trans-class, trans-gender audience around a *positive* project – at once economic and ideological – which is neither reducible to, nor explicitly against, dominant class interests, the series cannot be seen in monolithic terms as the 'perfect' expression of a dominant ideology.[65]

It is via this understanding of an objectively ambiguous text that Buxton theorizes the utopian possibility of a popular TV series like *Star Trek*.

> The defence of what are ultimately narrow class interests is displaced on to generalised popular values like the family, friendship, security, sexual and racial equality, worthy values which command a wide consensus. As Fredric Jameson argues, 'all ideology in the strongest sense ... is in its very nature utopian'.[66]

In other words, instrumental rationalism is not the complete and closed-off meaning of the popular science fiction text.

There is therefore more textual tension, less ideological certainty in Buxton's analysis of *Star Trek* than Goulding's. Buxton draws here on Macherey's textual theory, arguing that series are 'ideologically vulnerable as previously convincing strategies and resolutions fall apart under the weight of their own internal tensions and strains arising from the failure to close over problems completely'.[67] As Macherey argues, since myth *chooses* the social contradictions which it can resolve, by the same token it is forced to ignore contradictions which it cannot resolve within the narrative structure it establishes. This is the 'structured absence' of myth.

> A text exists as much by *what it cannot say*, by what necessarily produces fissures and strains within it, destroying its internal harmony.... The series often gestures to what it cannot say, or is unwilling to confront further, in throwaway lines and verbal slips, in

other words, in scenes which fill out, but are incidental to, the main narrative.[68]

In Buxton's analysis of *Star Trek* there are three important formal elements derived from Macherey's argument:

(1) an ideological project or strategy which the narrative attempts to illustrate; (2) an assemblage which brings together and organises the concrete elements needed to realise the project; and (3) the narrative itself which involves setting the assemblage in motion. It is in the interrelation of these formal elements that the major strains and tensions of a text occur.[69]

Star Trek's ideological project, in Buxton's view, was to maintain a static, conservative conception of human nature which depoliticizes present-day moral dilemmas: 'an optimistic version of a universal human nature (in its puritan American form) can be upheld while the problems of the twentieth century (in first place, the Vietnam War) can be displaced on to others'. Despite the series' constant promise to 'go where no man has gone before', its universe is 'fixed forever so that the historical and mythical past states of Earth can be represented by others. . . . Each alien race encountered serves only as a philosophical sparring partner for the series' republican moralising.'[70] Based on an intuitive and unchanging concept of human nature, this assemblage operates according to

an ultra-empiricist conception of science as a giant accumulator of facts. With all existing knowledge stored in the computer, scientific method is child's play, the tautological movement from facts to deductions back to facts again. It is little wonder that human nature is the ultimate scientific object, continually 'proving' itself in its confrontation with reality and serving as a 'theory' for explaining it. Everything that can be known not only will be known but, in its broad outlines, is already known: human nature can only be proved over and over again, setting absolute limits to scientific progress.[71]

Thus, challenging Fiske's argument, 'good' and 'empiricist' science are fundamentally equated; since 'neutral' observation repeatedly confirms what we knew about (United States) 'human nature' all along.

It is in its narratives that *Star Trek* encounters what Macherey calls the fissures in its problematic, the cracks and tensions implicit in its assemblage. In the episode 'The Ultimate Computer', for instance, a scientist invents a computer which can virtually replace the whole *Enterprise* crew, making redundant the conquest of space – that 'logical extension of a forever expanding free enterprise system'.[72] As Buxton analyses the episode, the series' consistent linkage between science and human nature, which bridges between its technological utopian future and our

present-day problems, collapses: 'In the inevitable conflict between scientific change and a human nature which cannot change, it is the latter which is affirmed, forcing the series to renounce the very basis on which its utopian future is constructed.'[73]

But this is a renunciation that costs the text dearly; cracks have opened up between *Star Trek*'s assemblage and its narratives. A particularly clear example of this is the episode 'A Private Little War', where the *Enterprise* crew arm a hitherto totally peaceful people (despite the Prime Directive of a non-interference treaty) because the Klingons have done the same. Kirk has already told the villagers that the *Enterprise*'s mission is to ensure that Earth's own past violence is never reproduced on this planet: 'So that peoples can finally evolve without war and without weapons.'[74] Yet, as Buxton says,

> the actions of Kirk on the planet and the justifications he gives for them are in total contradiction with this ringing declaration: if humans have been able to eliminate war from their own planet, they are totally unable to prevent it on others.[75]

In almost throwaway lines which nevertheless reveal the tensions in *Star Trek*'s ideological project, Kirk says, 'It's not what I wanted, it's what had to happen.'[76] Closely premised on the United States' ideological rationalizations for first arming and then fighting for the South Vietnamese against the Russian/Chinese-armed Viet Cong, *Star Trek* betrays its own utopian mission.

Buxton's use of Macherey's 'textual problematic' has several advantages over some of the 'social control' theories of science fiction that we discussed earlier. First of all, it grounds its theory in history and social change: for instance, Buxton can point to later series like *Miami Vice* as representing a *new* problematic, and *new* fissures between ideological project, assemblage and narrative. In contrast, and for all their talk of *Star Trek* responding to the specific historical problems of the 1960s, analyses like Goulding's which emphasize the overweening power of commoditization, instrumental rationality and the passivity of 'spellbound' audiences[77] are curiously static and passive. These largely ahistorical readings often lead as Buxton says, 'to a stigmatising of the very mass audience in whom hopes for political change were placed'.[78]

Second, though Goulding does finally talk of *Star Trek* as 'replete with contradictions',[79] he offers no theory to explain this. Similarly, Russ offers little in the way of theory to explain the 'utopian possibilities' of *Star Trek*. What Buxton's Machereyan approach offers is a theory which examines these issues both formally and ideologically. Thus, third, it suggests formal, *textual* spaces which invite an 'active audience' process of working on the text, without resorting to the populist 'subject who is independent of the text'[80] of much that passes for viewer-centred theory. It helps

explain both the 'initial exposure' in utopian ideas that *Star Trek* gave to fans and their dissatisfaction with it, which Jenkins discusses.

FEMINIST READING POSITIONS

As we have seen from Robin Roberts's analysis, feminist science fiction and utopian writing have extended the 'objectively ambiguous text' by reconstructing the genre in opposition to the male-dominated 'grand narrative' of science. Does this feminist work, and the establishing of new feminist reading positions through it, have any significance for *Star Trek*?

In *Feminist Fictions* Anne Cranny-Francis argues that 'Feminist generic fiction, like socialist generic fiction, is a radical revision of conservative genre texts, which critically evaluates the ideological significance of textual conventions and of fiction as a discursive practice.'[81] Cranny-Francis's emphasis here on textual conventions and discursive practice adds one important theoretical element to Buxton's analysis of textual ambiguity and reading positions: the setting up of *new subject positions* by the deconstructive science fiction text.

Cranny-Francis distinguishes between *reading position*, which is 'the position assumed by a reader from which the text seems to be coherent and intelligible',[82] and *subject position* – for instance, the feminist subject position constructed by feminist discourse outside the text, which is 'predicated on the experiential recognition of contradictions and injustices generated by the dominant gender discourse of patriarchy'.[83] 'Reading position' is the textually inscribed audience; and Cranny-Francis agrees with the 'negative critique' theorists discussed in this chapter that conventional science fiction, with its central emphasis on 'entrepreneurship, courage or enterprise',[84] establishes reading positions which are colonialist, sexist and bourgeois. Cranny-Francis's feminist 'subject position' has also been pointed to previously for science fiction audiences; for instance, by John Fiske when he talks of 'feminist oppositional readers' of *Doctor Who* bringing to bear on it 'their extra-textual experience'.[85]

However, Cranny-Francis goes beyond this standard 'oppositional decoding' position to examine the ways in which formal ambiguities in the text can be reworked to establish both a feminist authorial practice and a feminist reading position for the audiences of science fiction. Drawing on Jameson, she argues that 'it is difficult to find a text which does not exhibit some characteristics of other genres, for example romance conventions in detective fiction, SF or utopian fiction'.[86] Consequently a text

> is not a coherent, organic whole, but a symbolic process or act harmonizing heterogeneous generic conventions, including narratives, each with their own ideological significance.... The convention itself thus

becomes the site of ideological contention. The multigeneric nature of many texts is merely a complicating factor, as writers, readers and critics are implicated in a more complex negotiating process – a process in which generic discontinuities mobilize ideological contestation in which the tenuousness of conservative ideological positionings may be recognized and from which new meanings may be constructed.[87]

Even in feminist science fiction, then, the ambiguous text remains, according to Cranny-Francis; and similarly Robin Roberts criticizes the 'essentialism' of early feminist utopias in contrast to the greater 'ambiguity and difference' of feminist science fiction.[88] 'Feminist utopias resolutely idealize all-female societies, while feminist science fiction depicts conflicts between opposing points of view',[89] including those of gender, race and class. Like Buxton, then, Roberts and Cranny-Francis point to the ideologically ambiguous nature of the science fiction text. But Cranny-Francis and Roberts take this further to indicate ways in which this ambiguity can be exploited to generate new, radical reading positions. Conservative textual practice, Cranny-Francis argues (echoing the 'negative critique' school), resolves contradictions: 'many Mills & Boon romances, for example, voice a feminist discourse which is subsequently devalued by being associated with a particularly unpleasant character or with the temporary misjudgment of the main female character'.[90] Similarly, Robin Roberts points to the way in which dominant female alien positions on the covers of pulp SF magazines were recuperated by 'the ends of the texts' where 'the female is put in her proper place, subordinated to the male characters'.[91]

But, Roberts and Cranny-Francis also argue that an oppositional aesthetic can work *through* an understanding of this textual practice. Roberts points out that many feminist science fiction writers were brought up on the pulps; and it was through the pulp magazines' portraits of powerful female aliens that science fiction transmitted to later feminist writing this 'notion of female empowerment'.[92] Cranny-Francis shows how feminist science fiction re-works and deconstructs what Macherey calls the 'assemblage' of the genre. Thus the sexist and colonialist knowledge implications of science and technology in science fiction may be challenged; the conventional SF device of estrangement can be used to identify women *as* alien, as other, rather than as a sexual prey to aliens; science fiction's convention of extrapolation can draw attention to the contrast between the utopian possibilities of a future world and the sexist power relations of our own; the linear quest narrative typical of science fiction (where the tough male hero gains the helpless, passive female victim/prize and/ or the alien race) can be employed, but then deconstructed by ensuring that the only way to make sense of it is from a feminist reading position.

Feminist SF often uses the quest narrative structure, but avoids the

cliché by building it (the cliché itself) into the story and deconstructing it as part of the text. The process of this deconstruction then becomes the process of construction of the feminist reading position, which is the major political strategy of the feminist science fiction text.[93]

Feminist science fiction exploits textual ambiguity by reflexively drawing attention to the conventions of the genre, and re-working them into a feminist reading position. At this point reading position and feminist subject position become one – where the only coherent and comfortable way of understanding the text is from the feminist subject position. Alternatively, the postmodernist science fiction text (epitomized for Robin Roberts by Ursula Le Guin) may elide the binarisms of male/female, high art/popular culture, hard/soft science to establish multi-vocal reading positions, which, while still critiquing patriarchy, will 'perplex, challenge and engage their readers'.[94] Postmodern feminist science fiction focuses on 'the deconstruction of patriarchal language and the construction of an alien language that does not stress hierarchy or any of the conventional, scientific ways of describing reality available to humans'.[95] Roberts describes Le Guin's postmodern emphasis of juxtaposing conflicting languages and discourses to induce textual polyphony, her use of a non-linear narrative, and her challenge to (in Irigaray's words) the 'excessively univocal' grand narratives of patriarchy.[96] Multi-vocal reading positions are established in Le Guin's *Always Coming Home* by a critique of linear directed time and space which draws on both native American culture and on feminism. But 'Le Guin's choice of words makes it clear that it is the masculine arrow being left behind and the masculine perception of linearity and univocality that is being rejected.'[97]

So where does this leave the more ambiguous ideological texts of science fiction that we have been discussing in this chapter? *Star Trek*, *Star Wars* and *Doctor Who* hardly seem to be texts that establish feminist (or other radical) reading positions in this way.

Cranny-Francis is as negative about *Star Wars* as Goulding:

the society of *Star Wars* is, in all but the most banal senses, contemporary American society. The reading position constructed is that of a political conservative, who accepts the dominant ideological discourses (of gender, race, class) of contemporary society as unproblematic, commonsense and natural.[98]

Like Joanna Russ, she ignores the potential of *all* texts (including *Star Wars*) for textual poaching, while seeing progressive elements in *Star Trek*. She emphasizes particularly *Star Trek*'s use of the SF conventions of estrangement and 'of the *alien*, the character from another planet through whose eyes we are given a different view of our own society':

Star Trek was more politically aware than most of its contemporaries

and made frequent use of aliens for the purposes of estrangement, most notably with the character of Mr Spock. Although the political commitment of particular episodes depended on the writer for the week, the Spock character was frequently used to comment on the organization of human society, his alien view showing it from a different perspective, pointing out injustices or discrimination.[99]

By way of Cranny-Francis's analysis, we can begin to answer our earlier question as to how a mass commercial product like *Star Trek* can *remain* utopian. First, certain key conventions of the generic assemblage, such as estrangement and 'the alien', have been used consistently to point out injustice and discrimination in our own time. Second, as Henry Jenkins has pointed out, female fans of *Star Trek* have, in fan magazines, gone further into the utopian than the text itself, transforming Spock himself and the series 'into women's culture, shifting it from science fiction into romance, bringing to the surface the unwritten feminine "countertext", and forcing it "to respond to their needs and to gratify their desires" '.[100] These female fanzine writers, thus, re-position the play of generic ambiguities and contradictions that Cranny-Francis talks about, but in this case *outside* the televised text. Third, in some cases, there is a utopian *return* to the commercial texts of *Star Trek*, as female fanzine writers like Jean Lorrah are commissioned as professional writers of the *Star Trek: The Next Generation* novels.

Jean Lorrah's work as audience member *and* author (both as fan and professionally) is a particularly good reminder of the Benjamin position that modern media technologies *can* be engaged with to open up a collective struggle over meanings. It also reminds us that when we speak of the 'texts of science fiction' we need to look further than a textual analysis of series like *Star Trek* and *Doctor Who* that is based on the selection of particular episodes by academics like Goulding, Buxton, or indeed ourselves. The 'texts of science fiction' include, in the case of long-running series like these, many different political inflections by different writers and production personnel. The *Doctor Who* episode 'Kinda' was, for instance, based on one of Le Guin's multi-vocal texts, *The Word For World Is Forest*; and although many changes were made to the notion of conflicting discourses and indeterminate narrative by a director who *did* make distinctions between high and popular culture,[101] much that Roberts describes as feminist and postmodern did remain: the critique of the 'arrow' of male time, science and militarism, the powerful woman as alien, the non-violent, communal, all-female utopia which values cooperation, communication (via telepathy) and harmony with nature, the uncertainty of space and non-linearity of time, and the critique of the excessively univocal male 'voice'.

Across a range of science fiction texts, then – fan writings, feminist

fans' rewriting of the commercial novels of *Star Trek* and *Doctor Who*, and feminist traces of science fiction and the postmodern in the televised texts themselves – a distinctive challenge is made to the male scientism and controlling grand narratives of our culture.

Chapter 3

The changing audiences of science fiction

John Tulloch

Para science fiction is a type of writing which is energised by the sudden popularity of science fiction among a new class of readers . . . an adaptation and updating of the old-fashioned space opera type of science fiction for the tastes of middle class consumers whose passion for gadgets is inexhaustible. . . . This type of science fiction has the tendency to leave the literary altogether and move into TV serials, films and comic strips.

(Teresa Ebert)[1]

This chapter parallels Chapter 2, in so far as that chapter surveyed theories of the science fiction text and this one surveys analyses of the science fiction audience. As we shall see, though, we should speak of 'audiences' rather than 'audience', particularly given the variety of media that carry SF. The fact that there are now a number of science fiction subgenres, each potentially with its own audience, extends further the possibility for readings 'against the grain' of the instrumental rationalism, discussed in Chapter 2, and hence develops our theme of ambiguity and resistance to the genre's dominant values.

Broadly speaking, there have been two main ways of conceptualizing the development of science fiction audiences: diachronically, that is, tracing historical changes in the constitution of its audiences over time, which includes looking at the developing connections between literary, film and TV science fiction; and synchronically, which is to emphasize the divisions into subgeneric fans of science fiction at any one time. Although there has been more systematic analysis of the diachronic kind, I will flesh out the synchronic analysis later in the chapter with a small audience study of science fiction fans conducted in the 1980s.

DIACHRONIC ANALYSES: THE DEVELOPMENT OF THE SF AUDIENCE

The nature, attitudes and values of early science fiction audiences can be measured by the changing responses to one of SF's founding fathers,

H. G. Wells (from whom, of course, the time-travelling idea for *Doctor Who* came). Initially, it was the social realist aspect of Wells that critics noticed most. Like other 'scientific' realist writers such as Zola and Chekhov, Wells was criticized by conservative reviewers for his zeal as 'a sanitary inspector probing a crowded graveyard'.[2] At this time, the social forecasting aspect of Wells's SF was generally regarded as a tiresome accretion on grippingly 'enjoyable and gruesome' Gothic romances.

But with the growth of new popular SF magazines in the 1920s, a new readership was generated. As Christopher Priest has noted: 'Science fiction did not exist as a discrete literature until Hugo Gernsback created *Amazing Stories* in 1926.'[3] It was in the pages of *Amazing Stories* that the scientific and socially predictive aspects of Wells's work came to the forefront. 'Gernsback's dependence on Wells was almost total: in the first three years he published no less than seventeen of Wells's short stories, and serialized six of his novels! So it was that Wells inadvertently helped create the modern science-fiction idiom.'[4]

Because of the 'ghetto' quality of popular commercial SF magazines which 'attracted writers who wrote specially for them, imitating each other and influencing each other', and because 'it was Wells' stories, some of which were more than thirty years old, that provided the original',[5] these short works of Wells now began to define the new popular SF genre. It was this new group of writers and readers in the popular journals of the 1920s who constituted 'Wells' as *science fiction* 'author', and who in doing so established themselves as the earliest SF 'audience'.

The appropriation by audiences of the author 'Wells', then, is determined by the conditions of reception in specific social conditions. Wells's earlier readership was the middle-class audience of general magazines like *Pall Mall Budget* and *Strand* (where the Sherlock Holmes stories first appeared), and it was the safer 'gripping' Gothic romance rather than the socially critical Wells who was appropriated by the critics as suitable for this broad clientèle. For them, this was 'H. G. Wells'. But in the new and popular SF magazines of the 1920s and 1930s, the *social prediction* element came to be seen more centrally as the 'Wells' signature.

Many observers both then and later (as we will see with the MIT fans) argued that what turned young people to SF magazines was 'the discrepancy in the world they lived in, sociopolitically a failure ... but technically and mechanically a brilliant success'.[6] Clareson has argued that the men who created and expanded the SF magazines, at least until the end of the 1930s, 'believed that science, technology in particular, gave me the tools with which to remedy the ills of society and advance it towards ... perfection'.[7] This drew strongly on Wells's own prediction, of the evolution of a rational scientific elite; and in the 1930s and 1940s there seemed to be some evidence, Gerard Klein has argued, that Wells's 'planned' society was actually being built, as the development of managed

capitalism developed apace 'on the ruins of a waning bourgeois liberal society'.

> During this time, the benevolent imperialism of the USA was directed against reactionary and militarily aggressive societies. Also, the needs of reorganizing production and waging war led the ruling class to adhere without reservations to technological values. The social group of SF could therefore believe in a universal rational society, where all conflicts would be solved in the scientific fashion to which this group pinned its hopes, and, above all, within which it thought it would play a decisive part.[8]

This was the beginning of the rise of 'managed capitalism' and the ideology of scientism that Dunn describes. Many SF readers came from the scientific/technical parts of the workforce, and as Berger and Klein have both argued, even if the majority of SF readers did not actually have a genuinely scientific education, they did 'entertain a specifically intimate relationship with science and technology either in their professional activities or purely in their ideology'.[9] Even in the 1970s, Berger found that:

> The science fiction community's perception of itself as better educated and more heavily involved in professional and technical employment is accurate. . . . Even if fans are inflating their occupational status, they strongly share a professional consciousness bolstered by at least the impression of an almost anachronistic sense of independence and freedom from constraint on the job.[10]

And most recently, in 1992, Jenkins found in SF fandom a deep ideological commitment to the 'search for technological utopias, a fantasy of human progress which facilitates their critiques of their own contemporary surroundings'.[11]

Klein also points to evidence of the homogeneity of the SF audience as a social group (especially in its early years), and adds that:

> Without much risk of error, this group can be classed as liberal with all the economical and political connotations conveyed by this vague term: a formal legality in the political process, tolerance, and a quite strong decentralisation – all of which leaves large scope for, and is indeed the obverse of, the quite primordial competition of production units.[12]

According to this argument, the emphases on intellectual leadership, a liberal politics and an educated audience were carried (from the era of Wells's time machine to the early 1960s beginnings of *Doctor Who*'s time travel) by an unusually homogeneous and stable subcultural group: the SF writers and fans. But by the 1960s, this group had become (in the view of Klein and Mellor) a sadly impotent shadow of Wells's scientific elite.

It discovered a new pessimism during the 1960s and 1970s as monopoly capitalism developed and as, Klein notes, corporate executives 'learned how to control – efficiently and not without brutality – scientists, technicians and other intellectuals, rather than coming to terms with them'.[13]

For Klein the pessimism of recent literary SF, and its preoccupation with near-feudal human relations, marks less the ritually repeated 'liberatory' moment of early capitalism discussed in Chapter 2, than the recognition by the technologically oriented group that scientific research and information can be easily coopted by big business. It could more readily spread human control and environmental degradation, than create a rational utopia with themselves as the intellectual elite. Symptomatically, perhaps, *Doctor Who*'s elite world of Time Lords (who are intellectually and scientifically far in advance of all other planets) is, by the early 1970s, a passive and somewhat effete world – watching, not acting in, the affairs of other civilizations.

But Klein is primarily analysing what Ebert calls 'mimetic' or 'literary' science fiction. Clearly the development of a pessimistic 'literary' SF by no means covers the full post-1950s' spread of science fiction and its audiences. On the one hand, SF's feeling of pessimism spread to a much more diffuse array of audiences, as SF fans came increasingly from the 'soft' social sciences and arts, concerned with the bleakness of a world determined by scientific capitalism; and some of these fans then became (as Robin Roberts shows) the much more positive writers of feminist science fiction, where the soft sciences and art became new sowers of morality, community and female power. On the other hand, a new film and television SF community has grown which (if Elkins and Dunn are right) perhaps finds little fault with the instrumental rationalism of organized capitalism or with its representation in films like *Star Wars*. As we will see (especially in the case of the MIT fans), there is still an 'optimistic' professional/technological audience for TV science fiction; although Jenkins argues that its members have a complex relationship with the institutions of power: 'their sense of commitment to NASA justifies their moral claims to challenge its fulfillment of those goals, providing a basis for opposition to government practices'.[14] Here again we find the ambiguity of social cooption and utopianism.

SYNCHRONIC ANALYSES: THE SUBGENRES OF SCIENCE FICTION

Clearly, the audience for modern SF is now broad enough to interact with the utopian, socially predictive aspects of Wells via a variety of subgeneric readings, each potentially with its own discrete audience. Teresa Ebert has, as we have seen, pointed to three distinct 'streams' of SF and audience. Ebert is especially dismissive of what she calls the

'para-science fiction audience'. Her reference to this audience for popular film and TV science fiction as 'consumers' is significant, consigning it to something akin to the passive dupes of 'negative critique' theory. And, notably, the distinction Ebert makes between 'mimetic' (or 'literary') SF and 'para' (or 'gadgetry') SF is one which many of our (particularly British and Australian) audience groups made between *Doctor Who* and 'American' TV science fiction. But *Doctor Who* has also had its period of 'meta' science fiction when Douglas Adams was script editor; as well as its traces of postmodern feminist SF, as we mentioned in Chapter 1. In fact, over the twenty-five years of its history *Doctor Who* has played across 'literary', 'meta' and 'gadgetry' schools of SF. It is arguable, then, that a long-running series like *Doctor Who* or *Star Trek* tries to target and access different 'streams' of SF audience at different times.

It does seem to be the case that different writers for the show position themselves in relation to these various schools or 'streams'. For instance, Christopher Bailey, writer of the 'Le Guin/postmodern' *Doctor Who* episode, 'Kinda', positioned himself quite consciously within 'quality' or 'literary' SF (in contrast to both 'meta' and 'para' SF).

> I don't go along with the Douglas Adams school of science fiction where you sneer at it and are clever. But the fact is that millions of people round the world read science fiction that contains very, very sophisticated concepts. . . . And that could be our audience for *Doctor Who*. . . . If you look at writers like Ursula Le Guin, they are dealing with very, very advanced ideas. The gadgetry school of science fiction in novels ended thirty years ago – it's a fifties thing.[15]

This kind of perceived division of science fiction across *different reading positions* may explain what otherwise appears as a contradiction among the different accounts we have so far examined. Whereas Dunn sees the pessimistic 'Frankenstein' image of science being replaced by the positive 'organisation/technological gadgetry' image at the beginning of the 1960s, Klein sees 'optimistic' SF being replaced by pessimism at the same time, and Bailey talks of the gadgetry school of SF *ending* in the 1950s. What seems to have happened is that it was *para*-science fiction texts which (very broadly speaking) became part of the ideology of scientism that Dunn describes, while it was 'literary' SF which became more pessimistic (as Klein says) after the 1950s. It is *here*, as Adrian Mellor describes, that we should primarily look for SF's 'tragic vision' and a very particular SF audience in the 'dominated fraction' of the middle class.

> Our thesis must be that science fiction remained culturally marginalised for just as long as it continued to embrace science and technology, and to view the future with optimism. To the extent that it abandoned this world view, embracing instead the values of pessimism and tragic

despair, so it was in turn embraced by the 'dominated fraction' of the dominant class. For the 'tragic vision' whose origins can clearly be discerned in SF from the 1950s onwards, is itself expressive of core values of the educated middle class. Mainstream culture's new interest in SF, the vast growth of college science fiction courses in the United States, the advance of certain SF texts to the status of cult objects within the (middle-class) hippie counter-culture all this becomes explicable as a meeting of ideological minds. It is not the educated middle class that has changed, it is science fiction. The retreat into pessimism and cosmic despair is viewed by the dominated fraction of capitalism's dominant class as a maturation, a welcome end to the isolation forced upon a subculture by virtue of its faith in the future.[16]

Mellor's thesis about the SF audience rests on two points. First, he argues (following Bourdieu) that there is a division within the bourgeois class

between the dominant fraction which is concerned with the sphere of production and which reproduces itself through material capital and, on the other hand, the dominated fraction which exercises symbolic power, and therefore reproduces itself through the use of cultural capital.[17]

Given the dominant fraction's orientation to economic production and the dominated fraction's (intelligentsia's) defence of the legitimacy and value of cultural capital, this latter group 'always exists in tension' with its masters. Its 'very existence depends on the continuation of the existing structure of capitalist society, but the basis of that society in material production fundamentally challenges the values upon which the group's claim to social privilege rests'.[18] Thus, unable to resolve 'an unresolvable contradiction', this group's social position constitutes 'the rebirth of "tragic" world vision'.[19] Here Mellor is referring to Lucian Goldmann's concept of the tragic world view, which the latter applied to the *noblesse de robe* and Racine's theatre in the centralizing state of Louis XIV's France: like Mellor's intelligentsia, this group depended on a dominant order (in this case, the king's) which was rejecting their values, and the tragic world view helped them adjust to this contradiction.

Mellor's second point is that just as long as science fiction was the preserve of the 'scientifically and technologically oriented middle class' (with its optimistic belief in its own future as the ruling elite of a rational, scientifically organized society) it belonged to a 'sub-culture' of the educated middle class which was not typical (in its values) of that fraction as a whole. But just as soon as the scientific/technological group lost hope (as, in Klein's words, they were 'allotted the role of an instrument rather than that of an animator'[20] of the new social order), so then science fiction 'returned home' to the broader educated middle class.

In these terms, those SF dystopias of the 1950's which Klein considers to have been atypical take on a new significance as visible indices of the processes at work. For it is precisely these works of science fiction which gained an audience beyond the usual readership of 1950's SF, and which, even up to this day, have been accorded some measure of acceptance by the dominant culture. Amongst the earliest products of the SF ghetto to achieve academic respectability was the work of Ray Bradbury, and it is significant that *Fahrenheit 451* presents a dystopian vision of a future whose chief characteristic is the systematic attempt to extinguish literary culture.[21]

Extrapolating from these theorists of the history of SF and its audience, we may perceive at least two broadly different 'fandoms' for SF: first, those from the tertiary educated middle class (perhaps incorporating the technological/professional group as they recognize themselves as cogs of instrumental rationalism, but now an audience increasingly with degrees in the 'soft' social sciences) who enjoy 'literary' SF (whether 'mimetic' or 'meta' SF); second, those identifying with the 'dominant' fraction of the bourgeoisie, and those wholly in tune with what Dunn perceives as the collusion between organized capital and the ideology of scientism in popular TV drama. However, Mellor also draws on Darko Suvin's theory to point to a further distinction – this time *within* Ebert's 'literary' SF category – which allows for a *radical* science fiction.

In so far as SF is an 'estranged' literature (the term is borrowed from Brecht and the Russian Formalists) then it is to that extent differentiated from literary 'realism'. SF presents us with a 'novum', 'an exclusive interest in a strange newness', which acts as an equivalent to the 'alienation-effect' of Brechtian theatre. It is a non-naturalistic device that produced in its audience an 'astonished gaze'. Rather than drawing us into the world of the story through the narrative conventions of realism, an estranged literature makes us aware of the narrative as a constructed artefact. It induces critical evaluation of the ideas it presents, rather than their unconsidered acceptance.[22]

This is also where Roberts and Cranny-Francis position much of feminist SF – and it is clear from her comments on *Star Trek* that Cranny-Francis does not confine 'estranged' science fiction to 'literary' SF.

In fact, examples of the 'alienation-effect' have existed in SF from the beginning, complicating the 'social control' explanations of Elkins *et al.* Wells, for instance, tended to radically disturb his readers' positioning. When, for instance, the bourgeois reader's identification with (Earth-white) 'us' against the alien 'them' in *War of the Worlds* was suddenly reversed, it became clear that Wells was comparing the Martian invasion of Earth with the British genocide against Tasmanian aboriginals. Simi-

larly, it became apparent in *The First Men in The Moon* that the narrator's description of the monstrously 'functional' culture of the Selenites was in fact a comment on the social reproduction of the English class system.

Precisely *because* of its origins in a reforming, professional middle class, science fiction as a genre has always included a tendency to convey a critical or utopian 'ideal possibility' to its readers via realist forms. But what was an optimistic tendency in upwardly mobile 'scientific' realists like Chekhov and Wells, became more desperate and despairing later. Elkins argues that 'with the rather abrupt loss of power and privilege of the professional-technocratic élite', the ensuing 'crisis in confidence' precipitated in SF an exploration of 'the possibilities of action and what it means to act in a specific role'.[23] At their worst, SF novelists in the recent period 'parallel the attitude of the bourgeois scientist, refusing to go beyond description and concentrating on uninterpreted phenomena. Usually, this stance produces a crude naturalism, with its counterpart, sensationalism.'[24] Or,

> unable to assent to superficial solutions which depend upon the con-tinuance of the present social order but unwilling to confirm the dire prophecies of their colleagues, more and more writers are taking refuge in quasi-mystical solutions which eliminate man ... the popularity of works such as Clarke's *Childhood's End* and *2001* and Heinlein's *Stranger in a Strange Land* suggests a present fascination with this solution.[25]

Stranger in a Strange Land, we should note, is Ebert's example of 'mimetic' or 'literary' SF. But Elkins distinguishes this from the 'best' recent science fiction novels, which, while always eschewing the represen-tation of '*collective action* in social change',[26] have rejected both scientistic naturalism and quasi-mysticism. The recent SF writer is 'less likely to Westernize the future universe. Indeed, from Stapledon's *Star Maker*, through A. E. van Vogt's *Slan* to Ursula Le Guin's *The Left Hand of Darkness*, the main character teaches us the folly of ethnocentrism.'[27] Like Roberts (but with much less awareness of the patriarchal nature of the rejection of 'mysticism' as non-'scientific'), Elkins positions Le Guin at the forefront of socially critical SF.

So, Ursula Le Guin's *The Word For World Is Forest* (on which *Doctor Who* writer Chris Bailey based 'Kinda'), with its strong critique of US imperialism in Vietnam, is by no means an anomaly within science fiction. Social critique – what Angenot and Suvin call the SF which situates itself within the 'general alternative of liberation versus bondage, self-management versus class alienation, by organizing its narratives around the exploration of *possible new relationships*'[28] – is as familiar within recent 'literary' SF as is technophilia and scientism typical of recent science fiction films and TV series.

These analyses of different trends within 'literary SF' point, however, to different reading positions embedded in recent science fiction texts (as between naturalism, mysticism, feminism, critical realism, etc.) rather than analysing varying actual, experiential subject positions within specific audience groups. As Cranny-Francis indicates, certain 'literary' science fiction texts work to *re-position* their audiences rather than appeal to different audiences. Nevertheless, work like Klein's, Mellor's and Ebert's on the changing nature of science fiction and its audiences tends to complicate still further the 'social control' perspective of Goulding, Elkins and Dunn. Rather than the universal (and somewhat de-historicized) reading position, positioned firmly within the ideology of productivity and scientism, we have now the sense of cultural divisions both within science fiction as genre, and within SF fandom. Consequently, we have the potential for shifting subcultural responses among both SF producers and audiences.

Television SF: positioning different audiences

Because of its own positioning within the BBC, *Doctor Who* has always operated at the 'quality' education/'current' entertainment interface which the BBC has found itself in since losing its television monopoly in Britain. On the one hand, this has led in the 1960s and 1970s to a 'state welfarism' inflection of the series – a liberal/left-of-centre position which, for Barry Letts (producer of 'The Monster of Peladon') is the 'naturally' intelligent position to take at the BBC. This could blend easily and imperceptibly with the traditional liberalism of science fiction (hence the 'Women's Lib' speech in Letts's 'Monster of Peladon'). On the other hand, the long-term run of the series has led to a variety of inflections of the show by different producers, frequently adapting the show to currently popular genres (historical romance, gothic horror, meta-SF – each with generically destabilizing possibilities), while no one show has ever looked for only one type of audience. Consequently, even the meta-SF period of Douglas Adams had to adopt a naturalistic generic form; while even the most consensual and institutionalized period of the show (with Pertwee as Doctor) was able to access 'bonus' ideas about environmentalism, feminism, and so on.

As *Doctor Who* script editor Eric Saward said about the 'pacifist' Buddhist ideas in Bailey's 'Kinda' (which, like Le Guin's native American cultural emphasis, were a key aspect of the text's 'multi-vocal' critique of male linearity and 'scientific' concepts of time and progress):

> We are attempting to appeal to a very broad audience of all ages, of all backgrounds.... All the Buddhist stuff in Chris's script, all the symbolism and so on – it's there if you can get it ... if you know about

it. But when weenie children are sitting there, they want a bit of something that will help them along too.[29]

Producer Graham Williams said something similar about his appeal to reflexive 'film buff' audiences via the *Metropolis* references in his *Doctor Who* story, 'The Sun Makers':

> We reckoned that we had a bedrock audience loyalty that we should feed and take notice of ... between six and eight million viewers. ... The rest of the audience we reckoned we could grab on the wing as it were, by tapping into various popular areas.[30]

Similarly, Jenkins notes a number of different reading positions in *Star Trek*: 'the final Frontier' style of SF, the 'buddy' (Kirk-Spock-McCoy) or 'family' aspect (the whole crew), the 'military chain of command' readings common to computer net fans, each with its own 'institutional base of support within fan culture'.[31] As Jenkins says, the 'most popular texts are undoubtedly those which offer "something for everyone", which provides sufficient resources to allow their easy appropriation by each of these diverse populations of fans'.[32] Like *Star Trek*, *Doctor Who* clearly constitutes itself to position several different audiences. How these – in their different subcultures and affiliations – read the show will be a main theme of the next section of the book.

In Chapter 4 we examine audience readings of *Doctor Who* among the two broad social groups focused on by Klein and Mellor in their diachronic analysis of science fiction audiences: technological/professional and social scientific, to examine the currency of their thesis about pessimistic and optimistic visions. We will conclude this chapter with a brief case study filling out the synchronic analysis (as in Ebert) of the audiences for different subgenres of SF to examine whether there are, in fact, different subcultural readings among SF audiences, as between 'para' and 'literary' (including both 'meta' and 'mimetic') science fiction. To what extent is Ebert's characterization of the para-SF fan ('whose passion for gadgets is inexhaustible') confirmed by actual audience readings? To what extent does popular science fiction like *Doctor Who* have a 'literary' SF audience following; and, if so, how does this subgeneric preference influence their readings? For this phase of the audience research, two institutionally distinct science fiction groups were approached: the first was at a 'para'-science fiction convention in Australia of popular film and television; the second was a 'literary' science fiction group who met regularly at Macquarie University in Sydney. In the case of this second group, in order to see their response to more 'literary' and 'meta' *Doctor Who* texts, they were shown Chris Bailey's Le Guin-based 'Kinda' and Douglas Adams's meta-SF influenced 'City of Death',[33] in addition to the more gadget-oriented Pertwee text. Although there is not the space to examine

these audience-texts at length, we will conclude the chapter with our main findings.

'Para'-SF fans[34]

This group was primarily from a technical/technological tertiary or professional background and had a main interest in film and TV science fiction. As Ebert might predict, this 'para'-SF group instantly moved into discussing the special effects and gadgetry in 'The Monster of Peladon':

> Phil: 'First of all, it was one of the better episodes from one of the better stories. . . . There's more action, better effects, and you can't see that it's obviously faked. Everything there – provided you get the technology – could have worked.'

Yet, though their dominant reading discourse positioned them in the 'hard SF' camp (i.e. science fiction as direct extrapolation from known technology), these were by no means the 'mere' para-SF fans of Ebert's put-down. The group in fact skilfully drew on a range of competences. Fan, generic, narrative and industry discourses were woven into a complex explanation which situated their discussion of action and effects. A concern for generically central concepts of SF (e.g. the balance between expansion and entropy, what it means to be alien, etc.) in fact led them to value *Doctor Who* well above the 'much more effects oriented' *Star Wars*. *Doctor Who* (though only when it was seen to match up to the possibilities of its genre) was 'more sophisticated than *Star Wars* will ever be'.

Certainly, the group's science fiction speculation was anchored in 'hard SF' discourse; and as they debated the relative use of technology in the Pertwee and Tom Baker eras, it was clear that what Dunn would see as the ideological dominance of technological rationalism generated real pleasure for the fans. Their sense of the Doctor was as a modern-day knight bringing the 'new principles of physics and mechanics' to the post-medieval world. In Klein's analysis these are the liberal believers in a universal, rational society; and in Elkins's sense, their Doctor is the hero of enterprise, innovation and technology 'liberating static, isolated, feudal societies'. The Doctor, they say, unlike his Time Lord race, is 'prepared to use their technology', thus protecting the 'weak and the ignorant' against 'the overdominant and strong'.

On the other hand, the 'gadgetry' and 'effects' orientation is always mediated in this group by their pleasure in the 'sophistication' of the series – their pleasure, for instance, in the particular bricolage quality of the Doctor's technology ('doing absolutely incredible things out of scrap metal'), or in the especially 'verbal' nature of the special effects.

Phil: 'It's a very class-oriented system that Doctor Who finds himself in.'

Ian: 'Did you notice that the refinery workers in "The Monster of Peladon" had a very low-class English drawl?'

Geoff: 'This provides a recognizable framework. You see, if you characterize them as equal-class English it would not carry credibility to the English audience.'

Phil: 'They're all *verbal* cues. A lot more of the special effects in *Doctor Who* are implied rather than shown directly.'

We will see this emphasis on the quality of *Doctor Who* being verbal rather than visual, something 'you listen to' rather than watch, among the teenage schoolboys.

These fans commonly work through the politics (feminism, class conflict) of 'The Monster of Peladon' via the 'quality' and 'difference' of *Doctor Who* as science fiction. In particular, this displacement of gender and class conflict is rationalized in terms of it being 'a children's pro-gramme for adults': *Doctor Who* works as a drama of reassurance for children and as a reassuring drama of 'balance' (between order and chaos) for adults. The group's focus on technology and progress is, however, itself embedded in political notions of 'making do with what you've got'; and 'opening the minds' is what fundamentally ties their child-oriented and science fiction discourses together. Just as the Doctor 'provides a catalyst', helping the oppressed 'to help themselves', so the programme *Doctor Who*, for these SF fans, provides the assurance of a progressive passage from childhood to adulthood by way of the stimulation of intellec-tual curiosity and non-violence.

Tom: 'It's very similar to the Victorian family, when science and tech-nology were being developed and it was percolating the home, and in quite a few homes the Victorian father would demonstrate the new principles of physics and mechanics that had just been discovered, using things like a teacup and a cane and a nail.'

The Doctor, in this reading, is a 'paternalistic' figure, a 'knight with his squire travelling through and outside Christendom' with his new tech-nology, 'showing that even with the most limited resources you can still come up with something'.

These 'para'-SF fans may not be as simplistically locked into gadgetry as Ebert thinks; but they do accept the patriarchal ideology of science in believing in a liberal and progressive social order based on scientific paternalism and technological curiosity. These are true descendants of science fiction's post-1920s' readership.

'Literary' SF fans[35]

Unlike the 'para'-SF group, this 'literary' group of male and female science fiction fans was primarily Humanities and Social Science trained. As we might expect of members of a university society for literary science fiction, they are as dismissive of 'laser science fiction' as Ebert is. They confidently use both their knowledge of 'serious' SF and their broader literary competence to dismiss 'Kinda' as 'stale', 'soapy' and 'lifted'. Over the course of the audience project 'Kinda' was shown to many groups, but this was the only audience group to recognize its origins in Le Guin.

Jan: 'The dream sequence was very like *Waiting for Godot* type stuff, isn't it? It's theatre of the absurd rather than science fiction at that stage.'

Joan: 'It reminded me a little bit too of *Through the Looking Glass* sort of thing. . . .'

Jan: 'I think it is science fiction, poor science fiction. . . .'

Jan: 'It reminds me of very early Ursula Le Guin . . . *Rocanon's World* or . . .'

Tony: '*The Word For World Is Forest*' (three voices together).

Joan: 'That's what I'm thinking of. . . .'

Pam: 'The whole theme is very, very old. It is well-worn, and that is why possibly it feels so loose and soapy.'

Whereas the 'para'-SF group used the different eras and personae of *Doctor Who* continuously and with an easy facility as the framework for their discussion, this 'literary' SF group used Le Guin and other canonical science fiction authors to establish their determining discourse: 'was this good science fiction?' 'Kinda', the group agreed, was bad; either because it was bad science fiction or because it wasn't science fiction at all. While not going as far as Suvin's science fiction of 'liberation versus bondage' (they rejected the anti-imperialist storyline of 'Kinda' as just political exposition, 'a combination of prologue and chapter 1 of a boring story'), the majority of the group agreed that 'good' science fiction is centrally about estranging the everyday world.

Ian: 'The essence of science fiction is looking at something in a totally different way to what a normal novelist would do.'

Joan: 'But actually having to develop a different world background, whether it is on Earth, a cowboy story or a normal suburban story.'

Particularly enjoying Douglas Adams's 'City of Death', this group adopted an 'estranging novum' rather than Adams's reflexive 'meta'-SF interpretation. Adams's own understanding of his storyline was as a reflection on discourse – on the constructedness and phoniness of art

discourse as much as of conventional science fiction discourse. But this group read the various narrative and meta-discursive strategies of 'City of Death' realistically – that is, as a series of devices estranging the everyday and phoney order of things. Primarily, their position was socio-logical and realist. It worried them, for example, that in 'Kinda'

> they really haven't established very well the position of the colonizing people in the Dome. You know, the guy who is cracking up – is that in fact common behaviour in his group?

and that 'we didn't see enough of the natives in their normal state'.

'Kinda', for them, was 'badly explained' because it didn't examine people in their opposing, alternative cultures. Consequently, it did not adequately meet their definition of science fiction: of 'taking a different look' at 'normal everyday experience', and of developing 'a different world background' whether 'on Earth or another planet'. They are very much Elkins's 'folly of ethnocentrism' generation of 'literary' science fiction fans – also Mellor's 'astonished gaze' fans post-*Fahrenheit 451* (though with no evidence of Mellor's 'tragic vision').

At the same time, however, this group emerged – rather surprisingly – as long-term followers of *Doctor Who*; to the extent at least of instantly recognizing the earlier Doctors, and in fact *liking* the emphatically action/gadget-oriented Pertwee episodes as representing the 'charm' and 'humour' of the 'authentic' *Doctor Who*. Yet they could also find, even in the Pertwee era, evidence of humour as an *estranging* device. As with Adams's 'send-up' detective Duggan in 'City of Death', so with the Brigadier in the Pertwee episodes:

> He plays a more important role than comic relief. . . . Actually he plays the same role that Duggan played in 'City of Death'. Mainly what he does, is he *contrasts* the science fiction element of it with the mundane sort of the normal person's reaction.

The knowledge of and affection for *Doctor Who* in this 'literary' SF group indicate that as well as 'fans' the series has many 'followers' who form part of an 'institutional' audience – i.e. the very wide public that regards *Doctor Who as* an institution, and have looked at it off and on over many years. This is another example of the complexity of audiences that a TV series at the 'BBC = quality' end of the spectrum accesses.

Part II

Chapter 4

'Throwing a little bit of poison into future generations'

Doctor Who audiences and ideology

John Tulloch

> Crucially, we are led to pose the relation of text and subject as an empirical question to be investigated, rather than as an *a priori* question to be deduced from a theory of the ideal spectator 'inscribed' in the text.... The relation of an audience to the ideological operations of television remains in principle an empirical question.
>
> (David Morley)[1]

In Chapters 2 and 3 we have examined historical accounts of science fiction texts and audiences. Yet, of course, audience theory itself has a history; and any audience project (like the *Doctor Who* one) which extends over a number of years is likely to be influenced by its changing paradigms and key texts.

David Morley's *'Nationwide' Audience* 1980 study was one such key text. It addressed head-on problems associated with the position of British film theory then dominant in the journal *Screen*. Although there were variations within this film theory tradition of textual analysis, its dominant emphasis is well addressed by Justin Lewis, who argues that *Screen*

> frequently granted films, programs or discourses more power than was dreamed of by even the most misguided members of the 'effects' tradition. Audiences disappeared from the construction of meaning altogether, to be replaced by a witless creature known as the 'textual subject'. The textual subject, like the unfortunate mouse in the behaviorist's experiment, was manipulated and forced (by the text's structures and strategies) to adopt particular positions. Once in position, the inexorable meaning of the message (produced with consummate wizardry by the analyst) would manifest itself.[2]

Published in 1980, Morley's *'Nationwide' Audience* was an important counter to this tradition, arguing for analysis of the 'actual' (empirical) audience, and marking the beginnings of a decade of 'active audience' studies. That the following decade of 'active audience' and 'ethnographic' audience research went too far in discounting the power of the text is

indicated by Shaun Moores' comment in 1990 that the 'time has come to consolidate our theoretical and methodological advances by refusing to see texts, readers and contexts as separable elements by bringing together ethnographic studies with textual analysis' (p. 24);[3] and also by Morley (1992) who argues that the 'power of viewers to reinterpret meanings is hardly equivalent to the discursive power of centralized media institutions to construct the texts which the viewer then interprets; to imagine otherwise is simply foolish'.[4] Ang (1990), too, notes that while audiences may be active, 'it would be utterly out of perspective to cheerfully equate "active" with "powerful" '.[5]

It is because we agree with the call from a number of theorists for a return to textual analysis, that we looked in an early chapter at 'the texts of science fiction'. However, Parts II and III of this book are very much influenced by the 'active audience' movement, which is still extremely important, despite its excesses. Inevitably (beginning in 1980) the *Doctor Who* audience project engaged with the kinds of problems and methodologies that Morley had raised in 1980. This 'debate with Morley' covers much of the field of audience theory discussed in Part II, whereas Part III is more influenced by the 'ethnographic' developments of audience study during the late 1980s.

THE *DOCTOR WHO* AUDIENCE PROJECT[6]

The early part of this audience research took place immediately prior to, and concurrently with, the circulation of David Morley's *'Nationwide' Audience* book, and reflected similar preoccupations: the concern with the excessive textual formalism of 1970s 'Screen Theory' and a wish to deal with 'actual' audiences; the emphasis on political and ideological readings of popular television; the focus on audiences' 'meaning systems' as a function of their positioning in relation to society's 'dominant' values. Morley, for instance, chose groups of trade union trainees, bank managers, sociology students, etc., to discuss texts about economic and social issues; the *Doctor Who* project chose groups of sociology students and mechanical engineers to discuss a text focusing on social change as a result of breakthroughs in engineering technology. In Morley's case and mine, the audience research was premised on the notion of decoding as an ideological process. 'The Monster of Peladon' is an unusually overt *Doctor Who* text in terms of its political statements, and this no doubt (though nonconsciously) influenced its selection for this stage of the audience research.

There were also significant differences from Morley's approach. First, the audience groups for the *Doctor Who* project were all chosen with reference to the programme's actual audience, not simply as a convenient cue to ideological discourse. In other words, these focus groups contained current or recent fans or followers of *Doctor Who*. Second, unlike Morley,

the methods used were designed to detect *differences* of meaning not only between but also within individual audience groups. This was to allow examination of discursive tensions, the different discourse relevances within each group, rather than reduce decoding to a single group meaning as Morley tends to do. Third, it was always intended to augment this 'ideological' focus with a 'generic' one – comparing, in terms of audience response, what (at that stage) we called the 'action' period of the series with its 'parodic' era. This generic emphasis sharpened into what (as a result of my 1982 research into the production history of the series, and later developments in feminist science fiction theory) are identified here as the 'Bondian', the 'meta'-SF and even the 'postmodern' inflections of *Doctor Who*.

This chapter considers audience readings of 'The Monster of Peladon' among two of the dominant audience groups for science fiction, according to Klein and Mellor: tertiary-educated social science students and technological/professional groups (represented here by tertiary-trained mechanical engineers). This part of the audience study was conducted in 1981, and (following Morley's approach) separate interviews were conducted with male and female students. There is only space to analyse the one group of students here; and because all the mechanical engineers were male, we have chosen to compare them with the male sociology students.

UNIVERSITY STUDENTS (MALE THIRD-YEAR SOCIOLOGY STUDENTS, UNIVERSITY OF NEW SOUTH WALES)[7]

Tertiary students have formed a significant part of the 'cult' fandom of *Doctor Who*. During the 1970s junior common rooms at universities would customarily be filled with (primarily male) students watching *Doctor Who*; and the official fan club in Sydney was run by Sydney University students, holding its conventions in the university's largest lecture theatre. The following discussion is with a group of third-year male sociology students, who were just beginning a 'Film and Society' course. Three of these five students had watched *Doctor Who* fairly regularly (two recently, one up to ten years previously). The fact that all five had seen *Doctor Who* before was not surprising, given the huge following of the show among students. In that sense *Doctor Who* as an 'institution' of the BBC is very visible. It has an *institutional* following *as well as* a fan club; nearly everybody knows about it, knows something about its characters. What was surprising in this group was that watching the show 'quite a lot' did not seem to equate necessarily with liking the show; in fact, one of the fairly regular watchers of *Doctor Who* said that it 'frightened' him. But, as we will see, 'frightened' here was contextualized very differently than when it was used by the young mothers (Chapter 6) to flesh out their 'parental effective technique'.

In discussion groups the university sociology students display significant differences from secondary students (Chapter 5) as well as from the UNSW mechanical engineers we discuss later. They are more used to informal class discussion, so that turn-taking is more routinized, with less formal questions from the interviewer. The much smaller size of the group facilitates this tendency for members of the group to dominate the discussion and determine its frames of reference. In this case, two of the five members dominated a discussion which articulated a number of positions pro- and anti- the 'politics' of *Doctor Who*, with the result that the interviewer did not need to ask questions to start the group off (as occurred with the school students). As it happened, though, the prompting 'generic' question which was used with the school students ('compare this as science fiction with . . .') was taken up first anyway.

> Graeme: 'I think it displays a very narrow-minded attitude towards what goes on on this planet, towards life in other areas of the universe. It seems to be that way in almost every outer-space movie, especially the B-grade ones, the really cheap ones that are on very late at night. People always seem to get the impression that other forms of life are always going to be vaguely human shaped. That *Doctor Who* episode was really outrageous because it assumed the existence of *trade union* movements and things, and that other societies on other planets run in a very similar way to here.'

The agenda for discussion offered here is of 'good' (i.e. 'folly of ethnocentrism') versus 'B-grade' science fiction. Had the group been constituted differently (of, for example, the 'literary' science fiction fans, Chapter 2) that agenda might well have been accepted and filled out with discussion of the contrast between 'The Monster of Peladon' and Lem's *Solaris*, Ursula Le Guin, and other recent science fiction authors who have challenged the ethnocentricity of the earlier 'positivist' vision of SF. But here that particular agenda was not accepted, and the next speaker opened what was to be the dominant debate. He accessed a 'radical' reading of *Doctor Who*:

> Paul: 'I thought there that they were using the outer-space situation to deal with problems on Earth, like Women's Lib and trade unions and colonial attitudes. . . . I don't know much about *Doctor Who* – I've seen it before but I've never watched much of it, but I didn't think they were *trying* to depict outer-space. I thought it was a figurative way of depicting problems in human society.'
>
> Graeme: 'But was there any advantage in putting that in an outer-space situation?'

Paul: 'I think so, because they could caricature and stereotype the situations more.'

Graeme was the student who had regularly watched *Doctor Who* up to ten years before. One suspects that his reading was in part an intra-biographical one, contrasting his period of 'fandom' with his present 'literary' SF position. But not recognizing this, he interpreted it as a change in the *programme* rather than in himself. He felt that the programme was not as good as it had once been:

Graeme: 'In terms of pure entertainment I think that one was as entertaining as any other. But as far as I could see it looked like they were running out of ideas – what's going to happen next to the good Doctor?'

Paul, in contrast, was comparing his present discovery of the show with his memory of it as something less interesting, less relevant to his concerns. In particular, he adopted a Brechtian 'astonished gaze' or 'estrangement' reading of *Doctor Who*.

Paul: 'I was interested by it. At the times I've seen it before I've thought of it as about outer-space, other planets, other creatures, or whatever – a zany science fiction show. But I thought this was incredibly political. I think it was good in the way it had the miners as like a race on this other planet, like you know the working class are like another *race*. . . . By making the ruling class – the people who were running the planet – and the working class almost different species, I thought it brought out the contrast between them in conventional society.'

Stephen: 'It's a kids' show and they're trying to introduce issues to the kids' show to give possibly the programme some justification for even existing. But it was so poorly done, with so many contradictions to the issues they were talking about, such as having that cyclops – the ambassador – with a silly, petty woman's voice – female, when all the other strong characters were male, I mean they were contradicting that Women's Lib issue in the programme. . . . Having Sarah-Jane Smith – she is his underling. I have seen her in other programmes, and she is a bit scared of snakes and spiders to a degree. She is trying to come out of it, but she is still in that position.'

Graeme: 'I think the ambassador was more presented as a totally sexless petty-bureaucrat, the way he–she–it always stuck to procedures, that once something's been set in motion you

can't stop it in any other way except the legitimate way which has been accepted already. . . .'

In the scene which Graeme is referring to, the ambassador had admitted to the Queen that Federation troops had been called to Peladon: 'Forgive me your majesty, but the situation had become so bad that I felt forced to send for help.' The female voice of the supposedly hermaphrodite ambassador offered a reading of this action as an impetuous and nervous 'female' response – which is how Stephen read it. However, the text immediately follows this with Sarah-Jane's medium-tone voice (contrasting with both the impotent male anger of the chancellor and the high-pitched 'female' nervousness of the ambassador): 'Well, can't you send them back?' The ambassador replies: 'Once summoned, they cannot be recalled', a response which picks up the ambassador's regular prefer- ence for the 'proper procedures' to mark this as dominantly a 'bureau- cratic' position. This re-marking of the ambassador as 'bureaucratic' more than 'female' leaves the latter discourse for Sarah (who has just given the Queen her 'Women's Lib' speech). At this point in the audience discussion, the text's marking of the ambassador as 'bureaucrat' rather than 'female' is accepted by Graeme; whereas Stephen's own feminist position allows him to ignore this textual move. The next student, how- ever, ignores this play of textual reading positions, and inflects the dis- cussion in terms of his own, experiential subject position, which is concerned more generally with 'children and ideology'.

Con: 'What frightens me, or surprises me, is this, that we perpetu- ate in this futuristic film the elements of our society today. We still have an authoritarian régime, we still have a two- tier system, and we have people working in mines, and have elites or the ruling classes. I have not seen this episode before, but the Federation was mentioned and *Blake's 7* is made from the same stable, with the same idea once again. And it frightens me *why*, since we are moving on to new forms – given new forms of life, for that matter, we have to bring our rubbish, this residuum which is bad in us, everybody agrees that our society is bad as it is now, and we are projec- ting this into the future as well.'

As a third-year sociology student, it is not perhaps surprising that Con's response to *Doctor Who* as a cultural form should echo, in its definition of the show's relevance, the critical theory position of Dunn (who, as we've seen, accused *Star Trek* of using science and technology 'to extend the status quo into the realm of the future, thus preserving the dominant values'). In the case of *Doctor Who*, Con believes the problem is vitiated by the fact that it is 'a children's show'. Like the young mothers (Chapter

6), but with a very different meaning, he discusses the 'frightening' aspects of the show in relation to the effect on children.

Stephen: 'Some people would argue that it [society] *is* bad and that it has to be studied so that it can be improved, and this programme would be one way of studying the problem.'

Con: 'Yes, but how many people *do* study things or take things just as a fact. I can see kids internalizing this, that they have to grow up and be amongst those above not the ones below.'

Int: 'But what about the actually foregrounded messages of that story that you've just seen, which were in fact asking children or whoever was watching to question certain things? Sarah-Jane Smith says to the Queen, "Don't just do what you're told because you're a woman", and the Doctor says "The miners *have* got serious grievances and they need to be changed. The profits shouldn't just go to a few people at court." Now those seem to be, at least on the surface, very strong statements in this programme.'

Con: 'Yes, but this is a token so far as I'm concerned. . . . It's a tokenism. Besides, I think the kids, they miss the point because it requires an awful lot of socialization before you can see the point. I can see it now, but the kids – you may squeeze them to get this out of them, but it's not going to mean very much to them, and personally I'm very sincere and very frightened about this situation for the present state of affairs.'

Int: 'Do you see it as a very conservative programme then? Politically conservative?'

Con: 'Yes, that's right. Like, from my own little research, I'll throw *Caligari* in, where the producer decided to change things to please the society out there, or perhaps the norms which had not quite died as yet. . . . Authority retains its position, so it's the same thing once again – you're perpetuating something which *I* think is bad.'

Here we should note that Con, like the interviewer, has the competence to mobilize quite easily 'second-order' concepts. The debate about producer Eric Pommer's conservative 'framing' of the originally anti-authoritarian *The Cabinet of Dr Caligari* – as analysed in Kracauer's *From Caligari to Hitler* – had been the first topic of the 'Film and Society' course. Later, the same student drew on theory about music hall in nineteenth-century England (which came from an earlier sociology course) as part of his own 'fear' about *Doctor Who*. So theoretical discourse in the social sciences, rather than the generic framing of 'common sense' discourse which we will find among school students (see Chapter

5), organized his response to the text. It was this 'negative critique' theory which led to him neither 'liking' nor being 'bored by' the episode, but rather being 'frightened' politically. Despite being a fairly regular viewer of *Doctor Who* he was not a fan; in other words he was not part of an interpretive institution which distinguished this show from others as having its own particular history with its own particular world of relevance and pleasure. Rather, for him, *Doctor Who* was representative of television generally in reproducing the class system and structures of power in society. 'All futuristic films in television and the cinema – I don't know about the theatre – they tend to do the same thing, as if there was a group of people somewhere who dictates what should be put on film.'

Paul: 'You see, I think on the content level that the show is trying to be *radical*. It's sort of taking things as they are; like basically the women's movement hasn't got very far, basically unions are still in a similar position they've been in for a while; and I think that at an obvious content level it's putting up a critique of some of our situations. And so I'd say it's being radical rather than being conservative. I mean the *form* of, the structure of, the whole programme was like having a couple of hero people who go around helping oppressed groups or whatever – I mean that *structure* may be very conventional, but the content of it is I think *trying* to raise issues.'

Con: 'Yes, but so was the later years of industrialism in England when they structured people's sport and they came up with rugby, and they created the music hall and so forth. It's paternalism. I can see this in the same vein, that we do talk about women but still we give the same structure. Now perhaps I appear terribly radical in my views; well, so what, I am. But I feel this is the way to criticize, to look critically at something, particularly something which refers to society.'

Con and Paul have really taken over the discussion, arguing with a degree of theoretical competence not displayed by any other audience group in the research programme. Con adopts a critical theory position and talks about the ideology of popular cultural forms within capitalism; Paul attempts a more 'ambivalent text'-focused analysis, arguing interestingly about some kind of tension between *Doctor Who*'s content and form.

 Graeme and Stephen do, however, re-enter the discussion at this point, differentiating between the miners. The text of 'The Monster of Peladon' clearly differentiates between the moderate leader, Gebek, and his fanatical rival, who wants to use the laser technology to kill everyone in the Queen's citadel (including the Doctor and Sarah). Graeme argues that 'if they had wanted to be highly critical of that radical side they would have

presented *all* of the miners as being the way that the background radicals
were ('Kill them! Kill them!') and they would probably have emphasized
the nastiness of Gebek'; Stephen argues that 'had they really wanted to
put Gebek's plight forward they would have made them all sensible
instead of just one'.

Paul: 'He was also portrayed as the moderate ... who it was
 possible for the Queen to deal with, whereas the other guy
 who was like an alternative leader just wanted to attack all
 the time.'

Int: 'We seem to have two people who feel it's conservative and
 two who feel it's a bit more radical. Do you want to come
 in on this?' (to John)

John: 'It sort of brought out the fact of – if it is a show that's
 aimed at children – the fact that maybe the working class
 were kind of better people and the fact that they were treated
 badly was trying to get the kids to be on the side of Doctor
 Who who was helping them. . . .'

Stephen: 'The fact that it was a kids' show should present the message
 quite well, and the inconsistencies that I drew there would
 not be noticed.'

Int: 'I see, so you are talking about different audiences now. You
 think for *kids* it might be a little bit more radical, particularly
 with the Women's Lib one, because the inconsistencies
 wouldn't come through?'

Stephen: 'Yes, and the fact would be new to them because they
 wouldn't yet know about Women's Lib because it's usually
 talked about in adult circles and they wouldn't understand
 it, so it's their first perhaps initiation to Women's Lib or one
 of the first.'

Int: 'Everyone here does seem to be assuming it's a children's
 programme, is that right?'

Graeme: 'I was going to raise that. I don't think it is necessarily only
 a children's programme.'

Stephen: 'It's made so that it gets as large an audience as possible,
 like Batman and Robin.'

Graeme: 'Yes, in a way, because I know an awful lot of adults who
 watch it as well. . . .'

Paul: 'I think a lot of that dialogue is directed at adults. I don't
 know how exactly contemporary that one we saw is, but it
 parallels the situation in Poland if it's contemporary. . . .
 There's the parallel with the Russians putting troops into
 Poland. It seemed to be an indigenous ruling class who were
 running the planet. I mean, it was just a very general parallel;

it could have been ten years ago a parallel with Czechoslovakia, or whatever. . . . I felt it was talking to me quite a bit, like as an adult rather than just talking to kids – talking to people who are adult and aware of contemporary events, and just figuratively playing around with some of the stereotypes you have in those events. Even the crude way it dealt with feminism and feminist representation – like the Queen and Sarah – Sarah seems very tokenish given that she's the one who's meant to be the feminist. I mean, she doesn't take much of an active role in fighting that monster; she *says* feminist things, but she doesn't seem to act very many of them – I mean, it's even the Doctor that prompts her to say them. . . . It seems to me that the writers are using very conventional styles and structures, and within those styles it's often a contradiction to raise radical issues. . . . It's a bit like a great man theory of history.'

Notably, here, there is a very different critique of the 'structure' of *Doctor Who* than we will find among fans. As we will see (Chapter 7), the fans criticized the show's structure from the individualist perspective of psychological naturalism and 'believability'. In contrast, this radical sociology student criticizes it for perpetuating social structures. Con takes up this point:

Con: 'Well, this has triggered my mind that it's really very conservative the whole thing, terribly conservative. *Within* our structure we shall allow *you*, we will allow women, to be liberated, but still within *our* structure. Even feminism has these connotations, I feel. Now perhaps I sound, I repeat myself, very revolutionary in my ideas. But I would like to be left alone and completely free. Why shouldn't I be? Or perhaps as free as the aborigines were without the constraints – although they did have some constraints too – of my society's constraints which tell me how to dress and how to behave and how to even use my hands, being a Greek. So it's the same thing – women are going to be liberated, but within that context. Like the unions – they're free; we have unions, but they're under the jurisdiction of the courts. You may say, "Well, what do you want? Anarchy? The unions take over?" Well, perhaps yes; because then perhaps the rest of society can see the injustice of the system. But the unions perpetuate the two-class system we have now; and so perhaps women may do precisely the same thing.'

Paul: 'Well, I don't think a lot of unions intended that. The intention of a lot of aspects of the union movement was to trans-

form the society, and get rid of the two classes. Unions these days are very much a part of the situation.'

Graeme: 'You've got to take into consideration which groups you're speaking about, and to what degree each of those groups go. Like there are some forms of radical feminism which advocate not just a bit of social change within that structure but turning the whole society upside down. The same with some unions; some of them think that they rule the world when they've managed to win themselves a ten-dollar-a-week rise for all their members; but others . . . like the Spartacist movement, will go all out to create as much change as they can. So it depends on which group you're talking about – you can't just bung them all into one category. . . . Each of those huge groups are divided into a lot of smaller subgroups, and often between those groups there's an awful lot of conflict.'

By this stage, the dynamics of the discussion have led to a debate between different critical theories of society *per se*, and have left the text of *Doctor Who* some way behind. Even Graeme, who began with a 'Lit-Crit' discourse, has waded in to show his social science/radical history credentials. Recognizing this, Stephen literally asks permission to bring the discussion back to the text, and formulates a Fiske-like view (in his analysis of *Doctor Who*, at least) about the popularity of television.

Stephen: 'There is the idea that something that's popular isn't worth as much. I know it's a rather arrogant idea, but I think it has some validity sometimes. If something really does try and put a message across, it sometimes hurts, worries or antagonizes the general mass because it really conflicts with what their ideas are. Now anything that's popular – novel, films and so on are to me only a type of Valium of some sort. . . . Now this has high ratings with kids and adults, and the very fact that it can please two audiences is a bit worrying; it means it's made to please as many people as possible – to please, to attract and then to give messages will be too difficult to do successfully. . . . The very fact that it's popular means that it's not hurting or antagonizing people.'

Paul: 'I don't know, sometimes things can grow to popularity that are critical of mainstream. What becomes popular tomorrow might yesterday have been something that was only believed in by a small group. In it becoming popular is one way in which the society changes.'

Graeme: 'In cases like those quite often where something starts off unpopular, I think the best way society has ever found of squashing the dangerous elements inside each of those

movements – like the Punk movement was a very, very good example of it – in a matter of a few months it turned from a group of uneducated ultra-radicals into something, a bandwagon that was jumped on to by an awful lot of people . . . and it became a fashion, and after a year or two it sort of blanded out to the point where now it's only manifested very vaguely in forms of brightly coloured clothing. Nobody puts records out like the Sex Pistols did in 1977.'

Stephen: 'So in *Doctor Who* they're trying to. . . .'

John: 'Build on established cloth.'

Graeme: 'Yeah.'

Con: 'But why in heaven's name this has got to be projected into the future, that's what annoys me. . . . Once we have a gun which depends on particles, this is high physics now, no bullets any longer; which does not substantiate our thinking and our logic any longer, our logic has crumbled down, the western logic through sub-atomic physics and so forth. This, as far as I'm concerned is the futuristic bit; but it's a hybrid, because we still have people working manually and therefore my thesis is that we project our current ideas and we throw a little bit as it were of poison into future generations by doing so. That's what disturbs me about *Doctor Who* or similar things. . . . The music hall is the same thing once again. The later research has found that the actors were working class but the writers were *aspiring* lower-middle-class people; therefore society has its ways of purifying the messages.'

Int: 'Would you think that's an explanation in the case of *Doctor Who*: that writers are middle class?'

Con: 'Yes, yes.'

Two distinct theories of the social usage of popular cultural forms are beginning to contest with each other by the end of this discussion: (i) that potentially radical cultural forms (music hall, punk rock) can be generated within the working class, but are then appropriated and 'purified' (or 'blanded out') by middle-class writers and artists; (ii) that conservative cultural forms ('this hero, Doctor Who, who goes running round outer space interceding on someone's behalf . . . a bit like a great man theory of history') can be put into contradiction by writers with radical intent. What is common to both positions is that the *relevance* of *Doctor Who* (whether enjoying it or being frightened by it) is embedded in the assumption that it is a *political* form of communication.

Various commentators (for instance, Morley in his critique of the *'Nationwide' Audience* project) have noted that a competence in the codes of politics is central to white, middle-class 'discourses of masculinity'; and

that is clearly the case with these male sociology students. However, this facility to talk about politics was embedded in a second-order critical/theoretical competence which emphasized ideology, 'meaning system' and social control (as the fate of the opening 'SF' gambit in this discussion indicates clearly).

Now, of course, there is another factor to be taken into account here: that the students were concerned to show me as interviewer/teacher how competent they in fact were in course theory! We will examine this ambiguity of teacher/interviewer/fan in Chapter 7. Nevertheless, it is clear that the two historically dominant cultural theories of the media that we noted in Chapter 2 – of social control and social change – were also dominant here, with some attempt, too, to grapple with the 'objectively ambiguous text'.

UNIVERSITY STUDENTS (MALE STAFF/STUDENTS, MECHANICAL ENGINEERING, UNIVERSITY OF NEW SOUTH WALES)[8]

The group of university students we have just discussed were majoring in sociology – one of the 'soft' social sciences which Mellor and Klein see as reconstituting the field of SF and its fandom since the 1960s. But what of the technological/scientific tertiary educated middle class? Do they watch *Doctor Who*? And if so, how do they compare with those students from sociology? Are they more optimistic? Or does Mellor's 'tragic vision' determine their pleasures in this text?

In fact, there was no difficulty in finding a group of six technological/scientific staff and senior students who were followers of *Doctor Who*. This was a group of undergraduate and postgraduate students and staff at the School of Mechanical Engineering, UNSW. This group was less overtly articulate than the sociologists, required more lead-in questions (such as our generic prompt, 'How does *Doctor Who* compare to other science fiction . . .?'), and its members often laughed in a slightly awkward and embarrassed way at their own theories about *Doctor Who* – for instance, the idea that *Doctor Who* sometimes presented strong religious symbolism. None the less, this group was no less able to theorize about the relationship between television and society than the sociologists; and in fact continued talking about the episode of *Doctor Who* after the end of the discussion, directing the interviewer to switch the tape recorder back on.

Like the sociology students much of the discussion focused around their view of *Doctor Who* as 'a kids' show'. But this did not prevent them watching it regularly and quite obviously enjoying it.

Int: 'How does *Doctor Who* compare to other science fiction that

you've seen like *Blake's 7* or any of the other television and film science fiction you've seen?'

Bill: 'Some shows very good, other shows very boring.'

Int: 'You watch it fairly regularly do you?'

Bill: 'Yes. Quite a good show – basically it's not a bad sort of show.'

George: '*Doctor Who* as a series improved once they replaced the girl in that show.'

Bill: 'Oh, rubbish! Go back to your coal face.'

Int: 'Why didn't you like Sarah?'

George: 'She acted too irrationally for me.' (laughter) 'I don't know, I just didn't like her.'

Bill: 'Well, that's all you have to say?'

Int: 'She appeared to you irrational?'

George: 'Yes – hysterical female sort of thing.'

Bill: 'I reckon most probably she'd be the best of the whole lot of them, personally.'

Int: 'She was less hysterical than some of the others, was she? No? How do you see the women generally in *Doctor Who*?'

Bill: 'You don't. You mostly see creatures, don't you . . .? But the creature that he's fighting against doesn't seem to lead on till right near the end of the episode, so it keeps you interested.'

Clive: 'This did make some comment about there being a woman in charge of that. . . .'

Bill: 'Oh, yes.'

Clive: 'That I'd say is unusual for that sort of comment to go round there.'

John: 'That's right, because they've all been very sort of passive. They're just there for window dressing obviously.'

There followed some unelaborated discussion about the importance of the female assistant 'as a foil' to the Doctor, 'more or less a companion buddy-type of thing', until John situated the discussion of women in *Doctor Who* within a 'kids' show' interpretation.

John: 'I think the whole programme is aimed towards sort of ten-year-old children, isn't it?' ('Eh, eh, eh!' from Bill) 'No, the way it's written – I reckon the bloke that sat down and wrote it was devising a programme to keep kids happy, like Biggles books did, in days gone by. And I think the characters in there are like the sorts of things that children imagine the heroes to be. So the little girls would look at it and probably can happily identify with her, and the boys probably see themselves as marvellously successful scientists, or something

like this. I think, you know, it's a bit hard to put adult sort
of roles into it.'

As with the young mothers (Chapter 6), the discussion of Sarah-Jane as
a 'hysterical companion' led the group to draw on their series knowledge
to compare companions, rather than (at this stage) taking up John's
implication of 'putting adult roles' (the 'Women's Lib' stuff?) into it.

David: 'I think the classic opposite was Leela who was, remember,
 the primitive he found on one planet. She was very aggressive,
 she was the one with the knife all the time, whereas he would
 never touch the knife and never touch a gun, and quite often
 she would rescue him or would protect him, physically. . . .'
Kevin: 'Actually, one of his female assistants, Romana, she's sup-
 posed to be very highly intelligent too, almost as intelligent
 as he is.'
David: 'That's right, Romana, she's a later one, she's a Time Lord.'
John: 'Yes, she used to drive the actual machine, didn't she? He'd
 be out on the floor. . . .'
George: 'And she'd come up with some of the solutions.' (laughs)
Int: 'So do you see a change in the function of the women?'
John: 'Yes, that'd be right.' (general agreement)
Int: 'They're becoming more. . . .'
Bill: 'More liberal.' (laughter)

This group is less competent and more self-conscious when talking about
politics in relation to the show than the sociology students. They find it
easier to talk about it as a children's series which they also happen to
like.

Bill: 'But again, you take a lot of the other science fiction units
 and more or less there is always some relationship, some love
 scene going on *within* the space or monster movie, whereas
 Doctor Who is more or less away from that – it's factually
 down to the facts of "Right, we've got to get rid of this, this
 is trying to rule us, right it's time to get into action" – none
 of this, "Oh, we'll have a bit of a night together and a drink
 and all that." That's one of the reasons why I quite enjoy that
 thing, they get right down to the nitty gritty. . . .'
David: 'Also that's why it's something that appeals to the children as
 well.'
John: 'That's right.'
Clive: 'Nothing complex about it.'

But what is the 'nitty gritty' of *Doctor Who*? What are its 'straightforward
issues' for this group?

Kevin: 'He's always got a problem to solve and he's always on a planet with some sort of problem. . . .'

David: 'Those monsters use physical force, without thinking, no conscience whatever, in order to subjugate say those people there, that monster wants to take them over and lay his eggs or something and Doctor Who will defeat them. . . . Often, also, the places he goes to is a minority or something that's being oppressed or something like that. . . . For instance, what the Daleks use to rule, how they used to treat the human slaves – he would help the humans defeat the Daleks. He saw what the Daleks were doing and how they were going to spread this through the whole universe and he had to stop them. . . .'

Bill: 'Yes, they seem to be extremely powerful until he comes along. In other words, nothing wins against them at the time. When he shows up and starts putting his little brain into action, then they start getting somewhere. . . .'

John: 'He wins by superior intelligence all the time.'

Kevin: 'There's always a simple way of defeating them.'

Since the villains are 'also very highly intelligent', Doctor Who is a 'superperson', a 'computer whiz' using 'superior knowledge to make use of existing means'.

John: 'At times he just uses his chemistry or electronic ways at reversing a cycle, and puts the monsters back where they actually come from. . . .'

Kevin: 'He's superhuman but he's got human weaknesses. . . .'

David: 'In a lot of the other science fiction shows like *Blake's 7* there is a sort of computer there, he knows absolutely everything; computer probability for every course of action. There's no uncertainty about what goes on.'

Int: 'But that's not true, you're saying, of the *Doctor Who* series?'

John: 'No.'

Int: 'There's more of an element of what? Human uncertainty?'

David: 'Yes, human uncertainty.'

Bill: 'He uses his own mind, and thinks, "Ah, that's an idea!" '

Kevin: 'There seems a bit of uncertainty; you never know whether it's going to work until right at the end of the show.'

David: 'They probably don't *always* work either. Not every one of his ideas do work.'

Bill: 'No, that's right . . . until the end. He'll try one thing and that'll not quite work, and then goes back again.'

On the one hand, this group clearly enjoys the humour and the 'very simple, very light' storylines, which make it (like James Bond films) an

'exciting' and 'larger than life' show. Bill notes the Doctor's capacity to improvise, which also makes him like Bond – and it is this 'Bondian' aspect of the show that appeals to them as adults. On the other hand, the group differentiates *Doctor Who* from James Bond in that 'Doctor Who is a very moral sort of bloke', and the programme itself (with its White Guardian and its Black Guardian) sometimes acquires 'almost religious overtones'.

The comparison with James Bond on the one hand and Biggles on the other, leads them to a theory of popular culture quite different from the critical theory of the sociology students. For the mechanical engineers, popular culture operates in terms of inculcating social values *only* in children's shows.

John: 'The thing is that Biggles and *Doctor Who*, ... are trying to teach kids ... things like team spirit and loyalty and all these kinds of values. Actually that's probably the word – there's values in them. ... Whereas, James Bond. ... In fact, I think that's probably one of the things that makes programmes written for children so different from those written for adults. Children seem to get given to them by books and TV. ... a world that's got basic values in it. There is right and wrong fairly well defined in the programme – Doctor Who always wins, good wins against evil.'

Int: 'But what happens in the James Bond movies?'

John: 'But in the James Bond, alright, his objective is clear enough, he's going to perhaps sink a nuclear submarine or something. But they no longer need to worry about whether the audience learns a lesson and goes away feeling that they know themselves what's the right and wrong in the play. James Bond was obviously written just for titillation. There was no clear lesson to be learned, there was no *clear* right from wrong. For instance, James Bond would casually shoot someone or garrotte them or throw them over a cliff if they were standing in the way between him and his goal.'

'Values' in this group means something 'basic', something like 'non-violence' which they see as above gender, class or creed; and the Doctor is 'moral' because he does not use violence against 'human forms'. Conflict is not against people, but against 'robots', 'monsters', 'grotesques' which 'a young audience wouldn't identify with', so 'there is never a moral problem'.

There is a sense here of 'values' = 'morality' = 'basic and universal truths'. However, the members of this group do recognize changing social values in *Doctor Who*. They see, for instance, the shift between earlier and later female companions as reflecting changes in society generally.

John: 'I reckon that it changed so much over the length of the series, because at the end, Romana was a very capable sort of person. . . . I think it was just because of the change of the times. I think that it's written for kids, I think little girls were meant to identify with the Sarah-Jane character and they weren't meant to be content with washing dishes. She was essentially out of her location; whereas Romana was in new times.'

David: 'And Leela was even more so, she was really the aggressive female, playing a man's role to a certain extent.'

Int: 'Do you see this paralleling anywhere the evolution of women's liberation?'

John: 'Yes, that's right, I think it ties in with that.'

Their views regarding the changing characterization of the Doctor displayed a similar logic.

David: 'Well, I just think that in the early days you see him as an old grey-haired professor, being all-wise, whereas now he's a middle-aged or youngish sort of man . . . and he's still very clever and a bit trendy and a bit eccentric. . . . The scarf is very characteristic now of him, isn't it . . . and the jellybabies and things like this. . . .'

John: 'So what's going on really I suppose is that the writer is just very observant of changes in society. He's sort of giving the kids a picture of what you expect of them when you grow up, or what they expect to be when they grow up. . . . Tom Baker's just a good mate. . . . Perhaps it's easier to identify with him than with that old grey-haired professor.'

Clive: 'I think that modern society is progressively doing away with artificial barriers, really.'

David: 'Well, very simply they're saying "you don't need to be sixty-five to be a brilliant man" or something like that. "Look at that guy, he might be thirty, forty and look where he is".'

There was no sign at all of Mellor's 'tragic vision' in this group of mechanical engineers. Indeed, in their urbane view that 'modern society is progressively doing away with artificial barriers' – whether in gender terms, or in the age of successful business leaders and politicians – they had much more in common with Klein's earlier technological/professional elite (and with the 'para'-SF fans of Chapter 3) who believed 'in a universal, rational society, where all conflicts would be resolved in scientific fashion'.[9]

What we called earlier 'the emphases on intellectual leadership, a liberal politics and an educated audience carried from the era of Wells's

time-machine to the early 1960s beginnings of Doctor Who's time travel'
continued into the 1980s among these technologist followers of the show.
Interestingly, while the members of this group argue that the technical
language of Doctor Who is 'invented technical language', they elevate it
as being 'as imaginative as poetry'.

John: 'It's brilliant really when you think of the imagination that's
 gone into doing that, sort of making up a little sub-language.'
 (laughs) 'There is no way in the world I could ever write
 science fiction. I couldn't invent the terms.'

Provided that this aestheticizing and invented sub-language works to
'create the atmosphere of science and technology' among children, it is
wholly approved of. There is no worry here about 'throwing a little bit
of poison into future generations' by 'perpetuating the two-class system
we now have'. Nor is there any sense of textual ambiguity and contradic-
tion. The UNSW engineers' view of the world is uniformly more optimis-
tic. In contrast, the UNSW sociologists' view is more pessimistic, with
some of them at least – in their 'fear' of popular culture – only escaping
Mellor's tragic vision in so far as they reject the continuation of the
existing structure of capitalist society. Rather than adhering overtly to
'the dominated fraction of the dominant class' some of these sociology
students want – at least in their rhetoric – to reject the class system
altogether. As one of the male sociologists said, 'To criticize your society
and be a capitalist you cannot criticize' – which is why he is rejecting
the 'unresolvable contradiction' Mellor describes among the 'dominated
fraction' of the ruling class.

'It's meant to be fantasy'

Teenage audiences and genre

John Tulloch (with Marian Tulloch)

> That makes it boring because they said it's meant to be fantasy and yet it takes a lot of the excitement out of it if you realize it's sort of scientific.
>
> (Sydney schoolgirl)

In previous chapters we placed a major emphasis on science fiction as an ideological form. On the one hand, we examined science fiction texts in relation to the ideology of scientism. On the other hand, we have observed audiences who concern themselves with the 'social control' or 'social change' possibilities of science fiction. Not all audiences, however, respond to the 'politics' of *Doctor Who*. As we will see, among the Australian fans (Chapter 8) detailed discussion about the show's politics leads to a breakdown of dialogue; among the young mothers (Chapter 6), while politics *is* specified as important, it is not engaged with in any particular way (except by one feminist); and among the 'literary' SF fans (Chapter 3) the show's politics was rejected unless this worked *via* notions of 'serious' science fiction.

In the 1981 'Postscript' criticism of his *'Nationwide' Audience* work, Morley makes a similar point. He notes that his earlier analysis assumed that one was dealing with a broadly political form of communication, and that his emphasis on audience decoding simplistically positioned the possible range of decoders in terms of where they stood in relation to the society's dominant values. Indeed, one might argue that his choice of audience groups – trade union trainees, bank managers, white and black sociology students, etc. – was *premised* on the notions of 'dominant', 'negotiated' and 'oppositional' ideological reading positions which he brought to his analysis; that he chose bank managers assuming they would agree with the dominant economic discourse of the current affairs programme he showed them; and shop stewards assuming they would disagree with it. His tendency to reduce decoding to a single meaning within any particular class or occupational group exacerbated this tendency.

In some respects, we are open to the same charge. There has been some emphasis in previous chapters on groups who might be *expected* to respond to *Doctor Who* 'politically', *particularly* where the interviews were conducted in class time (an issue we take up in Chapter 7). In addition, our choice of an overtly 'political' episode of *Doctor Who*, 'The Monster of Peladon', may have further promoted this decoding tendency. One answer to this charge, is that although 'The Monster of Peladon' did engage unusually directly with current political events, it was by no means unusual for episodes in that era to raise the issue of 'Women's Lib'; and in any case its fundamental focus on freeing the oppressed from feudal relations of power is both a systematic theme of *Doctor Who* (as virtually all the audience groups recognized) and an important focus of science fiction generally. Another answer to the charge is that science fiction fandom has historically defined *itself* politically; and that a significant part of its audience has come in recent times from those educated in the social sciences. It was for this reason that we focused on readings by 'social science' and 'technological' tertiary students in Chapter 4. A third answer is that, unlike Morley, we chose our initial audience groups in terms of the programme's *own* audiences and reference groups, so that although this included a significant number of university-educated people, it also included people who were not. In particular, it included primary school students and teenagers, as well as young mothers of pre-schoolers, non-tertiary fans, television producers, etc.

None of this, however, is to disagree with Morley's point that the focus on 'political' decoding tended to

> suggest a *single act* of reading a text. Perhaps what is involved is a *set* of processes – of attentiveness, recognition of relevance, of comprehension, and of interpretation and response – *all* of which may be involved for a single audience member in front of the screen.[1]

So, for instance, in our audience groups we did have the occasional response that had 'The Monster of Peladon' come on their screens they would have switched it off (attentiveness, relevance); and others who said they had seen it before, but maybe it was because of the interview situation that they now recognized new things in it (attentiveness, comprehension and interpretation). Clearly (as we examine later) these particular viewers are, in their particular situation, pressurized readers; and a few of them were not fans or followers of the series, even in the loosest sense. On the other hand, there were some advantages in exposing fans and followers to the company of these 'critics', as we will see in the cases of the young mothers of pre-school children (Chapter 6). Forced by critics to respond, fans clearly articulated for us attitudes and values which they held but may not otherwise have spoken, since these were part of their taken-for-granted common sense. Further, to discuss *Doctor Who* with

groups composed of both followers and non-followers certainly focused the issues of attentiveness and relevance, and, as we will see in this chapter, well illustrated their *generic* underpinning.

Morley's 'Postscript' adds to his original three hypothetical decoding positions (dominant, negotiated, oppositional) three others, which are derived from whether they enjoy, feel bored by, or recognize the programme 'as at all relevant to their concerns'.[2] Each of the three original categories 'must itself be subdivided across this dimension, allowing positive or negative versions of dominant, negotiated and oppositional decodings'.[3] This, of course, only begins to unpack the range of responses available. But the important shift in audience theory here is, as Morley says, in moving from the assumption 'that we are principally dealing with the overtly political dimension of communications' to a position that understands decoding in terms of genre. In other words, it is the genre of the programme which initially determines 'the relevance/irrelevance and comprehension/incomprehension dimensions of decoding'.[4]

Even at a superficial level the relevance of Morley's shift in position seems immediately useful. This book, indeed, defines its agenda *in terms of* the issue of generic 'liking' (i.e. science fiction fans and followers), and therefore in terms of the *relevance* of these texts to their readers. For some groups, 'why we like *Doctor Who*' often became a controlling preoccupation in their response. In other cases where the audience groups were mixed (followers and non-followers of the series) as in the secondary school groups, the relevance/irrelevance issue became quite central: expressed, for instance, by the incomprehension of non-followers as to 'how anyone from Year 10 doing their School Certificate can sit down and watch a moronic programme like that'.

At a more theoretical level, Morley's shift is valuable in adding to the earlier, limited concept of 'meaning systems' 'a more developed notion of the complex repertoire of generic forms and cultural competences in play in the social formation'.[5] Morley develops his theory by drawing on Cohen and Robbins's work on youth cultures which tries to

> explain the specific popularity of one genre of texts (Kung-fu movies) among one section of a society – urban/working class/male/youth. The argument is that the genre is popular to the extent that it 'fits' with the forms of cultural competence available to this group.[6]

For Cohen and Robbins, 'the crucial factor is the linkage of two forms of "collective representation" – a linkage between the forms of some oral traditions in working-class culture and some genres produced by the media – i.e. a correspondence of form rather than content'.[7] Certain *forms* of competence allow for the appropriation of some programmes rather than others by specific groups in specific socio-historical conditions. So, Morley argues,

soap opera presumes, or requires, a viewer competent in the codes of personal relations in the domestic sphere. The viewer is required to have a particular form of cultural capital – in this case in the form of the ability to predict the range of possible consequences attendant upon actions in the spheres of the domestic/familial. Correspondingly, current affairs TV presumes, or requires, a viewer competent in the codes of parliamentary democracy and economics. The viewer is again required to have available particular forms of knowledge and expertise, because the assumptions/frameworks within which reports/discussions move will rarely be made explicit within the programmes.[8]

Doctor Who, however (particularly in the Letts/Dicks era of 'The Monster of Peladon'), deliberately emphasized *both* political/economic matters *and* 'soapy' relationships. If it is the case, as Morley argues, that 'without prior access to these codes the particular content/items within the programmes will remain incomprehensible';[9] if it is also the case that access to these codes tends to be gendered (so that 'persons culturally constructed through discourses of femininity' are most likely to acquire the competences necessary for reading soap opera, and those culturally constructed through discourses of white, middle-class masculinity are most likely to acquire the competences necessary to read current affairs TV), how then might *Doctor Who* (which ostensibly mixes these generic forms) become 'comprehensible' to either of these gendered audience positions (with the additional problem of how will this vary *within* genders as between followers and non-followers of the series)?

To examine this particular problem of reading position, the research team considered groups in the process of 'cultural construction through discourses of gender': male and female teenagers (including both followers and non-followers of the series). There the value of Morley's shift from ideological 'preferred' meaning systems to generic cultural competences became clear as we heard girls debate 'The Monster of Peladon' in terms of its difference from soap opera (non-followers) and as fantasy (followers) – while even Year 10 girls seemed unable to comprehend the politics of the episode; and where we heard boys debate its 'relevance' and 'reality' in contrast to more action-adventure 'hardware' science fiction. Two Year 10 classes were contacted in northern Sydney. These were both in the 'North Shore' area (predominantly affluent, professional/managerial middle class); consequently among the boys (on Morley's prediction) we might expect to find a developed cultural competence in reading 'political' genres. We approached one all-female class, and one mixed male–female class to see whether discourse contexts and relevances differed by gender.[10]

The interviewer was instructed to allow for as free a flow of discussion as possible in her 'Monster of Peladon' groups, in order to try and access

the respondents' own frames of reference and patterns of relevance and comprehension. She was also provided with a set of questions focusing on genre ('how does this *Doctor Who* episode compare with other science fiction you have seen?') and (following Elkins *et al.*) focusing on the narrative's 'models of action and social order' ('what kinds of hero?', 'what is "villainy" in this episode?', etc.). She was asked to introduce these more directed questions as naturally as possible into the flow of the conversation, in order not to interrupt or cut across it. In this respect the combination of non-directive and structured questions was intended to be similar to Morley's early research, though (influenced by his 'Postscript') with a particular focus on generic competence.

We found that things did not always work out that way. Sometimes the interviewer felt the need to introduce at least the 'how does this compare with other science fiction' question at the beginning 'in order to start them off' when she felt some reticence or awkwardness in the group (this could also happen, of course, with adult groups like the mechanical engineers). At other times (not often) when we examined the transcripts we noted that her question (asked during a pause in the conversation) may have prevented the elaboration of a particular theme. And in the case of the girls' high school, problems with the tape recorder led to a particular focus on her authority as interviewer. These were 'North Shore' girls, and their subversion of authority was perhaps gentler than one might experience among Paul Willis's 'lads' in his well-known research into working-class children in England.[11] Indeed, for any of us who have taught secondary students, perhaps the surprising thing is *how* restrained in their 'subversion' these girls were. Nevertheless, their challenge to the authority of the interviewer (inflected no doubt in class and gendered ways) was one of the 'meanings' and 'relevances' of *Doctor Who* in this context. It allowed these girls the 'power to play' in the classroom.

GENRE COMPETENCES: DISCOURSES OF 'REAL LIFE' AND 'FANTASY' (YEAR 10, GIRLS' HIGH SCHOOL)[12]

In our audience research with highly academic (selected high school) 14-year-old male fans[13] of *Doctor Who*, we found that the series was most 'entertaining' when it drew on their school knowledge of history. The boys particularly liked *Doctor Who* episodes which used what they called 'twists' to historical events: such as the origin of life on Earth in 'The City of Death', the cause of the global disappearance of dinosaurs in 'Earthshock', or the Fire of London in 'Visitation'. In these cases, conventional genre themes like the invasion of 'garden' Earth by aliens and robots were, in the boys' words, 'tied in with history ... tied in with something you already believe'. For these boys, science fiction as genre was enjoyable when it gave entertaining twists to the well-rehearsed

history of the formal curriculum. They tended to reject series like *Buck Rogers* ('basically all space ships and laser beams') and *Battlestar Galactica* ('just these shoot-them-ups'), preferring science fiction with 'ideas' and 'concepts'.

But at the girls' high school there was no similar 'formal curriculum' response to *Doctor Who*. Rather than seeing science fiction as potentially giving interpretive twists to the historically 'real', many girls found the real in a different genre: soap opera.

> '*The Restless Years* isn't like *Doctor Who* because *Doctor Who* is science fiction, whereas that is more realistic and soap opery.... They try and make it like realistic everyday life in *The Restless Years* and *Doctor Who* is fantasy and all science fiction.'

These girls' dominant discourse concerned 'real life', 'real personal relationships' (which underpinned their definition of 'good' acting as against 'stereotyped' ones). Hence certain soap operas in which the acting was not 'realistic' (such as *The Young Doctors*) could also be rejected. Even the girls who *liked Doctor Who* justified it as part of a science fantasy genre that was 'not *meant* to be believable'. But then, other non-fans argued, its mixture of 'fact' (science) and 'fantasy' is what makes it poor entertainment.

> 'That makes it boring because they said it's meant to be fantasy and yet it takes a lot of the excitement out of it if you realize it's sort of scientific.'

For all the girls then, both those who liked and disliked the show, it was important to separate 'reality' (as portrayed in the 'better' soap operas) from 'fantasy', and the problem of a mixed 'fact/fantasy' genre clearly worried them.

> 'Because a lady's voice is something that is not fantasy and it's just really strange to have this lady's voice coming through on this big green eye.'

Unlike the tertiary sociology students, these 15/16–year-old girls seemed less concerned with what the ambassador's female voice signified about the status of women in the world than with the location of women in a *mixed genre*.

> 'And then just to add to it the guy says "Oh, because she's a woman her acts aren't important", and people don't carry on like that.'
> 'They wouldn't do anything like that where there's all these monsters.'

The girls (as Morley would predict) seem much more concerned with the 'domestic' truth of interpersonal reactions and emotions than with the 'public' world of women's issues.

'They sort of took everyone to the extreme. They were either really perfect or infallible or you were a baddie-baddie.'

'It's just the people's reactions. Like I know the set and stuff like that is meant to be emphasized as a sort of a fantastic thing because it is science fiction. But the people's reactions and things like that are overemphasized, like their emotions and things like that.'

'That makes it unbelievable to me.'

The producer and script editor of 'The Monster of Peladon', Barry Letts and Terrance Dicks, were perfectly conscious of having produced a programme combining 'serious' science fiction with the 'emotional relationships' of soap opera. Indeed, it was their preferred narrative form. As Letts said, 'good science fiction' should not take

> too deadly serious an attitude towards the whole thing. . . . The other element which is absolutely essential is the audience being involved in the emotional lives of the characters ... that soap opera element is absolutely essential. If you lose that, and you just have plain ordinary science fiction on the screen without giving a damn about the people involved, then it's gone. Which is why the Doctor and his assistants must have very strong personalities of their own, so that you are interested in what is going to happen to them, and interested in their emotional relationships.[14]

However, the one thing which *Doctor Who* has felt unable to do because of its 'family' scheduling is to engage with precisely the currency that soap opera deals in (i.e. emphasize love/sexual relationships). Schoolgirl groups could be quite inventive in constructing a subtext for the show in those terms. For instance, in 'Kinda' one of the actresses (who was going on holiday) had to be written out of the story, which is achieved by having her character, Nyssa, faint at the beginning of the first episode and be placed for safety inside the Tardis. It is an extremely minor moment in the action, and some of it is almost hidden, back of frame, behind the Doctor. Yet some girls noticed the young teenage male, Adric, supporting the fainting Nyssa with his arm, and said they often talked of the potential 'love' relationship of these two in the show. But by and large the absence of developing personal relations in the show (as compared with *Doctor Who*'s reiterated *social* relations of oppression and liberation) leaves many girls cold.

Whereas the tertiary sociology students commented on the sexism of the allocation of a female voice to the totally ineffective ambassador, and so tended to dismiss the politics of 'The Monster of Peladon' as reactionary, these girls were more concerned with the problematical nesting of soap opera features within a 'fantasy' genre. As for the representation of women themselves, the girls were satisfied with the *political* represen-

tation of Sarah and the Queen, worrying only about the inappropriateness of mixing 'reality' like 'Women's Lib' with monsters, and also about the 'stereotyping' as 'Goodies' and 'Baddies'. Hence the Queen of Peladon was rejected not for her representation as a woman but for her stereotyping according to recognized generic conventions (e.g. the Western).

> 'There is this rebellion. . . . The Queen is the goodie and there's all these other baddies, and it's just like the typical stupid sort of thing. . . .'
> 'I knew he was a baddie, he was dressed in black. . . .'
> 'Baddies are dressed in black. . . .'
> 'Black hats and white hats.'
> 'And goodies in white in this episode. . . .'
> 'Everything is fixed up.'
> 'Everything is sorted out, there's no war.'
> 'They all live happily ever after.'
> 'That's why it's so predictable. You know what's going to happen.'

Whereas the continuous form, open-ended narrative and complexity of relationships in soaps make their stories unpredictable, for these girls *Doctor Who* repeats itself.

> 'And then he goes off to another planet and fixes that up.'
> 'So there's always a happy ending.'

As a number of feminist commentators have noted, girls and women take pleasure in 'the perpetual sense of irresolution' in soap opera, and 'in the ongoing personal involvement which the cyclical nature of the programme allows'.[15] In contrast, *Doctor Who*, for these particular girls, offers a perpetual sense of resolution, linearity and repetition (as the Doctor 'goes off to another planet and fixes that up'). Drawn to 'good acting' which 'makes you believe in the story', and to the open-endedness and complexity of relations in soaps, some girls would prefer science 'fantasy' to dispense with pretensions to 'reality' altogether, because when it tries, in their eyes, it fails.

> 'The actors just looked as if they were reading. . . . They weren't really *in* character. They were just reading their lines. . . . And when they did try to show enthusiasm it just didn't look real because they went sort of 'Oh, no!' If you were in those circumstances and all those monsters and things were around you, you wouldn't start talking about Women's Lib and things like that. That's ridiculous!'

Certainly it seems to be the case that these upper-middle-class girls were more oriented to personal than to political relations. While they had a very coherent understanding narratively of what *happened* in this rather complex episode, while they could efficiently read visual cues (Eckersley's

'shifty' eyes gave him away as 'villain' from the start, they said), while they could make generic distinctions and predict endings, they did not comprehend the fairly overt political message.

'The miners were rebelling. I'm not quite sure why.'

One thing which seems curious about this school discussion is that even though the girls who *liked Doctor Who* were probably in the majority (or at least, only nine out of twenty-six thought that 'The Monster of Peladon' was 'stupid' and 'uninteresting'), these followers of the series were unable to sustain an argument as to why they liked it. Undoubtedly, the dominant discourse in this audience interview was that of girls hostile to *Doctor Who* on the grounds of it being 'not like realistic everyday life', 'badly acted', 'corny' and so on. In contrast the followers' responses tended to be *reactive*, responding to specific criticisms of the show.

> 'The acting is not that great but that doesn't really matter. The people that make the programme know that it's not very good, but it doesn't matter.'
> 'Sometimes it's pretty corny, but it's funny.'
> 'But it's not supposed to be believable; science fiction is a fantasy.'

When encouraged by the interviewer to expand their comments, the followers either could not, or trailed off quickly, or else were cut off by girls hostile to the show. This school classroom was (unlike, say, a fans' convention) a very defensive discursive space for *Doctor Who*, and these girls had few of the fans' cultural competences to explain the show and their liking of it. Their 'memory' had none of the impressive 'archival' detail of the 'real' fans; all they could appeal to here was a casual memory of the show, which only signified 'knowledge' among those girls who had not seen the show at all over a period of time.

At certain points in the discussion, the interviewer encouraged those who liked the series to talk by appealing to their memory of the show. But only once is 'fan' memory used to *counter* the hostile responses by way of its own stock of knowledge.

> 'If you were in those circumstances and all those monsters and things were around you, you wouldn't start talking about Women's Lib and things like that. That's ridiculous.'
> 'In that situation, you'd inform the Queen about it.'
> 'And what good did it do? The Queen *still* didn't do anything.'
> 'Yeah, she did in the next episode.'
> 'She starts standing up for herself in that episode anyway.'

In this case the 'fan' memory, defending the 'believability' of the show against hostile attack is buttressed by the voice of authority, the interviewer.

Int: 'Yes, indeed that's true – for those of you who know that particular series, she does become stronger.'

But this was the only discursive victory for the followers of the series, and the only time that series memory was drawn on in debate. As we said, nearly all the other defences were reactive (as indeed this one was initially). One other discursive strategy the followers practised in this respect, though, was to appropriate and *re-activate* the critics' own terms, as for instance the criticism 'This all sounds rather stupid' by way of:

'It was stupid and it was good.'
'I thought it was like a big mockery but it was funny.'

The most elaborated criticisms and defences of *Doctor Who* were, however, generic. The interviewer asked what other science fiction had they seen, and this elicited, on the one hand, the response '*Star Wars* has much more special effects, it's a bigger production', and on the other hand the response that *Doctor Who* is preferred because 'everything's pretty fantastic ... there's all these crazy animals ... like that one [in 'Peladon'] with the big eye'. There then develops a debate about science fiction as between what is 'interesting' and what is 'believable'.

'I think *Lost in Space* is better.' (laughter, groans)
Int: 'Why do you think *Lost in Space* is better?'
'It's not a fake set.' (loud protests) 'Well, *Lost in Space* is a fake set, but it's believable.' (laughter)
'I don't think *Doctor Who* is meant to be believable.'
'Yes, but that's really annoying.... They sort of anticipate how everyone is going to react. No one would react the way these people do. It sort of makes it look so stupid.'

Later in the discussion the point was raised again.

'I know another programme which is better than *Doctor Who* which is British too ... *Space 1999*.' (laughter)
Int: 'Why do you think it's better?'
'It's more realistic.'
'But science fiction isn't supposed to be realistic.'
'I think that's a matter of opinion.'
Int: 'Somebody thinks *Space 1999* is boring.'
'It's too much like *Buck Rogers in the 25th Century.*'
'Oh, it's not.'
'It's too much the same.'
'With *Doctor Who* you're in another world, another time, another ... it's all different.'
'Well, if you are in another world, another time, perhaps they

should make it more way out, instead of having such dopey reactions of the people.' (laughter)

On the one hand, the critics of 'The Monster of Peladon' were clearly hostile to the mix of 'fantasy' with the 'politics' of 'Women's Lib' etc. On the other hand, the followers of the series were trying to carve out an area of 'difference' for *Doctor Who* compared with other, more hardware-oriented TV science fiction. Unlike them it was not 'into' special effects; rather it has this Doctor who

> 'is sort of different all the time ... he's different every time he comes on.'
> 'I liked Tom Baker better' (general 'yeah') 'with his long scarf.'

The followers seem to be articulating the relevance and interest to them of *Doctor Who* both in terms of its difference *within* its own format (as a result of the Doctor's regenerations – Tom Baker is preferred to Pertwee because his acting idiolect was more 'fantastic' and 'bizarre'), and in terms of its difference *from* more action-oriented SF, which is 'too much the same'. A clearly articulated feminist discourse about the value of fantasy in science fiction – as presented, for instance, by Robin Roberts in *A New Species: Gender and Science in Science Fiction* – is not yet available to these girls. Yet their strong emphasis on the value of fantasy, that 'science fiction isn't supposed to be realistic', and on the value of 'another world, another time' where 'it's all different' certainly gestures towards the worlds of magic, fantasy, indeterminate space, non-linear time and female community that Roberts sees as central to feminist science fiction. Between them, the girls who prefer the domestic-world irresolution of soap opera, and the girls who enjoy the unbelievableness of fantasy claim their pleasure in its 'difference' from the scientific 'rationality' of the genre.

'HE'S GOT DEEP POCKETS': SCIENCE FICTIONS OF IMPACT AND IDEAS (YEAR 10, SYDNEY MIXED HIGH SCHOOL)[16]

Int: 'How does *Doctor Who* compare with other science fiction?'
M: 'It's not as good, it's a lot simpler.... It's been going for ten years or something like that and it's started running out of ideas....'
F: 'You don't really run out of ideas in science fiction.'
F: 'It's all fantasy.'
M: 'I like it – there's action all the time.'
M: 'It's more spaced out than most of them.'
M: 'They don't really have sort of dynamic images like if you see in some of the science fiction movies. Some of them, the endings

have a real big impact on you. I can remember one, like it might be that everyone gets killed but some of them you really remember for a long time for their endings.'

In response to the interviewer's generic question, there is an initial division on gender grounds. Girls like it because it is 'fantasy' and different all the time ('You don't really run out of ideas in science fiction'). Boys like or dislike it according to how it shapes up to other science fiction in terms of action, dynamic images and 'big impact' endings.

However, as we saw at the girls' high school, this is not the girls' *only* response – nor is it the only boys' response.

F: 'I really think *Doctor Who* is just a joke. I can't see how intelligent people watch it. . . . I cannot see how anyone from Year 10 doing their School Certificate can sit down and watch a moronic programme like that. A flash of light and somebody is dead. Things like *Buck Rogers* and other things like that are believable, this isn't.'

M: 'Everybody has got their own opinion on things. Well maybe you watch *Buck Rogers* or whatever. I can't understand that. . . . I can't stand things like *Buck Rogers* or *Flash Gordon*. . . . I think like if you had a hard day and you come home you don't want to watch something that's really sort of fast moving like *Buck Rogers*. Something like *Doctor Who* is different, it's interesting. . . . You can listen to it. But in *Buck Rogers* they don't really say anything. *Buck Rogers* is visual.'

F: 'It doesn't make you think, it's stupid.'

M: '*Doctor Who* isn't really relevant at the moment. . . . Like all those spaced out things he goes on about. Just jumping from planet to planet and things like that. *Buck Rogers* is the positive sort of thing that could happen.' (laughter) 'It might happen, even though it's doubtful. But there is no way that the stuff on *Doctor Who* could happen.'

Int: 'Are you saying that a programme like *Buck Rogers* depicts a situation that could just conceivably happen?'

M: 'No, it's more like an Earth – but an Earth in space a couple of centuries away or something like that. . . . A space station that's really big could become another Earth. Like there's an Earth down here and another Earth up there sort of thing. But Doctor Who just travels around and there's no . . . and all these really big, massive operations and stuff – it could never be conceived or happen. *Buck Rogers* is just sort of like a more modernized Earth.'

M: 'I think why some people go for *Doctor Who* rather than *Buck Rogers* is maybe because *Doctor Who* is sort of far-fetched and fantasized and that can be enjoyable even though it can't happen

every day.... It's a complete fantasy that you wouldn't find in
everyday life.'

F: 'I think there should be a better-looking actor.' (laughter)

As at the girls' high school, the followers of *Doctor Who* (both male and
female) here try to mark it out as 'different' from other science fiction
like *Buck Rogers* and *Flash Gordon*. And again they are opposed on the
(not uncontested) ground that the latter are more 'believable'. But
the *quality* of that 'believability' is spelled out here – by the boys. There
is the 'hard' science fiction definition of a plausible, *technological* extrapol-
ation into the near future ('sort of like a more modernized Earth'). At
the same time, this 'hard' science fiction is 'fast moving', has 'dynamic
images' and 'leaves a big impact' – all qualities associated with the 'latest'
technology. This is Jay Goulding's 'negative critique' *Star Wars*: 'a whirl-
wind of action ... bombs, laser blasters ... exploding planets and star-
ships';[17] but the boys evaluate it differently.

M: 'I went to see *Star Wars* and I thought that was really enjoyable.
The fact that you go and think 'wow, fantastic'. But I think this
Doctor Who was the corniest thing I have ever seen.'

In contrast, the Doctor – for those who like him – is seen as not 'wow,
fantastic' but just 'a common sense, human good guy.'

F: 'He knows a lot of scientific knowledge, not necessarily more than
the people he goes to see, but he uses mainly all the common
sense and humour. They are talking about him not being an all-
round good guy, like the all-American dream, *fantastic* man, the
American thing.... Even though he uses all this fantastic mad
machinery, he's just your general, human good guy.'

The qualities of the Doctor which were only hinted at at the girls' high
school are fully fleshed out here: non-violent, practical, intelligent, logical
yet resourceful ('he's got deep pockets'), helper of the underdog, the
underprivileged, and all those who are being discriminated against, scien-
tific but with plenty of common sense and humour – in a word, not the
'fantastic' man of the 'all-American dream' but the 'general human good
guy'. With this 'human good guy' definition, another reading of *Doctor
Who* as science fiction is beginning to emerge here. Far from being 'just
fantasy', the girl quoted above is reaching for the definition of science
fiction as the introduction of a *novum* ('all this fantastic mad machinery')
into an otherwise plausible, believable and relevant social situation. This
is a step towards the 'estrangement' evaluation of 'good science fiction'
that we considered in Chapter 3.

The emphasis on the 'ideas' of *Doctor Who* by and large determines
this group's view of women in the show. Sarah is (from a boy) 'The

women's answer to Doctor Who'; she (from a girl) 'gives a gentler side of Doctor Who'; she (from a girl) 'gives him ideas'; and (from another girl) 'he'll develop them'. One girl does see a personal aspect to their relationship ('he's fond of his sidekick, and that develops which makes it interesting'), but this 'soapy' reading of the show is not elaborated by others. Though one boy says 'she is there to get into trouble', this is not seen as a particularly sexist aspect of the show – rather a matter of major and minor partners helping each other, as in *The Sweeney*.

It is almost entirely boys who respond to the *other* 'political' dimension of 'The Monster of Peladon' – the class factor.

M: 'Most of the villains want power.'

Int: 'Did you see the miners as villains?'

M: 'Yes, they were trade unionists.'

M: '... Oh, they're just sort of fighting for their own rights as well. In some respects they were villains. That's sort of related to life in a certain way too.'

F: '... They are just getting angry and trying to get back. The people who are in charge ... just want to shackle them all of the time. I think those with more power over them are really the villains than the miners.'

M: '... Remember they made the agreement at the end to act normal so that they would leave.'

M: 'They weren't really scared of them. They just didn't want them to interfere in their planet.'

M: '... Like we don't want Russian interference here.'

Presuppositions of an overtly ideological kind, in the sense of becoming the 'common sense' of interpretation ('trade unions as villain', 'the Russian threat') are, as Morley might predict, solely the discursive property of boys in this discussion.

Morley's caution that his earlier audience research failed to 'recognize, in the first instance, the question of the viewer's positive or negative response to the text as a particular cultural form – do they enjoy it, feel bored by it, recognize it as being at all relevant to their concerns?'[18] – is certainly well illustrated at this mixed high school. These Year 10 students spontaneously use just these categories ('enjoy', 'bored by', 'relevant') to position their responses to 'The Monster of Peladon'.

On the one hand, there are those (male and female) students who structure their responses generically: 'good' science fiction is about 'a more modernized Earth', and villains who are 'human level, not monsters'. None of the obvious political 'relevance' of the text seems to have shifted this view. They notice the political statements, but see them as 'not really relevant' to the contemporary world.

On the other hand, the followers of *Doctor Who* react against 'fast

moving' science fiction like *Buck Rogers*, arguing that it 'doesn't really say anything'. *Buck Rogers*, in this interpretation, is something you *see*, *Doctor Who* is something with different 'ideas' which you *listen* to.

If we move on from questions of these teenagers' negative or positive responses to the text, to exploring their agreement or not (as in the earlier Morley research) with its ideological propositions, it seems that we have three generically coded positions represented here.

1 The critics of *Doctor Who* who do not contrast it with the 'everyday believability' of soap opera, as was the case at the girls' high school. Rather, they contrast it with the 'believability' of recent, 'special effects', technological, 'hardware' science fiction – with its psychological 'impact' and its social relevance (as a 'more modernized Earth'). Finding *Doctor Who*'s debate about workers' rights and women's liberation 'not really relevant' to the contemporary world, these students understand the 'relevant' as further technological mastery over the environment. The ideology of scientism, defined by Dunn as 'the form of a religious/magical belief in technical mastery over evil forces', equates these (mainly male) students' preferences with *Star Wars*, *Buck Rogers* and so on. Their only criticism of the 'action' SF television shows is in their tendency to 'fake sets', lacking the 'big production' budget of the movies. Notably, the most 'technocrat' and 'organization man' of the Doctors, Jon Pertwee in 'The Monster of Peladon', is *not* appropriated for this 'hard' SF reading in the way that, at the girls' school, Tom Baker was appropriated for 'fantasy'.

2 The followers of *Doctor Who* who (like those at the girls' school) comprehend the series as 'a complete fantasy that you wouldn't find in everyday life', *despite* the textually foregrounded political 'relevance' of 'The Monster of Peladon'. Alien villains are neither 'boring' in this discourse, nor 'wanting power' in an analogy to the contemporary world, but rather are 'way out' and 'amusing'.

3 The followers of *Doctor Who* who like to 'listen' to its 'ideas' – about gender relations, about power conflicts, etc. Although sexist ('Women should stay in their place') and anti-union slogans are mobilized by individual boys as classroom rhetoric, these followers by and large seem to adopt the 'welfare consensus' of 'The Monster of Peladon' text, agreeing with its liberal definition of modernity:

 (a) in class terms ('Gebek is a good bloke. He didn't want to do anything violent ... but get things back to their mining'; 'the people who are in charge ... just want to shackle them all the time ... those with power over them are more the real villains than the miners');

 (b) to some degree, in gender terms ('The Queen had a suppressed

strength. I reckon if she wasn't so dominated by men like the way that was said, she would have been a really strong ruler'); and

(c) in national consensus terms ('They just didn't really want them to interfere in their planet . . . like we don't want Russian interference here').

In this mixed audience group, the *dominant* discourses were those of the two opposed notions of 'relevant' science fiction – technicist versus 'the good society', and both of these were elaborated in detail by boys. As at the girls' high school the discourse of 'fantasy' was more minor and remained unelaborated. To put it another way, we would argue that these teenage girls' subject positions – experientially leading them to pleasure in fantasy, and boredom with 'male-dominated science fiction [that] emphasizes how technology develops' – have not yet found feminist reading positions. Consequently they cannot resolve 'the conflict between masculine science and feminine magic'[19] that Robin Roberts finds in feminist science fiction. Yet, the girls who agree that 'The Monster of Peladon' is 'boring because they said it's meant to be fantasy and yet it takes a lot of the excitement out of it if you realize it's sort of scientific' are (in terms of Morley's *process* through attentiveness and recognition of relevance to comprehension and interpretation) very clearly on the way. As Morley predicts, the teenage girls' discourse is all about 'enjoying it, being bored by it, and recognizing its relevance to their concerns'. Most students (and nearly all the girls) did not decode the text ideologically.

Yet Morley's speculation about the generic competences of teenage girls is also constricting. Clearly some girls' enjoyment and sense of relevance (in relation to soap opera) was related to 'discourses of feminin- ity' associated with domesticity. But there were other pleasures (associated with fantasy) that were harder to articulate, but equally strong. This was a form of competence, in its unarticulated critique of male- dominated science fiction, that could well provide a linkage to the fan- tasies of feminist science fiction.

TEENAGERS AND VIOLENCE: A QUANTITATIVE APPROACH

So far our approach to the *Doctor Who* audience has been qualitative. Although some forty audience groups were interviewed – so that in fact nearly 300 people were involved in discussion of the programme – our approach has been to examine the discursive and rhetorical strategies which individual groups adopted. And this chapter in particular has per- haps illustrated what Morley calls one of the 'worrying tendencies' of qualitative audience work: of 'generalizing radically' from specific instances.[20] Rather impressionistic generalizations like 'it is almost entirely

the boys who respond to ... the class factor', made from one mixed audience group, bear all of the hallmarks of that tendency which Morley finds in Fiske of an analysis where a response 'in quite particular circumstances, is decontextualized and then offered as a model for decoding in general'.[21] The issue of contextualizing student interviews will be addressed in a later chapter.

Meanwhile, we should note that Morley criticizes Fiske in particular for this tendency as an example of oversimplistic 'resistant reading' approaches to audience and text. In this book we make our own critique of the usage of 'resistant reading', arguing that though readers play an active role in interpreting the texts they consume, they nevertheless do so within a socio-historical context that shapes their discursive competences, an institutional context which both frames their desires and helps form their readings, and a textual context which may help facilitate or resist the reader's interpretive work.

Nevertheless – and the issue of resistant readings aside for the moment – as a primarily qualitative approach to audience analysis, this book runs the risk of the familiar accusation of generalizing from particular instances. There are a number of (also familiar) responses to this. First, where we analyse audience transcripts *as* text, we are drawing on a different kind of validation for our interpretation; seeking to expose, as Morley has argued, the 'logical scaffolding', the cultural frames of reference 'through which respondents construct their words and their own understanding of their activities'.[22] It is for this reason that in Chapter 6 we quote extensive sections of the audience-text, to try to show how these fans' logics-in-use negotiate the programme and the interview. Readers of the book can then assess for themselves the plausibility of the analysis.

Second, the more general argument (following Clifford Geertz) is that rather 'than beginning with a set of observations and attempting to subsume them under a governing law', cultural analysis 'begins with a set of (prescriptive) signifiers, and attempts to place them within an intelligible frame'.[23] The task here is an interpretive one (of seeking meaning) rather than a scientific one (of seeking laws). So, as Jensen says, qualitative analysis focuses on meaning (rather than quantitative information); on the occurrence of logics-in-use in specific rhetorical contexts (rather than the statistical recurrence of pre-chosen categories in different contexts); on an internal approach to understanding cultures (rather than a detached external stance); on exegesis of the individual experience (rather than manipulation via experimental method); and on the contextualized process of meaning production (rather than produced media 'effects').[24]

Jensen rightly notes of this kind of research, that though 'responses could not be considered representative of these groups in the population at large, the specific lines of reasoning can suggest differences in the

modes of reception which may be examined in further qualitative as well
as quantitative research'.[25] For example, the schoolgirls' response to
science fiction as fantasy reported in this chapter could be explored
further by replicating these interviews to establish a quantitative ground
for the analysis (and indeed were replicated by other girls' high school
interviews); or they could be explored further via the long interview
technique, whereby individual girls' interpretive repertoires, adoption of
generic modes of address and other aspects of their 'logical scaffolding'
are revealed. In the *Doctor Who* audience project both long interview
and quantitative approaches were used. There is space here only to
comment briefly on an aspect of the quantitative study, which was part
of our broader 'TV Violence' study.[26]

Recently a number of theorists have argued for the need to bring
together qualitative and quantitative methods in audience analysis.
Schroder, for example, emphasizes that:

> one of the tasks ahead will consist in conceptualizing a method which
> makes it possible to incorporate and preserve qualitative data through
> a process of quantification, enabling the researcher to discern the
> demographic patterning of viewing responses, for instance the pro-
> portions of 'preferred' or 'aberrant' responses within demographic
> groups.[27]

In our 'TV Violence' project (an extension of the audience project which
examined readings of violence in six television genres) we attempted to
do this. *Doctor Who* was included in this project particularly because fans
in Britain and Australia were complaining bitterly at this time about
violence in the 'Doctor Whooligan' period of Colin Baker (see Chapter
8). How would the broader audience view this era of violence in *Doctor
Who*? We chose as our audience text for this project the Colin Baker
story, 'Vengeance on Varos', which was both violent (focusing on the use
of 'video nasties' for social control) and political (focusing, like 'The
Monster of Peladon', on a 'transnational'/transgallactic mining operation
which reduced the victim planet to 'Third World' conditions).[28]

Both quantitative (questionnaire) and qualitative (open-ended summar-
ies of 'what was the programme about?'; and focus group interviews)
measures were used. The summaries (administered prior to the
questionnaires) were designed to assess narrative saliency; i.e. what was
it that happened in the narrative that the students deemed relevant?
Would they emphasize the violence, or the use of the violence for social
control? Would they, for instance, emphasize the exploitation of primitive
cultures by 'multinationals'? Would they link the economic exploitation
with the social control, as the text 'preferred' to do?

We used narrative summaries of 'what was the programme about?' as
a way of establishing the 'discourse topic' (van Dijk 1977, Tulloch and

Tulloch 1992).[29] We administered these open-ended summaries immediately after screening the episode; this was deliberately prior to students completing questionnaires, since these latter texts would inevitably guide responses via their selection of questions. However, the qualitative narrative summary results could then be compared with quantified responses.

Three aspects of this TV violence research will be summarized here:

1 To what extent did the narrative summaries and/or questionnaire responses confirm our impression (and Morley's prediction) that girls (in particular) lack the cultural competences to read a science fiction text 'politically'?
2 To what extent does television violence influence emotional attentiveness and subsequent comprehension as part of the process of attentiveness, comprehension and response that Morley points to?
3 To what extent does the modality of science fiction's violence influence comprehension and evaluation?

Quantitative answers to these questions would, we felt, 'incorporate and preserve qualitative data through a process of quantification' – a step towards the integration of quantitative and qualitative methods that Schroder and Morley call for.

An overview of the narrative summaries makes it clear that many students found the plot very difficult to follow. In contrast to other programmes used in the TV violence study (soap opera, war series, police series, 'political' documentary, sports talk show) the goals of the characters in 'Vengeance on Varos' were deeply embedded in social structural processes (economic exploitation and social control). This made it hard for students to explain what was happening purely in terms of personal motivations. Instead, younger students (especially middle-class Year 4 boys) who attempted to recount the plot often focused on the violence: 'people being executed by laser guns'. It was not until Year 10 that an analysis of the social, economic and political structure occurred.

To what extent was Morley's prediction supported that adolescent boys (especially those from the middle class) are more likely than their female classmates to decode the 'politics' of the narrative? And if so, to what extent would this be extended to decoding the structures of power, exploitation and social control portrayed in the narrative? To help answer questions of this type, each student's written account of the programme was classified as (a) evaluative, (b) description of characters or events, (c) description or analysis of social system, (d) no response. The accounts of forty-one middle-class Year 10 students (fifteen boys and twenty-six girls) were so categorized with some students giving responses in both the evaluative and one or other of the other two substantive categories.

Of particular interest in terms of cultural competences is that two-thirds of the boys but only one-third of the girls produced any account

of the social system. The majority of girls replaced an account of what the programme was about by what they *felt* about the programme. Evaluative statements were made by over half the girls but only one-third of the boys, with nearly all these girls' responses being extremely negative. Moreover, a quarter of the girls but only one boy wrote nothing on their paper. The differences that emerged in the discussion response to 'The Monster of Peladon' seem both mirrored and taken a stage further when written scripts are categorized. A sense of the difference can be gained from comparing a typical male student's response:

> I think it was quite realistic, in that I could see that sort of society evolving on a prison planet. The governor seemed as much a prisoner of the system as his people. It was pretty good even if the special effects were crumby. Not that I like blood and gore but it could have better laser blasts and stuff.

with a female student:

> I thought that the programme was extremely pathetic. It was boring, way too violent and dumb. It was sadistic because people got pleasure out of torturing others and I think that's pretty sick. Above all, I thought it was one of the dumbest things I'd ever seen.

Even a female student who produced a quite detailed account of the working of the social system concluded:

> I thought it was very violent and stupid, there was no real point in the programme. If you take that seriously I think your level of intellect must be pretty low.

This replicates the schoolgirl's comment discussed earlier: 'How anyone from Year 10 doing their School Certificate can sit down and watch a moronic programme like that'. However, there is an added and quite specific evaluative dimension here. What is striking about the two girls' summary responses that we have quoted is the strength of their hostility: the programme is not just boring, it is sick.

To further explore these gender differences and to see how they were mediated by the *age* of the subject, student responses to a six-item semantic differential scale were examined using discriminant analysis, a statistical technique which identifies dimensions on which groups of respondents differ. Two significant discriminant functions were obtained.

The first function[30] which was most highly correlated with the adjectives 'interesting', 'exciting' and 'disturbing' was mainly attributable to statistically significant gender differences. The nature of these differences can be most clearly seen by looking at the group means on these adjectives. Means are based on a five-point scale with 3.0 representing a neutral point. Girls found the story significantly less interesting (girls 2.07, boys

2.77), significantly less exciting (girls 1.82, boys 2.42) but also significantly more disturbing (girls 3.28, boys 2.25) than boys. This makes clear that lack of pleasure and attentiveness does not mean lack of response. As the girls' summaries also indicated, the meaning 'sick' (replacing the *social* interpretation of the text) led not to the cognitive response, 'This system is unfair, it has to be changed', but rather to a deep emotional concern.

The second statistically significant[31] dimension of group difference was in terms of modality, realism and violence. Older (Year 10) girls and younger (Year 4) boys were most sharply contrasted on this dimension, with the older (Year 10) boys also differing substantially on this measure from the girls. While the younger boys saw the programme as not particularly violent (2.63) and placed it near the midpoint on realism (2.98), the older girls rated it as violent (4.16) and very unrealistic (4.45). We have seen from the discussion groups, too, the tendency in girls to rate the programme (for both negative and positive reasons) unrealistic. What is particularly interesting here, though, is the issue of modality: the combination of a lack of realism with a high violence rating contrasts sharply with the claims (by Hodge and Tripp (1986),[32] Gunter (1985),[33] and the Australian Broadcasting Tribunal (1990)[34]) that when programmes are seen as unrealistic they are not perceived as violent. Specifically, it contrasts with Barrie Gunter's finding that science fiction (in this case *Buck Rogers in the 25th Century*) was not seen as violent because of its low realism.

In an attempt to explain these quantitative findings it is necessary to go back to the summaries written by the older girls. Common to many of them is a strong rejection of the violence and a denunciation of it as unrealistic. Several summaries suggest that those making the programme and even anyone watching the programme must have a 'mental problem'. These responses suggest that the viewers take a depiction of violence (in this case people watching torture as entertainment) as an endorsement of such behaviour, rather than as a critique of the system which uses such 'bread and circuses' for social control. The unusual strength of this reaction resembles quite closely that found by Docherty (1990)[35] from adult viewers of a documentary-drama about football hooliganism. None of the students' summaries mention the possible parallel, intended by *Doctor Who* programme creators, between the role of video violence on the planet of Varos and current concerns with video nasties.

The strength of some adolescent girls' negative reaction seems indicative of a challenge to their view of how interpersonal relations work in the world. As one Year 10 girl who could see some redeeming features in the episode commented, 'There are a few good people who are trying to save the innocent, thank goodness.' Thus in the rare cases where the

programme is viewed positively by a Year 10 girl, it is in terms of 'codes of personal relations'.

In terms of Morley's processes of attention, comprehension and response, it appears that for many female viewers a strong distaste for the violent generic form limits an attempt to understand: as one student wrote, 'I really didn't understand it, because these movies don't appeal to me.' However, it could equally be argued that this textual context of interpretation is dependent on the social/cultural context that shapes the girls' discursive competences. It is this social context that limits the girls' relative access to different explanatory discourses (the lack here, for instance, of a socio-political discourse to explain the programme violence) as well as to different generic models (such as feminist science fiction) for making sense of the programme. This seems to be a very clear case where a 'resistant reading' ('pretty sick show') is not socially empowering, nor does it allow these girls the pleasure of fantasy, as was the case with some girls' responses to 'The Monster of Peladon'. In the next chapter we will look at the relationship between ideological decoding and pleasure among older audiences who do have more empowering discursive competences.

Chapter 6

'But why is *Doctor Who* so attractive?'
Negotiating ideology and pleasure

John Tulloch

> This text may be closed in its sense of delimiting the space within which a preferred reading can be arrived at. But within this space the reader has a certain amount of freedom.... Different readers can place the discourses in a different hierarchical order, foregrounding them and relating them differently within the limits proposed by the text. But these limits are crucial: the text does not encourage us to correlate despotism with free market economics... neither does it allow us to perceive that the Doctor's liberal democracy requires dominant and subordinate classes.... These readings are radically opposed, ones that would be produced by readers who *dislike* the text, that is who put themselves outside the realm of its popularity.
>
> (John Fiske)[1]

In this chapter, we will explore the notion that different viewers place the discourses of science fiction in a different hierarchical order, as Fiske suggests. But I will also be disagreeing with Fiske's view that 'radically opposed' viewers cannot enjoy *Doctor Who*. In doing so, I will be exploring further the issues of decoding, ideology and pleasure begun in the previous two chapters.

Television audience members are, as David Morley argued in his *'Nationwide' Audience* research, not unitary subjects. So it is not surprising that we get different readings from differently constituted audience groups, nor that we see a contestation of discourses *within* any one audience group (or even within one individual member of an audience group). Yet Morley admits that he actually ignores 'contradictory positions within the same group' in his *'Nationwide' Audience* work.[2] In addition, as Justin Lewis pointed out, he ignores the effect of group dynamics in the interview situation as the group moves towards a unified interpretive position.[3] Among followers and fans, this achieving of a unified interpretive position is a significant part of their pleasure in the programme, so it is important to consider it. A unified interpretive position is what makes fans a cultural unit, an interpretive community.

To explore this question of interpretive community, pleasure and the dynamics of the interview situation, we can begin with our findings about pleasure and 'recognition of relevance' in Chapter 5. There we began to look at textual reading as a set of processes, which raised matters of attentiveness and recognition of relevance prior to comprehension and ideological decoding. As we proceeded further with the *Doctor Who* audience project, this issue of the recognition of relevance (prior to decoding) became clear in many other audience groups. A 'recognition of relevance' response related particularly to perceptions of the show's degree of 'realism'.

For example, many of our schoolgirl audience evaluated the text's degree of realism negatively compared with the 'real world' of soap opera (while others found it too real and 'scientific'); audiences of TV producers assessed its realism (and therefore their enjoyment) against their own professional competences in being able to spot continuity errors and other (minute) naturalistic details;[4] mothers of pre-schoolers who watched *Doctor Who* with their children preferred to undercut the 'realism' of its monsters by telling the very young fans that these were 'only actors dressed up';[5] audiences of actors deplored the 'one-dimensional', 'unrealistic' acting and sets, but nevertheless enjoyed certain eras of *Doctor Who* for a 'quality acting style' of 'send-up'. They saw Tom Baker's 'bizarre' acting persona as 'a kind of indulgence you don't get in things that take themselves more seriously and don't come off like *Star Trek*'.[6]

Unlike the fans, these adult followers of the series very often base their evaluation of, and pleasure in *Doctor Who* in their own 'professional' values of practice. For the TV producers, this was their professional skill in attending to continuity errors. The dynamic of the interview with this group was determined by a negotiation between the producers' own professional 'recognition of relevance' (annoyance over failures of naturalism) and their own obvious enjoyment as followers of the series.

In the case of the young mothers, the dynamic of the interview situation was in some ways similar, in so far as they, too, negotiated between their 'professional' competence as parents and their own adult pleasure in the series. These young mothers of Sydney pre-schoolers instantly positioned their discussion of 'The Monster of Peladon' in terms of their own 'professional' values of practice as responsible parents.

Karen: 'Well, I thought it was scary for little ones, yeah. You really need to sit with them when they're only small to watch anything like that, so that you can tell them, oh, you know, "this isn't a scary monster, it's just a rubber mask", and you know, you can interpret for them and then they're not so scared.'

Mary: 'Oh, I think it would be scary for a child, especially a 4–year-old because children just don't understand it.'

> Joan: 'They just don't know what science fiction is, do they?'
> Karen: 'And they don't understand the difference between television and reality. They just think those are real monsters really.'
> Joan: 'Well, Ericka, my 5-year-old has actually had nightmares from one particular episode, I can't remember which one it was. I had to go and reassure her in the night.'

At this point, an inflection of this 'responsible parent' discourse emerged via one mother's *memory* of herself being scared by *Doctor Who* as a child.

> Terry: 'I can remember watching them at about 10 years old and then after realizing how frightening it was I refused to watch them for *fear* was giving me nightmares. I mean, that was an age when, knowing they were only rubber masks, but still I was too frightened to watch them, being much older than 4. It's a ridiculous show in one way, because it's such ridiculous science fiction. But it's entertaining in another way. But you wonder why they put on such a frightening series for children.'

In this case, the mother expressed two different notions of the show's relevance: to her as mother, and to her as adult. This interpretive negotiation (why I *as adult* like this 'ridiculous/entertaining' *Doctor Who*) was recurrent in nearly all of our audience interviews. It articulates the ambiguity of 'children's show/adult audience' which, of course, was a founding aspect of the series itself, in so far as it was a show designed for children which came out of an 'adult' department (BBC TV Drama).

As *adult* entertainment, *Doctor Who* is enjoyed by these mothers for its 'ridiculous', 'eccentric', 'unusual', 'not something that happens', 'not reality' qualities as science fiction – which seems close to the 'fantasy' enjoyment of the series by some of the schoolgirls; and, like the teenage girls, the mothers don't expand on this pleasure. Similarly, these mothers (who say that it is 'probably the political side of it that appeals to adults') have in fact nothing to say about its politics – simply that 'the trade union issue' in 'The Monster of Peladon' would probably go over their children's heads. Asked directly by the interviewer what *kind* of politics is incorporated in the expertise of the Doctor, the mothers collapse their own and the Doctor's parental responsibility together.

> Karen: 'I would say he's a problem-solver. He applies PET.'
> Mary: 'Parental Effective Technique.'
> Joan: 'He's a father figure.'
> Terry: '... Isn't that the role of the good father figure after all, to make decisions for his erring children.'

The mothers are negotiating towards a unified interpretive position here, reconciling the relevances of the show to them as mothers and as adult

women. As adult women, they seem distant from the generic competences appropriate for decoding 'political' television. Thus they draw on the 'professional' relevance of *Doctor Who* to them as mothers. They fuse their own and the Doctor's position, reinterpreting the latter, not in terms of its politics but in terms of its 'parental' role. The mothers had said that a main theme of *Doctor Who* was that 'he's a sort of ombudsman who comes along and tells everybody what they're doing wrong'; so that the 'erring children' for them were both the victims of civil injustice in the text and their own children. The notion of PET became their guiding interpretive position, explaining both the text and their work in bringing the text to their children. The reception of *Doctor Who*, they admitted, structured their domesticity in certain ways. Shopping became a matter of 'the children wanting jelly babies just like the Doctor has', and cooking the evening meal was a matter of routine organized around *Doctor Who*. 'The daily series becomes part of your life, because the children always know what time *Doctor Who* is on. So your life's geared in the early evening to make sure everything is organized to watching *Doctor Who*.'

The mothers' experience of watching the programme's content was thus embedded in a concern for 'what's good for the children'. In particular, 'scariness' for children was embedded in the 'security' of appropriate PET.

> Karen: 'Just going to my eldest son, Clare my daughter went through that scary stage, but she had the added advantage of her saying to him, "What happens next? Doctor Who fixes this up, doesn't he?" And Kevin always knew what was going to happen next. . . . And they seem to be reassured by that, definitely. It's scary, but it's not that scary that it's left up in the air. It all comes right in the end. And they know as long as Doctor Who is around everything is going to be OK. He's their security.'

Here the paternalistic and patriarchal position of the Doctor is interpreted via the consensual notion of familial security: like a parent, he is there when needed.

However, against this response of domestic ritual and the unifying interpretive discourse of 'parental effective technique', one woman makes a fairly determined feminist intervention, focusing specifically on 'The Monster of Peladon' to do so. Directly challenging the mothers' consensual, comfortable debate about the Doctor as a super, selfless parent who is good for children in so far as he always resolves things on the side of the 'good', this woman intervenes with:

> Molly: 'He's the original male paragon of virtue, isn't he! All this token "Women's Lib" stuff – what a load of nonsense that is! If it was Doctor Who being a lady, then I'd say they were putting a

message across. But he's the male paragon of virtue. He's the patriarch who's going to make everything all right again.'

Her assertion that the women in *Doctor Who* are 'satellites, the same as everywhere else.... The little woman is always tagging along in his wake, isn't she?' evokes slightly awkward laughter in the other women, and a limited degree of support.

Joan: 'Actually, Sarah-Jane was the worst ... even the children used to complain about her.'

Yet in the following discussion, the feminist intervention was safely contained by the other mothers' resorting to the parent/child relationship, and, unaware of the sexist irony, one mother argued: 'I think Romana must have made a bit of an impact because my daughter named one of her dolls after Romana.'

To a limited extent, the women negotiated an agreement with the feminist, Molly, trying to distinguish better or worse female roles. They felt that 'as the series got older, the women got stronger'. The feminist disagreed.

Molly: 'Oh yes, so she's given a token amount of control. She's allowed to tell him that he's wrong sometimes, and she's allowed to be right sometimes. Big deal, but he's really in control.'
Karen: '... Was it Leela, Terry?'
Joan: 'No, it was a funny name....'
Molly: 'I think it's an illusion of power they're giving the women, not ...'
Karen: 'Romana ... she's given a little more power ... to make decisions.'
Molly: 'How magnanimous of them!'
Karen: 'There was a fairly aggressive one too, very attractive, very physically attractive, and also physically aggressive. She came from a caveman-type era, and she always had a knife in her boot and was quite physically aggressive.'
Molly: 'I'm sure she did it in a lady-like manner though, didn't she?'
Mary: 'No, she didn't.'
Karen: 'No, she was actually very masculine. She in fact was quite likeable for that in that she sort of ...'
Mary: 'That was the only way that she knew how to solve problems, like with violence.'
Molly: 'She wasn't allowed to be intelligent as well, then.' (laughter)

The feminist mother is neither fan nor regular follower of the series: she hasn't the fan memory; she has never seen or heard of Leela. Lacking a follower's knowledge about the history of the series (imperfect though it

is in the other women), she mobilizes the particular episode, 'The Monster of Peladon', against them; and otherwise accesses easily and skilfully a range of extra-textual feminist subject positions, changing her argument but not her political position (e.g. Leela at first is 'lady-like', and when this interpretation is defeated by the series knowledge of the other mothers, she quickly wins her point with 'not allowed to be intelligent as well, then').

In contrast, the young mothers draw on their memory of the show to establish their point that the female companions are getting stronger. These young mothers are clearly not fans in the primary sense – no real fan would grope for companions' names like these mothers do. So, although some of them insist, 'I never miss an episode, I really love it', the young mothers might be called secondary followers – remembering their pleasures and fears in *Doctor Who* from childhood, and, in the present, keeping regularly, but probably distractedly abreast with the series while cooking the tea for their children.

We are dealing here with the effects of the dynamics of a focus group interview situation in moving towards a unified interpretive position. All of the groups we interviewed were followers of *Doctor Who* over many years; yet their hierarchical ordering of discourses (to use Fiske's term) was very often dominated by their recognition of programme relevance as 'professional' readers of the text: the TV producers by their professional dedication to television naturalism, the actors to 'authoritative' styles of acting (such as the 'bizarre'), the young mothers to PET. Unlike the fans, these followers regularly drew on an interpretive community (and thus subject positions) *outside* the programme history.

Yet, as we see in the next section, this is not to say that professional workers could not also be fans, drawing also on the interpretive community of fandom to negotiate textual ambiguities.

IDEOLOGICAL DECODING/AUDIENCE PLEASURE: NEGOTIATING CONTRADICTIONS

We consider here an interview with a group of professional friends (university tutors, young radical lawyers, teachers, professional artists)[7] who were keen fans of *Doctor Who*. I have chosen to focus on this interview because it raises the issue of female representation in *Doctor Who*, while negotiating 'oppositional' decoding, enjoyment and programme relevance. As we are focusing centrally here on the interview as text, I will quote more fully from the audience tape to examine in some detail how group dynamics work towards a unified interpretive position.

An interview with tertiary-educated adults who admit, more than half seriously, that their 'mental health has certainly got worse since the ABC is not showing *Doctor Who*', is likely to contain a degree of

self-legitimation. The entire discussion was an exercise in negotiating political landmines (like the programme's sexism) on behalf of a unified interpretive position: 'Why we are right to like *Doctor Who*'.

In the discussion many of the terms and patterns of argument that come up again and again in audience interviews – 'cheap sets', 'for children?', anti-American SF, etc. – are mobilized, but inflected in terms of this consuming goal. What is especially interesting here is that this was, politically speaking, a radical group, so that many of their ideological attitudes (against sexism, against multinationals, against the war in Vietnam, etc.) might very well act as a check to their liking of the show. How would the group square its politics with the conventional sexism of *Doctor Who*? The choice of 'Monster of Peladon' which foregrounds issues such as feminism and working-class radicalism could be expected to focus this problem.

What in fact occurs during the interview is a systematic displacement of these threatening contradictions by means of their incorporation within other, less dangerous, discourses. Although this was a politically conscious group (able, for instance, to read, and enjoy, the role of the Ice Warriors as 'like some sort of grotesque multinational'), the series-text's foregrounded issue of 'Women's Lib' was hardly touched on by the group, except indirectly. However, the issue of 'sexism' did enter the discussion at regular intervals. It was virtually always introduced by female members of the group, but – with the implicit consent of the women – it could never become a determining discourse. The terrain of its debate was always prepared for via other, more dominant concerns (anti-Americanism; utterances about 'paternalism' not patriarchy, etc.).

So, for instance, the first anti-sexism response from a woman that it is 'wonderful' that the Doctor is not a 'stud', is generated by, and incorporated in, the anti-American discourse of this Australian group.

Int: 'How does *Doctor Who* compare with other science fiction dramas, like *Blake's 7* or *Buck Rogers*?'

John: 'Well it's infinitely superior to anything American' (laughter). 'Rule number one.'

Joan: 'That's because they take a more subtle approach ... than the blatant sensationalism of *Flash Gordon*.'

Fred: 'The overbearing impression from *Battlestar Galactica* and all those, is it's American.'

Int: 'You say you think it reflects national characteristics?'

Fred: 'I think it's part of the commercial machine to generate America.'

Joan: 'So that whereas even though the acting on this show [*Doctor Who*] isn't real great, it's not 100 per cent as far as I'm con-

cerned, you can overlook it, because it's not as corn-ridden' (laughter) 'as American shows. . . .'

Adam: 'I think it's very much . . . the approach of the British that they tend to be able to say things that might on reflection be blatantly incorrect. But the *way* they say them tends to engender this feeling of security in being able to believe what they say. But I think that *Doctor Who* is as indicative of the way British society is as American science fiction programmes like *Battlestar Galactica* are indicative of that society. For example, tonight on 'Monster of Peladon' you have the workers who were revolting, and the nobles who were repressing them. OK, class conflicts being overshadowed by everybody working together after there was an external threat. Well, that's the same sort of thing that the Americans do, except they actually come out and say it, whereas the British programmes don't come out and say it. They just portray it.'

Jenny: 'It's a lot more subtle.'

Int: 'So what is Doctor Who's role, then, in this class conflict that we've seen depicted in this programme?'

Fred: 'Doctor Who is the ultimate and most eminent of all democrats.'

Jenny: 'But he's not a superhero in the American style.'

Until this point in the male discussion about 'why we like *Doctor Who*', their pleasure in the show is articulated in terms of social (British versus US) and political (democrat versus superhero) categories. The following speaker supports a contradictory position: that the Doctor is himself an elite rather than a democratic figure.

Jenny: 'He's a British aristocrat in a way, this Doctor Who especially.'

Joan: 'He's a Time Lord. I don't perceive him as a British aristocrat. On that level, in terms of space dimensions or anything like that. It's not because of birth or anything like that. It's because of his powers of mind.'

Fred: 'But it's still a paternalism/deference system, isn't it? It's the idea that Doctor Who, whether he be an aristocrat or whatever has the answers, and other people relate to him to find out what they are. Now in the American programmes – the way the answers are given are again not as subtle and not as intelligently put. They are more blatant because they need to be able to understand them. But nevertheless, it's still reflecting the same sort of social divisions. . . .'

John: 'He sort of talks his way around things. Like the pendulum with the monster is the perfect example in the "Peladon" one. . . . Like the difference between the British way of talking and the American way of "shoot it if it moves".'

Adam: 'Shoot first and ask questions later.'

At this point in the discussion, programme knowledge ('He's a Time Lord') is brought to the rescue to suture over the contradiction; and it is now his intelligence and creativity which is contrasted with 'shoot it if it moves' American physicality. This contrast of mental versus physical attributes immediately generates a further potential problem, however: the Doctor's attitude to women.

Jenny: 'In his relationship with his partners, the Doctor's more or less superior through virtue of mind than through physical attractiveness or sheer muscle power.'

Adam: 'That's the character, though. He's a Time Lord, so he's seen it all before somewhere else, several times. . . .'

Joan: 'He's not a football hero. . . .'

Fred: 'He's not a stud either.'

Jenny: 'No, which is wonderful.'

Fred: 'Yet he always has extremely attractive women supporting him in support roles, like all the Romanas and Sarah and Leela. They have all been very attractive.'

Adam: 'But actual romance very rarely comes into it, though.'

Jenny: 'They usually are complementary characters in some way or another.'

Adam: 'I think he did lose one in the earlier episodes a few years ago. He lost one to a Trojan, I think it was . . .'

Int: 'So what are you saying about the relationships to his women assistants? . . . Do they have anything in common?'

Adam: 'It's more a secretary-like role.'

Joan: 'Not completely, because in some of the later *Doctor Who* episodes it was more than that. But it was never stated in the show. It was just that the Doctor was less paternalist and he treated Romana much more as a partner than as a secretary or as almost something of a nuisance that he has to protect.'

Adam: 'Yes, well she is also a Time Lord.'

Joan: 'Yes, that's a change that occurred in the later years of the programme. . . .'

Jenny: 'A lot of the earlier assistants, like Sarah in "The Monster of Peladon" are there as a way of creating a situation, almost. She's a dramatic tool at times because she blunders so much and blurts things out that just happen to work out right.'

Adam: 'Yeah, Gebek sneaks through the curtain and she yells out.'

Jenny: 'Oh Gebek, Gebek.'

Adam: 'Yes, that's right.' (laughter)

Fred: 'That's only Sarah-Jane though. I mean Leela was a little bit

different in that she used to make mistakes, but she had native cunning which got her through.'

Jenny: 'Yes.'

Fred: 'The second Romana almost rivalled *Doctor Who* in terms of his understanding of the world.'

Jenny: 'But it was a different understanding from what he had.'

Joan: 'Yeah. It was always a contrast, I think.'

Fred: 'Sure, but even so the level was that he would accept things that she said, put them into action and then say he was glad that he thought of it, and clearly it was obvious that he hadn't thought of it, but that Romana had thought of it. But he still played the game of being the paternal figure.'

Adam: 'It was the same with nearly all of them really – like with Leela as well he did things like that.'

Joan: 'In a way I sort of see it rather as the woman being a dramatic type of effect or tool, rather than being a contrast. You've got two people totally external to the situation that they find themselves in. It's not just the Doctor who's always fixing things up. He's not the only outsider. There's always a contrast between the male and the female in terms of them being out-siders in the societies they enter into.'

In this discussion, the group bring to the interpretation of the text several subject positions: fan ('he did lose one in the earlier episodes years ago'), 'anti-American' (coded as 'artistic quality = subtlety'), sociological (British culture/ideology). Together, these generate an internal debate implicitly concerned to illustrate why they like *Doctor Who*. And it is the women who (rather than challenging the 'British/paternalism' discussion in terms of 'sexism/patriarchy') re-orient the debate in terms of the *producers*' own preferred discourse, justifying the role of women in the show in terms of dramatic motivation and 'contrast'.

A similar deflection of the 'sexism' threat operates the second time it appears – again raised by a woman. On this occasion the position of the Doctor is justified in advance via his perceived stand against imperialism and profiteering, and the intellectual relationship of this to SF generic codes (of order and chaos).

Jenny: 'Yes, but there are planets and vast forces who are evil in the show and who seek to impose their own autocratic rule, such as the Daleks who want to be supreme rulers of the universe.'

John: 'That's sort of a law, in a way, sort of like a system.'

Fred: 'System – but chaos. Because Davros's dream is to dominate the universe through creating chaos. He even says that.'

John: 'Chaos, or just sort of restrict everything?'

Adam: 'Nothing but Daleks and slaves.'

Fred: 'Which is an ultimate order in a way.'
John: 'Yes, well, I suppose then you could think that chaos, the fringes of chaos become law.' (laughs)
Jenny: 'The ultimate dialectic.' (laughs)
Adam: 'Organized chaos.'
Jenny: 'The Doctor's usually on the side of more naive, independent groups rather than the large structure which has a lot of power. It's usually the mining company, the imperialistic planet, the non-human invaders who are trying to use other planets.'
John: 'The mad scientist.'
Int: 'Is Doctor Who a mad scientist?'
John: 'No, no.'
Jenny: 'He's very detached and objective. He doesn't make emotional statements. He doesn't show emotions. That's always the function of the female side of the partnership, if you like.'
Joan: 'Yes.'
Jenny: '. . . That's often I think why they give Doctor Who an assistant who's very illogical usually. The most logical of the assistants is still being, acting more or less 99 per cent by intuition and good luck or whatever.'
John: 'The second Romana wasn't. And neither was the first in fact.'
Fred: 'I don't think Leela was either.'
Jenny: 'Oh yes she was. She was all instinct, completely.'
John: 'Yeah, but that wasn't emotion.'
Jenny: 'Oh well, I mean not so much emotion in the sort of wet and flowery meaning that we may associate, but non-logical thought processes anyway. Non-deductive thinking.'
Joan: 'Yeah.'
Fred: 'I don't even agree with that, because I think Leela was very deductive in her thinking. She just based her thinking on different premises, that's all.'
Jenny: 'But she often didn't know why she felt a certain way. She just felt fear.'
Joan: 'Yeah.'
Jenny: '. . . all she could say is "I sense danger".'
Joan: 'Whereas Romana's more like you're saying, the first Romana. You know, the stunner.'
Fred: 'Yeah, the stunner. *That* Romana, yeah.' (men laugh)

What seems clear in the discussion is the *pleasure* this group of intellectuals get in playing around with ideas accessed from a range of generic and social discourses. And this in itself (this extensive competence in 'ideas') is both a protection against the threat of 'sexism' (in so far as there is always a handy 'idea' to deflect attention) *and* a key to their liking

of the show. The Doctor's 'powers of mind' (rather than the American 'if it moves, shoot it' physicality) are obviously something the group shares and enjoys. And in this game of intellectual dexterity, it is the 'progressive' qualities of the show (anti-multinationals, anti-imperialism, liberationism, etc.) which are articulated as *coherent* discourse and therefore fore-grounded. Even the intellectual game itself can be foregrounded as a source of pleasure – and this is as much to do with the friendly (i.e. confident) rivalry of former tertiary students as to do with the 'artificiality' of the interview situation.

> Int: 'What did you mean when you said you thought Doctor Who was the ultimate dialectic?'
>
> Jenny: 'Well, because . . .' (men laugh)
>
> Adam: 'Trendy university student.'
>
> John: 'Yeah, *history* student.'
>
> Fred: 'Trying to convince us that she's read Marx, that's what it is.' (men laugh)
>
> John: 'Yeah, right, right.' (laughter)
>
> Jenny: 'John said, was talking about this sort of fluctuation between chaos and order and the tinges of grey in between, and just on whatever level we approach it, whether we see it as law becomes chaos as much as chaos can come back into being law, or order or whatever you want to call it, and, er, as I said before I see him as the ultimate harmonizer.'

The group dynamics here are interesting. It is a moment of threat to the consensus of the 'why we like *Doctor Who*' meta-discourse. Although contained by other, safer subject positions (science fiction, social progressivism), the 'sexism' debate is very close to the surface: because while not articulated as such, the debate about 'woman = intuition, male = reason' has, for a moment, completely divided the women from the men in the group. However, this threat is immediately displaced to a different terrain. The 'healthy' rivalry of tertiary-educated people reincor-porates the female/male division as a competitive 'joke'. From this point the discussion regroups via the safer debate of 'does the Doctor always remain unaltered?' The unified interpretive position is resecured, is back in control: 'who has the best of memory of *Doctor Who*?'

Although this was a critical moment in the discussion, the trajectory of the discussion at this point is typical of the debate as a whole.

On the one hand 'sexism' is deflected into programme mythology:

> Adam: 'All the women tend to be dressed in a very flattering way. I mean, you can minimize the sexual aspects by having Doctor

Who's assistant as a young boy, which they did attempt to do. . . .'

John: 'No, originally the first two Doctor Who's there was a lot more, there was none of this sort of real spunky girl/single assistant. There was a lot more little boy – well, for a while there was a guy, Scottish guy from the sixteenth century who went for a long time with Doctor Who, just raging around. He was totally berserk. And there was a woman, a girl, from England in, it would have been the earlier 1900s I suppose, who was very Victorian and totally unfemale in a way. And the girl before Jo, in Jon Pertwee. . . . She was a Doctor of Science, and she wasn't at all in that sort of spunky role. She was more sort of relaxed and not a very gregarious person. Not at all a female object.'

Jenny: 'Yeah.'

Adam: 'She was the one who remained behind in Troy. . . . She married a Trojan or something.'

John: 'No, I don't think we're talking about the same one.'

Adam: 'She married Troilus. She changed her name to Cressida during the episode.'

Fred: 'Oh, did she really? I wish I'd seen that one. That's great.'

On the other hand the 'sexism' problem is displaced by emphasizing the intellectually 'expansive' and 'inventive' qualities of the show. In other words, the group obliterate its most dangerous problem by playing between the poles of its most relevant subject positions: as fans of the series and as academically trained professionals.

Jenny: 'I just had a thought about that invalidation of time in *Doctor Who*. In fact a lot of the portrayals of the societies have been manifested throughout history. One can always identify with them. We know that this guy represents the imperialist and the other one is the multinational, and he's the colonialist power, etc., etc. And that too, I think, invalidates time in a way, showing that this situation can happen *anywhere*, even on this remarkably distant planet in the year X.'

Adam: 'The one with Pluto with the false suns around it, and the multinational was in charge of the suns, and people had to pay taxes.'

Jenny: 'Yeah.' (laughs)

Joan: 'There've been some episodes which were almost a word on pollution, or references to . . .'

Jenny: 'Like today's was on Women's Lib.'

Joan: '. . . women's rights . . . I thought that was really funny.'

Here the discussion was perhaps teetering between a critical *questioning* of the de-historicizing of 'problems' like feminism and the notion of SF being used for an analysis of present exploitation. The interviewer, herself cued by the woman's comments that the 'Women's Lib' representation was funny, helped the group to a resolution they clearly preferred: the show's comic 'inventiveness', and its use in generating equality between the Doctor and his female companions.

Joan: '... women's rights ... I thought that was really funny.'

Int: 'What about the humour? Somebody mentioned something about Tom Baker being more sarcastic.'

Jenny: '*Brilliant* sarcasm. It's just fantastic. ...'

Joan: 'Particularly with the, I think it must have been the dark-haired Romana, because she was really sarcastic too. It was always tit for tat between them. I felt that she was much more of an equal of his than any of the other female accomplices.'

Adam: 'She won a better mark. ... She received an A+ or something, and ... he failed. ...'

Int: 'So it's a kind of undercutting comedy, is it?'

Jenny: 'Yes.'

The suggestion that Romana was much more of an equal with the Doctor than any of his other female companions carries, of course, its own critique of the series' history. This has been, one female fan is implying, a profoundly sexist show. Something is needed to take these fans (whose politics and pleasure are implicitly conflicting here) out of this impasse.

Fred: 'But then, of course, there's the aspect of the great English amateur, and *Doctor Who*, like I was saying earlier on – it's the paternalism/deference system whereby a majority of the population deferred to the lord of the manor, not because he knows any more or he's had any more experience, but as a matter of course, the God-given right, etc. That person is *there*. Now Doctor Who is there, and even though he hasn't the professional training, doesn't have the expertise and so on. There's all these young upstarts, right. What he is, he embodies not only this sort of aspect of training, but also the wisdom of years, and also the fact that he's *there* and he is deferred to by a majority of people. ...'

Int: 'Do you see him as the ultimate gifted amateur then?'

Fred: 'Yes, he is. ...'

Int: And you see this as a sort of national characteristic?'

Fred: 'Absolutely, just like *Battlestar Galactica* is typically American.'

Int: 'Because of its emphasis on what, professionalism?'

Fred: 'No, because of its emphasis on "this is the way the world should be in five centuries away".'

Fred: 'Yeah, the American dream.'

Adam: 'Apple pie should be heated up in the oven whether it is this century or in . . .'

John: 'And everyone should have white teeth and all the females should be spunky.'

Adam: 'When you compare *Buck Rogers* and *Battlestar Galactica* and *Star Wars*, they're virtually identical. But the same show, *Doctor Who*, with different stories in *Doctor Who*, is so different.'

Joan: 'Yeah, it varies so much. . . .'

Peter: 'On one level it's the same story again and again, but on another level it's different every time. It depends on the way you perceive it. I'm no doubt looking for things in *Doctor Who* that a lot of people aren't, and vice versa. A lot of people are looking for things that I'm not looking for.'

Int: 'What are you specifically looking for?'

Peter: 'I think I'm looking for the thing we were talking about a moment ago. The idea of the gifted amateur. How it always comes out a bit of the Sherlock Holmes in many ways.'

John: 'Yeah.' (chorus)

Peter: 'Sherlock's not professional – even though he gets paid occasionally for his work. He does it for the love of it, because he's a man of means anyway, which is Doctor Who. He's got the Tardis anyway. He can get around as he chooses.'

In the early 1970s, *Doctor Who* contained many 'Bondian' references. However, in addition to the Bondian inflection, the Doctor was *also* marked by the producer in the Pertwee period as a 'Sherlock Holmes', 'gentleman-amateur' type. Given that this was a throwback to a patrician British imaginary which the 'Bondian' professional meritocracy had replaced,[8] how would audiences deal with this inscribed textual ambiguity? The radical/academic audience group focused this problem especially clearly as a matter of ideology and pleasure. What is interesting here is the way 'Sherlock Holmes' has been *appropriated* and located for predictive effect within the discourse sequences. By quoting lengthy passages of conversation, we have been able to see how certain utterances (for instance, about 'sexism') have been deprived of their contradictory charge (for people who both like the programme *and* approve of feminism) by their positioning in the discourse sequence. An initial (and recurring) equation of '*Doctor Who* = British = subtle = innovative = intellectual = good' as against '*Battlestar Galactica* = American = blatant = stereotyped = macho/spunk physicality = bad' has not only deflected the potential 'sexism/patriarchy' discourse sequence, but additionally has

clouded over the contradiction of a politically 'progressive' group enjoying the *patrician* relations of *Doctor Who*. Particular ('high culture') inflections of *national imaginaries* have been mobilized to efface the contradiction.

Dominating all other discourses then, generating them, predicting them, inflecting them (and stifling others), is the group's concern to explain their reasons for liking *Doctor Who*. And, symptomatically, this breaks through as a coda when the interview seems finished.

John: 'Well, I think on behalf of all of us, we should say that our mental health has certainly got worse since the ABC is not showing *Doctor Who*.'

Jenny: 'Definitely.'

John: 'And, if you can possibly do anything to get them to show *Doctor Who* again we would be very pleased.' (laughter)

Int: 'The thing you said about mental health. . . . Is it coming back to that word "balance"? I mean – I know you said it as a joke . . .'

Joan: 'Balancing your day with a glass of *Doctor Who*.'

Fred: 'I don't think he *was* joking.'

John: 'Well, no I wasn't *really* joking. I think, well, for me *Doctor Who* really does sort of say that you can do things differently, you can be an individual. There is not a set way of going about things. You *don't* have to conform. Interactions between people don't follow set rules. You can experiment. You can expand. There's a lot more adventure in being alive than what you're socialized into, you know, behaviour.'

Fred: 'You didn't ask us why we really like *Doctor Who*.'

Int: 'All right, why do you?'

Fred: 'Well, that's the answer. That's the only thing you didn't ask us really. You asked us all these other opinions about *Doctor Who*, but you didn't say at any stage, "But why is *Doctor Who* so attractive?" And I think what John just said is the reason. And I think also, if you want to move on to other science fiction like *Blake's 7* and so on, you'd find that that was the same thing there. There isn't just a set pattern portrayed. Like in 99 per cent of American science fiction there's only one way of doing it, and that's . . .'

Jenny: 'The American way.'

Fred: '. . . the straight up the middle, drop the shoulder, up the centre, even though you cry all the way, and that's the only way to do it.'

Joan: ' "All the way with LBJ".'

Peter: ' "Nuke the lot of them".'

Adam: 'And the aliens aren't as convincing on American shows, are they?'

Jenny: 'Even though technically, you know, they're far superior. But it still doesn't compensate.'

Peter: 'It doesn't matter what they do, the aliens always look like Chinese communists. I mean, they can't do anything about it. They're always gooks, you know.' (laughter)

Politics and pleasure finally merge, as the discussion returns to its initiating (anti-American SF) discourse. The contradiction that, while US anti-communism in American science fiction is disapproved of by the group, British aristocratic paternalism is regarded as an 'innovative' feature of the show, remains unnoticed. But it has been implicitly *denied* as a contradiction, and this has been done by re-coding 'anti-US capitalism' as 'anti-*violence*', and re-coding 'pro-British gentleman-amateurs' as 'pro-*intellectualism*'. 'Powers of mind' have been systematically valorized and 'if it moves, shoot it' devalued. *Doctor Who* is most prized because 'he uses his brains all the time, tries to think up ways of approaching situations as opposed to resorting to the cavalry or his badge'. It is this 'innovative' intellectualism that ties together the show's English 'gentlemen-amateurs' with the subject positions of this audience group of progressive middle-class professionals. 'Individualism' (not class) and 'subtlety' (not 'blatant' apple-pie 'propaganda') are the qualities which ultimately tie the entire interpretive process together.

In this chapter I have been examining two aspects of reading popular texts which take us beyond the 'ideological decoding' analysis of Chapter 4 and the 'generic pleasure' approach of Chapter 5. First, I examined the way in which the interview situation is used to establish an interpretive community: for instance, the young mothers initially negotiated a unified position for themselves as both mothers and adult readers of the text; and then they tried to establish a common interpretive community between themselves and the feminist critic of the series. Second, I examined how the dynamic of the interview situation was deployed to allow ideological 'readings against the grain' which were also pleasurable, even while some of the group were admitting (at least implicitly) that the Doctor is both sexist and undemocratic.

But what of the role of the interviewer in this dynamic? How does this relate to the negotiation of an interpretive community? This issue of the role of the interpreter/interviewer is currently an important one in audience theory and cultural studies, and will be looked at briefly in Chapter 7. Fans and followers less interested in such academic matters may want to pass straight on to Chapter 8, where I will be looking at the *Doctor Who* fans themselves (though the issue of fandom as reading formation is first introduced in the second half of Chapter 7).

Chapter 7

'But he's a Time Lord!
He's a Time Lord!'

Reading formations, followers and fans

John Tulloch

> Texts constitute sites around which the pre-eminently social affair of the struggle for meaning is conducted, principally in the form of a series of bids and counter-bids to determine which system of inter-textual co-ordinates should be granted an effective social role in organizing reading practices.
>
> (Bennett and Woollacott)[1]

In the chapters so far, we have examined accounts of popular science fiction which have 'preferred' a variety of different interpretations. Our approach has been of two kinds: a survey of those theorists who go primarily to the texts to find their meanings (e.g. Dunn's 'instrumental rationalist' interpretation); and a study of different audience groups' meanings (e.g. the young mothers' 'PET' understanding of *Doctor Who*). Surveying his own analysis of text and audiences in the *Nationwide* project, David Morley asked the question whether 'preferred meaning' is in fact a property of the *text*, or something generated from the text by the *analyst*, or the reading which the analyst predicts that most members of the *audience* will produce.[2] We need to ask a similar question of ourselves: more than predict audience meanings, perhaps as interviewers we actually help them *produce* them?

The simple answer is: yes we do. But rather than worrying about this recognition as somehow compromising our findings, we should articulate it. Indeed, we need to extend it to recognize that all readings take place in contexts where some agents and agencies will have more power in determining interpretations than others. In this chapter I will explore this issue by comparing fan readings in two very different contexts: a student class and a fan convention. We'll start with Morley's question about preferred readings.

PREFERRED READING: TEXT, AUDIENCE OR ANALYST?

Although it is clear from earlier chapters that different meanings and pleasures are available to viewers of science fiction, certain shared

interpretations do occur again and again. This suggests that *Doctor Who* does, as text, contain certain preferred meanings: that it is a programme of 'ideas' in contrast to the 'action/special effects of the *Star Wars* ilk'; that the Doctor is a man of science and ingenuity with 'deep pockets', helping people against power-hungry, single-minded oppressors; that, as well, there is a 'different', 'eccentric' and 'idiotic' side to the Doctor which is inflected differently in different eras of the show, and which is interwoven textually with the changing representation of the female companions.

Clearly, then, *Doctor Who* does have certain textual practices which limit reading and interpretation. In addition, there are certain things that the texts of *Doctor Who don't* prefer. John Fiske points out that *Doctor Who* does *not* encourage us 'to correlate despotism with free market economics', or to 'perceive that the Doctor's liberal democracy requires dominant and subordinate classes'. These particular readings of *Doctor Who* 'don'ts' are, of course, audience readings: as Fiske puts it, they are 'readings against the grain' that derive from subject positions outside the text.[3] Yet we have also seen that fans of the series who share some of Fiske's political views find a lot more pleasure in the series than he does. So Fiske's reading of 'Creature From The Pit' is also a particular analyst's preferred reading, part of an intellectual trajectory which Fiske-as-analyst shares with others, in seeking a progressive politics in popular texts.

Just as the texts of popular science fiction are often multi-generic and ambivalent as regards 'preferred meaning', so too specific audiences and analysts themselves contain a mix of generic relevances and ideo-logical competences, even if normally striving (like the text itself) for the closure of a 'preferred reading'. Fiske's analysis of *Doctor Who* overem-phasized the 'smooth harmony' of textual meaning, in contrast to the textual ambiguity we suggested in Chapter 2; and likewise Morley's early work overemphasized the uniformity of specific audience group readings, ignoring the ambiguity of reading positions, and the work involved in negotiating interpretive communities. Part of the problem here was the analysts' restricted choice of texts (or audiences) to analyse. For instance, John Fiske's choice of episode for his *Doctor Who* analysis, 'The Creature From The Pit', regularly ranks in the fans' 'all time low' lists. So if these textual accounts focus on what fans see as the untypical, how can we be more sure that the audience interviews do not do the same? To what extent is it the interviewer's questions and the situational context of the interview that elicit the audience readings?

The problem of the interviewer's reading is an important one in con-temporary theory, and cannot be overlooked. David Morley has been criticized by Justin Lewis (among others) for ignoring this aspect of the audience research process; and the whole role of the researcher and analyst in ethnographic research is a highly contentious one at present. Morley himself recently commented on the 'researcher-as-enthusiastic

fan' tendency that worries Modleski: 'this manoeuvre merely obscures the researchers' dominant relation to their subject in terms of access to cultural capital'.[4] Yet in the case of the *Doctor Who* audience project, I was both researcher and fan – and sometimes interviewer as well. How can we best examine, then, this issue of the researcher's cultural capital and power in the interview situation? In this chapter I am arguing that both parts of this 'researcher/enthusiastic fan' equation need examining. Both researcher *and* fan can have dominant relations to their subjects in terms of access to cultural capital. Both in the classroom *and* at the science fiction convention – that is, both among student followers and fans – the concept of reading formation is a valuable approach. By contrasting the influence of both 'researcher' and 'fan' reading formations on readings of the text, I hope to indicate that Modleski's 'researcher-as-enthusiastic fan' cannot escape the problems of power that she warns against simply by conducting interviews outside the classroom and among the fans.

SCIENCE FICTION AUDIENCES: READING FORMATION AND FANS

The notion of reading formation has not had a particularly good run in media or audience studies. This seems curious, because in their definition of reading formation in 1987 in their *Bond and Beyond* book, Tony Bennett and Janet Woollacott mapped out a whole potential terrain of further research. Reading formation, as they define it,

> is the product of definite social and ideological relations of reading composed, in the main, of those apparatuses – schools, the press, critical reviews, fanzines – within and between which the socially dominant forms for the superintendence of meaning are both constructed and contested.[5]

The emphasis here is on the *superintendence* of reading: its construction and contestation. And the mapping Bennett and Woollacott offer is of those institutions – both high culture (critical reviews and theory) and popular culture (fanzines) – which do seek to superintend reading.

In working through the implications of reading formation, I will also be drawing on Norman Fairclough's very useful discussion of the situational and inter-textual contexts of reading. Of situational context, Fairclough notes how:

> recent research into the nature of discourse processing ... has shown situational context to be a more significant determinant of interpretation than it had been thought to be. It is not the case, for instance, that interpretation consists first in computing 'literal meanings' for the

sentences of a text, and then modifying those meanings in the light of context, as has often been assumed. Rather, interpreters operate from the start with assumptions (which are open to later modification) about the context, which influences the way in which ... features of a text are themselves processed, so that a text is always interpreted with some context in mind. This means that the values which particular features of a text have, depend on the interpreter's typification of the situational context.[6]

The concept of reading formation should, in my view, be elaborated in this context of situational and inter-textual context. To try to begin, then, to understand the speaking positions of interviewer and science fiction audience and their typifications of situational context I will turn to two rather different audience interviews conducted around *Doctor Who* episodes.

UNSW GENERAL STUDIES AUDIENCE GROUP: SITUATIONAL CONTEXT

I will start by considering the situational context of a UNSW General Studies Sociology of Mass Communication course discussion of the *Doctor Who* episode, 'The Monster of Peladon'.[7] This was situated in a university tutorial. Consequently, students were carrying with them certain assumptions about what was going on. These general studies students were from a number of different faculties whose main interest lay elsewhere in directly career-oriented majors – mechanical engineering, food technology, wool and pastoral science, architecture, etc. At the same time, there were distinct advantages for teachers and students in general studies as many student surveys indicated: students often pointed to the much greater informality in general studies compared with the 'overhead projec- tor' pedagogy they complained about in their majors. General studies courses, they said (as 'soft arts' courses), gave many of them the chance to 'let go' with opinions and ideas; and the sociology of mass communi- cations course in particular was designed to allow this since there were no formal lectures, but a three-hour tutorial each week based on prescribed theoretical reading, and on the screening of television episodes, extracts and so on. Thus, while the students were quite aware that the purpose of these classes was to give them a critical grounding in social theory, they also felt that it was an institutional space for *relatively* more equal debate.

In the case of this particular general studies 'Monster of Peladon' discussion, the tutor certainly had complete control over the content of the class: this week it would be 'a discussion about *Doctor Who*'. But the relation between interviewer and addressees was, at face value, relatively equal (though strongly influenced, as we will see, by the tutor's prescribed

course theory). The students themselves were a mix of knowledgeable followers of the series and less knowledgeable general studies students who nevertheless consistently drew on other film and media examples as they judged appropriate to a mass communications course. Although the role of the tutor was central, the role alternation of speakers and listeners was relatively loose, partly because of the greater informality of the teaching situation, and partly because the tutor was, in this specific interview situation, also researcher, seeking material for this audience study. Consequently, the power relations here were less clear-cut than is often the case in situations of instrumental language use – for instance the situation many of us will have experienced where policemen file a report via questions to eyewitnesses[8] – since in the general studies interview the tutor was keen for students to elaborate their ideas and interpretations in group discussion, rather than to establish 'knowledge' on the basis of his own formal agenda, or his own 'skilled reading' of the text.

As far as students' perception of the situation went, this was, on the one hand, a particularly informal general studies class in which they were encouraged to talk about 'any reactions' they had to that particular episode; yet, on the other hand, they could see that it was *connected contextually* (via the familiar screening of a TV episode) to what had occurred earlier in the course, and that it therefore invited responses which were tied inter-textually to these earlier classes. One student, for instance, interpreted the gender exploitation of the Queen in the episode with 'she'd had to put up with the media, that's all' – a reference to the previous week's class which screened a British programme that looked critically at advertising's representation of women. It is especially by way of this inter-textual referencing (drawing on the students' *typification of the situational context*) rather than directly by way of lecturer-to-student speaking position that the greater power of the interviewer in the interpretation situation was evident. Other voices (as we will see) actually acted *for* the tutor in accessing course theories.

UNSW GENERAL STUDIES AUDIENCE GROUP: INTER-TEXTUAL CONTEXT

Let us turn now more specifically to the inter-textual context of this general studies discussion. 'Discourses', Fairclough argues,

> and the texts which occur within them have histories, they belong to historical series, and the interpretation of inter-textual context is a matter of deciding which series a text belongs to, and therefore what can be taken as common ground for participants.

This 'what can be taken as the common ground' of the discussion will clearly have an influence on the negotiation of an interpretive community,

and will (as I have said) depend on the interviewee's typification of the situational context.

In the case of 'The Monster of Peladon' discussion, the debate was frequently about *which* inter-textual context the text belonged to: as for instance in the following discussion which was generated by the students' immediate emphasis on the foregrounded 'feminism' of 'The Monster of Peladon'.

Michael: 'There's another assistant he's got later in a different episode, another Time Lord, Romana. And she can't get out of situations the way the Doctor can because even though she's got as many powers and I think she's meant to be smarter, graduated with honours or something' (laughs), she's a . . .'

Int: 'Whereas he failed or something.'

Michael: 'Yeah.' (laughs). 'She can't get out of situations the Doctor can because she hasn't got his experience.'

Int: 'Is it just experience? – and this is crucial, this area of experience. I don't want to devalue it. Or is it because she is a woman? Now we've got to come back to this "Women's Lib" aspect of this programme which was so clearly put forward there. Now, how do the women relate to Doctor Who, in general for those of you who have seen the other programmes, and in this programme in particular what is the role of women? So we've got to talk about Sarah, we've got to talk about the Queen as well.'

Phil: 'I couldn't figure that one out because what they were saying didn't seem to coincide with what – like Sarah was so obviously beneath Doctor Who.'

Michael: 'But he's a Time Lord!' (laughs slightly incredulously at the previous statement) 'He's a Time Lord!'

Jane: 'Yeah, but she also like had some ideas and she said, you know, that "I think something's down there in that refinery"; and he considered that and said "Right-oh, I'll act on it".'

Int: 'There's actually one time when she had the opinion, wasn't there?'

Jane: 'That's right, yeah. But I don't think she – what I thought was bad about it was that when she was supposed to give some advice about Women's Lib, she didn't do it very well. . . . They had an opportunity there to really spout a few theories or something about feminism and all the rest of it, but she just said, "Oh you just can't let them do that".'

In this particular situation the interviewer invited the students to draw examples from either *Doctor Who* as historical series *or* the episode, 'The Monster of Peladon'. The first speaker after the interviewer's intervention,

Phil, took the second option, pointing (as many groups did) to the contra-diction between what Sarah is given to say (about 'Women's Lib') and what the narrative gives her to do. The second speaker, Michael, counters with the inter-textuality of option 1 (Sarah is dependent on the Doctor because of his superior knowledge as a Time Lord). Speaker 3, Jane, then counters with both option 2 (noting that in that particular episode Sarah *did* initiate action) *and* a further option, i.e. accessing not the historical series *Doctor Who*, but the textual series of the course (e.g. feminist theories of texts seen the previous week in the video about sexism in advertising) as well as her own general knowledge of feminist texts. In this particular conflict over meaning a variety of speaking positions are put into play to determine the presuppositions of what is 'common ground' for the group. For instance, Michael's laughing and incredulous 'But he's a Time Lord! He's a Time Lord!' challenges the feminist reading of the previous respondent (which had been accessed comfortably by the conflict sociology of the course) and counters the class's academic/political emphasis with that of the fan. In this situation the power of the tutor to determine presuppositions of 'common ground' is continually buttressed by students' own referencing of the textual series of the course; so that the fan who 'bids' with the series history of *Doctor Who* does so in a very different situational context from the fans we see next at a fan convention, and thus with very different situational typifications. Hence, I think, his slightly frustrated and defensive laugh.

In this case, the tutor/interviewer's next response invites not a 'fan' but a 'feminist' reading. Yet, on the other hand, the fact that the fan's inter-textual memory is regularly present throughout the discussion is itself supported by the interviewer partially opting out of the role of teacher and instead himself adopting from time to time the position of long-term follower of the series, as we will see in the next extract.

Interviewer authority: content, relations and speaking positions

We had moved on to discussing the villains.

Brian: 'Maybe the guy, what's his name, the one with the sonic lance, he didn't seem to come up with the right decisions and Doctor Who said he should have known better.'

Int: 'Eckersley?'

Brian: 'Yeah. I don't know whether he was representative of anything.'

Int: 'I think he, if I remember, is the one who's brought in the Ice Warriors. I think he's the real crook and . . .'

Jane: 'Yes, well you get a really slimy impression of him, like he's . . .'

Int: 'Is that acting, is that selection of actor, and so on?'

> Jane: 'Yeah, especially what he was wearing. The way he suggested to that, the Ambassador, something that was so obviously wrong, and then his face and the way he acted when Sarah was trying to stop him, you know, he saw on the pictures that Doctor Who was trying to get into that room, and he said, "Is that so?", like he was obviously, he obviously didn't like it. But he was sort of hiding it. You always get the impression that he's the real crook behind everything.'
>
> Int: 'So, if we're looking for signs to interpret it, you're saying "It's what he's wearing, it's facial gestures".'
>
> Jane: 'Expressions, yes.'
>
> Int: 'It's what else?'
>
> Jane: 'He's dressed in black too. You're always suspicious' (laughs) 'of black people. It's terrible, but all the cowboys always wear the white hats and all the bad ones always wear the black hats. You know' (laughs) 'it's so obvious, it's ...'

Having neither a cultural competence in semiotic theories of performance (this was to come slightly later in the course) nor in the history of *Doctor Who*, Jane reached here for a broader media knowledge, which she obviously judged as a relevant history for this sociology of media class.

> Int: 'Well, what about Doctor Who then, in terms of that? Is there an actual different physical presence that's different between, say, Eckersley and Doctor Who, and what is it?'
>
> James: 'Doctor Who is class, virtually, just the way he dresses and the way he talks and the way he carries on, it's obvious that he's a thinker, he's got that ...'
>
> Jane: 'Oh yeah, he's wise and ...'
>
> James: '... You can always tell who Doctor Who is because he always stands out. No matter who Doctor Who is, the way they structure the programme, he's always different to everyone else.'
>
> Jane: 'Yeah, he's a real individual.'
>
> Int: 'And what does, what makes his individuality, why is he ...?'
>
> Tim: 'He's amazingly resourceful. He can combat *every* situation. Nothing baffles him. He's been everywhere twice, and done everything twice, and ...'
>
> Brian: 'That sounds like what we were talking about with the detectives, isn't it?'
>
> Phil: 'Professionalism.'
>
> Tim: 'Yeah.'
>
> Jane: 'Yes, the true professional.'
>
> Jenny: 'He's very calm in the face of adversity.'
>
> Greg: 'He utilizes resources in the environment he's in and can sort

of pull something out of his pocket and be able to use it or use unusual objects around him to solve problems.'

Situational context

Looking at the situational context here first, I am arguing that a reading formation is established according to a series of bids and counter bids around specific situational typifications, in which the authority of the interviewer should not be underestimated. Despite the relative informality of the tutorial discussion, it is clear that the tutor sometimes still operates in a controlling and constraining way here. He has *authority*:

(a) Over contents: with repeated questions about 'is that the selection of actor, acting style?', augmented by attempts to embed responses to this question in some notion of a semiotics of performance: 'So, if we're looking for signs to interpret it, you're saying "It's what he's wearing, it's facial gestures".'

(b) Over relations: with the summarizing function of the interviewer/ tutor ('you're saying "it's what he's wearing, it's facial gestures" ') itself a sign of a one-way relationship (the students don't summarize what the tutor says) and therefore an indication of power, despite the informality of the speaking exchange.

(c) Over speaking and listening positions: which are, however, somewhat ambiguated by the interviewer adopting not only the position of teacher (in introducing course theory, via interruptions for clarification, etc.) but also of researcher and semi-fan ('He, if I remember, is the one who brought in the Ice Warriors'). The fact that he *is* speaking from the position of researcher/learner is apparent from the fact that the students feel authorized to cut *him* off from time to time.

Inter-textual context

The tutor is in the position of determining which discourse-types can legitimately be drawn on – directly (e.g. semiotics of performance), as well as indirectly via the course theory that students unprompted bring to the discussion as a result of their typification of the situational context. An interesting example of this, where the interview participants reach something akin to the 'common ground' of an interpretive community, comes near the end of the excerpt we have just heard – 'That sounds like what we were talking about with the detectives'. We should note here the unusual solidarity of interpretation among the students in confirming this inter-textual reference to Jerry Palmer's analysis of

professionalism in spy and detective genres (James Bond and Mickey
Spillane) which had been an earlier course reading.

Audience members in many groups made the interpretation of the
Doctor as 'amazingly resourceful' (e.g. high-school boy – 'He's got deep
pockets'; para-SF fan – 'very similar to the Victorian father... using
things like a teacup and a cane and a nail'). But in this case the 'inter-
textual bid' quite specifically accessed prescribed course texts, and the
Doctor's well-known resourcefulness was unanimously decoded in terms
of Jerry Palmer's reading. In the case of this general studies class, the
students' typification of their situational context accessed the reading
formation of conflict sociology; in particular, it was Jerry Palmer's text
which evaluated the 'resourceful Doctor' denotation.

The discursive negotiation of the text of 'The Monster of Peladon' in
this general studies interview occurs then via the ascription of its meaning
to a *series of histories*: the history of the *Doctor Who* series itself ('He
always stands out', 'Yes, he's a real individual', 'He's amazingly
resourceful'); the specific series of theories introduced during the course
so far (feminist theory, Palmer's popular cultural theory); and the recall
of a series of what the students saw as relevant (to a mass communication
course) generic types ('it's like in all those sorts of movies', 'in the cowboy
movies', 'all the cowboys always wear white hats').

As Fairclough says, 'the interpretation of inter-textual context is a
matter of deciding which series a text belongs to';[9] and in this the power
relation of interviewer and interviewee is crucial. It is because texts are
always in inter-textual relation with other texts that they are always
'dialogic';[10] and the choice of *which* dialogic relationship in which to
interpret a text (which depends on the students' typification of their
situational context) is what established the reading formation for that
particular text in that particular context.

How, though, does this dialogic relationship differ when fans are inter-
viewed at an SF fan convention? Is the interviewer's power in creating
'common ground' for discussion any less a factor?

SF FANS' CONVENTION: SITUATIONAL CONTEXT

A staple feature of Australian *Doctor Who* conventions is the 'Master-
mind' quiz. Here competing fans are briefly shown slides of the series
taken over its entire history and asked questions. Or they may be played
extracts of incidental music and asked which episode this comes from.
Or they play charades; in all of these cases the standard knowledge of
minute details of the series' history is prodigious, and is a major marker
of being accepted as a 'real' fan.

This degree of cultural expertise is made available by way of conven-
tions (where, in England for instance, early black and white episodes of

the series were screened at fan gatherings with special 'closed member-ship' permission by the BBC), by way of fanzines (run by the *Doctor Who* Appreciation Society (DWAS) in England and by the Australasian *Doctor Who* Fan Club (ADWFC)) as well as by commercial magazines like the *Doctor Who Monthly* in the UK. Target Books novelizations of all past *Doctor Who* stories are regularly sold at convention book-stalls – another source of detailed knowledge of a long-running series which began over a decade before its younger fans were born. Discursive hier-archies are established in the fan clubs and at conventions in terms of mastery of this detailed knowledge.

SF FANS' CONVENTIONS: INTER-TEXTUAL CONTEXT

Not surprisingly, fans acquire enormous cultural competence and facility in using this stock of knowledge when they interpret and evaluate the show. The following extract is from an interview conducted at a fan convention in Liverpool, England.[11] The topic for discussion (as deter-mined by me as researcher) was the third Peter Davison story, 'Kinda', which had just gone to air in 1982. In this case, DWAS president, David Saunders, conducted the interview for me; but, as soon became apparent, in this case the interviewer's speaking position was determined by a very different reading formation from the university one we have just dis-cussed. The fans had their own agenda, first discussing how the change of timeslot of the show might affect ratings; and then moving on to a consideration of Peter Davison as Doctor in the context of the early stories of earlier Doctors.

John: 'Most of the other Doctors started off with a bang – I mean when Baker [4th Doctor] came in you were hit in the face with the difference from Pertwee [3rd Doctor], and the same with Pertwee [and Troughton, 2nd Doctor]. But Davi-son – the other Doctors sort of mellowed as time wore on, but I think Davison started as a mellow character, and I don't think he's got a strong, surprising character.'

Tony: 'I don't think it was all that good an idea to have such strong links between "Logopolis" [1981 – Baker's last story] and "Castravalva" [1982 – Davison's first story], even down to the same incidental music and so on. I mean, the same trick – block transfer computation; the same foe – the Master. They're too similar, which perhaps softens the change too much. You should maybe exaggerate it, as in "War Games"/ "Spearhead" ["The War Games", 1969, was Patrick Trough-ton's last story, "Spearhead from Space", 1970, was Jon Pert-wee's first story].'

Graham: 'I think "Castravalva" would have been much better off later on in the series. It was an intriguing story, but it wasn't sort of – as you said, you weren't hit in the face with it immediately like you were with "Robot" [1974 – Tom Baker's first story], for instance.'

Peter: 'The first story that had Baker in wasn't as amazing as it could have been. But then he leaves to go into "Ark in Space" (1975) where there really was a big boost to the Doctor's character. There was a lot of good dialogue for him and you actually got the impression he was involved with the story. He was caring about what was happening. Peter Davison seems really drifting. The first story, "Castravalva", was very good, but after that it didn't seem to be as mind-blowing as the usual first couple of stories, and "Four to Doomsday" (1982) was a step backwards after "Castravalva" – it was just so mundane really.'

Graham: 'I think "Four to Doomsday" was necessary after "Castravalva" because of the next one. If you'd followed "Castravalva" with "Kinda" you'd have lost half your audience.'

Tony: 'Yeah, you can't have too many weird stories on the run – you've got to have something they can follow.'

The fans' emphasis on what '*they* can follow', and on the risk of losing half the audience is an aspect of interpretation we will take up in a moment. At this point, though, I should stress that the fans had been asked by David Saunders to talk about one particular *Doctor Who* episode, 'Kinda'. But the fans had to keep calling themselves back to 'Kinda'; their cultural propensity was to discuss its features – Peter Davison as the Doctor, the companions, the difficult storyline – in terms of the series history of *Doctor Who*. That series history is (uniquely among the forty-odd audience groups that we interviewed) often the *only* inter-textual history accessed. As we will see from the following extracts (which came immediately after the 'Castravalva' discussion), David Saunders had to call them back twice to discuss 'Kinda' and away from interpretation via the series history.

Int: 'Do you think we could get back on to "Kinda" because that is what we are supposed to be talking about.'

Mark: 'It was interesting they missed the Tardis materializations. That was interesting. We didn't see it in the first episode, and didn't see it in the last episode.'

Peter: 'I think part 4 was very disappointing really after the great build-up of part 3, with that vision thing and everything, and they turn around and say "she is dead". Great ending, 'cause everyone expected it to end in the vision, and were watching

to see what happened then. But it just seemed to be a run down ... slowly ... to the ending.'

Tony: 'Part 4 was basically a battle really. It was rather predictable once the Doctor had started getting matters together. You know basically what is going to happen next. You could stop watching. I mean you wouldn't, but you could.' (laughter)

At this point the interviewer himself adopted the agenda that the other fans were clearly most comfortable with: drawing on programme history to evaluate 'Kinda'.

Int: 'I thought part 4 of that was really very very similar to part 4 of "State of Decay".'

Tony: 'Yes, he has got all the thickies together against the big powers which is going to become an even bigger power. What I want to know is why the Mara caused this wheel of civilization. ... Why was it caused by the Mara? Was it just that every time civilization or intelligence emerged on Deva Loka ...'

Mark: 'It is a bit like the "Fendahl" type of syndrome. You know, it keeps coming back for more. It just works in a cycle. It is one of the plot things one has to accept.'

Graham: 'Do you not find that there has been a lot not explained generally in the series. "Kinda" was probably the best as somebody said before for explanations. But there has been so much left. People that I work with that aren't fans of the programme specifically – they have been watching it which is good, but they have also been coming back and saying he is getting it together in the last three minutes of a story and that's it, that's the end of the story, and they don't like that. It is irritating people outside the Society, people that, you know, are your floating voter, your floating viewer. It is irritating them, there is so much being unexplained.'

Mark: ' "Castravalva" being a prime example.'

Graham: 'It spoils it when it's not explained because you can't follow it.'

John: ' "Four to Doomsday" is another.'

Int: 'What was not explained in "Four to Doomsday"?'

Graham: 'It just didn't knit a lot of it together, I found.'

Tony: 'I would agree with you there, yes.'

Mark: 'The worst thing I thought it was the pressure in space, that made you ...'

Peter: 'There was no pressure, and yet they didn't explode.'

Tony: 'I loved the helmets without the visors. I suppose they fire a supercharged stream of ions.'

Int: ' "Kinda", "Kinda", "Kinda".'
Tony: (Laughter) ' "Kinda", yes, sorry, sorry.'

Even at this point of rather desperate intervention by the interviewer, the discussion of 'Kinda' was immediately placed in the context of other *Doctor Who* episodes, and the important issue of the 'average viewer' was raised.

Graham: 'That's just the thing, talking about the explanations where all the others haven't explained, I found "Kinda" the best but it still left a lot.'
Tony: 'Right. I mean, not giving explanations well enough is stupid. I mean, OK, looking back on a story that has got explanations you might find them laboured. But your average viewer does *not* look back on a story. What's more, you can't follow the action – you don't know what the hell the Doctor is doing with the mirrors, and you can't follow it and you're not worried about whether or not he is going to succeed.'
Peter: 'All that mind sequence, at the beginning of the story it was Adric and Nyssa playing chess, and they said to Tegan, "Oh go away, we're trying to play chess." I can't remember the lines exactly, but in the dream sequence you have got these two, a male and a female playing chess. I reckon that's Tegan's idea, her feeling towards Adric and Nyssa.'

At this point the interviewer intervened in an interesting way. As President of DWAS, David Saunders had the potential of privileged knowledge of production details. Consequently, his confirmation of this fan-reading in terms of what it was 'meant' to mean was important.

Int: 'That's exactly what it's meant to be.'
Tony: 'You notice she sees them as older.'
Peter: 'And there was like, all the silly costumes. That bloke was meant to be Adric wearing the sort of silly costume, and Nyssa was like Elizabethan type, and then the Dukkha/ Doctor, that's what I reckon. This Dukkha didn't explain anything to Tegan. He said, "It's all childishly simple", and that's exactly what Peter Davison kept saying to her – "Oh yes, it's all very obvious" and everything, and she couldn't stand it. And that was her feeling for the Doctor. And also with the fact that the *Radio Times* said "Will the Dukkha release Tegan?" – that seems to be like Tegan wanting to get back to Earth and the Doctor not letting her go there. It's almost like the Dukkha was her feelings towards the Doctor, with the silly costume on and everything – with the little red rose and everything.'

Graham: 'She feels sort of outside.'

Tony:　　'Left out.'

Graham: 'Adric and Nyssa are usually discussing metaphysical imagery or block transfer computation or something like that, which she is not at all interested in. She feels outside of it, and that's probably where her antagonism comes from.'

Peter:　　'Did anyone think about the Mara representing evil – the Mara, also the Master represents evil. It's as though there's a similarity there – like an in-joke type of thing?'

Tony:　　'Similarly phonetic.'

Peter:　　'Yes, sort of like both being evil, representing evil – I thought that. It seems to fit in with all the names being similar.'

Tony:　　'What were the old couple called?'

Mark:　　'Anatta and Anicca.' (Pause. Laughter.)

Tony:　　'Maybe if we combine all the names we can pull out all the letters of the regular characters.'

Graham: 'Another Tremas.'

Tremas was the character in 'The Keeper of Traken' (1981) whose body the Master took over in order to regenerate. At the same time, as an anagram for 'Master', 'Tremas' was a textual cue seeded in the narrative to predict the episode's finale. It is this kind of textual conundrum that intrigues the fans; and it is noticeable that in the case of 'Kinda' the fans looked for this kind of explanation for the names 'Anatta' and 'Anicca' rather than to the Buddhist texts that actually generated them.[12] Two things seem evident from these extracts from the Liverpool convention.

(i) Despite David Saunders's attempt to focus the discussion on 'Kinda', he himself finds it impossible without calling up the series history – he evaluates 'Kinda' in the context of the earlier *Doctor Who* story, 'The Visitation'; others compare the rushed ending with that of 'Four to Doomsday'; and, asked to explain the Mara's relationship to the wheel of time in 'Kinda', another fan draws on the 1970s story, 'Image of the Fendahl'. In fact, the Mara, Anatta, Anicca, and a number of other characters are in the text as an attempt at a Buddhist over-writing by script writer Christopher Bailey of Ursula Le Guin's source text, *The Word For World Is Forest*. As a feminist tale, *The Word For World Is Forest* posed a postmodernist challenge to patriarchal history, linear classification and the male 'scientific' voice by way of the familiar multivocal Le Guin text. Bailey's text inflected Le Guin's novel in terms of Buddhist ideas, using the *doppelgänger* relationship between Doctor and Dukkha to ambiguate heroic male identity, and to indicate that suffering ('Mara') was the result of human striving for definition, the desire to control identity and to control experience via a fixed idea (in this case military/scientific exploration). Villainy, in Bailey's text, came from within

(for example, from within the male soldiers' desire to tame the forest and the matriarchal Kinda people), and not from a Dalek-style villain.

But rather than drawing out the implicit notion of a *doppelgänger* – and Bailey's further (Jungian) notion of evil emanating from the cultural inside – the fans personalized the relationship between the two characters (Doctor/Dukkha) in terms of the relationship between Tegan (as perennial companion) and the Doctor as had developed over previous episodes.

This particular reading is worth considering in relation to Morley's 'preferred reading' debate. The reading of Le Guin as a postmodernist feminist who produces multi-vocal texts is clearly an analytical one (primarily Robin Roberts's). It is not Bailey's, who draws on Le Guin as an exemplar of the 'sophisticated science fiction' that he wants to inject into *Doctor Who*. His own authorship in this inter-textual process is to inflect Le Guin's tale in terms of Buddhist and Jungian ideas. His choice of names for characters like Mara, Dukkha, Anatta and Anicca are thus textual markers for these ideas. But the fans read little of either the analytical or the textual preferred meanings, drawing instead on their own preferred inter-textual history. This is, of course, an 'active' reading. But in this book we argue that, while readers do play an active role in interpreting the texts they consume, they do so (a) within a social and historical context that shapes their relative access to different discourses and generic models for making sense of the programme; (b) in relation to the institutional power of producers to shape texts; and (c) in relation to the texts themselves which may facilitate or resist readers' interpretive activities. The Liverpool fans' interpretation of Tegan watching the board game in 'Kinda' is a good example of the conjuncture of specific generic or programme competences, the institutional power of the producers and textual cuing together working to guide readers' interpretive activities.

(a) Institutionally, what is at work here is the producer's desire for narrative pace and action/drama, in the service of which he constructed Tegan as 'the Doctor's JR', constantly and aggressively insisting that the Doctor return her to Earth – this conflict replacing the conventional Tardis materialization followed by the familiar (and to the producer, boring) 'Well, here we are on another planet – let's have a look around.' As one of the fans remarks, there is no materialization of the Tardis in 'Kinda', and Tegan (already outside it) moves straight into her confrontation with Adric, Nyssa and the board game.

(b) In terms of programme generic competences, the fans read this 'JR' interaction directly into the history of the Doctor/companion relationships in the series, comparing Tegan, for instance, with the earlier 'feminist' companion, Sarah-Jane Smith. Hence the Adric/Nyssa board game is read interpersonally as Tegan's Earth-feminist distancing from these other, alien, companions.

(c) Textually, the series facilitates the fans' reading by similar camera set-ups, similar left-to-right movement by Tegan (as she approaches both the Adric/Nyssa and the Anatta/Anicca board games), and analogous 'Tardis' structures for the Doctor and Dukkha.

The fans once again, then, drew on the textual history of the series to establish the 'common ground' of their interpretive community rather than either Bailey's Buddhist texts (which the fans had heard about but not followed up), or Le Guin's postmodern feminism. In this inter-textual context of bids and counter-bids, fans are remarkably univocal (especially in the situational context of a fan convention).

(ii) We can also see in this fan conversation the 'Society' fans defining themselves in comparison with 'they', the wider audience ('you've got to have something *they* can follow'), on whom, of course, they rely for the survival of their show. The use and exchange of videotapes has, as Jenkins notes, 'become a central ritual of fandom and one of the practices which helps to bind it together as a distinctive social and cultural community';[13] so, symptomatically, it is a central part of the self-definition of the Liverpool *Doctor Who* fans in contrasting themselves with the 'floating voter'. The fans argue that the 'society' fan, facing the complexities of 'Logopolis', 'would have seen "Logopolis", and videotaped "Logopolis", and spoken to the person who wrote "Logopolis" ' (or at least read his interview in a fanzine). But for the general viewer: 'It is irritating people outside the Society, you know, your floating voter, your floating viewer. It is irritating them, there is so much unexplained.'

The same worry was expressed by the London and Sydney fans that we interviewed. Fans could tackle these 'complicated' stories through discussion, through fanzines or, more rarely, via inter-textual references to parallel plots in other science fiction series like *Star Trek*. But the 'floating voter', they feared, would just switch off. And if they did switch off in sufficient numbers, the fans' favourite show would be switched off too.

In terms of their cultural capital (i.e. their phenomenal knowledge of the series which they can draw on to fill in gaps in the storyline) these fans are an elite among readers of the series. But in an important sense they are a powerless elite, because the future of their show depends on ratings, and therefore on viewers 'outside the Society'.

Fans interviewed at a fan convention constantly move between these two polarities: the accurate historical *continuity* of the series (in which regenerations play an important part) and the *comprehensibility* of individual episodes (for the 'floating voter'). Since programme continuity depends on producers over whom fans also have little control, they can feel doubly disempowered: over what pleases the wider audience, and over what pleases fans. Fan conventions are typified as the situational

context where these readings of their show are discussed via (as we have seen) continuous and almost solipsistic inter-textual references to the series' history.

FANS, FOLLOWERS AND READING FORMATION

I have tried in this chapter to consider reading formation not so much as a top-down superintendence of meaning, but rather as the construction and contestation of speaking positions determined by typification of situational context and the related series of inter-textual bids and counter-bids. Fans, I have suggested, in the situational context of a science fiction convention, almost solipsistically call up one textual history – that of the show itself, and structure their evaluation of particular episodes on the one hand in terms of its history of continuity (for which they depend on the show's producers), and on the other hand in terms of its narrative history (i.e. what has 'been explained in the series generally', where they are nervously deferent to the 'floating viewer' outside fandom). In contrast, fans establishing situational typifications in very different contexts will find their appeal to the history of the series positioned more marginally and defensively (as in the case of the general studies class) as the result of a very different reading formation. In this case, the power to which they deferred, and to which they directed their interpretations, was not economic (producers and 'floating voters') but academic. The point is, though, that in both cases the interview was influenced in its 'preferred readings' by the situational and inter-textual context. There *is* no neutral place where we can get access to the 'real' interpretation of *Doctor Who*. The influence of the researcher/interviewer is not, therefore, 'artificial', obscuring 'true' readings. Like any other reading situation, it is positioned in power relations which need to be taken into account. In the case of the general studies class, we have seen how the power of the interviewer resided in the situational typifications constructed by the students, and how these led to the 'common ground' interpretation of the 'professional' Doctor. In the case of the fan convention, despite being a surrogate for the researcher, the interviewer in fact was part of a very different reading formation, and marked his authority by legitimating the other fans' reading of Tegan, Nyssa, Adric and the board game: 'That's exactly what it's meant to be.' As president of the Doctor Who Appreciation Society his power was his knowledge of the programme and its production.

In the case of both interviewers, however, this knowledge-as-power was embedded in broader institutional contexts: in the case of the researcher/interviewer, in the interrogatory role of critical theory (whether situated in general studies, cultural studies or wherever) in universities supplying students to 'the job market'; in the case of the fan/interviewer, in the positioning of fans between economic forces – of industry and audience

– that they cannot control. In the face of 'the market' in both cases, then, the researcher/interviewer and the fan/interviewer turn to interpretation: the researcher in constructing courses and writing books; the fan in (as we will see in the next chapter) the power to gloss.

Chapter 8

'We're only a speck in the ocean'
The fans as powerless elite

John Tulloch

> Fandom is a cultural community, one which shares a common mode of
> reception, a common set of critical categories and practices, a tradition
> of aesthetic production, a set of social norms and expectations. I look
> upon fans as possessing certain knowledge and competency in the area of
> popular culture that is different from that possessed by academic critics
> and from that possessed by the 'normal' or average television viewer.
>
> (Henry Jenkins)[1]

The academic critics and the fans that Henry Jenkins speaks about are,
as we said in Chapter 7, 'superior' readers in the sense that they establish
institutions for the 'superintendence of reading'. In the last chapter we
examined 'reading formations' constituted by 'academic critics', in the
context of university tutorials, and by fans at conventions. Here we take
further the notion of reading formation to examine the aesthetic of a
particular generation[2] of *Doctor Who* fans in terms of their structural
position as a powerless elite between the power of the industry that makes
the show, and the general public on whose 'votes' its future depends.

I will examine the 'set of critical categories, the aesthetics and the
social norms' of fans in the context of their own perceptions of their
difference in 'knowledge and competency' *from* that of 'average' tele-
vision viewers. Here I will attempt to establish 'mutual knowledge' with
fandom via a twenty-five-year personal engagement with the series,
Doctor Who, as well as several years of interaction with *Doctor Who* fans
at their conventions, in group discussion with them, socially at pubs and
parties, at their homes and by reading their fanzines. Thus, this chapter
is a transition point between the 'reading formation' analysis of Chapter
7 and the ethnographic audience analysis which follows in Part III. In
particular, by drawing on participant observation, interviewing and fans'
written material it adopts a methodological triangulation approach fam-
iliar in ethnographic work.

Mutual knowledge is the '*inside*' knowledgeability of a social group –
the researcher 'knowing what its constituent actors know, tacitly as well

as discursively'.[3] For that reason many of the ideas in this chapter come from the fans themselves. However, as Giddens says of ethnographic research, there is always a 'double hermeneutic', where the critical distance of the social researcher establishes 'second-order concepts'. In this chapter my main second-order concept is that of the fans as a powerless elite, structurally situated between producers they have little control over and the 'wider public' whose continued following of the show can never be assured, but on whom the survival of the show depends. I then relate this structural positioning to the fans' aesthetic, as they play between production values which interpellate them specifically *as* fans, and the narrative coherence and closure which they think is important to the 'wider public'.

But in bringing back my 'second-order' concept to the fans for their opinion of it, they reminded me of what I should have known already: that each national fan club is contextually positioned and determined, that there are important differences between the 'powerless elites' of England, the USA and Australia. And in explaining these differences to me, in positioning the English and US fan clubs as 'other', one Australian fan, Tony Howe, drew on a second-order concept from *Doctor Who: The Unfolding Text*. That, as Giddens points out, is how the double hermeneutic works in social life: there is a constant 'slippage' from one level to the other involved both in the practice of the social sciences and the practice of social life. It is in that sense, as Giddens says, that all social research has a necessarily cultural and ethnographic aspect to it.

GOLDEN AGES AND THE 'UNFORGIVABLE'

What, then, constitutes a 'good' episode that would keep the 'floating voter' (and the fan) switched on? This question plays a central role in the fans' reading of individual texts.

Doctor Who fans' sense of a good episode is constructed in terms of quite a precise aesthetic: it should not 'leave things unexplained' (in order not to lose the wider audience); and it should adhere to the history and continuity of the series (in order not to lose the fans). 'Society' fans are, in effect, situated as a privileged group with few powers – a powerless elite with little control over the floating voter on one side, the producers of the show on the other. Consequently their explanation and evaluation of any one episode is strongly determined by this positioning as experts who have little control over either the conditions of production or reception of 'their' show.

In the absence of this, their power is *the power to gloss*, and to write the aesthetic history of the show – dividing its twenty-five years into a series of 'golden ages' and 'all-time lows'. They, thus, establish an officially constituted reading formation, which supervises reading of the show. Ian

Levine, for many years a very senior British fan (and at one time unofficial continuity historian to the producers) had this to say.

> Levine: 'The series had a mood, and a charisma and atmosphere and a sort of gripping drama to it during Philip Hinchcliffe's era. The stories were meticulously made. A TV play or TV series like *Doctor Who* can turn out to be a work of art if everything comes together in the end which a lot of Hinchcliffe's were and a lot of John Nathan-Turner's are. Hardly any of Graham Williams's were, and if they were it was by accident.'[4]

'Unforgivable' was a word that sprang easily to the lips of fans when they were being critical, and it is a word used especially often by *Doctor Who* fans about 'the Graham Williams era' (1977–80). For instance, Ian Levine noted that

> facts they have given in one story clash grossly in the next. . . . We are told in one story that only the Doctor can fly the Tardis and in the next story he has got the savage Leela, who has no grasp of electronics at all, asking the Doctor what the co-ordinates are and flying the Tardis herself. That was unforgivable, that really was unforgivable.

Similarly another senior English fan Jeremy Bentham (author of *Doctor Who: The Early Years*) observed, 'I can't forgive Williams for the line he gave to the Sontarans in "Invasion of Time" [1978], "primitive rubbish" ';[5] Levine adding, 'We know the Sontarans aren't as advanced as the Time Lords, so how could a Sontaran walk into the Tardis and say, "This machine is a load of obsolete rubbish"? – that is the exact line.' The producer behind both of these 'unforgivable' examples was Graham Williams.

'Errors in continuity' (which Levine spotted throughout the series) entered, in his view, a qualitatively new stage as they became systematic under producer Graham Williams (1977–80). Under Williams, 'errors in continuity' combined with a 'send-up' style which most fans disliked intensely.

> Under Graham Williams the decline set in as a rot. . . . The three stories in a row, 'The Creature from the Pit' [1979], 'The Nightmare of Eden' [1979] and 'The Horns of Nimon' [1979–80], *Doctor Who* reached an all-time low then and the ratings plummeted.

Despite Levine's error of fact here (current fans note that the ratings were very high for these stories, 'Horns of Nimon' rating 11 million), we should nevertheless recognize the integral link in fan consciousness between programme aesthetics and ratings 'outside the Society'. Fans quite generally agree with Levine that Williams's 'seventeenth season'

was the worst in the show's history. Australian fan, Pat Fenech, writes in the fanzine *Zerinza* about their 'worst stories' survey results.

> The most notable feature here is the placing of 4 out of the 5 stories broadcast in the 17th season as amongst the worst stories ever. This season is reputed to be the worst in *Doctor Who* history. These results certainly suggest ADWFC members consider it so.[6]

Of those four stories, Australian fans rated 'The Horns of Nimon' the worst story ever, 'Destiny of the Daleks' (1979) second worst, 'Nightmare of Eden' (1979) fifteenth and 'Creature From The Pit' (1979) sixteenth worst.

Fans are thus far from being uncritical or sycophantic about their show. Rather, they establish an aesthetic history of 'classics' and 'worst ever' episodes which they circulate through the fanzines. This aesthetic is articulated quite self-consciously in their discourse about 'continuity' and 'programme structure'.

CONTINUITY: TEXTUAL EXEGESIS AND THE FANS' POWER TO GLOSS

The fans' particular competence is their intimate and detailed knowledge of the show; consequently any producer or script editor who needlessly breaches the continuity and coherence of that knowledge is 'insulting their intelligence'. Many fans particularly enjoy episodes which call up that knowledge and so address them directly *as* fans. Levine, for instance, 'loved "Logopolis" ' (produced by Nathan-Turner) because

> events in 'Logopolis' revolved around the myth itself of *Doctor Who*. In other words, the whole story started because the Doctor wanted to change his broken chameleon circuit which has been broken since the very first story – and even the reference back to Totters Yard which was in the first story, to explain it. . . . Bring in anything from the series' past and you get my vote anyway.

The 1981 DWAS president, David Saunders, and secretary, Garry Russell described 'Logopolis' as 'a nice fannish story' and 'all fandom and padding'.

> Saunders: 'It started off with a policeman looking around which is supposed to be reminiscent of the very first episode.'
> Russell: 'The reintroduction of the Master and the fight at the end on top of a radio telescope which was completely taken from the original Master's very first story where there was a fight on top of a telescope'

> Saunders: 'The Tardis, within a Tardis, within a Tardis is straight out
> of "Time Monster" [1972].'
> Russell: 'It's a fan story.'
> Saunders: 'We love it. But it's made for our thousand [DWAS mem-
> bers] instead of made for the BBC's millions.'[7]

As Levine put it, 'Logopolis' was especially enjoyed by fans because 'the entire plot of "Logopolis" arose inside the myth of *Doctor Who* rather than taking the myth of *Doctor Who* to an outside planet'.

Fans on the other hand do not usually enjoy episodes which overtly undercut that myth. One of the 'most hated' *Doctor Who* stories in the ADWFC poll was Douglas Adams's first as script editor under Graham Williams, 'Destiny of the Daleks'. Mary Tamm, who played the companion Romana, had unexpectedly quit the show, leaving the producer with a number of scripts featuring her. As Romana was, fortuitously, the first companion who was also a Time Lord, the decision was taken to make Romana 1 regenerate as Romana 2, and thus plausibly explain a new actress playing the part. The way in which this was done infuriated many fans.

> Levine: 'I could never forgive Graham Williams for the regeneration
> scene. . . . It has been clearly established that a Time Lord can
> only have twelve regenerations, clearly established. In many
> stories that fact has been stated. So how can they have some
> supposedly responsible female Time Lord in the Tardis trying
> on about six different faces before she decides which one she
> wants? – which is obviously wasting six regenerations. It is just
> ludicrous. It is that sort of non-attention to the detail of the
> series that gives me no regard for Graham Williams at all.'

Jeremy Bentham agreed:

> It was something that was done purely for a laugh – there is no other justification for it. If he knew that Mary Tamm wanted to leave, well at least you could have written something a bit more doom-laden – there is an outlet for it in 'The Armageddon Factor' [1979] where the Shadow is torturing her very severely. The idea of that could have triggered off an involuntary regeneration.

And in Australia, fan Stephen Collins wrote:

> There is no good reason for this regeneration. The body of Romana I is functioning perfectly at the end of 'Armageddon Factor', there is no hint of a decay in the bodily functions. Neither is Romana I very old – 'City of Death' (1979) establishes her as only 120. This is not a natural regeneration, Romana has forced it upon herself in a display of extravagance (considering she only has twelve to fool around with).[8]

Rather desperately, Collins looks for reasonable explanations within the history and myth of *Doctor Who* to explain this 'extravagance'.

> There appear to be three valid approaches to the question. One stems from Baker's comment in 'Robot' about the stability of his regeneration. If you assume from that there is a period of instability around every Time Lord regeneration, during which the new physical appearance may change, and clearly that is what Baker is suggesting in 'Robot', then the changes Romana makes as she searches for the correct body can be construed as occurring during that period. . . .
>
> The second theory . . . concerns 'The Key to Time' (1978–79). The White Guardian, having utilised the power of the key whilst it was assembled in the Tardis, decided to relocate the Sixth segment. He decided to rest the segment in Romana, triggering her regeneration cycle. Romana then utilises the ability of the segment to 'try on' the other bodies – 'Stones of Blood' (1978) established the ability of individual segments to allow transmutation of the possessor of the segment.
>
> Finally, it is possible that the ability displayed by K'anpo Rinpoche in 'Planet of the Spiders' (1974) provides the solution. After regenerating into her new form, Romana shows the Doctor the finished result. He is not pleased, but she has no intention of changing her appearance to make him happy. So she retires from the control room and summons up possible future projections of herself, sending them to the Doctor to receive his appraisal. After she thinks the Doctor has had enough, Romana returns to the control room in her Princess Astra form – the only one she regenerated into.[9]

Whichever the right answer might be, Collins insists that

> Romana was not utilising normal powers of regeneration when she 'tried on' the three bodies to please the Doctor. Romana is far too intelligent to waste valuable regenerations on such a frivolous enterprise.[10]

This degree of exegesis of the 'holy writ' of *Doctor Who* may seem humourless to some, positively medieval to others. However, Collins is reading the episode in the same way as the university students discussed in Chapter 7 – inter-textually; the only difference being the degree to which fans call up *series history* in their quest for meaning. What Collins's analysis indicates is that the power of *Doctor Who*'s executive fans (i.e. fans who are executives of the fan club and its magazines) is discursive rather than institutional. In this aspect of series continuity, the fans are clearly in the hands of the producers, who responded to the situation differently. John Nathan-Turner, according to Levine, was 'careful to consult the facts to make sure that he is not clashing with anything'[11] – and

during this period Levine 'helped out the Doctor Who office with con-
tinuity errors and continuity problems' (which is one reason for Levine's
initial view that Nathan-Turner had 'restored *Doctor Who* to a golden
age again'). Other producers, like Graham Williams, kept the 'Society'
fans (who, numbering not more than 1,000 in the UK, constituted a tiny
part of his audience) in their place. Williams told us that, as regards
influence on the programme, fans had 'none whatsoever' even though
'they would rather like to think they have'.[12] We also asked DWAS
executives David Saunders and Garry Russell whether they had an influ-
ence on the production of the show:

> Russell: 'I think there is a straight answer – one has to take in the
> BBC's approach which ... is "fob them off with a few
> stories". No, they don't take a great deal of notice.... The
> fans don't make up the complete viewing public of *Doctor
> Who*.'
> Saunders: 'When all is said and done we hop around the thousand
> mark, and *Doctor Who*'s audience is millions. We are in
> some respects only a speck in the ocean.'

But in the absence of power over either production of the series or over
the wider viewing public, these senior fans do have *discursive* power in
establishing the 'informed' exegesis for their subculture of fans. Thus they
establish and control an important reading formation. Stephen Collins,
for instance, as letters editor of the Australian fanzine *Zerinza*, special-
ized for a while in 'regeneration theory'. In this way, editors of fanzines
can have an important agenda-setting function. Thus *Zerinza* editor, Tony
Howe, noted after the latest skirmish between a correspondent and
Stephen Collins: 'as *Zerinza* editor I think it is time that more attention
be given to discussing other topics such as the new stories soon to be
seen, the Survey results, the Season Reviews; Regeneration has been well
covered for the present'.[13]

So executive fans' opinions matter within the subculture – on, for
instance, which issues are controversial at any one time as well as the
way in which these issues are interpreted and closed off. It is in the pages
of the fanzines that the unfolding myth of *Doctor Who* is articulated,
positioned and circulated – the view, for instance, that Tom Baker polar-
ized the fans between, as Collins put it, 'the ones who are fans of *Doctor
Who*' (who hated Baker for 'sending up' the show) and 'the ones who
are fans of Tom Baker'; or the view that Sarah-Jane Smith and Tegan
Jovanka were the 'all-time favourite companions' because of their 'strong,
well-defined characters' (whereas, in Australia, Tegan was much less
popular because of her 'pseudo-Australian character'); or the view
(especially strong in Australia) that *Doctor Who* – far from being in a

new 'golden age' under producer John Nathan-Turner – was 'going down the drain'.

For instance, discussing the lack of cultural background in 'Kinda', Tony Howe commented: 'I think that's because *Doctor Who* is beginning to follow *Star Trek* down the drain in becoming too limiting. They were obsessed with making sure that every pepper shaker was the same colour as in the episode before, and that sort of thing.' Was Howe here breaching the fundamental fan aesthetic value of continuity? Not at all:

> In *Doctor Who* they've got an almost strident disregard for continuity. If there's an established thing like the Daleks in one story, they'll have them doing this, and in another story ... they'll have attitudes and reactions to things which are totally different, which is completely unbelievable.[14]

Was Howe, then, being inconsistent between his comments on *Star Trek* and *Doctor Who*? Not that either:

> Basic aliens, like the Cybermen are not supposed to be emotional, and then in the last story, 'Earthshock' (1982), they're positively hysterical, they're ranting and raving, they're very violently emotional. ... It's often trotted out that the breaches of continuity enable the series to be more flexible and to respond to changing audience demand and so on, with which I concur to a point – that the pepper shakers don't matter, that you can have a pink pepper shaker in one episode and a purple one in the next and you can say it's the same one. That's what *Star Trek* got worried about, that sort of trivia. But when you say that a basic character or an entire civilisation is like X and then you say the same civilisation two years later is like Y and is totally different from X ... it's impossible, you can't reconcile it. ... Given that kind of thing is ignored over the years, it undermines its credibility.

However, it was not bad continuity in *Doctor Who* that was sending it 'down the drain' in the post-Hinchcliffe period. It was not this which was 'too limiting' in Howe's opinion. Howe's discussion of Cyber 'character' and 'civilisation' introduces another major aspect of the fans' aesthetic: concern for structure, coherence and character.

PROGRAMME STRUCTURE: 'ARGUING WITH THE PRODUCER'

Elaborating on why he thought 'Logopolis' was 'all fandom and padding', David Saunders complained about it being only a four-parter.

> I said to John Nathan-Turner, it could have been a six-parter, because not a lot of attention was paid to the possible subplot with Nyssa

thinking that the Master was her father. I felt at least another episode could be made out of her betraying the Doctor, not realizing that it wasn't her father, whereas in fact it was all covered in half an episode.

For Saunders, all the self-referencing 'continuity' of 'Logopolis' could not make up for the weakness of the lack of development in a four-part story. And *this* in fact was the 'limitation' which ADWFC president Tony Howe saw as taking *Doctor Who* 'down the drain'.

> What I think they've done is deliberately un-limit themselves on that side by totally devaluing all of what went before in *Doctor Who* in terms of continuity, but completely impose a structure on themselves with this four episode thing. If somebody ... wrote a story considering all of the characters and stereotypes and thought about the civilisation of the Kinda – which was that this could become the case on Earth, that we could get so civilised that the entire civilisation would just disintegrate – that could have been done in a six episode story. But now they've got themselves into a totally rigid thing. Every producer, script editor and person connected with *Doctor Who* says it has to be four episodes in every interview I've ever seen, and whenever a fan tries to argue with them ... they get quite hot under the collar about it. ... If they limit the structure of the programme as they're doing, they're just going to stifle it.

The other Australian fans present at the 'Kinda' discussion agreed with Howe. ADWFC secretary Kerry Dougherty commented:

> In earlier times they had much greater flexibility. If a programme needed seven episodes, or five episodes, or two, or three ... or even one episode, it got what it needed. ... And that's why the stories were complete or much more complete. It was not so often that you'd find something like 'Kinda' left hanging in mid-air, as you get so often with the modern *Doctor Who*s'.

It was, as we saw, things 'being unexplained', 'left hanging in mid-air' which the fans felt was turning the 'floating voter' off the show.

Again, we notice how the history of *Doctor Who* is called up to position and interpret 'Kinda'; and how 'classics' of *Doctor Who* are drawn on as a point of comparison to enforce the argument.

Howe: ' "The Talons of Weng Chiang" (1977) easily justified six episodes. You couldn't have cut that down to four.'

Dougherty: 'You couldn't have made it in four. That would have destroyed it.'

Howe: 'That would have been absolutely impossible. But today they wouldn't allow a story like that to be made. They say it has to be four episodes, so it wouldn't be half the story.

It needed that development of the characters and the relationships which *Doctor Who* isn't allowed by its format any more.'

Dougherty: 'Yes, it's become so limited. I mean there's no development of the Doctor's companions really in the way there used to be. . . . In the earlier times you really got to see a lot about the characters – they developed as people in front of your eyes while they were there.'

From this point a 'golden age of *Doctor Who*' discussion readily developed. These golden days were particularly those of the first three doctors and the first period of the fourth doctor under producer Philip Hinchcliffe (before Tom Baker 'sent the part up'). These were times, the fans noted, when companions like Susan and Jamie and Zoe had whole episodes or parts of episodes to themselves, or when (under Pertwee) there would be the Doctor in one place, Sarah in another, and UNIT (the United Nations 'alien-spotting' task force) operating in yet another, providing 'depth' and 'development' to the narratives of *Doctor Who*. These were the kinds of narrative, the fans believed, which made the show widely popular. As Ian Levine put it, the continuity is mainly important for the 'fans' point of view'. To attract the wider audience 'good plots' are needed, and these rely on (a) naturalistic and 'believable' characters, (b) a narrative closure which ties all the loose threads together, and (c) a recognition that *Doctor Who* is not about 'media hype' and 'star' actors, but about 'relationships and aliens and a whole plethora of different concepts and strands'. Among other things, it is what the producers see as the 'soapy' element of the series ('relationships') which the fans think is important to the wider public.

While (as always) concerned about what would keep the 'floating voter' watching, the underlying aesthetic assumptions here are of a very particular kind. They belong to what Ebert calls the 'mimetic conventions of the bourgeois novel with its preoccupation with socio-psychological realism'. The elaboration of *believable characters* is what, in the view of many *Doctor Who* fans, distinguishes it from US 'sci-fi' (Ebert's 'para science fiction') and from 'media hype' generally.

BELIEVABLE CHARACTERS: 'IDENTIFICATION ITSELF'

Jeremy Bentham described his pleasure in the very first *Doctor Who* episode, 'The Unearthly Child' (1963):

That ultimate loneliness when you see London fading away when the Tardis takes off for the first time. Because you become so established with those characters and feel comfortable with them you can feel as well the sense of growing loneliness as you open the doors, again for

the first time, nowhere near where you were – it is a fantastic jump to try and imagine literally waking up somewhere you couldn't believe in a million years could exist.

He explained the 'incredible peak' in the ratings for Philip Hinchcliffe's 'Ark in Space' (1975) in these identificatory terms:

I think *Doctor Who* works best when you start inside the ship, the Tardis and then your first sight of what is beyond it comes as the travellers start to explore. . . . In 'Ark in Space' everything was gradually developing as new, as you see it through the eyes of the three people, two of whom it was totally new to in the form of the Doctor's companions. It's internal, if you like, identification itself.

It was primarily because fans felt that Graham Williams betrayed this naturalistic quality of encountering 'new experiences' (by way of the *senses* of the regular characters) that he was especially disliked for 'panto-mimic send-up'. Pantomime has a reflexive quality which draws attention to itself, becomes 'a little too obvious' in its inter-textuality, and so weakens the suspension of disbelief. For Ian Levine:

If you watch 'The Horns of Nimon' you see a pretty abysmal story. . . . It was like a pantomime . . . Graham Williams just sent the series up and turned it into mock comedy . . . instead of depending on good plots.

For Jeremy Bentham, Williams's notorious 'seventeenth season', 'suffered tremendously because of very poor execution of what could have been very, very good ideas. . . . What let it down was this almost pantomime-like execution that the production crew gave it for that story.'

So, whereas university students who followed (but were not fans of) *Doctor Who* told us they liked 'The Horns of Nimon' *because* of 'its pantomime quality', for many fans it was 'the worst story ever'. David Saunders noted that he was 'in a very, very small minority in actually liking "The Horns of Nimon" '. He pointed to ways in which an unfolding series like *Doctor Who* can appropriately have many signatures for the sophisticated fan provided that continuity is maintained on essentials.

In 'The Horns of Nimon' everybody is hamming. It's the equivalent of the old Batman. Everybody is going over the top, therefore it works. To go back to one that I think is even worse, which is 'Nightmare of Eden', that is so bad because . . . there are supporting cast being serious while Baker and Ward laughing and joking and all the rest of it. In 'Horns of Nimon' everybody is laughing and joking and therefore it works. . . . But there were elements in it that I can't approve of, like the Tardis making those horrible, stupid wheezing and groaning sounds at the beginning and the Doctor giving K-9 the kiss of life. . . . Graham

Crowden walking along the corridor, twice, saying (in a falsetto) 'Lord Nimon', I can take because it is within the context of that particular story. But K-9 and the Tardis are ongoing elements, and you know that the Tardis has never made that noise before and we hope never will make it again.

For *some* executive fans, then, 'one-off' pantomime (provided that it is coherent within its genre and does not send up such basic elements of the *Doctor Who* myth as the Tardis) might be acceptable. But other senior fans like Jeremy Bentham worry about the effect of this on the general viewer, particularly the new, young viewer.

Williams's . . . style was camp, but it was without the very necessary ingredient with camp where it is done totally seriously. You can do camp, you can do it with things like 'The Image of the Fendahl' [1977] and do it well. But if you take it too far, too excessively, then you send it up, and the easiest way you can find that out is by asking a youngster. If he is suddenly conscious that he is watching something that is making fun of his enthusiasm he will go off it fast.

NARRATIVE CLOSURE: 'WHAT SORT OF AUDIENCE ARE THEY AIMING FOR?'

We note, then, that fans regularly reference the 'wider audience' as the focus of their concern for naturalistically 'complex' (as against 'pantomimic') plots and characterization. The same is true of their concern that different ('metaphysical' and 'scientific') strands of the storyline be brought together by the end of the narrative. As we have seen, the 'metaphysical' and 'scientific' contrasts in 'Kinda' were a 'postmodernist' trace from the episode's origins in Ursula Le Guin. But the *Doctor Who* fans were concerned with a much more materialistic problem than postmodernism.

At the time of the Liverpool 'Kinda' discussion mentioned earlier, it was well known among fans that *Doctor Who* might be living on borrowed time. The other BBC science fiction series, *Blake's 7*, had recently been taken off air after a couple of seasons' poor ratings. In its seventeenth and eighteenth seasons *Doctor Who* had recently had two poor rating seasons, and it was widely thought that producer Nathan-Turner had to restore lost ratings or go off air. Hence the particularly ebullient emphasis of fans like Ian Levine that Nathan-Turner was 'restoring the series to a golden age again', with 'dazzling drama' as well as impeccable continuity.

The Liverpool fans were therefore well aware that more 'floating voters' were needed to save their show, and they discussed animatedly the new, twice-a-week evening time-slot which had just replaced the

twenty-year-old convention of *Doctor Who* once-a-week (at somewhere between 5.00 and 6.15pm) on Saturdays. They anxiously discussed the problem of attracting new adult viewers without losing the traditional children's audience.

> Graham: 'It's 7 o'clock or around 7 o'clock theoretically – it is an adult show and 'Kinda' should have been a lot more frightening because it was a frightening story. But it wasn't frightening. Hindle . . . was the best character for me. Some of the scenes where he was obviously disturbed – you wouldn't have got away with that at 5 o'clock on Saturday afternoon. . . . It's still hovering in between not knowing whether it's a children's series or adults.'

> Tony: 'It's sort of got to stick within children's limitations. They can't make it too frightening. And yet most children watching 'Kinda' wouldn't be able to follow it because it was high up enough intellectually for adults to follow. . . . I think they are really not sure what sort of audience they are aiming for. . . . If you try and move to a more adult slot then you have got to attract your adult audience before you can throw away your child audience, which is why moving a slot of any programme is really a bit of a risk.'

As we have seen, this group (like the Sydney group) was particularly concerned that 'Kinda' (and the nineteenth season in general) was 'not tying the threads together' and 'leaving the audience up in the air'. 'Not giving explanations well enough is stupid. OK, looking back on a story that has got explanations you might find them laboured. But your average viewer does not look back on a story.' These fans make a very clear distinction between their relationship to the texts of *Doctor Who* and that of the 'average viewer'. Fans 'look back' at a story via video recordings and/or fanzine discussions. The 'average viewers' see the episode once only; and it is for them above all that a clear narrative closure is needed.

'TOM BAKER *IS* DOCTOR WHO': THE FANS AND 'MEDIA HYPE'

The Australian fans discussing 'Kinda' had very precise notions of what was 'wrong' with *Doctor Who* – the writing in particular was criticized for its failure to conclude strands it had begun; for its inability to 'meld' together the 'psychic' and 'technological' strands (other *Doctor Who* stories like 'The Stones of Blood' (1978) and 'Image of the Fendahl' were drawn on here to make the point); for the underlying inability of *Doctor Who* to blend into one whole the 'intuitive, metaphysical' side of the

Doctor with his 'rational, scientific' side; and for the episode's failure to provide cultural background and perspective. Lacking completely feminist science fiction's emphasis on playing-off the 'magical' with the 'rational, scientific', these fans felt 'Kinda' failed too often to situate complex human characters coherently in their cultural context.

The Sydney fans' reference to the failure of *Doctor Who* as 'anthropological or sociological' texts reminds us that these are the modern generation of SF fans that Klein and Mellor describe – many with Arts or Social Science degrees (one Sydney fan drew briefly, for instance, on Fraser's *The Golden Bough* to discuss 'Kinda'). Yet despite this, they drew much more readily, in discussing 'Kinda', on their cultural competence in the history of *Doctor Who* than on these other, broader histories. No one followed up the *Golden Bough* reference; they knew (via the fanzines) that there were Buddhist references in 'Kinda', but they didn't know how these related to the text (had they done so, they might have understood better the relationship between the 'metaphysical' and the linear/scientific in the text[15]); and though they were able to recognize its 'Garden of Eden' references, these did not make sense of the plot for them. For the fans this 'making sense' was a major criterion of 'good' plot. It was important to them that the inter-textual analogies which abound in *Doctor Who* ('going back to the classics') must 'have a point' within a believable storyline.

In this area of narrative coherence and closure, too, it became clear as the discussion proceeded that the fans were not so much criticizing *Doctor Who* as a whole, but a particular period of the show, for which nearly all their critical comments were reserved. Again, this was the Graham Williams era, with the addition (in the case of the Australian fans) of the Nathan-Turner period. In these two 'worst ever' eras, 'complex', 'believable' stories ('good drama') were replaced by the idiolects of 'stars'. It was this 'star gazing' which led, they felt, to the 'mannered' self-reference and pantomime.

> Howe: 'Tom Baker and Peter Davison both babble on a lot. They're very mannered too. You notice they'll point and gesture in very mannered ways, while the earlier Doctors were much more relaxed about being "the Doctor". They now think they've got to have all sorts of affectations, which turn me right off.'

Tom Baker, in particular, was associated by many fans with this 'face-pulling affectation' which, Levine and Bentham argued, tended to draw attention to the star rather than the series.

> The thing about Graham Williams was that he was under very strict constraints to remove the violent element in the programme that Philip Hinchcliffe had introduced, and he did that by concentrating the

programme towards the character of the Doctor himself, this charis-
matic figure which in essence gave Tom Baker a lot more control over
the programme than perhaps he should have had – to the extent
where the actor was dictating what the director would show on screen.

In his role as president of ADWFC, Tony Howe encountered another
aspect of the star-making procedure surrounding Tom Baker.

> When I interviewed Baker for an hour ... it came across quite strongly
> that if Tom Baker wanted to present something ... he would bloody
> well do so whether the director or writer wanted to or not. I know
> people who have been on the set watching Tom Baker acting, and he
> will tell directors how to film it and how he's got to come across. ...
> *Doctor Who* is not one person. *Doctor Who* is relationships and is
> aliens and is the Tardis and a whole plethora of different concepts and
> strands that come together. But you get the advertising people and the
> merchandising people whom I've had to deal with again and again
> with this fan club, and all they can see is Tom Baker, or whoever the
> new Doctor is. ... We get great media hype – ' "Destiny of the Daleks"
> is a great Dalek story, we should all be pleased the Daleks are coming
> back' – and it's a disaster!

This view of Baker was one widely shared by senior fans in England and
Australia, and was consistently circulated via the fanzines. Stephen Col-
lins, for instance, replied in *Zerinza* to a fan's letter which compared
Baker favourably with his replacement, fifth Doctor Peter Davison:

> Tom Baker is not *the* Doctor. He was a Doctor. ... There is no question
> of Baker being better at doing what Davison is doing – Baker never
> tried. His Doctor was utterly and totally different, lacking in com-
> passion, sincerity and depth of feeling. If Peter Davison is terrible
> because he is incapable of rampaging through the scripts in the manner
> of Baker then I for one am glad that he is terrible.[16]

Underlying the fans' comments that Tom Baker was 'a bad actor', 'sent
the part up', 'was too much of a lunatic', 'outstayed his welcome and
wore out the inventiveness of the part', there are two distinct parameters
of fan concern. On the one hand, there is the fans' general inability to
control the TV industry which produces their show – indeed, which denies
in important ways that it *is* their show by replacing the fans' complex
history (of companions and aliens and Doctors and Tardis) with the
present of 'advertising hype' and 'star charisma'. Jenkins quotes one fan
as saying, 'I think we have made *Star Trek* uniquely our own, so we have
all the right in the world (universe) to try and change it for the better
when the gang at Paramount starts worshipping the almighty dollar.'[17] As
Jenkins says, the 'fans respect the original text and their creators, yet fear

that their conceptions of the character and other programme materials may be jeopardized by those who wish to exploit them for easy profits'.[18]

On the other hand, there is the perception that Baker led to 'TV sets being turned on all over the world to watch *Doctor Who*' – especially in the USA, where Tom Baker was the first Doctor screened, and so did become '*the* Doctor' there. Constantly the fans have to tread this institutional space between two bodies they are relatively powerless to control: the BBC 'who don't accord *Doctor Who* a very high priority at all' and the fickle 'average audience' of 'floating voters'.

Australian fans like Howe came to regard producer Nathan-Turner himself as even worse than Tom Baker at merchandising himself as the 'star' of the show. '*Doctor Who* has degenerated into a vehicle for the self-aggrandizement of Nathan-Turner who regards himself as the show's greatest asset and publicity tool.'

> Howe: 'It's a bit medieval the producer's relationship to the fans that's developed under Nathan-Turner. He controls all the patronage. He controls access to the news, access to the stars, access to the sets. . . . When I launched my attack on Nathan-Turner in 1985 . . . I criticized the fan groups in England for being so uncritical on the grounds that they were in Nathan-Turner's pocket because they were getting a lot of favours and goodies from him, but that these were benefiting the elite in England and America and not filtering down to the membership. . . . I think that raffling-off props, even if it's a good cause, is nothing compared to trying to save the programme from Nathan-Turner.'[19]

By 1987 Ian Levine himself was well into his own campaign against 'a totally sterile and disinterested producer who stubbornly refuses to face the fact of the pantomime edge he has tarnished the series with'.[20] Levine provided a 'JN-T Must Go Now' cover article for the *Doctor Who Monthly Bulletin*, at the end of which there was a cartoon of Tony Howe kicking Nathan-Turner out of his producer's chair:

> to 99.999% of the population, John Nathan-Turner (*Doctor Who*'s producer for the last *eight* years, in which time the show has been cancelled, halved in episode count, ridiculed in public by Grade, and has had its script editor quit in disgust at the producer's antics . . .) is a total non-entity. . . . On the other hand because of the knowledge we have as fans we are more than aware of the rot that has been silently corroding away the magical essence of a once, quite simple, brilliant concept.[21]

Underlying the urgency of Howe's and Levine's attacks on Nathan-Turner

is the fear that *Doctor Who* will lose the 'floating voter' and be taken off air (a very real possibility by 1985). For Howe,

> The style of 'Romantic' Gothic Horror used by Philip Hinchcliffe for Tom Baker's early years was very successful and achieved the series' highest ratings ever, with some of the best stories ever, so that attacks in the Press then caused little danger to the series. . . . Nathan-Turner's 1985 season with Colin Baker is NOT the scary, stylised horror of the mid-1970's *Doctor Who*. The new style is sick, shock violence like Andy Warhol's: the Cyber-leader crushes a prisoner's hand until it oozes blood; two men die in a vat of acid in 'Vengeance on Varos' (. . . the Doctor jokes at the men's suffering and walks off . . .); there is an attack with a kitchen knife in 'Two Doctors'; and in the new Dalek story someone is stabbed in the chest with a hypodermic needle. These incidents occur unexpectedly, they are not part of a total atmos- phere for the whole story, they do not make the stories interesting, they are for cheap shock value only and intended to provoke criticism in the Press to get free publicity – Nathan-Turner made this clear while in Sydney during 1984. But that is a dangerous publicity gimmick, because this time the show has very low ratings, unlike the mid-1970's – attacks in the Press weaken an already vulnerable show . . . Nathan- Turner's poor style lowered the ratings, his actions have ensured the show would be attacked while it was weak.[22]

Though there were clearly attacks on Nathan-Turner in England, Tony Howe felt that Australian fans responded more systematically to the need to 'save the programme' from its producer, and this was for very particular cultural reasons. First, there were the different cultures of the different national fan clubs which Tony Howe and Dallas Jones talked about; second, there was the decline, as Howe saw it, of British culture itself – which we will look at in the final section of the chapter.

> Howe: 'A point I want to make about fandom which I touched on in commenting on the English fan club, DWAS's obsession with trinkets is that, in a sense, you are setting yourself up as a representative on the audience's behalf for the programme, and I see that part of that is to lobby either for the pro- gramme's improvement or its continuation or, in the case of the ABC, to get it back on air and to get, as Dallas has been doing, good time slots and good scheduling arrangements. . . . The fan clubs shouldn't just exist for the self-gratification of just a bunch of fans. The fans' total membership will only amount to about half a per cent of the audience at the absolute maximum, and, only a tenth of those would be the active ones receiving benefit from these video screenings,

trinket selling, etc., at conventions. So fan clubs should have a public orientation as well, getting things out for the viewers who are not members of a fan club and may not want to join but are keen on the programme.'

Tulloch: 'So you feel that the Australian club is more active in that respect than DWAS?'

Howe: 'Yes, I think so. The point is that the origins of the two clubs are different. You were talking about the "powerless elite". If the people that run the clubs are these elites, the cultures they come from are different. We started out in combat with the ABC, trying to get the programme back on air ... whereas when DWAS began *Doctor Who* was getting higher and higher ratings under Philip Hinchcliffe and everything was sweetness and light in England. ... So they never had to battle to get any crumb off the table as we had to – even to get a photograph took years for us.'

Tulloch: 'You seem to have had a much more continuous executive than DWAS – you two guys have been around for a long time.'

Jones: 'DWAS's executive has been changing, but those people who move out of DWAS are still there, most of them, in fandom doing other things ... fan involvement with the professional side, the whole industry of *Doctor Who*. ... You've got Jeremy Bentham writing books about the programme, John Peel novelizing books, some of the people now actually work on the programme doing models and special effects, John McIllroy selling BBC photographs, some groups have gone into production of videos, producing video interviews, and they even produced a half-hour story called "Wartime" about the character John Benton'

Howe: 'Because they have got a bigger population and a bigger concentration of fandom, they are able to make some money out of it. ... So it's a much more comfortable situation for fans. They can really justify as adults devoting a lot of time to the programme, through into their 20s and 30s, whereas when you leave university here you can't be an adviser to a publisher, you can't be an adviser to the BBC and there's no role for a fan outside the fan club in Australia.'

Jones: 'The USA is a bit different again. ... They're not fans – or 75/25 per cent not fans – they are people who say, "This is important, people are interested in this." People like Norman Rubinstein from Spirit of Light – he's the biggest one, who more or less took over *Doctor Who* fandom in America and produced the two huge conventions for the twentieth and

twenty-first anniversaries, the mega conventions in Chicago where 8,000 people attended, with twenty-one guests for the twenty-first anniversary, and the twentieth anniversary had all four of the living Doctors. . . . Secondly, you have the *Doctor Who* Fan Club of America which was started by two "fans" – in inverted commas – who started the fan club based on similar ideas to professional fan clubs in America and proceeded to get guests and tour them over say ten cities, which is where they made their money. . . . Then, thirdly, there was the Barbara Elder corporation – she was from a group called the North American *Doctor Who* Appreciation Society, which was related to the English DWAS until she got more commercial and called herself a corporation and got an exclusive contract to use Tom Baker at conventions, where they also sold merchandise they were producing. So America went beyond the cottage industry in England to being big business. . . .'

Tulloch: 'So you see yourselves in a sense as much more pure fans because you are interested in getting the programme out to a much wider audience? Whereas you feel that particularly the US, but to some extent also in England, the whole merchandising thing is kind of . . .?'

Howe: 'Solipsistic, to use one of the words from your book.'

Jones: 'And also, because we don't have the guests at our conventions out here, all we have is the programme to watch. In America it was all about guests, and now also in England. . . . We haven't got the actors to talk to, we've just got the programme to look at, and I think that *Doctor Who* in Australia is more involved with the programme rather than the people.'[23]

While agreeing that the fan elite 'are setting the agenda for the other fans who don't make it to the conventions' by reviews of new material in their fanzines, Howe and Jones also emphasized the power of the producer via the *commercial* fan magazine in England, *Doctor Who Monthly*.

Jones: 'Once a year, once the season is in production, you will start getting hints in *Doctor Who Monthly* "this is going to be the dud of the season". So even before an episode goes to air, you will have a preview in the magazine, and this is usually coming from the production team – it's really strange.'

Howe: 'If you are going to talk about a powerless elite, in this sort of context it's not even an elite at all because it's been captured by the producer who is already determining the agenda himself and they just lock step in line. . . . In so far as the

> *Doctor Who Monthly* has got a vastly bigger circulation than
> all the fanzines in the world put together, Nathan-Turner's
> influence there in setting the agenda through reviews and
> previews . . . is quite dominant.'

For these Australian executive fans it was the media hype of merchandis-
ing stars, rather than caring for the programme itself that most distin-
guished US and British fandom from their own. But for Tony Howe there
were broader cultural reasons for the decline into 'Doctor Whooligan'
during the Nathan-Turner years. Under the sixth Doctor, Colin Baker,
the series had sunk, Howe argued, to the level of 'soccer hooligan ethics'.
Seeking to explain the series' lurch into the 'cruel and needlessly violent',
Howe began to see an entire culture in decline, emblematized by the
decline of *Doctor Who*.[24] He began to talk about the politics of the show.

'THE MONSTER OF PELADON' AND POLITICS

The features of expertise and intimacy with the 'ongoing odyssey' of
Doctor Who which we have looked at so far bear a close resemblance to
Bernard Sharratt's discussion of the constituent features of contemporary
popular culture.[25] Many of Sharratt's observations about fans of horror
series and other popular TV genres seem to hold good for *Doctor Who*
fans: the 'pseudo-knowledge' of individualism, intimacy and expertise (at
the expense of socio-economic and structural knowledge) which lies at the
basis of their aesthetic; the understanding of history (of the show)
primarily in terms of individuals (Tom Baker, Colin Baker, John Nathan-
Turner); the critical yet close (first name) relationship with the show's
personalities. Yet, of course, most of the fans – especially the fan club
executives – are middle class (often tertiary-trained, professional middle-
class), not the oppressed working-class viewers of Sharratt's analysis.

These science fiction fans are highly articulate, sometimes philosophical
in their comments about the show. Consider, for example, this discussion
of aliens by Australian fans:

Roach:	'I would be more concerned with the function of the monster than with its appearance. . . . I mean, as a representative of evil, I think evil would shun some of these monsters.' (general laughter)
Howe:	'That's something I find a bit tedious about the aliens in *Doctor Who*. Almost without exception – and there are some notable exceptions – they are all evil. They are totally, irredeemably evil.'
Int:	'Quite often, though, there's two groups – there's the baddies – '
Roach:	'And the oppressed!'

Dougherty: 'And they're always stupid oppressed, they're never very intelligent. . . .'

Int: 'Do you think this aspect of aliens reflects any view of society?'

Howe: 'Yeah, I think it's racism.'

Dougherty: 'It's xenophobic.'

Roach: 'It's obvious xenophobia, yeah.'

As we have seen, these Australian fans do have a very precise sense of their situation as a 'powerless elite' between industry and audience; and, as the above quotation illustrates, they can, when prompted, relate the show beyond personalities to structures of oppression, rather than to Sharratt's history of individuals. When Tony Howe was asked whether the 'decline' in the morality of the Doctor during the Tom Baker period reflected anything more general, he elaborated at some length:

> The standards in *Doctor Who* are declining because they are showing that violence is an acceptable answer to situations. . . . It reflects what's happening in England, the decline in the effectiveness of institutions to deal with problems, and a breakdown in society. . . . The generality is that crimes of passion and violence have gone up and hence become more acceptable. Terrorism is acceptable, and that is a decline. Innocent individuals are to be punished for what the system does. I find that morally repugnant; and in *Doctor Who* that is gradually coming in, that innocent parts of a system can be destroyed for the supposed good of some other part of the system.

Howe's views were hotly contested by other fans in the group, however, on the grounds that 'There is no one standard of morality. The point is that we are shifting from one set of morals to another.' This kind of contentious debate was typical wherever the 'political' was introduced into discussion by fans. Ian Levine, for instance, argued strongly against Jeremy Bentham's contention that 'there is a strong chauvinist element in *Doctor Who* – there don't appear to be very many women actresses appearing in it apart from the screaming companions'.[26] Or, alternatively, where there was some consensus (as among the Sydney fans) about the sexism of the show's use of female companions or its xenophobic representation of aliens, these were responses to the interviewer's leading questions: 'Do you object to the portrayal of women as being so dependent?', or, 'Does this representation of aliens reflect any view of society?' Whether one speaks with *Doctor Who* fans, or goes to their conventions, or reads their fanzines, one gets the very strong impression that 'politics' is – most of the time, and at best – no more than an auxiliary discourse which is summoned up to explain that other, and much more central, 'decline' – in *Doctor Who* itself.

The point, then, is that 'displacement of knowledge' (as 'expertise' and 'intimacy') among fans does not deprive them of political awareness (as primarily middle-class feminists, conservatives, or whatever), but rather is what determines their cultural constitution and reading position as fans. As *fans* they achieve remarkable consensus (spanning different continents and parts of the world); but as individuals inhabiting different class, gender and ethnic subject positions, they quite clearly differ in their political readings.

Speaking as fans

The response of the Sydney fans to the question 'How does *Doctor Who* compare with other science fiction shows?' was quite uniformly pro-British, and not at all simply as 'consumers of gadgetry and action', as Ebert would predict of TV science fiction fans. Indeed, the English fans Levine and Bentham emphasized *Doctor Who*'s '*cerebral*' quality as against the 'high gloss' and 'macho' action of US science fiction shows.

Bentham: 'The Doctor is entirely different from the conventional mould of hero. He doesn't go in for the three things that you find in all American heroes: (a) they are very, very macho, (b) they are usually interested in women and gambling, and (c) they all have a slant towards hardware and action. The Doctor breaks all of those boundaries, and he rarely resorts to violence. His personal interests he virtually keeps shielded and in fact he almost seems to enjoy them from a child-like level. . . .'

Levine: 'Personally, I would rather see a BBC science fiction production than an American one, because those "cardboard sets", as people call it in *Doctor Who*, have more character than all the American 35mm film gloss.'

The Australian fans were as convinced as English fans Bentham and Levine of the superiority of *Doctor Who* (and British SF products generally) over anything from the USA.

Howe: 'I think *Doctor Who*'s much better than *Star Trek*, because it's more original.'

Dougherty: 'Oh yes, the script is better.'

Howe: 'And as I said before, the format of *Doctor Who* is more flexible because they haven't got worried about whether the Tardis's nuts and bolts are the same from one episode to another.'

Dougherty: 'The thing is, too, *Doctor Who* doesn't worry about

offending minorities or anything like that, whereas *Star Trek* has always been.'

Howe: 'That's English television compared to American television.'

Dougherty: 'Yes, that's right, but it's something that's important in comparing them. And the other thing is, I know you were saying that they always meet evil aliens (in *Doctor Who*), but in *Star Trek* it didn't matter whether the aliens were evil, friendly, non-*compos mentis*, half-and-half, or whatever, their immediate reaction was "Aliens! Ugh! Horror! Horror! Horror!".'

Roach: 'Ugly, horrible aliens!'

Dougherty: 'Yes, for a show that's been glorified by its fans on its liberal attitude, aliens took a terrible beating in *Star Trek*.'

Roach: 'It's been glorified by its American fans for its liberal attitude simply because it conveys immediately and completely in condensed fashion the American ideal.'

Dougherty: 'That's right.'

Roach: 'I mean, at least you don't have *Doctor Who* waving the British flag everywhere. ... Saying "England stands for the Westminster system".'

Dougherty: 'You know, there have been a few times when he's made lots of derisive comments about English institutions and the English military.'

Howe: 'That's a strong tendency in *Doctor Who*. ... All authority figures are automatically suspect in *Doctor Who*. In a way it's a socialist type of view of the thing. Whereas in *Star Trek* authority was shown as good and benevolent and you bring benefits from being part of a team.'

Roach: 'And all weaknesses were based on individuals.'

Howe: 'That's true – individuals were always the weak points. ... The system wasn't wrong. ... In *Doctor Who* there isn't really such a system because he's not part of a chain of command. But whenever he lands somewhere there's always a bad president, or a bad dictator, or a bad boss or someone in authority over people.'

Roach: 'Bosses are bad.'

Howe: 'Well, that is a message in *Doctor Who*, that bosses are bad, always *per se*, because they're bosses. There are very few stories you can think of where anyone in authority is shown as good or sympathetic.'

Int: 'In "The Monster of Peladon", say, there was situation where they portrayed a bureaucracy or whatever that had gone wrong because it wasn't able to relate to its public,

and all it needed was Doctor Who to come in and fix it up and show them how they could have "responsible government".'

Dougherty: 'Sarah showed the Queen how to get into Women's Lib.' (laughs)

Roach: 'But you'll notice that the Doctor saw nothing wrong with the monarchy. I mean, it is just a monarchy that's gone slightly wrong!'

Howe: 'Because of bad advisers.'

Int: 'And, I mean, the whole solution of that problem was mediation, so that the workers got better conditions, but there was never any. . . .'

Howe: 'That's an exceptional story because of the political overtones.'

Roach: 'And it should be noted that when it was shown in Britain there was the background of the miners' strike.'

Dougherty: 'Yes, that was topical at the time.'

Howe: 'That was the time of the Heath government and the coal strike. But in other stories, all authority is forcibly overthrown. Frequently in *Doctor Who* any attempt at mediation automatically fails and it has to be overthrown by force. That happens in a lot of stories, from Dalek stories down to less obvious stories – it's force that has to be used to replace the people in charge. . . . You never have to look at the fact that running a planet may be a bloody difficult job.'

Doctor Who fans, whether in Britain or Australia, achieve maximum consensus (like many other followers of the show that we have analysed) in accepting the 'high culture' superiority of a 'British' imagined community. *Doctor Who* is 'inventive' and 'ingenious' in its scripts, while *Buck Rogers* and *Battlestar Galactica* are 'plastic' and 'glossy' in their action. *Doctor Who* is 'flexible' and 'liberal' in its politics, whereas *Star Trek* is inflexibly 'moralistic' in presenting the 'American ideal'.

What is interesting about this discussion among Australian fans, however, is the way in which total fan consensus gives way to individual dispute over what *Doctor Who*'s 'anti-authority' position signifies.

Speaking as individuals

As well as being president of the Australian fan club, Tony Howe was a Sydney University-based postgraduate, doing an MA thesis in history. In this thesis, Howe was critiquing Marxist historiography. It was perhaps this

particular cultural competence which began to provide inter-textual references as the discussion continued.

Howe: 'What I'm pointing up is the fact that it's automatically assumed that the authority figures are always the evil ones – and that's not necessarily so. . . .'

Roach: 'It's developing the Westminster system.'

Howe: 'No, it's not. . . .'

Int: 'Isn't it the liberal tradition?'

Howe: 'But it's more the left-wing liberal tradition, this tendency.'

Dougherty: 'Have you been watching *The Omega Factor*? – again the figures in authority are evil.'

Howe: 'Well, I think that shows the socialist bias in the BBC.'

It was from this point in the discussion (about all authority being represented as bad, and about Tom Baker's Doctor tending towards 'means-to-end' violence rather than responsible leadership) that Howe launched into his view about the 'moral decline' of both *Doctor Who* as series and British society in general – and into territory hotly contested by the other fans present. Indeed, the debate became quite angry before finishing.

M: 'In the past even working-class people that didn't want ruling-class people to have palaces and things didn't want innocent people to be blown up for political slogans, and that's what's happening today.'

F: 'That's why there was a Paris Commune?'

M: 'What about the Paris Commune? The Paris Commune was much more complicated because it was besieged by the Prussians for several months beforehand – the situation was quite complicated. Yeah, and I've read a book on it too!'

F: 'I hate to tell you – '

F: 'Oh, forget about it.'

They had, by then, stopped talking as 'fans'. Their self-concept as a unified subculture of fans could easily embrace a 'British' imaginary. But it broke down into hostility and silence when it began to encounter discussion about what 'the British way' actually meant in terms of power and class.

CONCLUSION

Our view is that fans are not 'fan-atics'. They are not simply the mindless, middle-class 'consumers whose passion for gadgetry is inexhaustible' of Ebert's analysis. Indeed, they are often closer to Ebert's 'serious' SF fans, with their assumptions of 'bourgeois realism'. Still less are they the psychologically 'deviant' personalities that the media like to construct.

Indeed 'fans' are best understood not as unified individuals at all (whether 'deviant' or 'normal') but rather as a subculture with sets of discourses appropriate to a 'powerless elite', positioned in relations of expertise and intimacy with 'their' show. They are *necessarily* positioned, structurally positioned, in an immediate context of industry ('producers') and audience ('the floating voter'). Reliant on both these areas of culture industry – for the 'quality' of their show and for its very continuance – the fans' discourses readily refer to 'golden ages' and 'eras of the unforgivable'. Golden ages are times – usually in the fans' past, often transmitted before they were fans – when communication between producers, fans and audiences is perceived as transparent and true. As the 'fan' in the Nathan-Turner *Doctor Who* story, 'The Greatest Show in the Galaxy' (1989) puts it, 'Although I never got to see the early days, I know it's not as good as it used to be, but I'm still terribly interested.'

Golden ages are, Raymond Williams points out, partly a feature of nostalgia: 'we notice their location in the childhoods of their authors, and this must be relevant'.[27] This clearly seems true of *Doctor Who* fans – for most of them the 'golden ages' of the show are set prior to 1977 which, given the average age of ADWFC members (in 1982, when first interviewed) of 'about eighteen or nineteen', means that their first valuation of Hartnell, Troughton and Pertwee eras was as children.

Golden ages, Williams also points out, have very precise social and historical constituents as well as personal and psychological ones. For instance, in *The Country and the City*, Williams analyses the 'structure of feeling' based on a 'temporary stability' in the process from feudalism to capitalism, a particular 'golden age' perspective of idealization based on 'a deep desire for stability, served to cover and to evade the actual and bitter contradictions of the time'.[28] As we pointed out in Chapter 2, the themes of science fiction are frequently about just this historical transition – from feudalism to capitalism. But in this chapter Williams's example is most interesting analogously, as a model for considering the audiences of science fiction.

Williams speaks of 'golden ages' constructed by both the lordly and the landless in this early-modern period, but the 'most interesting' construction depended on the social experience of the 'shifting and intermediate groups'.

> An upper peasantry, which had established itself in the break-up of the strict feudal order, and which had ideas and illusions about freedom and independence from the experience of a few generations, was being pressed and expropriated by the great landowners, the most successful of just these new men. . . . A moral protest was then based on a temporary stability. . . . Such men, who had risen by change, were quick to be bitter about renewed or continuing change.[29]

The interest of this as analogy for the analysis of SF fans relates to the Klein/Mellor thesis of the SF audience as the exploited fraction (with 'ideas and illusions about freedom and independence') of the exploiting capitalist class (including 'the most successful of just these new men'). Perhaps the 'politics of decline' so deeply felt by Tony Howe is a late expression of what Mellor describes – the 'tragic vision' of a temporarily optimistic middle-class fraction.

But in this chapter we have preferred to examine the discourses of fandom, as it were synchronically – as a kind of perennial system (though with different national/cultural variations) in which the stable points of reference have been 'the producers', 'the floating voters' and the fans' own cultural competences in 'intimacy' and 'expertise'. It is in that communication system of industry, audience and fans that what fans call 'polarizing debate' (for instance, over Tom Baker as Doctor) becomes meaningful. Positions are clearly ascribed ('fans of Tom Baker', 'fans of *Doctor Who*') and discourse relevances (to the show's 'unfolding odyssey', or to 'television sets switched on all over the world') equally clearly understood.

In contrast, polarizing debates about wider histories, about Britain's 'contemporary decline', about the 'socialist bias' of the BBC, have much less relevance in this fan discourse, and are ascribed to 'personal opinion' in an indefinable moral order which is in 'shift not decline'. The 'political' representations of British or US values in *Doctor Who* are most easily accommodated by the fans (as fans) in terms of national imaginaries – 'the British way', 'the American ideal' – and these in turn are related to 'cerebral' versus 'high gloss' science fiction styles. Any political analysis beyond this was uncomfortable, personalized, contentious – and finally closed-off, 'forgotten' as not relevant to fan debate.

In this sense, the Australian and British fans of *Doctor Who* seem quite different from the more politicized fans that Henry Jenkins describes for *Star Trek* and other programmes within US fandom. Yet, although the weight of emphasis in Jenkins's book is certainly on fans whose pleasure comes in resisting the preferred meanings of the texts and ascribing to them oppositional meanings, if we look carefully, we find in Jenkins's science fiction fans quite the opposite as well.

> To say that fans promote their own meanings over those of producers is not to suggest that the meanings fans produce are always oppositional ones or that those meanings are made in isolation from other social factors. Fans have chosen these media products from the total range of available texts precisely because they seem to hold special potential as vehicles for expressing the fans' pre-existing social commitments and cultural interests; there is always some degree of compati-

bility between the ideological construction of the text and the ideological commitments of fans.[30]

Fans, as Jenkins notes, are not ideologues; rather, they define their relationship to the text in terms of pleasure rather than politics, and cobble together their own culture from fragments of pre-existing media content: 'A poached culture, a nomadic culture, is also a patchwork culture, an impure culture, where much that is taken in remains semi-digested and ill-considered.'[31]

Interestingly, Jenkins points to the fact that *Star Trek* fans feel happier discussing 'politics' *via* the series rather than outside it.

> *Star Trek* fans found the discussion of abortion appropriate as long as it was centred on the fictional characters and their on-screen adventures. Objections were raised to the introduction of 'politics' into this fan form as soon as the debate shifted onto a direct focus on the real-world implications of this issue.[32]

Jenkins argues that in particular situations – such as the role of women in science fiction – this helps to 'make the abstract concrete, to transform issues of public concern into topics of personal significance'.[33] Consequently, far from being apolitical, such discussions allow women who have traditionally felt excluded from political discourse to examine 'issues central to feminist debate and analysis', such as the 'marginalization' of women in the workplace (through Uhura and Chapel) or traditional masculine authority (through Kirk). Fans, Jenkins argues, 'are drawn to specific programs in part because they provide the resources for discussing issues of central concern to them or because they pose questions they would like to more fully explore.'[34]

In the case of the *Doctor Who* discussion quoted above, however, something different is happening. Here a female fan is explicitly laying claim to a competence in abstract political dialogue, and her 'That's why there was a Paris Commune?' directly challenges what has been an almost entirely male-dominated theorization about ideology and *Doctor Who* up to this point. One fan's dismissive 'I've read a book too' works to re-position this 'extravagant' female gesture; and it is this potential male/female argument that other fans (including female fans) quickly move to cut off. It may well be for reasons of fan consensus (as in this case) that 'Female fans are often uncomfortable identifying themselves as feminists and adopting its terms within their own discourse.'[35]

Fandom provides, as Jenkins says, an 'institutional filter' which adds to and mediates other sets of social identities which fans have. In the *Doctor Who* argument over politics discussed above, that institutional filter operated consensually through its own, familiar reading protocols, until the 'Commune' intervention threatened the series text with quite an 'other'

text. The fan's claim to have 'read a book on it too' accesses this 'other' field of reading competence, ones where other fans compete or have nothing to say. As with Jenkins's *Star Trek* fans, it was not 'politics' as such which fans objected to, but 'politics' attached to *another reading formation*. It was on the edge of that arcane 'other' that the fans protected their community consensus with silence.

Among American *Star Trek* fans, however, that silence has increasingly been challenged. In the final section of the book, Henry Jenkins will examine the relationship of fans as 'powerless elite' with the *em*powering reading formations made available by what Raymond Williams has called 'residual' and 'emergent' cultures – the residual but professionally still powerful values of technological utopianism among MIT students; and the emergent self-consciousness of feminist and gay *Star Trek* fans in negotiating with and challenging the series' founder-author and its owner-producers.

Part III

Chapter 9

'Infinite diversity in infinite combinations'
Genre and authorship in *Star Trek*

Henry Jenkins

The Federation was founded not by force, nor by expediency, nor in response to an outside threat. It was founded on a dream – a dream of greater goals and greater good, of common purpose and cooperation, but beyond all else, it was a dream to know more, a dream to explore to the furthest limits and then go beyond. . . . In every language in all the worlds, the words were always the same: the dream of the stars. Not traveling to them, not stopping at them, but moving among them, ever outward, always farther, no end to space or to their quest. Or to the dream.

(Prime Directive, 1990)[1]

James T. Kirk, captain of the USS *Enterprise*, has been called before a special subcommittee of the body which has assembled to draft a new constitution for the Federation. As he awaits his turn to testify, he listens with surprise and alarm as a 'soft-spoken Andorian biologist' offers a 'blistering indictment' of the Federation's treatment of its non-Terran citizens. 'Could it really be that life in the service was *that* out of touch with the needs of nonhumans? If so, it was a wonder the Federation had lasted in its present form for nearly a century.'[2] When Kirk takes the stand, he faces sharp questions from the Andorian delegate, Thirlev, who reviews many incidents when the captain had made decisions based on human morality and logic, decisions which led him to violate the Prime Directive's edicts against non-interference in developing cultures.

Through this dramatic device, Jacqueline Lichtenberg's fan novel, *Federation Centennial* (1976) rethinks a number of the episodes which have provoked ideological analysis, examining and often criticizing the logic upon which Kirk based his actions. Thirlev questions him about his actions in 'A Private Little War', for example:

A similar situation occurred on a recently explored planet where you confronted the Klingons. The balance of power between a pacifist culture and an activist culture had been upset by the Klingons' introduction of primitive firearms. Again your antidote to an initial infringement of the Prime Directive was a second and more massive

violation of the Directive. Specifically you incited the pacifist culture to violence and provided them with firearms and instruction in the use thereof.[3]

Kirk's defences are clumsy, appealing to Terran 'common sense' categories which are not necessarily shared by his questioners, making arbitrary judgements about the quality of life in these alien cultures.

Under Thirlev's interrogation, a pattern of insensitivity to non-human cultures emerges:

In each case you singlehandedly passed a value judgement on a non-human society. In each case you took action to mold that society into the form of human social health lauded by modern Terran culture. In each case the First Officer's log records doubts about the necessity of your chosen action. In each case, the human-dominated Admiralty upheld your decisions.[4]

Kirk has repeatedly imposed his values upon alien worlds; Kirk has failed to listen to the advice of his Vulcan first officer who offered a different, non-Terran perspective on those cultures. Kirk, Thirlev concludes, 'has acted with swift decisiveness in matters involving *whole civilizations*'.

As Kirk's testimony draws to a close, Thirlev confronts him about the events in 'Amok Time', about his initial reluctance to divert the *Enterprise* from a diplomatic mission in order to bring Spock to Vulcan during a medical emergency. The Andorian ambassador notes that Vulcans have died on other ships as a result of Starfleet's refusal, despite diplomatic protests, to change its policy against granting automatic home leave for Vulcans. (Vulcans are shy about discussing the details of their mating urge (Pon Farr) with the Federation, yet Kirk and Thirlev's shared knowledge of this problem forms a subtext here.) As Thirlev explains, 'Because Starfleet regulations are oriented to the needs of humans, countless non-human members of the Service are daily put through personally agonizing experiences ... which are totally senseless.'[5]

In this scene and elsewhere in this novel, Lichtenberg examines the ideological assumptions governing *Star Trek*, focusing particularly on the series' representation of the relationship amongst the many alien races that constitute the Federation. If academic critics step outside the narrative's fictional framework to focus on larger social determinants or institutional contexts, fan criticism operates within the fictional world, framing interpretations that are consistent with fandom's prevailing realist aesthetic. Ideological contradictions are understood as conflicts between characters and the alien cultures they represent rather than between opposing discourses within a constructed text. In this case, the narrative links *Star Trek*'s 'utopian' possibilities, its acceptance of difference, to Thirlev and the tribunal, while its attempts to prescribe moral standards

and intervene in other planets' developments are tied to Kirk and his long history of gross violations of the Prime Directive. Much like David Buxton and other 'social control' theorists (Chapter 2), Lichtenberg recognizes an ambiguity between the series' utopian vision of human nature and the need to address contemporary moral and political realities. Lichtenberg, in fact, examines such a contradiction in *Star Trek Lives!*:

> *Star Trek*'s respect for diversity is balanced by a conviction that there are some truths which are universal. To be different is not to be wrong. But there are some things which are wrong and which can be objectively demonstrated to be wrong. Slavery, for example, is wrong for all known intelligent beings. The respect for differences is stated in the Prime Directive. The conviction that truth, even moral truth, is knowable is embodied in Kirk, who acts with moral confidence, when he must act against something which he sees not as merely different but fundamentally wrong. . . . The Federation needs to make it as tough as possible for a captain to come even close to breaking the Prime Directive and needs a captain who will do it when he must.[6]

Forcing Kirk to defend these decisions before a tribunal thus allows Lichtenberg (and her readers) to acknowledge their awareness of the complexity of *Star Trek*'s ideological construction, to explore both the potential and the limits of tolerance as exposed within the series.

Much like Anne Cranny-Francis and other 'utopian' critics (Chapter 2), Lichtenberg recognizes the value of an alien vantage point from which to examine and criticize the myth of 'universal human values'. She uses the Andorian ambassador to pose difficult questions about the programme's logical consistency while allowing Spock to serve as a mediator between Kirk and the tribunal. Governed by the Vulcan's high ethical commitment to professing truth and making rational decisions, Spock must say what he knows about his friend, no matter what the cost. Spock testifies that Kirk sometimes made decisions with which the Vulcan sharply disagreed, that Kirk often did not take full advantage of his advice, and that Spock has sometimes been made to feel uncomfortable because of his Vulcan ancestry in a service dominated by humans and their values. Yet, at the same time, Spock's affection for and loyalty to Kirk allow him to see that such moments do not represent the whole truth of their relationship, to recognize the utopian dimensions of Starfleet's mission. Acknowledging the human tendency to colonize other planets and 'to sell their values with their merchandise', Spock asserts that only humanity had been able to bring together the diverse cultures of the Federation into a peaceful, if sometimes unequal, coexistence.

Lichtenberg's criticisms are gentle and constructive, muted by her respect for the programme, its characters, its creators and its fans. Directing this criticism at the characters and their actions, rather than at the

text or its producers, preserves the myth about Gene Roddenberry as a social activist and utopian visionary which partially shapes her own relationship to the series. For Lichtenberg, much like Cranny-Francis or Russ, the utopian dimensions of the programme ideology emerge as the standard against which other aspects are evaluated. Those episodes cited by ideological critics, such as Buxton and Goulding, are read as local inconsistencies, failures to achieve or preserve programme ideals. Much as the novel's hero, Spock, protests against Thirlev's one-sided account of Federation culture, fans would view Buxton and Goulding as incredibly reductive in their tendency to focus on only one dimension of a more emotionally and ideologically complex universe.

Both fan and academic critics face a major difficulty maintaining a stable basis for their analysis when confronted by the proliferating texts of *Star Trek*, a problem which requires both groups to select which stories will be privileged for their analysis. Academic critics often assume that the close analysis of any given episode reveals the ideological assumptions of the whole series, as if a single drop of *Star Trek* 'stuff' contains the entire molecular structure. Fans, on the other hand, display their cultural competency as a 'powerless elite' through their ability to read any given episode in relation to the larger programme history, to trace a series 'tradition' that runs across multiple narratives and many seasons. Yet, both fan and academic critics, through their selections, construct the *Star Trek* they critique. Ideological critics, interested in exposing the social control mechanisms of mass culture, turn towards episodes (such as 'A Private Little War') dominated by the programme's most reactionary impulses, while fan critics, interested in defending their taste for the series, turn towards episodes (such as 'A Devil in the Dark') where its utopian vision is most fully articulated. To understand how both groups may find a legitimate basis for their judgements within the aired episodes, we must consider more closely the way that *Star Trek* represents an unstable composite of multiple generic and ideological traditions which becomes coherent only within specific reading formations.

STAR TREK AND SCIENCE FICTION

John Tulloch and Manuel Alvarado's *Doctor Who: The Unfolding Text* offers a valuable model for writing the history of a television series' production and reception. Tulloch and Alvarado reject the notion that a programme's ideological and aesthetic norms are static and fully visible in any chosen episode. Rather, they are interested in the shifts in *Doctor Who*'s style and attitude throughout more than twenty years of its history, as it 'unfolds according to a wide array of institutional, professional, public, cultural and ideological factors'.[7] Unfortunately, there is no similarly comprehensive account of *Star Trek*. The writing of such a history

is well beyond the scope of this current project, but we can outline some central sources of the *Star Trek* mythos and suggest how the American series may also be seen as a dynamic rather than static narrative.

The Writer's Guide for the original series expressed an interest in the ways that a science fiction series could tell many different stories aimed at many different audiences:

> Science fiction (as all SF classics indicate) permits an enormous range of audiences – the child, the housewife and the truck driver can enjoy the colorful peril of Amazons wielding swords (or even muscled romance) while, at the same time, the underlying comment on man and society can be equally interesting and entertaining to a college professor.[8]

Star Trek could be seen as self-consciously merging multiple generic traditions: the technological utopianism associated with 'hard' science fiction, the social utopianism of 1960s 'soft' science fiction, the action adventure of the space opera.[9] Let us look at each of these in turn.

Technological utopianism

The *Star Trek* Writer's Guide includes a cryptic yet suggestive section discussing what Earth would be like in the twenty-fourth century:

> Mankind has found some unity on Earth, perhaps at long last even in space. References by our characters to Earth will be simply a logical projection of current scientific and social advances in food production, transportation, communications, and so on. If you want to assume that Earth cities of that future are splendidly planned with fifty-mile parkland strips around them, fine. But for obvious reasons, let's not get into any detail of Earth's politics of *Star Trek*'s century, for example, which socio-economic systems ultimately worked best.[10]

Roddenberry attempts to evoke the iconography of the technological utopia ('fifty-mile parkland strips', etc.) while dissociating that iconography from the tradition's ideological framework. If, as Howard Segal notes, the original technological utopians of the early twentieth century, such as Edward Bellamy (*Looking Backwards*), were middle-class reformers who wrote narratives to promote their solutions to the ills of industrialization, Roddenberry calls for the *image* of a utopia without specific content.[11] The Earth of the twenty-third century will be the reference point within the series, but will never be directly shown. Something of that culture is suggested, however, by the elegant circularity of the *Enterprise*, which evokes a long tradition of utopian architecture and graphic design, especially the work of Norman Bel Geddes. When Earth has been directly depicted in the feature films or in *Star Trek: The Next Generation*, the

most prevalent image is that of the Federation headquarters in San Francisco (not, coincidentally, the birthplace of the United Nations). *Star Trek*'s San Francisco is a glistening white city surrounded by lush strips of parkland and a pure blue harbour, an image bearing more than faint echoes of the utopian metropolis depicted in the final sequence of *Things to Come* or in the illustrations of countless issues of *Amazing Stories*. Segal sees this particular image as characteristic of the technological utopian tradition, which represented the future city as possessing 'perfect cleanliness, efficiency, quiet and harmony', an ideal balance of the machine and the garden. Such an image reflects a faith in technology as 'the means of achieving a perfect society in the near future'.[12] By mastering technology, humanity would learn to live in harmony with itself and its environment. A recurrent myth running through *Star Trek* is the belief that technological progress, the creation of new systems of communication and transportation, the mastery of disease and starvation through scientific advances, the expansion into space, had led to a resolution of the sources of human conflict.

Star Trek remains uncomfortable with the technological utopia's highly efficient and hierarchical structure. The early twentieth-century utopias were governed more by rational planning than by human emotion and intuition, ruled by technocrats and social engineers, whose expertise and problem-solving ability allowed them to function as this utopian tradition's philosopher-kings. These glistening white cities were characterized by mass conformity, self-control and regimentation. Some of these traits, particularly the focus on rationality and self-control, are associated with the Vulcans, but *Star Trek* consistently expresses discomfort with the social ideals of the utopian tradition and with the notion that the machine might model human behaviour. Kirk's anti-machine bias is vividly portrayed in such episodes as 'What Are Little Girls Made Of?' where he is outraged by Dr Roger Korby's attempts to transplant his mind into an android's body; 'A Taste of Armageddon', 'The Ultimate Computer', 'The Apple' and 'For the World Is Hollow and I Have Touched the Sky', where he weans people from their domination by master computers, and 'The Doomsday Machine' and 'The Changeling' where all-powerful machines pose a threat to the *Enterprise*'s survival. More generally, episodes such as 'This Side of Paradise', 'The Paradise Syndrome', 'Plato's Stepchildren' and 'The Way to Eden' reflect anxieties about utopian cultures which crush the human need to struggle towards a better society or which otherwise dehumanize their inhabitants. *Star Trek*'s celebration of 'cultural diversity' and individualism directly counters the technological utopian's celebration of citizens as 'happy cogs in the machine' of state. A 1966 memo to the programme writers, for example, complained that many early scripts depicted 'an autocratic, regimented, inhuman Earth of

the future' which contradicts *Star Trek*'s 'optimistic projection from Earth of today'.[13]

Star Trek confronts the same dramatic problems which crippled the earlier utopian tradition: since utopian societies achieve a state of perfection, they become static, existing outside of history and thus outside of narrative; utopian stories have little potential for human conflict or dramatic changes. Most such works depend more on description than plot, laying out a society and its achievements rather than dealing with characters and conflicts. *Star Trek*'s writers have similarly complained that the programme's utopian vision severely restricted their ability to construct dramatically interesting plots or to develop conflicts between the regular characters.

Social utopianism

The shift in the late 1950s and early 1960s from hard to soft science fiction led to a reconsideration of the technological utopianism which had been the founding myth of the Hugo Gernsback tradition as many of the newer writers based their stories on social scientific premises rather than on science and engineering concepts. *Star Trek*'s original series has long garnered praise for its recruitment of established science fiction writers to contribute scripts. Many of those writers were linked to the changes which were taking place within the genre: Harlan Ellison, Theodore Sturgeon, Norman Spinrad, Jerome Bixby, Richard Matheson.[14] Few of the *Star Trek* writers are closely associated with hard science fiction. *Star Trek* reflected these writers' increased interest in character psychology and sexuality, while pulling back from some of the counter-cultural politics associated with their fiction. As Gerard Klein notes (see Chapter 3), one consequence of this shifting focus within the genre was a more pessimistic characterization of the future. Such writers were often critical of the regimentation and inhumanity they associated with the technological utopia. *Star Trek* transplanted these anxieties onto alien worlds which facilitated the exploration of dystopian possibilities that could not be contained within the more utopian Federation. In this way, the emerging dystopian science fiction could exist side by side in the series with the utopian tradition it rejected.

Series writer David Gerrold suggests that *Star Trek* provided a 'set of fables – morality plays . . . about contemporary man but set against a science fiction background'.[15] The problems of 'contemporary man' were most often represented in two ways: either the *Enterprise* crew beams down to another planet, whose culture has not yet resolved problems which lay safely in twenty-third-century Earth's past (as in 'The Omega Glory', 'Bread and Circuses', 'The Cloud Minders' or 'Patterns of Force') or outsiders bring their conflicts on board the *Enterprise* where they must

be confronted and resolved by the crew members (as in 'Let This Be Your Last Battlefield'). As the Writer's Guide states, 'We want the exotic, the inexplicable, the terrifying – but *not* in the U.S.S. Enterprise, its organization and mission.'[16] The *Enterprise* crew was to function simultaneously as a focus for audience identification and as a utopian alternative to contemporary society.

Not all of the soft science fiction to emerge in the 1960s adopted the pessimistic perspective Klein and Mellor describe. Peter Fitting identifies an alternative model of utopian fiction that emerged from the intervention of feminist writers, such as Joanna Russ, Marge Piercy, Ursula K. Le Guin, Samuel Delany, and others.[17] The major works Fitting cites within this tradition (*Triton, The Dispossessed, Woman on the Edge of Time, The Female Man*) did not appear until the 1970s. These writers, however, were publishing works by the early 1960s which reflect many of the tendencies Fitting identifies in their later fiction. The newer utopias focused on 'the forms and textures of everyday life' rather than on large-scale social organization. The social utopias often dealt with societies in process rather than societies which had fully realized their potential and thus allowed more room for developing plots and character conflicts. Stories within this tradition were centred around issues of equality and acceptance of difference rather than efficiency and mastery. Their worlds were governed by cooperative rather than hierarchical principles.

Star Trek never embraced the radical feminism Fitting sees as characteristic of this tradition. The programme shares with these writers, however, the reconceptualization of utopian fiction in personal rather than large-scale terms and the focus on tolerance and equality. *Star Trek*'s Writer's Guide consistently stressed the importance of individual characters and their 'needs, fears and conflicts', using the crew as a microcosm for reflecting larger social transformations. *Star Trek* was, in Roddenberry's words, a series 'about people, not hardware' and should avoid 'wayout fantasy and cerebral science theorem'.[18] *Star Trek* models a social utopia in its representation of the *Enterprise*'s multi-cultural crew; people of diverse backgrounds work side by side in episode after episode, forming friendships despite and often because of their differences. The crew serves as an extended family, displaying mutual support and loyalty in the face of extreme hardships. Roddenberry described the programme's fictional universe as one where 'there is complete equality between members of the crew, between sexes and races, as well as between humans and aliens', as one where people have 'learned to delight in the essential differences between men and between cultures'.[19] Like the characters Fitting associates with the social utopian tradition, *Star Trek*'s characters were examined as people 'in process' rather than the 'perfect humans' associated with the technological utopian tradition, displaying occasional signs of

self-centredness, aggressivity, prejudice and irrationality. 'You can project *too* optimistically', Roddenberry warned would-be series writers.[20]

Space opera

Gene Roddenberry sold Paramount and NBC on *Star Trek* as an action-adventure series, based on analogies with successful television Westerns: 'The format is "*Wagon Train* to the Stars" – built around characters who travel to other worlds and meet the jeopardy and adventure which become our stories.'[21] The producer told how science fiction plots could be constructed by reworking situations derived from other generic traditions:

> Consider the ease with which *Stagecoach, Caine Mutiny Court Martial, Shane, King Solomon's Mines, Pygmalion, Beau Geste* or *Requiem for a Heavyweight* could become an exciting science fiction story. Science fiction is the greatest untapped field of story and story adaptation available today.[22]

Such analogies can be understood as part of Roddenberry's project to sell network executives on the viability of science fiction as television entertainment by suggesting its continuities with rather than differences from other action-adventure programming. It can also be seen as a vehicle for retooling seasoned television writers, who, like Roddenberry, came to *Star Trek* with a background of writing for Westerns and cop shows.

Such analogies also reflect a tradition of writers reworking stories from other generic traditions for sale to the pulp science fiction magazines. Paul A. Carter, for example, has discussed how early pulp writers portrayed Mars as analogous to the Old West so they could redo and resell stories originally intended for Western magazines.[23] Other writers within the Gernsbackian tradition drew on the swashbuckling tradition to construct heroic narratives about space adventurers and Amazon women. Brian Aldiss summarizes the generic features of this space opera tradition:

> Ideally, the Earth must be in peril, there must be a quest and a man to match the mighty hour. That man must confront aliens and exotic creatures. Space must flow past the ports like wine from a pitcher. Blood must run down the palace steps, and ships launch into the luring dark. There must be a woman fairer than the skies and a villain darker than the Black Hole. And all must come right in the end.[24]

Kirk, whom Roddenberry compares to a nineteenth-century sea captain, can easily be read as a swashbuckling hero who saves the day and wins 'a woman fairer than the skies'. Many of the series plots (and particularly the feature films) have required Kirk and his crew to save the Earth from certain destruction, to confront powerful aliens who threaten the ship's survival ('Arena', 'The Corbonite Maneuver', 'By Any Other Name', 'The

Tholian Web') or to engage in intergalactic struggle with the Klingon–Romulan Empire ('Balance of Terror', 'Errand of Mercy', 'The Enterprise Incident'). Kirk's interventions into other planetary cultures may have as much to do with this generic legacy as with the specific political context of the series' production and can be seen as part of the programme's address to the core science fiction audience. Roddenberry specifically cites space opera as one of the science fiction traditions which *Star Trek* can evoke, seeing it as attracting an age-, gender- and class-specific following of 'the child, the housewife and the truck driver'. At the same time, Roddenberry's instructions to his writers specifically break with other aspects of the space opera tradition, insisting on greater psychological depth in character development and a greater attention to motivating alien assaults on the *Enterprise* and her crew.

Star Trek is not pure space opera, any more than it is a pure example of technological utopian or social utopian fiction. Rather, the programme sought to mix and match aspects of these diverse traditions in courting the broadest possible audience for its episodes. The series negotiated between competing models of science fiction at a time when the genre was undergoing dramatic transitions and its core audience was broadening to encompass a wider segment of the American society. Much as Anne Cranny-Francis has argued about feminist intervention within science fiction (Chapter 2), *Star Trek*'s generic hybridization helped to create a text charged with ideological contradictions and open to multiple appropriations.

STAR TREK: THE NEXT GENERATION

In the twenty-five years since the programme was first aired, *Star Trek* narratives have continued to proliferate at an extraordinary rate. A full account of the series would need to consider four different television series (*Star Trek, Star Trek: The Animated Series, Star Trek: The Next Generation, Star Trek: Deep Space Nine*), the feature films, the printed adaptations of those films and episodes, the series of original novels, the programme-related comic book series, etc. Subsequent narratives have self-consciously reworked and updated the core myths of the series to reflect changing audience demographics and shifting ideological frameworks. The first season *Next Generation* episode, 'Too Short a Season', for example, offers a response to the controversial original series episode, 'A Private Little War'. In the original episode, Kirk violates the Prime Directive to arm one group of villagers who are sympathetic to Star Fleet; he hopes to achieve a 'balance of power' with another group, already being supplied by the Klingons. In 'Too Short a Season', Admiral Mark Jameson (clearly modelled after Kirk) returns after twenty years to confront the bloody aftermath of his earlier decision to arm one group of

villagers within a planetary dispute. In this case, rather than providing a 'balance of power' that ensured peace, as Kirk had predicted, the actions resulted in a protracted war and the deaths of countless people. Here, Jameson is forced to repent his earlier choice in a story which, like *Federation Centennial*, judges a Starfleet officer for the ideological contradictions of the original series.

Star Trek: The Next Generation had to carefully negotiate between the need to maintain continuity with the original series (in order to preserve the core *Star Trek* audience) and the need to rethink and update those conventions (in order to maintain the programme's relevance with contemporary viewers and to expand its following). The Writer's Guide for *Star Trek: The Next Generation* specifically rejects the intervention stories which ideological critics see as characteristic of the old 'Cold War' series:

> *We are not buying stories which cast our people and our vessel in the role of 'galaxy policemen.'* (See Prime Directive). Nor is our mission that of spreading 20th Century Euro/American cultural values throughout the galaxy.... *Stay true to the Prime Directive.* We are not in the business of toppling cultures that we do not approve of. We will protect ourselves and our mission whenever necessary, but we are not 'space meddlers.'[25]

Similarly, the series guide sought to distance itself from a long history of machine-bashing in original series episodes, rejecting 'stories in which technology is considered the villain' in favour of conformity to a general ideology of technological utopianism: 'It doesn't make sense for a group of 24th century interstellar travelers (whose lives depend on the successful workings of technology) to be Luddites.'[26] The android, Data, became a constant reminder of the happy coexistence of man and machine, while guest characters' discomfort with his status on the ship, in episodes such as 'The Measure of a Man', reflect the persistence of archaic and undesirable forms of technophobia. Despite such disclaimers, some of the most powerful episodes in the series pit the humanity of the *Enterprise* crew against the mechanization of the Borg, a race with a group mind and a cyberpunk-like melding of man and machine. Here, the technological utopians confront the threat that mechanization can pose for human culture and must, like the Luddites, smash the machines to save humanity's soul.

If the Borg can be seen as *Star Trek*'s response to cyberpunk, the series' increased focus on the sympathetic elaboration of alien cultures, most visibly in the many episodes centring on Klingon power-struggles but also in such stories as 'Darmok' or 'The Host', reflects other recent shifts within literary science fiction. Writers such as C. J. Cherryh, Orson Scott Card and Octavia Butler, among many others, use soft science fiction and biologically-focused hard science fiction to explore cultures

radically different and sometimes opposed to Terran perspectives. Such anthropological themes can be found in original series episodes, such as 'Devil in the Dark' (oft-cited by Gene Roddenberry to characterize his ideals for the series), but, in practice, such narratives were relatively rare in *Star Trek* compared to their increasingly central role in *Star Trek: The Next Generation* and *Star Trek: Deep Space Nine*.

Responding to decreasing Cold War tensions, *The Next Generation* reconceived the Klingons as potential allies rather than the absolute enemies of the Federation. Newer stories embodied malice in the form of multinational capitalism (the Ferengi) and Third World terrorism (the Cardasians). Such a dramatic reconfiguration of the series' universe was achieved by shifting the programme time-line so that *Star Trek: The Next Generation* is set seventy-eight years into the future of the original series.

Despite such changes, other aspects of the programme universe remain constant across the two series. *Star Trek* still centred around a utopian social community, maintaining what the Writer's Guide describes as 'the same band of brothers feeling. (*And* sisters too, of course)'.[27] At the same time, *Star Trek* still balances social utopian themes with technological utopian imagery of the machine and the garden:

> *Earth in the 24th Century is a Paradise.* . . . Most (if not all) of the major problems facing the human species have been resolved and the Earth has since been transformed into a human paradise, with large protected wilderness areas, grand parks, beautiful cities, and a literate and compassionate population that has learned to appreciate life as a grand adventure.[28]

Star Trek has, thus, expanded its generic repertoire to encompass new shifts within the science fiction genre, while remaining faithful to the utopian impulses which shaped the original series.

'RODDENBERRY THE PHILOSOPHER'

In positioning *Star Trek* in relation to the various generic traditions of science fiction, I have drawn more heavily upon extra-textual discourse (particularly the Writer's Guides and other statements by Gene Roddenberry) than upon the aired episodes. Such extra-textual discourse both defines the interpretive frameworks with which readers will encounter the episodes and also defines the generic perimeters which script-writers must adopt if they want to sell to the series. In practice, as the opposing readings of the series offered by ideological and utopian critics suggest, the aired episodes offer a far more contradictory vision of the future than this extra-textual discourse acknowledges. *Star Trek* is neither consistently progressive nor consistently reactionary, neither operates fully within a utopian tradition (either technological or social) nor remains

fully complicit with American interventionist policies. Fans and other programme followers must somehow resolve the contradictions contained within that aired material by appeal to a more abstract conception of *Star Trek*'s moral universe. Most of them construct an ideal version of *Star Trek* against which the consistency and coherence of individual episodes can be evaluated.

Non-fiction books such as *The Making of Star Trek*, *Star Trek Lives!* and *The World of Star Trek* play a central role in defining the discursive context within which viewers situate the series. A key element of that context was Gene Roddenberry's self-presentation as a producer who struggled to create a television programme that would address contemporary social concerns within a media known primarily for its mass entertainment. Roddenberry sustained the image of himself as a visionary producer through his convention appearances, occasional writings to fanzines, magazine interviews and his *Inside Star Trek* record album. In a 1991 interview, Roddenberry offered a characteristic summary of the factors that motivated him to create the series:

> It's fair to say that I was then a very successful freelance TV writer. But I was getting very, very tired of never being able to write about *anything*. TV writers, as they do today, can't really write about labor and management, industrial military machines, the pros and cons of socialism and capitalism, religion and other subjects. Television avoids such real ideas. One day, I found myself thinking of Jonathan Swift, who had faced similar problems. He wanted to write about the crooked prime ministers, idiotic politics and problems of his day, but his head would have been chopped off for doing it. So, he invented Lilliput and *Gulliver's Travels*. I started thinking. 'Well, maybe if I could have all my stories happen on far-off planets, then I could talk about all those things I wanted to talk about. If my series idea involved little polka-dotted whatevers in another galaxy, I could probably get the ideas past the studio, the network and the censors.' We spent three years doing just that with *Star Trek*.[29]

Roddenberry, thus, constructs himself as a latter-day Swift, satirizing contemporary society through tales of the fantastic, challenging a system of production which allowed little space for social commentary or personal expression.

The centrality of this authorial myth to fan interpretation is not surprising. Media fandom emerged from literary science fiction fandom where issues of authorship are more clear-cut than in network television and where readers often have direct interactions with the writers of their favourite books and short stories. Many important science fiction authors came from fandom, while many writers within the genre regularly attend fan conventions. Roddenberry sought, from the outset, this same

relationship with his audience and actively courted literary science fiction fans. Roddenberry, story editor D. C. Fontana, and other production staff members read and contributed to early fanzines. Film producer Harve Bennett and several of the writers of the professional *Star Trek* novels continued to participate in fanzine publishing well into the 1980s, while series producers can sometimes be contacted today through computer bulletin boards. As the fans shifted their focus from literary to television science fiction, they were already accustomed to discussing works in terms of their authors and tended to view Roddenberry's job as a television producer in similar terms to the way earlier generations of fans had looked upon pulp magazine editors, such as Hugo Gernsback and John Campbell:

> In the beginning, this philosophy was very personal to Gene Roddenberry. . . . Roddenberry chose other creators who shared some spark of that philosophy, or who were open enough to pick it up, amplify it, play with it, integrate it into their characters, their scripts, their particular jobs.[30]

Fans, thus, acknowledge the collaborative aspects of the production process while ascribing primary inspiration to a single author, Roddenberry, and his 'very personal' philosophy. The myth of the author remains a central determinant of audience response to *Star Trek*. Michel Foucault argues that the myth of the author serves three basic functions.

(1) The author serves as a principle of classification, helping to organize the relations between texts. The various *Star Trek* narratives are already linked by their common title (which serves as a trademark or brand name). Roddenberry's participation in the production of *Star Trek: The Next Generation*, however, smoothed the way for the new series' acceptance by fans, who were initially suspicious of the production of a *Star Trek* programme without the previously established characters. On the other hand, Harve Bennett suffered sharp rebukes from some fans when he seemed to displace Roddenberry as the creative force at the helm of the feature film production. The legitimacy of these texts as *Star Trek* narratives depended on their fidelity to Roddenberry's philosophy, which could be ensured only by his personal participation within the production process.[31] The introduction of *Star Trek: Deep Space Nine* has sparked a crisis of authenticity since it was the first *Star Trek* product which was not created or supervised by Roddenberry. Producers anxious about the series' initial acceptance by the programme fans tried to rewrite the programme history. As new producer Rick Berman explained in a *TV Guide* interview,

> What the fans never knew was that Gene's hands-on involvement in *The Next Generation* diminished greatly after the first season. But he

knew we were developing *Deep Space Nine* and he gave the project his blessing. And he'll always be sitting on our shoulder.[32]

Roddenberry's authorial legend also allows his other projects, such as the pilots for such unproduced series as *Genesis II*, *The Questor Tapes*, *Spectre* and *Battleground Earth* to be shown at fan conventions.

(2) The author serves as a principle of explanation. Foucault writes:

> The author explains the presence of certain events within a text, as well as their transformations, distortions, and their various modifications. ... The author also constitutes a principle of unity in writing where any unevenness of production is ascribed to changes caused by evolution, maturation, or outside influence. In addition, the author serves to neutralize the contradictions that are found in a series of texts.[33]

Roddenberry's contribution to *The Making of Star Trek* and subsequent extra-textual discourses allowed him to articulate a personal vision for the series and to define a canon of core episodes ('Devil in the Dark' for example) which conform most closely to that philosophy. Roddenberry is often characterized as ensuring the continuity and consistency between the various *Star Trek* texts, reading all scripts and checking them to ensure their proper fit with previously aired information. His involvement with NASA and his relationship with various scientists is often cited as ensuring the programme's scientific accuracy. (Here, Roddenberry seems to have followed the practice of early pulp editors, publicizing letters from scientists endorsing the series' technical integrity.) Roddenberry's status as a liberal activist, his associations with the New Frontier rhetoric of the Kennedy era, bolster claims for the programme's ideological coherence and utopian vision. As the dedication of one *Trek* anthology explains, 'Gene Roddenberry not only created *Star Trek*, he personified its ideas and ideals. He stood as a shining beacon of idealism, integrity and intelligence to every *Star Trek* fan.'[34]

Violations of the programme ideology, on the other hand, are often described as a 'betrayal' of Roddenberry's personal vision, thereby displacing discomfort with the series content onto some other aspect of the production process (Paramount, the networks, other members of the production team). The tendency is to ascribe the series' virtues to those agents with whom the fans have the most direct personal contact (the producers, the writers, the actors) and to ascribe its faults to forces more removed from the fan's world and less easily conceptualized in personal terms (the studio, the network, the ratings system). As fan critic Tom Lalli explains,

> Most fans stop short of blaming *Star Trek*'s creator and producer for its sexism. We all feel a great deal of fondness, gratitude and respect

for Gene Roddenberry. He has given us so much that it seems almost a betrayal to level strong criticisms at him or his creations.[35]

(3) The author functions as a sign of value, since only certain texts are read as authored. Seeing *Star Trek* as reflecting the artistic vision of a single creator, Gene Roddenberry, thus allows fans to distinguish it from the bulk of commercial television which they see as faceless and formulaic, lacking aesthetic and ideological integrity. *Star Trek Lives!* suggests what separates *Star Trek* from the rest of television programming: '*Star Trek* began with *saying* something – something which had profound meaning to one man, Gene Roddenberry.'[36] The authorial legend of Gene Roddenberry helps *Star Trek* to cohere as a narrative and justifies fans' interest in it. The emphasis on his 'optimistic' vision of Earth's future and his celebration of cultural diversity focused fan attention on those episodes which most closely adopted those themes, while intensifying their distaste for episodes which violated that 'vision'. Consider, for example, a readers' survey conducted by *Trek* magazine in 1986, which asked respondents to identify the best and worst episodes of the original series.[37] Those episodes most often identified as 'least favourites' include many of those which figure prominently in ideological critics' analysis of the programme, including 'The Way to Eden', 'Let This Be Your Last Battlefield', 'The Apple', 'Plato's Stepchildren', 'Who Mourns for Adonis?' and 'The Omega Glory'. Many of these episodes have proven particularly controversial with fans because Kirk's actions in violating the Prime Directive and imposing his values upon alien cultures undercut *Star Trek*'s utopianism. Conversely, those episodes most often cited as 'favourites' include many that stress the close bonds between Kirk and Spock, a relationship which is regarded as embodying the series' commitment to the acceptance and celebration of cultural difference ('City on the Edge of Forever', 'Amok Time', 'A Piece of the Action', 'The Empath', 'Journey to Babel' and 'The Enterprise Incident'). Others more directly articulate the utopian aspects of the series through themes of cross-cultural understanding ('Devil in the Dark'), look at the ways the utopian Federation emerged from Earth's violent past ('Space Seed') or offer an inverted vision of its world ('Mirror, Mirror') or its characters ('The Enemy Within'), thus defining what constitutes a utopia through its absence.[38]

If Roddenberry's utopian perspective has provoked such strong commitments and intense interests, it has done so while remaining almost entirely devoid of any specific content. The extra-textual discourse evokes abstract concepts, such as 'idealism, integrity and intelligence' or 'diversity' or 'tolerance' which can be placed within many different ideological frameworks. Shortly after Roddenberry's death, there was a heated exchange within a Usenet computer discussion group centred on *Star Trek*. One fan proposed that 'a scholarship in the sciences or engineering

for minority students' would be a fitting tribute to the series' creator. The contributor explained: 'One of the unique elements of the original *Star Trek* was its vision of the future in which one's racial background did not limit one's opportunity.' For this fan, affirmative action became the vehicle for realizing Roddenberry's vision of a future without racial prejudice. Other contributors, however, saw a race-specific scholarship as directly antithetical to Roddenberry's utopianism:

> Strange, but I always thought Roddenberry's vision avoided this sort of tokenism: i.e. a vision in which all people, of all races, creeds, and species lived together in blissful, boring harmony – and on an equal footing. I guess I was wrong.

Or another writes:

> I don't think Roddenberry would have wanted it for minorities. I think he spent his life trying to eliminate race and sex as a factor for making decisions. Therefore, I would think that the scholarship should be for everyone to apply to.

Or again:

> The premise of the scholarship was that Gene imagined the future to be a time when race distinctions were not a factor of any kind in the Federation, i.e. all people had equal opportunity. Why, then, do we want to dishonor his ideas by naming a racist (yes, I use the word) scholarship in his name?

This discussion, thus, operates within a seemingly shared frame of reference (Roddenberry's vision of racial tolerance) which nevertheless lends itself to different inflections, depending on the reader's other ideological commitments. Neither interpretation constitutes a resistant reading since both groups see their position as totally consistent with the text's original and preferred meaning.

STAR TREK AND POPULAR MEMORY

On the one hand, then, this open-endedness empties the liberal potential of *Star Trek*'s utopianism of any specific content, as David Buxton has suggested (Chapter 2). On the other hand, it empowers individual viewers to participate in the search for justice, tolerance, equality, in response to their immediate social and historical context. For many, the programme's evocation of these values, however abstractly, became the basis for their initial political awareness. Many fans trace their commitments to feminism, gay rights, vegetarianism, pacifism and/or multi-culturalism to *Star Trek*'s 'IDIC' philosophy ('Infinite diversity in infinite combinations'). As readers give these abstract notions a specific content through their lived

experiences and growing political awareness, the fans' sense of these ideals breaks with their specific realization within the series. Feeding this shift is the constant recirculation and re-airing of those narratives within contexts radically different from that of their original production. The experience of watching reruns, Jenny L. Nelson argues, alters the viewer's relationship to the represented events and to the programme's ideology.[39] The same narrative re-enters our lives at different points in our own social and personal development; the same episode is read within discursive frameworks not available to the original viewers.

Our re-experience of a rerun episode invites us to reconsider what has happened in our own lives since we last saw it. In an essay called 'Reflections on *Star Trek*: Past, Present and Future', *Trek* magazine contributor Gail Schnirch traces her own shifting relationship to the series:

> And so the innocent, carefree days of childhood passed. *Star Trek* was canceled; I entered high school. Robert Kennedy was assassinated; Martin Luther King was murdered; Vietnam escalated. . . . I graduated from high school and wondered if I would live to graduate from college. Somewhere, amid all the turmoil, the resignation, the personal upheaval, *Star Trek* returned in syndication. It was a breath of hope for many of us, a moment's respite from the pessimism around us. I watched all of the episodes again, hardened by my newly acquired sophistication and skepticism. Peace and understanding? What a laugh. Kent State had ended *That* particular fairy tale. Honesty? Take a look at Watergate. Universal brotherhood? Vietnam screamed for attention. . . . We had absorbed nothing of the philosophy of *Star Trek*, I told myself bitterly. We had learned *nothing* from our past mistakes. . . . In my younger years, I had watched *Star Trek* for sheer entertainment. Now I watched for its social commentary.[40]

Schnirch's personal narrative suggests how our recurrent exposure to rerun episodes fits within the process of 'Popular Memory', a means of sorting out the interplay between personal (high-school graduation, college years) and larger social events (Watergate, Vietnam, Kent State) through the mediation of television narratives.[41]

For many fans, *Star Trek*'s utopianism is closely linked to popular memories of the Kennedy era. As *Trek* contributor Judy Klass notes, 'In creating the universe of tomorrow, *Star Trek* may have been . . . unconsciously trying to recapture the aspirations of a fallen president, and to rescue the vision of Camelot . . . and carry it majestically to the stars.'[42] *Star Trek*'s 'final frontier' echoes Kennedy's 'New Frontier', which also called for the American nation to go where no one had gone before, into 'uncharted areas of science and space, unresolved problems of peace and war, unconquered pockets of ignorance and prejudice, unanswered questions of poverty and surplus'.[43] (The words are Kennedy's but the

images fit *Star Trek* equally well.) James T. Kirk, the youngest captain in Star Fleet history, was the fictional embodiment of the heroic myths surrounding John F. Kennedy, PT boat captain, the youngest president in American history. Much like Kennedy, *Star Trek* envisioned a world charged by 'invention, innovation, imagination, decision'.[44] The programme embraced many key aspects of the Kennedy era – the commitment to civil rights, the concern with preserving the 'cultural diversity' of unaligned societies, the interest in space exploration. Star Fleet represents a space-age variant on Kennedy's Peace Corps, moving through space, employing the 'weapons of peace' in building diplomatic relations with other planets.

David Gerrold's *The World of Star Trek*, on the other hand, treats the series as an artefact of the Vietnam War era (and it was in that context it was first aired and encountered by large numbers of viewers):

> It was a time when the Vietnam 'adventure' was at the core of the American dilemma – were we supposed to be the world's policeman or not. As far as *Star Trek* was concerned, we were – because *Star Trek* was the galaxy's policeman. By implication, that ratified and justified the American presence in everybody else's culture. The mistake was that the *Enterprise* was a cosmic meddler. Her attitudes were those of twentieth century America – and so her mission was (seemingly) to spread truth, justice *and the American Way* to the far corners of the universe.... Never was there a script in which the *Enterprise*'s mission or goals were questioned. Never did they run into a situation that might have been better off without their intervention.[45]

Far from idealistic, the series, according to this interpretation, embraced the most cynical and politically suspect aspects of America's foreign policy, criticizing rather than endorsing the anti-war movement.[46] The same series can be seen as embodying the idealism of the Kennedy era and the militarism of the Johnson era (political categories which themselves represent mythic re-presentations of those periods rather than reflecting the complexity of the actual political practices of either administration).

The further we are removed in time from those initial ideological frameworks, the more we need to rethink *Star Trek*'s utopian vision to reflect our current world views. The particular nature of that vision – the creation of a utopia without a specific ideological content, the merging of multiple traditions within science fiction – allows viewers the flexibility to constantly rework *Star Trek*'s utopianism in new terms. As this process continues, the fans' series meta-text (their own subcultural creation of the *Star Trek* myth) breaks more and more with the aired material, so that their encounters with the rerun episodes may be jarring and displeasing. The fans find themselves in the paradoxical position of criticizing

Star Trek for its failure to operate within the ideological framework which its producer so consistently articulated. One way that fans resolve this conflict is by the creation of new narratives which more perfectly reflect their own sense of the programme's utopian vision.

In the next three chapters, we will continue our exploration of the benefits and limitations of ethnographic research. Here, the focus will be on looking at the different reading formations which emerge within alternative groups of *Star Trek* fans. Those different interpretations of the primary text reflect the generic diversity and ideological contradictions of the broadcast narratives as well as the different needs and desires which draw these different populations to the same programme. These fans share much with the *Doctor Who* fans discussed in Chapters 7 and 8, including an awareness of their status as a 'powerless elite' and a commitment to continuity, consistency and emotional realism. *Star Trek* fans as a whole share certain additional knowledges and assumptions, particularly those which emerge from the extra-textual discourse that constructs Gene Roddenberry as *Star Trek*'s author and invites viewers to read the episode as an expression of his utopian vision.

Despite such commonalities, there are also significant differences in the ways that different fan communities construct the utopian vision of *Star Trek* and the modes by which they respond to the programme. The female fan writers considered in Chapter 10 will be seen as ideological critics whose mode of criticism often involves reconstructing the text in alternative terms through the production of new fictions utilizing its characters and situations. A close consideration of the work of one fan writer, Jane Land, shows how she both evokes and critiques the programme's utopian vision, resolving tensions in its treatment of gender relations.

The MIT students studied in Chapter 11 draw upon an alternative conception of *Star Trek*'s generic placement, one anchored in the traditions of hard science fiction and technological utopianism, one which validates their own emerging technical competencies and scientific literacy. A case study of these technically-oriented viewers further complicates accounts of science fiction's relationship to the 'crisis of the educated middle class'.

Chapter 12 looks at the Gaylaxians, an organization of gay, lesbian and bisexual science fiction fans. They regard the inclusion of a queer character within the *Star Trek* narrative as the logical extension of Roddenberry's historic embrace of other civil rights movements and as consistent with the programme's utopian image of multi-cultural (and even multi-planetary) acceptance and harmony. This chapter adopts a mode of ethnographic criticism, modelled after John Hartley's concept of 'intervention analysis', to trace the conflicting expectations of audiences and producers towards the issue of queer visibility in *Star Trek*. More generally, the chapter re-examines and re-positions cultural studies' model of resistant

reading. It is important to stress the similarities and differences between these three conceptions of the *Star Trek* mythos: all three groups foreground the utopian dimensions of the programme narrative, yet each sees that utopia in alternative terms which reflect different generic expectations and social needs.

'At other times, like females'
Gender and *Star Trek* fan fiction

Henry Jenkins

> *What is the role of female crew members aboard our vessel?* During ship's operations they are treated as complete equals. At other times, like females. Again, we would like to avoid dehumanizing our people and hope to retain some of the pleasant conflict which presently exists between the two genders.
>
> (Gene Roddenberry)[1]

> He [Roddenberry] believes in the equality of women as long as it doesn't interfere with his home life.
>
> (Majel Barrett)[2]

Amateur fanzines devoted to commentary and original fiction involving the *Star Trek* mythos began to appear by the start of the programme's second season with *Spockanalia* (1967), *ST-Phile* (1968), *T-Negative* (1969), *Deck 6* (1969) and *Eridani Triad* (1970) being noteworthy early examples. By 1973, the Star Trek Welcommittee listed eighty-eight different *Star Trek* fanzines in circulation; these numbers increased dramatically with the influx of new fans in response to the programme's syndication and the feature films. In 1980, the peak of their activity, *Star Trek* fans produced 406 amateur publications.[3] *Star Trek* has since been joined by other television programmes (*Blake's 7*, *The Professionals*, *Starsky and Hutch*, *The Man From UNCLE*, *Star Wars*, etc.) within the underground literature of media fandom, yet it continues to be a major focus for fan publication. Fanzines, sometimes hand-typed, photocopied and stapled, other times offset printed and commercially bound, are distributed through the mail and sold at conventions, building upon traditions established within literary science fiction fandom as early as the 1920s. Fanzines publish both non-fiction essays speculating on technical or sociological aspects of the programme world, and fiction which elaborates on the characters and situations proposed by the primary text. Often, this fiction pushes the *Star Trek* mythos in directions quite different from those conceived by the original textual producers.

As recent scholarship suggests, *Star Trek* fan writing is a predominantly female response to mass media texts, with the majority of fanzines edited

and written by women for a largely female readership. These fan writers rework the primary text in a number of significant ways: they shift attention from action and adventure aspects of the show onto character relationships, applying conventions characteristic of traditionally feminine genres, such as the romance, to the interpretation and continuation of materials drawn from traditionally masculine genres, such as the space opera or the cop show. Female characters who were marginalized and subordinate in the original series (Uhura, Chapel) become the focus of fan texts which attempt to examine the problems women might experience as active contributors to Starfleet. In the process, these characters must be strengthened and redefined to accommodate more feminist interests. Fan writers explore erotic aspects of texts which could not be directly represented on network television and, sometimes, move from homo-social representations of male bonding and friendship towards the depiction of a homo-erotic romance between Kirk and Spock. Fan writers expand the series time line to explore incidents in the characters' pasts or to speculate about potential future developments. They cross programme universes, allowing contact between characters from multiple programmes. Fan writing offers a range of different possibilities for fans to find pleasure within and rethink their relationship to the commercially circulating texts of *Star Trek*.[4]

Fan writing can be seen as a tactical response to the ideological contradictions of the original *Star Trek* episodes, a means of keeping the series 'alive' within a constantly shifting reception context. Fan writer Helen Jean Burn offered such an explanation for her activity in *Star Trek Lives!*:

> The series gave us a future characterized by hope: a world where the computers which threaten our personal privacy are man's obedient servants; where man the predator can decide not to kill, not to wage war; where a Washili communications officer and a doctor from the deep south and an oriental helmsman and a Russian navigator and a Scott engineer and a half-alien science officer not only work well together but love each other.... All right. It's all there in the old series.... Why bring it back anew? Because the problems to which the show addressed itself not only still exist but have in recent years become magnified and because other aspects of the times have changed. The vision of hope *Star Trek* provided needs updating.[5]

For the female fan writers, one of the most acutely felt contradictions within *Star Trek*'s ideology was the programme's treatment of its female characters. Extra-textual discourse stressed its commitment to gender equality, while the aired episodes fit women characters in miniskirts and put them into the constant service of the male protagonists. As fan critic Tom Lalli notes,

Star Trek's reputation for progressiveness is due more to its *suggestion*

of a future society devoted to equal rights than to what was portrayed in the show. . . . The supposed sexual equality of the Federation was left largely to the viewers' imaginations.[6]

Another fan, Toni Lay, expressed her mixed feelings about *Star Trek*'s vision in a letter printed in *COMLINK*, a media fanzine:

> It was ahead of its time in some ways, like showing that a Caucasian, all-American, all-male crew was not the only possibility for space travel. Still, the show was sadly deficient in other ways, in particular, its treatment of women. Most of the time, women were referenced as 'girls' and women were never shown in a position of authority unless they were aliens, i.e., Deela, T'Pau, Natira, Sylvia, etc. It was like the show was saying, 'Equal opportunity is OK for their women but not for our girls.'[7]

Lay and other female fans insist that Uhura should have been given a chance to demonstrate what she could do when confronted by the same problems her male counterparts so heroically overcome. Those involved with the series have sought to justify the gap between its promise and its realization. Nichelle Nichols (the actress who played Lieutenant Uhura) suggests 'whether I ever took over the ship or not is immaterial . . . I was capable of it', while fan liaison Richard Arnold notes, 'the philosophy of the show is more important than the gender of the lead characters'.[8] *Star Trek* thus offered a potential or a 'philosophy' of gender equality which did not often translate into on-screen images of female *characters* being treated equally.

The Making of Star Trek describes Roddenberry's efforts to have a woman placed in the position of second-in-command of the *Enterprise*, only to bow to network pressure: 'I decided to wait for a 23rd century audience before I went that far again.'[9] The character of the 'almost mysteriously female' Number One (played by Majel Barrett) can be seen in the aired episode, 'The Menagerie' and her background is known to fans through the reproduction of the original series proposal in Rodden-berry's book. As Lalli notes, however, Number One 'possesses the stoic nature of Mr. Spock, but without the alien ancestry that would explain her emotional repression. The implication is that a normal woman could never have attained such a high rank in Star Fleet.'[10] Roddenberry recast Barrett as Nurse Christine Chapel, who remains perpetually misty-eyed and seems defined primarily by her unrequited love for Spock. The extreme shift from a woman described as 'glacier like' to a woman defined entirely through her emotional outbursts reflects the series' polarized conception of its female characters. Both Chapel and Uhura were essentially after-thoughts in the series' development; neither appears in the two programme pilots nor are they referenced in the early Writer's

Guides. When descriptions of female characters did appear, the Writer's Guide prose often exaggerated their femininity and put particular emphasis upon their sexuality, as when Rand is characterized as having 'a strip-queen figure even a uniform can't hide'.[11]

The women of *Star Trek* are represented either as being too emotionally and sexually volatile to perform their duties adequately or as having totally repressed all emotions and much of their 'femininity' in order to function within a male-centred workplace. One extreme version of the series' apparent anxiety about female ambition is 'Turnabout Intruder', an episode based on a Gene Roddenberry scenario, centring around Janice Lester, a woman whose ambitions to be a Star Fleet captain have been frustrated and who has thus developed a strong resentment against Kirk. Lester is described as having developed a 'hatred of her own womanhood', while Kirk suggests that 'Her life could have been as rich as any woman's' if she had learned to accept her lot. An obsessed Lester finds the means to take possession of Kirk's body, while Kirk, trapped inside a woman's body, must somehow regain his command.

The show's use of recurrent secondary female characters, such as Chapel, Uhura or Rand, was a breakthrough for its period, yet these characters serve in traditional feminine roles as the space age equivalent of nurses, telephone operators and secretaries. Women in individual episodes were sometimes portrayed in more professional roles, but more often than not their narrative function was reduced to that of a love object for one of the male leads, and they are often portrayed as either psychologically unstable or as possessing dubious loyalty.

WRITING THE ROMANCE, REWRITING *STAR TREK*

Star Trek invited female fans to think of themselves as active contributors to its utopian future, yet offered them little substantive representation within the programme episodes. As these fans began to write and publish their own *Star Trek* stories, they were logically drawn towards the task of reconceptualizing the series' sexual politics. As many recent studies of fan fiction have suggested, a primary focus of their writing activity centred around the reconsideration of the male protagonists who, having dominated the screen time, also tended to be a major focus for their interests. Fan writing in all genres (but especially within the homo-erotic Kirk/Spock romance stories) offers alternative conceptions of masculine identity and male sexuality. Fans move beyond Kirk's casual flirtations and Spock's emotional repression to imagine outlets where these characters may establish and maintain more mature and satisfying relationships. Other fan writers have, however, focused on the task of reconstructing the series' female secondary characters, trying to transcend the programme's sexist stereotypes.

C. A. Siebert, for example, has written a number of stories fleshing out the character of Lieutenant Penda Uhura, allowing her to mature into a first-rate officer capable of exercising her own command. In doing so, Siebert confronts the difficulties which block her advancement:

> There were too few men like Spock who saw her as a person. Even Captain Kirk, she smiled, especially Captain Kirk, saw her as a woman first. He let her do certain things but only because military discipline required it. Whenever there was any danger, he tried to protect her.... Uhura smiled sadly, she would go on as she had been, outwardly a feminine toy, inwardly a woman who was capable and human.[12]

Here, Siebert attempts to resolve the apparent contradiction created within the series' text by Uhura's official status as a command officer and her constant displays of 'feminine frailty'. Uhura's situation, Siebert suggests, is characteristic of the way that women must mask their actual competency behind traditionally 'feminine' mannerisms within a world dominated by patriarchal assumptions and masculine authority. By rehabilitating Uhura, Siebert criticizes the overt and subtle forms of sexual discrimination that an ambitious and determined woman faces as she struggles for a command post in Starfleet (or, for that matter, within a twentieth-century corporate boardroom).

Leslie Fish offers a more militant picture of Uhura in her epic fan novel, *The Weight*. Confronted by the strong-willed Jenneth Roantree, an anarchist leader who finds herself aboard the *Enterprise*, Uhura tries to explain the difficulties women face within the Federation:

> Once machinery could take over most physical work, it was possible again to let women spend most of their time breeding, nursing and raising children.... Oh, women are still allowed to try for any work they want – but they're hardly encouraged at it.... They're disliked, considered neurotic, pressured into marrying, passed over for awards and positions they deserve.... Ah, let me put it this way, there are no female Starship captains. Not in all of Starfleet.... My chances [of getting her own ship] are poor. 'Insufficient training and experience' they say – after neatly sliding me into a position where I'm unlikely to get either.[13]

Fish expresses both Uhura's frustration with the social structures which block women from achieving their full potential within Starfleet and the female fans' frustrations over the programme's unwillingness to realize the social vision it publicly proclaims.

Some of the most controversial fan fiction, such as *The Weight*, builds upon the social utopian tradition within science fiction to deal with the process of social change and political transformation. Fish's novel brings many of the series' characters to the state of open rebellion against the

Federation, having been radicalized by their encounters with the anarchists and increasingly disillusioned by the hierarchical structure of their own world. More often, fan writers focus on the immediate personal interactions of the principal characters, looking for utopian transformation within the formulas of traditional romance, seeing the personal as essentially political.

The potent mixture of romance and science fiction allows the fans to envision a world where men and women can work together and love together as equals. Such narratives often begin with a recognition that perceived gender differences block full intimacy within contemporary society. Cold Vulcan logic, the desire to suppress all signs of emotion, make Spock and his father Sarek especially rich figures for examining the emotional repressiveness of traditional masculinity. Jean Lorrah's *Full Moon Rising* represents Amanda's relationship to Sarek:

> The intense sensuality she saw in him in other ways suggested a hidden sexuality. She had noticed everything from the way he appreciated the beauty of a moonlit night or a finely-cut sapphire to the way his strongly-molded hands caressed the mellowed leather binding of the book she had given him. . . . That incredible control which she could not penetrate. Sometimes he deliberately let her see beyond it, as he had done earlier this evening, but if she succeeded in making him lose control he would never be able to forgive her.[14]

As in traditional romance, Lorrah's heroine, Amanda, must construct some sense of Sarek's emotional and sexual state by the slightest clues in his surface behaviour. In Lorrah's writings, the alienness of Vulcan culture becomes a metaphor for the many things that separate men and women. She describes her fiction as the story of 'two people who are different physically, mentally, and emotionally, but who nonetheless manage to make a pretty good marriage'.[15] Vulcan restraint suggests the emotional repression of traditional masculinity, yet their alien sexuality allows Lorrah to propose alternatives. Her Vulcans find sexual inequality to be 'illogical', allowing very little difference in the treatment of men and women, an assumption shared by many fan writers. Moreover, fan writers have suggested that the Vulcan mind-meld grants a degree of sexual and emotional intimacy unknown on Earth; Vulcan men even employ this power to relieve women of labour pains and to share the experience of childbirth. Her numerous writings on the decade-long romance between Spock's parents represent a painstaking effort to construct a personal feminist utopia, to propose how traditional marriage might be reworked to satisfy the personal and professional needs of both partners.

Frequently, the fictional formulas of popular romance are tempered by women's common experiences as lovers, wives and mothers under

patriarchy. In Karen Bates's novels, Nurse Chapel must confront and over-come her feelings of abandonment and jealousy during those long periods of time when her husband, Spock, is totally absorbed in his work:

> The pattern had been repeated so often, it was ingrained.... Days would pass without a word between them because of the hours he had labored and pored over his computers. Their shifts rarely matched and the few hours they could be together disappeared for one reason or another.[16]

Far from an idyllic romance, Bates's characters struggle to make their marriage work in a world where professionalism is everything and the personal counts for relatively little.

Unlike their counterparts in traditional romance, these women refuse to accept marriage and the love of a man as their primary goal; rather, these stories push towards resolutions that allow Chapel or Uhura to achieve both professional advancement and personal satisfaction. Unlike almost every other form of popular fiction, fanzine stories frequently explore the maturing of relationships beyond the nuptial vows, seeing marriage as continually open to new adventures, new conflicts and new discoveries.

The point of contact between feminism and the popular romance is largely a product of these writers' particular brand of feminism, one that, for the most part, is closer to the views of Betty Friedan than those of Andrea Dworkin or Susan Brownmiller. It is a feminism that urges a sharing of feelings and lifestyles between men and women rather than envisioning radical separation or identifying unresolvable differences. Fan writing is a literature of reform, not of revolt. The women still acknowl-edge their desire for the companionship of men, even as they are asking for those relationships to be conducted in different terms. Each of these writers grapples with these concerns in her own terms, but most achieve some compromise between the needs of women for independence and self-sufficiency on the one hand and their needs for romance and com-panionship on the other. If this does not constitute a radical break with the romance formula, which Janice Radway has already suggested con-tains a utopian potential for women, it does represent a progressive reformulation of that formula which pushes towards a gradual redefinition of existing gender roles within marriage and the workplace.

In Radway's account, reading the romance allows women to experience and re-experience a story 'about the transformation of an inadequate suitor into the perfect love-protector ... [and] the concomitant triumph of a woman.... Her achievement of sexual and emotional maturity while simultaneously securing the complete attention and devotion of this man'.[17] Writing the romance, for these female fans, involves something more than that. It involves rewriting the social order represented in the

aired episodes and redefining the relationships between *Star Trek*'s male and female characters. It involves creating a space not where a woman can demand the constant attention of her mate but where she earns her mate's respect for her professional competence. The professionalism embraced by *Star Trek* may inspire these female fan writers to focus on the autonomy of their female protagonists, while the romance plot structure allows them to express the emotional costs and benefits of redefining professional spaces to accommodate women's full participation.

Writing the romance is only the first step, however, since circulating these romances brings these female fans in contact with other women, allows them to share and talk about those concerns within a broader social context. Writing and sharing these fan romances represents a movement from domestic isolation towards community participation, often allowing for alternative sources of status as these women gain recognition for their creative output. The political importance of fan fiction cannot therefore be reduced to the content of the stories alone, but must be understood in terms of the dramatic step towards self-determination that comes when someone decides to share their story with the wider women's community of fandom. Camille Bacon-Smith characterizes fandom as a support network by which women translate their personal pain into shared experience, learning to manage the risks that surround their feelings of vulnerability and loss.[18] Despite good intentions, the focus in Bacon-Smith's account on pain and victimization comes close to restoring the pathological stereotype of fans to the core of her explanation of fanish behaviour. Fandom constitutes a site of feminine strength, rather than weakness, as women confront and master cultural materials and learn to tell their own stories, both privately and collectively, through their poached materials. Bacon-Smith's refusal to contextualize her argument with a larger feminist critique means that she must isolate the fan women's experiences from their larger social history, treating situations many women, fan and non-fan alike, face as somehow explaining these particular women's creative output. My approach to fan writing, on the other hand, stresses the collective and political basis of these stories, their role not as self-expression but rather as collective cultural capital within a rich and varied subcultural community.

'AN ARTIFICIALLY IMPOSED CASE OF FOOLISHNESS': JANE LAND'S FAN NOVELS

Given the complexity of this fan culture, no single fan narrative can adequately summarize the forms of ideological critique and rewriting represented. However, a closer consideration of the work of one fan writer, Jane Land, will suggest some of the ways that female fan writers have rewritten *Star Trek* to better accommodate the experience and

identities of the series' secondary female characters. The questions that motivate Land's novels are central to feminist concerns:

> Just how sexist is the Federation? Granted that *Star Trek* was unusually enlightened for the mid-sixties, there are elements of it which seem offensive in the eighties. And if we accept it as a depiction of the 23rd century, where does that leave us? (Yes, I know, it leaves us blaming NBC and Paramount, but putting that aside). . . . If sexism is still a fact of life several hundred years in our future, why? And how do the women feel about it? How does it affect them, personally, professionally, politically, socially?[19]

Like the other fan writers mentioned above, her responses to those issues most often take the form of romance. Much as Jean Lorrah's *Night of Twin Moons* series reconsidered the courtship and marriage of Spock's parents, Sarek and Amanda, Land's novels rework the relationship between Spock and Chapel. Chapel's unrequited love for Spock had surfaced as a subplot in several aired episodes, most notably 'Naked Time' and 'Amok Time', where her hopeless mooning after the Vulcan is the object of ridicule by Doctor McCoy and of pity by Captain Kirk. Fan critic Elizabeth Rigel writes of the original series character:

> Christine Chapel was the only minor character who did not enter the service for career opportunities. She has never wanted to be anything other than a wife or mother. To her, Starfleet is neither thrilling nor burdensome – it's just a way to make a living until the right man comes along. . . . Christine has virtually no place in the series as a professional. . . . She was born to be in love and most of her appearances emphasize her failure to find a man who wants her.[20]

Such a woman does not seem a likely feminist role model. Land, however, recognizes greater potential and describes her first novel, *Kista*, as 'an attempt to rescue one of *Star Trek*'s female characters from an artificially imposed case of foolishness'.[21] Land's Chapel is a consummate professional who nevertheless possesses unfulfilled emotional, romantic and erotic desires for Spock; she has learned to live with and master those emotions, sublimating them into her professional accomplishments. Chapel's love for Spock continues to be a central character trait. *Kista*, after all, is a romance, exploring what forces might bring these two characters together. But Land adds substance and nuance to those feelings, using Chapel as a vehicle to think about the compromises men and women make with each other in their pursuit of a satisfying relationship.

Chapel is not simply defined by that relationship, however. As she writes in *Kista*'s introduction:

> Try to think objectively for a minute about what we know of Christine

Chapel's background, education, accomplishments... and you will come up with a far more interesting character than she was ever allowed to be. The Christine I found when I thought about her was neither wimp nor superwoman, but, I hope, an intelligent, complex, believable person.[22]

Land's Chapel adjusts well to new situations, be they among the primitive Domii in *Kista* or the feminist space colonists in *Demeter*. Fiercely independent, she is unwilling to compromise her integrity as a doctor even when it risks hurting her marriage (*Demeter*) or requires confronting a powerful tribal leader (*Kista*). Spock's description of Chapel in *Kista* captures something of the way Land characterizes her in these novels:

> She was an excellent mixture of sturdiness and softness. Strong where she needed to be, soft where it gave pleasure.... Strong enough both physically and mentally to have endured the madness of the pon farr. Soft enough to have offered both compassion and forgiveness. To have, at the end, turned his pain into joy.[23]

In the process, Land rewrites *Star Trek*, moving away from action-adventure elements and towards a greater focus on the character's psychological and emotional lives. She shifts the series focus off the central male protagonists and onto women, both the established series characters (Chapel, Uhura) and new characters she introduces. Land explores the relationships between women (the friendship between Uhura and Chapel, the love between mothers and daughters, the community of women on Demeter) and their interactions with the men of the Federation (not simply the Chapel–Spock romance but also the varied responses of Kirk, McCoy and Scotty to the women under their command).

Land's *Star Trek* is far from a finished utopia. Much like the novels of Joanna Russ and Ursula Le Guin which seem to be obvious inspirations for her fiction, Land shows her characters struggling to define and achieve a more perfect society. *Kista* centres on the negotiation of a mutually satisfying marriage that acknowledges Spock's biological needs and accepts Chapel's autonomy. *Demeter* involves an ongoing discussion of the nature of a social structure that might allow both men and women to achieve their full potential. To achieve such utopian possibilities, Land finds in both novels that she must pull her characters away from the *Enterprise*, away from the spaces represented within the established canon. She transplants them into new worlds, the primitive and patriarchal world of the Domii in *Kista*, the feminist separatist space colony in *Demeter*, which mark a break in their fixed routines and a shift within the existing hiearchy. These alternative spaces allow the characters to re-examine and redefine their relationships, to come to a new understanding of their personal identities and social interactions. These new societies

are more often agrarian than technological and are organized according to cooperative principles rather than the structured chain of command that characterizes the *Enterprise* crew. Land and her characters never fully embrace such worlds as permanent homes but instead choose to return to Federation space and fight to make it more receptive to the possibility of sexual equality.

In *Kista*, the first of her two novels, a group of Orion slave-traders kidnap Chapel and Spock from their previously separate shore leaves on Wrigley's Pleasure Planet. Discovering that Starfleet may be pursuing them, fearing the repercussions of having shanghaied Federation personnel, the Orions dump them on an uncharted planet. Land's Chapel responds very differently to this situation than might have been anticipated from her previous behaviour, a fact not lost on Spock:

> Her approach to the situation was so calm, so restrained, as to be slightly unnerving. He was accustomed to thinking of her as the most sentimental and emotional of humans (with the possible exception of McCoy). But he now realized that it had been some time – years? – since he had witnessed an impulsive outburst from her. Interesting, he thought. Something – growing older, or getting her medical degree, perhaps – had given her a new serenity.[24]

Land treats the series' representations of an overly-emotional character as a phase in Chapel's larger life history rather than as a fixed aspect of her personality.

Chapel and Spock are soon adopted by a primitive tribe, the Domii, modelled upon the Neanderthals from Jean Auel's best-selling *Clan of the Cave Bear* novels.[25] Much like Auel's stories, *Kista* involves the confrontation between an independent woman and a rigidly patriarchal society. As the story progresses, the two become more and more central to tribal life: Chapel serves as medicine woman (the job assumed by Auel's protagonist) while Spock, a pacifist and vegetarian, joins the hunting party. As they feel more at home with the Domii, sometimes challenging and reforming their practices, sometimes accepting them, the characters also become more comfortable with each other, adjusting to accommodate the other's personal needs. Chapel has never abandoned her love for Spock, though she has devoted herself to her profession rather than settle for another man who can only be second best in her mind. What attracts her to Spock is his respect for her professionalism and the absence of many traditional masculine behaviours: 'In all the time she had known him, watched him, loved him, he had never shown the usual male fondness for power games. He had not seemed to feel the need to prove his masculinity to himself or anyone else, and she had liked that.'[26] Her new physical closeness to Spock re-awakens these old desires, though she struggles to control them since they discomfort him.

Spock, as always, suppresses the signs of his emotions, retreating into his loneliness. Here, as in the Lorrah story cited earlier, Vulcan stoicism is a metaphor for the masks of traditional masculinity: 'He gently but firmly deflected her attempts to probe his feelings, and she didn't dare push. Their relationship was slowly, tentatively becoming comfortable, but there were still parts of him that were off-limits.'[27] Spock's calm exterior protects deep personal wounds left by T'Pring, the Vulcan woman in 'Amok Time' who was engaged to be his wife but rejected him at the marriage ceremony. Spock cannot bring himself to be emotionally and physically dependent upon another woman.

Chapel learns to read Spock's face and body for signs of his changing feelings:

> Since the Summer Festival they had somehow found themselves sleep-ing curled close together most nights. Christine often woke to find one of his arms draped warmly across her. She did not sense in him any of the sexual tension or response she would have expected from a human male under those conditions. He seemed simply comfortable.[28]

The lonely Spock also starts to reassess his feelings for Chapel, taking inventory of his emotions as he watches her sleep:

> Her breath tickled his skin. The feel of her was comfortable, familiar, just as everything about her was coming to be familiar; her thoughts and beliefs, her likes and dislikes. . . . Even her occasional irrational emotions or bursts of temper were in some way comfortable and comforting. She was his friend. The perception came suddenly, surpris-ing him. He could not remember when it had happened.[29]

Their relationship grows not simply from passion or desire but from their awareness of their 'comfort' with each other. Land (and her characters) value familiarity, friendship and mutual respect as the cornerstones of a satisfying romance.

About half-way through the book, Chapel and Spock become 'bond-mates'. Unlike most commercial romance, the confession of feelings, the consummation of love, in Land's novel represents the beginning rather than the resolution of a relationship. A Vulcan bond is not simply a social commitment, although this is an important part of it. When Spock goes into Pon Farr, the Vulcan mating frenzy, he will become totally dependent upon Chapel and will die if he is unable to find and sustain sexual relief. A Vulcan bond is also a telepathic link, so that all of the feelings (positive and negative) which Spock once contained behind his cool green façade come explosively to the surface:

> The intellect first, a crystal precision. It would always be the first thing apparent about him. Then, beneath that, the feelings. Kindness,

gentleness, unselfishness, loyalty, integrity, a profound reverence for the universe and everything in it, a deep appreciation of beauty.... She explored it with happy wonder. She had known this, but to share it so directly.... But then, more deeply buried, there were darker things. Anger, and shame, and pain, and loneliness. These too she had suspected, and she accepted them. But the loneliness.... She reached to comfort it. It had been filled in part by his work, by his friendship with Jim, but there was an emptiness there which needed her as well.[30]

Land, like other female fan writers, describes this process of creating intimacy in passionate terms. Her writing captures the characters' hunger to find a vehicle for communication across sexual and cultural differences. Radway sees romance as centrally a 'protest' against male inattention to female needs and desires, a movement away from the male's 'initial inability to understand a woman and to treat her with sensitivity' towards fuller communication and recognition.[31] The romance novel, Radway argues, brings us to 'a utopian state where men are neither cruel nor indifferent, neither preoccupied with the external world nor wary of an intense emotional attachment to a woman'.[32] Such a vision 'reforms those very conditions characterizing the real world that leave so many women... longing for affective care, ongoing tenderness and a strong sense of self-worth'.[33] The mind-meld offers a fantasy vehicle for realizing just such a transformation within male–female relations. Yet, the mind-meld, in and of itself, does not ensure consistent communication and a stable commitment between Spock and Chapel.

Despite the joy of that moment of initial intimacy, Christine's life with Spock will be far from simple. His dependency on her for his survival makes him possessive; the Vulcan language and culture assume the right of the male to speak of his wife as his property and to command her obedience. Spock and Chapel must learn to separate their experience of their marriage from Vulcan cultural categories which are insufficient to express that experience. If the bond allows them tremendous intimacy, it also increases the pain when Spock pulls back, following the death of their first child, refusing to let her see his response or to offer her comfort in her mourning.

> Spock had gone away into some place that she couldn't reach, and fenced himself in behind logic and Vulcan aphorisms. There were times when she hated him for leaving her alone with her grief. There were times when she cried for him, for the pain that must have driven him to this. But whatever she tried, he would not respond.[34]

Spock enters Pon Farr at a time when they have not yet resolved these tensions; his desperate needs test their previous commitments:

> She shook her head slowly, unable to verbalize her instinctive revul-

sion. She took a sharp breath, suddenly aware of the musky odor of his skin. The familiar smell had become strong and rank, the animal scent of a male in rut. . . . 'You cannot refuse.' The fever madness was bright in his eyes, and sweat glistened on his skin even though the air was cool. . . . He took another step forward, and she found her voice. 'Are you going to rape me, Spock?'[35]

Frightened by Spock's madness, Christine retreats, unsure how she should respond to the conflict between his primal need and her right to control her own body:

> 'He had no right. No right,' she said to the empty woods. 'My mind and my body are mine. Mine! He has no right to use me.' But she couldn't let him die. . . . The bond was pulling at her, urging her to go to him, almost forcing her to. She hated the compulsion, even as her reason agreed with it. . . . Her face was wet with tears, cold in the wind. She pounded on the tree trunk with a clenched fist. My husband, where has he gone, the man I made those promises to? Where has she gone, the woman who made them?[36]

The scenes of Spock's Pon Farr are powerfully written and emotionally disturbing; they refuse to deal with sexuality in simple terms, but rather grapple with both the pleasure and the danger of sexual relationships. We are, at this point, far from the one-dimensional stereotype of a woman who defines herself totally through her desire to find a good man to marry. Land has had to establish Chapel's autonomy in order for us to fully understand the demands Spock places upon her and confront the hard choices she makes. Marriage in Land's novels is never totally resolved, but rather requires a constant renegotiation of needs, feelings, desires, frustrations and ambitions. Such compromises become intolerable if they are all one-sided but the process of negotiation becomes a source of pleasure if conflicts are mutually resolved.

If *Kista* focuses almost entirely on the shifting feelings of Spock and Chapel, its sequel, *Demeter*, places their relationship within a larger social context, dealing more directly with how women are treated within the Federation. Some time has passed and, after a lengthy stay on Vulcan, Chapel has chosen to leave her children under the care of Spock's mother and return to Starfleet, so that she can pursue her career and be close to her husband once again. Her difficult decision focuses attention on the ways that the Federation has failed to provide appropriate means of accommodating women's personal and professional needs. As she complains to Thelit, a strong-willed Andorian woman, 'I spend my life weighing the children's needs against my needs against Spock's needs, and at any given time, I know I'm shortchanging someone.'[37] Thelit has, herself, made a difficult choice, breaking with the traditional role of women within

a warrior society, disobeying her father and abandoning her husband in order to pursue her own career: 'We're valued for our ability to produce the next generation of soldiers! Educated just enough to be dutiful wives and mothers, but not comrades in arms, and never, never equals!'[38] Fiercely independent, professionally gifted and emotionally volatile, Thelit is portrayed as a woman who is still pained by her irreparable break with her past and with her culture.

These opening scenes point towards the novel's central concerns – the choices women face within a male-dominated society and the possibilities to redefine that society so that it offers new options. Land's central plot concerns the threat a group of intergalactic drug-runners pose to Demeter, a feminist space colony, a world where women have lived without any contact with men for several generations. The drug lords' attempts to harvest the planet's natural narcotic resources has resulted in radiation leaks that are damaging the colony's supply of biogenetic materials and threatening its ability to reproduce. Demeter thus requires Star Fleet help, but will only allow itself contact with an all-female landing party. As a result, Uhura is at last allowed to command a mission and Chapel is able to serve as chief medical officer. The situation provokes all of the characters, men and women, to think about the role that gender differences play in their everyday lives and Land's novel explores the characters' shifting responses to the concept of female separatism and the quest for equality.

Jim Kirk initially cannot grasp what would motivate women, many of whom had high professional accomplishments, to establish a separatist colony: 'It was a waste of their talents. Mankind needs women like that.'[39] As Uhura explains, the Federation is far from a utopian culture for women. The aftermath of the Eugenics Wars (mentioned in 'Space Seed') has led to a cultural taboo against 'any interference in the reproductive process', ensuring that women will have 'very little time for anything but motherhood'. The possibility for advancement within Starfleet is severely limited:

> A woman in Starfleet can go only so far. It shows up all the time in the promotion patterns if you look. A promising young male officer tends to get moved around, exposed to a lot of different areas. If a woman is good at what she does, she gets patted on the head and left there. . . . If a woman wants more than that – more than she's allowed – at best she's unwomanly. At worst, she's crazy.[40]

Still smarting from his confrontation with Janice Lester ('Turnabout Intruder'), Kirk responds defensively to Uhura's charges of sexism in Starfleet, but soon reassesses his attitudes towards women:

> Were Uhura and Chapel right? Neither of them struck him as

the radical type. They were both. . . . What? Womanly, Kirk? Gentle, unthreatening? That was what he liked, wasn't it? Had his experiences with Janice Lester made him that wary of ambition and aggression in women? . . . He could make one concrete decision right now. He didn't know if he'd been unconsciously giving more duties, more chances for leadership and responsibility to his male officers, but if he had been, that was going to change right now. He'd always prided himself on his fairness. . . . And he was damned if he'd let himself or the Enterprise be caught in this situation again.[41]

Such intellectual exchanges and self-reflections are characteristic of *Demeter*, a book fascinated with staging and restaging the many different characters' responses to the alternatives posed by the feminist colony and its hopes for a planet of one's own. Some of Land's characters react with initial hostility to this bold new world. Nurse Grace Dawson, a religious zealot, views the separatists as violating God's law and accepts as her mission teaching them the errors of their ways. T'Nilla, a Vulcan woman struggling with her grief over the death of a bondmate she never really got to know, fails to grasp the logic of their social organization. Others, such as the fiery Theliat or the independent-minded security officer, Keiko Ichigawa, see Demeter as offering alternatives to their own frustrating experiences in the Federation. Uhura reconsiders her professional ambitions, while Chapel confronts Spock's paternalism. Theliat and Keiko must decide whether they will remain in the colony as it rebuilds itself or whether they will return to the Federation to fight for more recognition in a man's world. All of the women will be given a chance to demonstrate again and again their professional skills, as they confront and overcome the suspicions of the colonists, as they struggle to locate and cure the genetic problems plaguing the colony, and as they must take up arms to protect the colonists against the marauding drug lords. If, as Land writes in her introduction, 'there were times when I felt like disowning, without exception, the opinions of every single character in this book', she also struggles to make the reader understand and appreciate each conflicting position, to help them grapple with their shifting feelings.[42]

The utopianism of *Demeter* comes not within *Star Trek*'s Federation but rather is embodied by the space colony, which struggles to remain independent from Starfleet control. If Land portrays Starfleet as hierarchical and discriminatory, Demeter is shown to be democratic and egalitarian, governed by cooperative principles. If Chapel must leave her children behind to pursue her career aboard the *Enterprise*, children are fully integrated into the professional sphere on Demeter. Yet, Land never fully embraces the option which Demeter represents, expressing occasional discomfort at the women's lesbianism, insisting that for most women, the most satisfying lifestyle requires interaction with rather than

isolation from men. If her lesbian characters are sympathetically drawn and she struggles to understand their different lifestyle, Land's fiction assumes that mandatory heterosexuality still rules the Federation and that its draw is so powerful for most of her characters that Demeter is never really posed as a desirable option. Yet, as she notes, all of the women, regardless of their perspective, understood why the women of Demeter felt the necessity to establish such a world as a refuge from a male-dominated society. The Starfleet women develop self-sufficiency, a sense of themselves, through their experiences on Demeter, but choose to return to their familiar, albeit imperfect, world and struggle to make it live up to its own utopian ideals. In having her characters reach such decisions, Land perhaps reflects on her own role as a *Star Trek* fan, her own dissatisfactions with the programme's ideological compromises and con-tradictions, her own desires to work to redefine that world in terms which more fully satisfy her feminist fantasies.

Star Trek's utopian vision is worth fighting for, even if or perhaps precisely because that utopia is so abstractly drawn and so empty of concrete social philosophy. The generic multiplicity and ideological con-tradictions of *Star Trek* invite fans to construct their own utopias from the materials it provides. Land builds upon the social utopian tradition, drawing inspiration from the works of feminist science fiction writers like Joanna Russ or Ursula Le Guin. Such a vision is not alien to *Star Trek*, as we have seen, though its implications were scarcely developed there. By rethinking the utopian vision of *Star Trek*, she finds a way to rescue the female characters from their stereotypical on-screen behaviour while explaining, within the fiction, rather than in terms of the programme's production and reception context, those forces which do not allow *Star Trek*'s women to achieve as much as their potential suggests.

'How many Starfleet officers does it take to change a lightbulb?'

Star Trek at MIT

Henry Jenkins (with Greg Dancer)

John: Before I knew of any colleges that taught this stuff, I said to people that I wanted to go to *Star Trek* college. I wanted to go somewhere where I could learn all the technology and sciences they have on the *Star Trek* show and now I ended up here.

Henry: Is MIT your *Star Trek* college?

John: Yeah, definitely.

When John, a PhD student in physics at MIT, talks about how he became a scientist, he talks about *Star Trek*. He tells the story of growing up in a small town in rural Wisconsin, an 'outsider who preferred science to football' and whose parents and friends didn't understand his interests. John discovered his chosen profession through the pages of *Popular Electronics* magazines and during after-school viewings of *Star Trek* reruns:

In some ways, *Star Trek* was my main access to science and technology at the time. I think in the older episodes there seemed to be more science. There was a lot of excitement that, wow, technology is going to do a lot of great things.

For John, remembering *Star Trek* means recalling a time when science was 'very much part of the culture', when he saw 'people walking on the moon on television'. *Star Trek* sparked his curiosity about the experimental process and spurred his optimism about the future:

I would sit there watching the *Star Trek* episodes and say I wish I could make this or that. Finding out that some of these things, like antimatter, were based on real science was very exciting. . . . There was a sense of adventure and danger, a sense that science could solve everything. We will apply technology and it will just fix everything. People are not so convinced of that anymore. There is a backlash against technology now.

John becomes wistful when he speaks of how America lost faith in science,

even as he has found a place for himself at MIT (his '*Star Trek* college') where science is still valued. He expresses disappointment that *Star Trek: The Next Generation* reflects those shifting attitudes:

> The old series was out there to explore and understand new things. It seems like on the new series, they just sit back in their living room and watch everything happen. There is an acceptance of technology but it isn't the driving thing anymore.

Just a few weeks from graduation, a job awaiting him at Stanford, John is part of the 'scientifically and technologically oriented middle class' which, as Gerard Klein suggests, has historically constituted the primary audience for science fiction.[1] As we have seen, Klein argues that the dystopian turn of recent science fiction expresses a crisis of faith within the scientifically literate middle classes about their own dwindling authority and 'frustrated ambitions'. John's sense of a shift in the role of science within *Star Trek* betrays some of the tensions Klein identifies. Clearly, for John, the future isn't what it used to be. John, however, could not be described as having fully embraced the newer dystopian flavour of the genre. Rather, John judges contemporary science fiction's darker visions within the discursive framework provided by the earlier technological utopian tradition. What Klein's theory overlooks is the degree to which interests of readers and writers, producers and consumers, are never in perfect alignment. Not only do readers select from the range of generic options available to them at any particular moment but they also inflect their readings of those selected narratives to reflect their own particular orientations and interests. Science fiction enthusiasts, like John, recognize the potential problems within the genre's characteristically optimistic vision of the future. At the same time, they are attracted to the older stories' vision of the future as a utopian alternative to their lived experience; hard science fiction provides them with a set of core myths which facilitate their own practical activities and flatter their own need for professional dignity.

When I teach science fiction at MIT, my students often complain that the contemporary novels are 'too pessimistic', expressing a desire for fictions which share the optimism about the future they find elsewhere at the Institute. Those students who are drawn towards the darker visions are often those who have more generally embraced the humanities and the social sciences rather than those who have identified themselves with the hard sciences and engineering. As Adrian Mellor suggests, the shifts Klein identifies may reflect not so much a loss of faith within the scientific base of science fiction's dominant readership as a broadening of that core audience to encompass a wider segment of the educated middle classes.[2] In Mellor's careful reworking of Klein's original argument,

the vocabulary of science fiction shifts to accommodate a changing reading demographic which brings new interests to bear upon the genre.

But what happens in this process to the original audiences for hard science fiction? Do they fall aside to make way for more humanistic readers who embrace the genre's repudiation of its old ideals or do they remain committed to those ideals and use them to evaluate the generic shifts? Can an audience fascinated with a fantasy of technological empowerment coexist with an audience fixated on nightmares of techno-logical destruction? All I can say is that they do coexist in my classroom when I teach science fiction as students restage, at a microcosmic level, the shifts and controversies which have shaped the last thirty years of science fiction. The tendency to read the history of science fiction in linear terms – as a set of shifting paradigms for constructing fictions about the future – masks the degree to which all of the earlier options (technological utopia, social utopia, space opera) remain viable for both readers and writers while the generic repertoire expands to encompass a broader range of acceptable fictions. Not only do the older books remain in print, accessible to new generations of readers, but on the margins of the genre, writers continue to produce according to the old formulas and readers continue to evaluate the newer fictions within the older frame-works. Readers who embrace generic options no longer in vogue are perhaps more apt to be disappointed than readers who are prepared to adapt their interpretive and evaluative criteria to contemporary fashions, yet it is possible for them to create a space for themselves within the genre.

For those students, like John, who represent the original science fiction audience, hard science fiction still holds sway, though it is important to reconsider what that genre means during a period of declining respect for scientific authority and growing caution about technological progress. This chapter maps the discursive context within which John and other MIT students encounter *Star Trek*, its relationship to the formation of their professional identities, and the categories by which they comprehend and evaluate its episodes and recurring characters. MIT students have adopted the generic conventions of hard science fiction and accommo-dated them to their particular needs as students in training for a future role within the technological elite.[3]

MAPPING THE GENRE

John doesn't read contemporary science fiction; he says he doesn't have time, but he makes time to watch *Star Trek*, even if he has to timeshift it to watch later. When science fiction enters his discussion, it is apt to be the classics of the earlier era, the works of Isaac Asimov or Arthur C. Clarke. This same pattern holds true for most of the other students

involved in my study, though younger students may make occasional references to more recent hard science fiction writers, such as David Brin or Gregory Binford. The science fiction story most reverently evoked was Arthur C. Clarke's *2001: A Space Odyssey*, a work which surfaced in almost all of the interviews and which exemplifies the group's emphasis upon technologically-oriented stories. Missing from the discussions were any references to the cyberpunk writers who have dominated recent critical surveys of the science fiction field and reflect the darker vision which Klein sees within post-1960s works within the genre.[4] William Gibson's 'cyberspace' metaphor has been a founding myth within the emerging research on virtual reality.[5] MIT undergraduates, however, show a marked interest in works which follow hard science fiction's tradition of technological utopianism.

Cyberpunk originated as a spontaneous point of reference only within my discussion with two graduate students whose education required a greater focus on the social consequences of technological development: Wade, a graduate student in MIT's innovative Science, Technology and Society program and Amy, a graduate student at the Media Lab who had an undergraduate background in art history. These two students evoked cyberpunk as a specific point of comparison with *Star Trek*:

> Wade: 'Gibson's dystopia is really credible to me. . . . Part of what makes it interesting is that it is fairly uncommon for a science fiction writer to decide that the world is not daisies as in 24th century *Star Trek* and inequality has not been conquered by technology.[6] In fact, the technology that looks so great in *Star Trek* is exactly what is destroying people.'

What fascinates Wade about cyberpunk is its repudiation of the technological utopian tradition:

> The world of *Star Trek* is an extension of a 1950s utopia where the United Nations is the great hope for the salvation of mankind. This is the one way to peace and international harmony and it's an amplification to a galactic scale where, of course, Earth is the seat for the government and the Federation is run by humans. It is an Eisenhower/ Reagan–Bush view of the future in which America really is still on top. . . . I think I would probably feel very stifled by the society they represent on *Star Trek*. It seems to be drained of all the interesting conflict in human existence.

Amy shares Wade's critique of its technological utopian ideology:

> In a way, Roddenberry's utopia is as potentially damaging as Gibson's dystopia. The dystopia upsets me a lot more because of the racist and sexist stuff that goes with it. . . . I am fascinated by the hierarchy they

[*Star Trek*] construct. In reality, I think hierarchy is to be avoided if at all possible but in the *Star Trek* world, it is very much a paramilitary organization. It is very interesting but also not something I would approve of.

Amy and Wade pose classic liberal critiques of the technological utopia, focusing on its appeal to hierarchy and mass conformity and its blind faith in the notion of technological progress. Their current positions, in departments which are innovative in their attempts to explore the social and aesthetic consequences of new technology, allow them to speak critically of ideological assumptions taken for granted elsewhere within the institution. Their humanistic education provides terms with which to analyse *Star Trek* from a social rather than a technological perspective.

Their scepticism about the human costs of living within a 'technological utopia' is largely absent from the other groups I interviewed. In fact, for other MIT students, watching *Star Trek* allows them to exercise their growing expertise and to reaffirm their belief in scientific authority, a cultural competency that is validated by the programme's sense that technological development will provide the tools for human betterment. These students draw upon the knowledge they acquire in their classes to spot the technical errors within the programme, while at the same time drawing on the programme as a vehicle for exploring their own shifting relationship to science and to the social life of MIT.

These MIT students follow a long tradition of science fiction fans acting as arbiters of the scientific validity of popular fictions. As Paul A. Carter notes, science fiction fandom originated in the United States around the pulp magazines edited by Hugo Gernsback, a sometime inventor and former publisher of popular science and ham radio magazines, whose technologically utopian visions helped to define the early evolution of science fiction as a popular genre. Gernsback's insistence that science fiction could become a major force in popular scientific education as well as a predictor of potential technological developments ('Extravagant fiction today, cold fact tomorrow') shaped how his young readers made sense of his magazine's contents. Some early fans urged him to 'print all scientific facts as related in the stories, in italics'.[7] Gernsback insisted that his publications would 'publish only such stories that have their basis in scientific laws as we know them, or in the logical deduction of new laws from what we know'.[8] The letter columns of *Amazing Stories* and other Gernsback publications were often filled with challenges to the technical accuracy of the pulp fiction, while Gernsback and his successor, John Campbell (himself a former MIT student) recruited many of their writers from eager science and engineering majors. It was from the ranks of these literate scientists that the classics of hard science fiction emerged.[9] The categories MIT students now apply to the interpretation and evaluation

of contemporary science fiction maintain a strong continuity to the notions of scientific accuracy and advancement posited by Gernsback, Campbell and the pulp editors.

Confronted with a text which does not respect scientific authority or reproduce basic myths of exploration and technological innovation, these students often discount its status as science fiction. Scott, an MIT undergraduate, asserts:

> I am perfectly comfortable saying that there have only been a small handful of shows or movies that are science fiction. People who care enough about science to demand that are a small part of the population.... What I would call science fiction makes a stronger attempt to be faithful to science. If you want to make stories about the future, call it speculative fiction. But science fiction deals with science.

His friend, Dave, concurred:

> Let me do a quick check here. Out of the nine movies shown at the LSC's [campus film society] science fiction marathon, I wouldn't call any of them science fiction. *Aliens* was *Rambo* in space. *Enemy Mine* was two people getting to know each other – maybe *When Harry Met Sally* in space. *Silent Running* is an eco-thing in space.

Scott's assertions provoked a heated response from Philip, another discussion participant, which resulted in further attempts to map generic boundaries:

Philip: 'Just because it doesn't focus on *this* new scientific discovery, you can't dismiss it. Name a single thing in *Silent Running* that contradicted any element of science now known.'

Dave: 'I can't name a single thing in *When Harry Met Sally* that contradicts known science but that doesn't make it science fiction. ... If there's science in *Silent Running*, it's ecology.'

Philip: 'And that's not science?!'

Dave: 'That's kind of soft science at best.'

Philip: 'Now you are not only designating science fiction as dealing with the sciences, you are designating science fiction as things that deal with physics, engineering, chemistry. What else counts? Would you include biology in this category?' (he glances at Val, another participant who is a biology major)

Dave: 'I think that if the biology of alien races is treated as a science, I would probably be comfortable calling it science fiction. ... I probably wouldn't rule out biology from what would constitute science fiction.'

Scott: 'I would say biology is definitely in the realm of science fiction

if it is dealt with as a science, not as a handwaving exercise. . . .
I think the way it was done in *Silent Running* was simply
handwaving.'

Such debates are frequent at MIT. In another interview, Rob, a senior
physics major, rejected *Star Wars* as 'space opera, not really science
fiction'. Rob explained that 'In all science fiction, you have some kind of
idea – a concept – a new concept. You don't rehash the same shit over
and over again.' Here, a thematic conception of the genre as centring
upon the consequences of technological innovation or scientific discovery
merges into a more strictly evaluative one, which centres around concep-
tions of originality and creativity. *Star Trek II*'s use of the Genesis Project
made that film science fiction, Rob insisted, while there was little such
emphasis upon innovation within the most recent film: 'Actually very few
of the other *Star Trek* movies could qualify as science fiction. *Star Trek
VI* wouldn't because it is just old problems in a new setting. . . . More
like political bullshit which they've had too much of lately.'

The students employ the term, science fiction, not descriptively but
rather evaluatively; they have firm prescriptions about what constitutes
science fiction, prescriptions which reflect their demand that genre works
respect and privilege scientific mastery. Such discussions represent not
simply a regulation of generic boundaries but also a series of negotiations
within the hierarchy of knowledge. Not all works that claim to be science
fiction really belong to the genre. Not all sciences are created equal in
their eyes. Biology is grudgingly accepted as a 'soft' science, ecology seems
a more suspect form of 'handwaving', while political science amounts to
'bullshit', totally unworthy of their attention.

When MIT students say that they accept *Star Trek* as one of the few
'real science fiction series' television has produced, they pay the pro-
gramme a high compliment. Works such as *Buck Rogers* or *Battlestar
Galactica*, which fail their exacting criteria, are not only rejected as 'junk'
but are treated with moral outrage; such works have 'no right or reason
to exist'. One MIT student describes the process of taping over a science
fiction programme that fails to meet his high standards as a 'mercy killing'.

MIT students claim for themselves a special role as custodians of the
genre and defenders of the faith. As journalist Stewart Brand reports in
his study of MIT's Media Lab:

Science fiction is *the* literature at MIT. The campus bookstore has a
collection as large as some science fiction specialty stores. Every com-
puter science student knows and refers to John Brunner's *Shockwave
Rider*, Vernon Vinge's *True Names* (Afterword by Marvin Minsky),
William Gibson's *Neuromancer*. The world's first popular computer
game, 'Spacewar', was created at MIT's Project MAC in 1961 by
student Steve Russell and his fellow hackers based on the *Lensman*

series of space operas by 'Doc' Smith. Tod Machover at the Media Lab composed an opera called 'Valis' from a science fiction story by Philip K. Dick.[10]

Brand could have continued: the MIT Science Fiction Society, one of the first in the nation, hosts one of the largest private collections in the world. Hugo Award-winning science fiction writer Joe Haldeman, a staunch defender of the hard science fiction tradition, spends half the year teaching genre writing at the Institute, and the Physics Department recently proposed hiring a science fiction writer in residence as a catalyst for more imaginative research. Strong cords of technological utopian thinking run through the Institute's official rhetoric and self-promotion. Brand's own account of the MIT Media Lab, subtitled *Inventing the Future at MIT*, adopts imagery which would sound familiar to Gene Roddenberry but which blends seamlessly into the general atmosphere of the campus: 'The Media Lab is inventing the technology of diversity. . . . Connecting, diversifying, increasing human complexity rather than reducing it – these are instruments of culture.'[11]

Star Trek enjoys a particularly privileged place within MIT's techno-culture. The campus cable-access station runs a regular talk show ('Stay Tuned') focused on the programme following its weekly syndicated airing. A language course on 'Advanced Klingon' was offered during the campus's Independent Activity Period. Instructors sometimes draw on *Star Trek* references in constructing exam questions and problem sets. An editorial about the 'sexual harassment' experienced by female students watching *Trek* in the dorm common areas sparked heated controversy in the student newspaper, *The Tech*.[12] One campus dormitory, Random House, begins each school year with marathon showings of all of the episodes of *Star Trek: The Next Generation*. MIT students and faculty maintain a highly visible presence in the national *Star Trek* computer-net discussions and generate enough additional computer chatter to maintain a small but active local electronic bulletin board discussion. For the MIT student, watching *Star Trek*, in between problem sets, design competitions and molecular chemistry lectures, the one thing which can be taken for granted is the centrality of science and its potential for human betterment.

FACING THE FUTURE

However, MIT students do display some of the 'crisis in faith' which Klein identifies within the 'scientifically and technologically-oriented middle class'. Even at this elite institution, with its 'best and the brightest' self-image and its 'can do' rhetoric, students recognize the shifting status of the scientist in contemporary life and regret that their concerns are not always central to the programme's interests. The university gives its

sanctions to such speculations through frequent forums on topics like the growing problem of science illiteracy in the American education system or the need for scientists to assert a stronger leadership role in political life. The students often claim that the reason *Star Trek*'s writers sometimes seem indifferent to scientific accuracy is that their 'non-technical' audience lacks the science literacy to appreciate such attention to detail.[13]

As John talks about *Star Trek*, one hears an occasional doubt slip into his voice, a sense that the world of real science is different from that of his childhood imagination:

> Initially, I thought people would just work on things and your whole experience with science would be based on how well you did something, but in fact it's very political.... There are a number of graduate students who are competing for resources and there is certainly a lot of this interplay going on as to who dominates. If you are in a very desirable position, many people want your job and you have to defend it.

John has lost some of his idealism about the meritocracy of pure scientific research; he has come to respect moments in *Star Trek: The Next Generation* where these power struggles surface, as in Riker's sparky exchanges with a rising young female officer who 'wants his job' in 'Best of Both Worlds': 'She [Shelby] was trying to dominate him and he [Riker] was trying to dominate her.... I think it's more realistic, the way things work, the way office politics really works.' John has watched his dreams about the space programme crumble in the face of more earthly demands:

> It's kind of disappointing that the main reason for going out into space today is to improve TV reception. I used to imagine when I got older, we would have regular flights to the moon and I would get to go into space myself and that would be a lot of fun. But people don't do that now. We found out it would be too expensive.... I don't think the future will look anything like the *Star Trek* universe because of that basic fact.

The younger students seemed more willing to suspend such doubts and accept *Star Trek* as a reasonable extrapolation of future technological and social developments. Scott, a sophomore in electrical engineering, said that he would like to be a part of making the world of *Star Trek* a reality and was planning to work on space robotics:

> I like the technology they have and the ideals they stand for. They're very dear to me. Fundamental humanity. Respect. The focus on the individual. In our society, the individual matters. Caring. Restraint ... communication across differences – all of the principles Picard is always

pontificating about. I hope our human culture learns to live up to these ideals.

Philip, a sophomore physics major with an interest in astronomy, suggests that what he appreciates about the series is the way that it allows him to see a way past contemporary problems:

> The thing about *Star Trek* is that humanity survives into the 24th century. But they didn't say we would get there unscathed. In the original series, they create Khan and face the eugenics wars. At the very beginning of the *Next Generation*, you've got a reference to a third world war. It's still a violent place in *Star Trek*'s future but the essential message is that whatever we do to ourselves, we are going to survive. We may hurt ourselves. We may have to fight amongst ourselves to maintain our freedom and humanity. We may have to suppress the more dangerous cultures that arise – to pose a now thankfully dead example, Nazi Germany. . . . But *Star Trek*'s view is that we are going to make it out there and we are going to overcome our own bad impulses.

Dave, a computer science major, envisions space travel as holding the key to achieving global balance and mastering humanity's more destructive tendencies:

> If we get off the planet, we will be able to escape war and all that. Take the European exploration of the New World. The European nations were all very small nations, always at war. The New World – the United States – is a very large group of people who generally get along together. . . . Once we get the ability to separate people by vast amounts of distance, we will have peace.

Star Trek acknowledges and addresses their doubts about the perfectibility of human nature while fostering their confidence in the old master narrative of technological progress and Manifest Destiny. Gone here are John's doubts about the economic costs or technological limitations of space exploration. Little dampens their enthusiastic embrace of the future, a future which their work in artificial intelligence, robotics, astrophysics or computer interface design may help to realize.[14]

Star Trek allows them to imagine the triumph of technology over human nature. At the same time, it invites them to question the appropriate limits of science. John remarked near the end of his interview: 'Occasionally, I've thought about developing one of their light hand weapons but this just isn't right. The world would not be a better place if I worked really hard to develop a phaser.' Here, one encounters the nagging doubts about the official ideology of technological progress which led some MIT students

to join movements against nuclear power, animal experimentation or military research.

Such concerns run throughout discussions of the Prime Directive, Star Fleet's prohibition against interfering in the growth and development of alien cultures. Programme followers often complain that the Prime Directive stifles the potential for dramatic conflict. A joke circulated on Rec.arts.startrek expresses their frustration over *Next Generation*'s often strict adherence to this principle: 'Q: How many Starfleet officers does it take to change a light bulb? A: None. That would be interfering with the light bulb's natural development.' Net discussions are generally dismissive of *Next Generation*'s 'gratuitous politeness', suggesting that Kirk might respond to problems with forcefulness, while Picard simply talks the enemy to death. Yet, asked directly about their attitudes towards the Prime Directive, most of the MIT students defended its importance as a check on scientific research ('Whenever mankind tries to improve something it doesn't understand, it makes it worse rather than better') and a limit on colonialist impulses ('In our interactions with other people, we shouldn't be stepping all over them'). What troubles them, however, is that the series often uses the Prime Directive to deny the *Enterprise*'s civic duty to come to the assistance of endangered cultures: 'When they need help, maybe it's our roles as conscientious human beings to do something to help them. Do we not have some responsibilities as a sentient life form?' Others defend the concept against such criticism, claiming that it is better to be conservative about trying to shape other people's cultural development:

> We want to help, we have learned all of this and we want to pass it along. . . . On the other hand, there is a risk of crippling a culture so that it will always be a child culture. Starfleet shouldn't take that chance. We don't know what's best. The risk of harm is too high.

Such debates are frequent among regular viewers of *Star Trek*, allowing for the rehearsal of basic ideological conflicts and philosophical questions about America's place in the world and science's impact on our everyday lives.

TINKERS AND THINKERS

The MIT students' reception of the series is coloured at all levels by their professional ambitions and their fantasies of corporeal participation within the world of *Star Trek*. Val, a biology major, casually mentions that she would like to work somewhere like the medical lab on *Star Trek: The Next Generation*. Bill expresses a fascination with the technical problems posed by the character of Data, the android: 'My bias towards Data has to do with my interests in robotic engineering. I catch myself

asking how would I program something that could do that and usually come up with no clue.' For these students, the programme's advanced technologies trigger their own speculations, spur them to try to fill the gaps within their present scientific knowledge which must be overcome before *Star Trek*'s high-tech future can become a reality. Part of their interest in *Star Trek* resides in this process of mastering its vocabulary and learning as much as they can about its technologies. As Wade explained:

> It's a self-enclosed, well-defined universe. . . . Having the ship, knowing what the ship is like inside and out, knowing that there are a defined and unchanging set of characters involved with rather narrowly defined characteristics and motivations. Having this rather predictable starting point at the beginning of every episode and then wondering how these people and that technology will be used and react to the threat every week. It's fun to gauge your expectations against what the writers are doing and being able to say the writers really messed it up this time. It's almost a way of patting yourself on the back and saying that you know *Star Trek* better than the people who are actually making *Star Trek*.

The technical manuals and programme writers' guides are oft-cited in discussions with MIT students. Questions which the technical manuals do not directly address are extrapolated from information provided on the series or in the novels. There are, in fact, rival movements within 'tech fandom', each claiming to know the specifics of the programme technology, its history and its capabilities. Debates between these groups provoke constant 'flame wars' on the computer nets, resulting in a special space set aside for such discussions so that they do not intrude into the general discussions of *Star Trek*. Such technical information allows hard-core fans to develop new sources of expertise, an informal curriculum which is part of the shared culture of the MIT student body. At the same time, such debates draw upon the knowledge which the students are acquiring in their formal coursework.

Bernard Sharratt has dismissed such fan-generated knowledge as a 'pseudo-expertise' which compensates for the participant's lack of actual social influence or economic/political power.[15] Yet here, for these students who will, in most cases, move from MIT to high-paid jobs in the technical industries or to research posts at major universities, the development of this alternative body of scientific knowledge represents a dress rehearsal for the power they will soon exercise in reality. Reading and criticizing science fiction allows them an initial experience of technical expertise within a highly competitive and hierarchical academic atmosphere. The fact that such activities are often seen as frivolous 'time-killers' by their instructors may simply compound the pleasure the students take in them within a regimented culture which places intense demands on their pro-

ductive output. A common expression suggests that an MIT education is 'like taking a sip of water from a fire hose'. Playing around with the *Star Trek* technology may be one way to momentarily put a kink in that hose, to reduce, however briefly, the pressure. Yet, what is interesting is that MIT students choose to play with the same concepts and materials which constitute their work and that through playing, they rehearse the activities which will dominate their professional lives.[16]

The students clearly draw upon their experiences at MIT in making sense of the programme episodes. Scott, for example, referred to an upcoming episode as 'a Course 7 *Trek*', suggesting that he classifies episodes according to which aspects of his acquired scientific knowledge they access. (MIT majors are identified by numbers. Course 7 is biology.) Students particularly praise the *Next Generation* for its references to contemporary scientific concepts. As Tom, a mechanical engineering major, explained, 'When they talk about superstrings and wormholes and so on, that brings a touch of realism. By the future, they will have worked things out and discovered concrete examples of now abstract theories. It's good to see.' Asked about what types of stories they would like the series to develop, they often call for more such excursions into the realm of newly developing science: 'There are so many astrophysiological objects that people are talking about right now. They could actually go there! They could either go there to be observing them or they could actually incorporate them into the story.' Like other members of the 'powerless elite' of fandom, they acknowledge that such stories would probably not appeal to viewers who lack their expertise; they recognize that *Star Trek* is a work of popular entertainment, not a 'Mensa exam question', yet they take the greatest pleasure in those on-screen moments which allow them to show off what they are learning at MIT.

'THEY KEEP GETTING THEIR NEUTRINOS WRONG!'

The MIT students draw upon their textbook knowledge of real-world science to test the series' technical claims, often relishing their superiority over the writers' 'pitiful' errors. Robert, a senior physics major, protested 'sometimes they go a little far afield of science fiction. They keep getting Neutrinos wrong!' Robert, then, proceeded to lecture his friends about Neutrinos. Richard stops him to ask, 'This is real physics talking?' and is reassured that he is receiving a textbook-perfect explanation. Such judgements are delivered from a position of intellectual superiority and are greeted with collective laughter from the other discussion participants ('Oh God! Oh God! Don't even mention that episode!').

Commentary on *Star Trek* science is the stock in trade of computer-net discussions, with each week's critical response constituting a 'debugging operation' trying to locate and resolve what one netter called 'technical

kludges' and another referenced as 'bogosities'. As in other forms of popular criticism, some complaints centre around obvious plot mechaniz- ations or contradictions of common sense. As one contributor explained:

> The main trouble I have with *Trek* is not the technology used, but the stupidity of some of the writing. For the sake of the story, I can swallow warp drive, shields, cloaking devices, even the transporters. But not the amazing lack of common sense that the people seem to display (such as regularly going hand-to-hand with the monster of the week instead of phasering it, or not exploring in formation, or not sending back reports when trouble seems about to start).

More often, netters demand a greater degree of scientific rigour, protest- ing that 'clearly, the technical expertise of the writing staff is pretty low'. Netters cite repeated problems in the series' conceptualization of three- dimensional space or inconsistencies in warp speed: 'Why is it that two approaching crafts, even the Romulan ones that suddenly uncloak, always have the same up vector? ... Why can't the *Enterprise* grab something that is upside down, or at some weird angle in its tractor beam?'

A typical controversy on the net revolved around the treatment of radiation exposure during the *Next Generation* episode, 'The Final Mission'. One student framed the question:

> The computer was busy ticking down the number of seconds until 'Lethal Radiation Dosage' ... uh ... people usually get sick at dosages below lethal radiation. Even if you grant that this magic drug which they were spraying into the ship's atmosphere would stop any ill-effects even ten seconds before 'Lethal Radiation Dosage', why wasn't the ship and all of its equipment contaminated by all of that radiation? Can you say 'plot device'?

A second netter responded by evoking the programme history, seeing the error as symptomatic of *Star Trek*'s tendency to play fast and loose with science:

> They've been guilty of radiation inconsistencies before – the time when they were trapped in the asteroid field by those old power transmuters that turned the motions of the ship into power to be beamed back at it as radiation. I guess we have to assume that after the show ended, there was 'ship clean-up' during which decontamination took place.

Another contributor offered a more detailed lecture on the biological consequences of radiation exposure:

> Well, I think we can assume that in the TNG universe they have a cure for cancer. Perhaps the drug helps with that. That means that the biggest danger from radiation would be from massive cellular damage.

Obviously, the drug helps with that, either by providing resistance to damage or by helping the body to repair damage (and thus possibly helping prevent future cancer). But massive cellular damage could kill quickly, as body systems shut down. If the radiation becomes great enough, it will simply kill people. At lower levels, I would expect some radiation sickness, but the drug might help many of those people recover. Still, even making the above assumptions (which may not be realistic but the writers are using the drug as a minor plot device), they cut it far too close. You just can't predict the lethal dose that accurately. It is different for different people, different areas of the ship will have different protection, etc.

Such discussions transform the episode content into a problem set which can be resolved through mobilizing the correct bodies of scientific knowledge and which can be graded according to the series writers' grasp of MIT-sanctioned information. Positions can be advanced through appeals to the programme canon or the technical manuals ('the official word on that question is . . .'), mathematical proofs ('The speed of sound is around 300 m/s. The volume transport of air out of the cargo hold door is A times V, where A is the area of the door and V is the velocity . . .') and scientific experiments ('To understand the experience of a vacuum, try this: hold your breath with your mouth open, such that if you want to, you can breath through your nose. "Close" your nose (i.e. don't let yourself breathe through it). Now push with your lungs like you do to equalize pressure in your eardrums . . .'). The discourse of science is the dominant framework for analysis here with only limited discussion granted to the social or character-based issues which seem primary to other fan discussions of the series.

A COMPUTATIONAL AESTHETIC

Writing about the 'hacker' culture at MIT, Sherry Turkle argues for a particular complex of cultural choices: '[The Hacker culture is] a culture of mastery, individualism, nonsensuality; it values complexity and risk in relationships with things and seeks simplicity and safety in its relationship with people.'[17] Hackers, she argues, reject the 'sensual caress' of art in favour of 'intellectual contact' with works of rigour, precision and complexity. Their 'computational aesthetic' favours the technical expertise of Bach to the over-emotionalism of Beethoven, values the sharp lines and recursiveness of Escher over the diffused colours of Monet, and finds its true home in science fiction.[18] As Turkle explains, 'A science fiction story is a microworld, isolated from all the assumptions of everyday reality, including assumptions about sexuality. . . . Science fiction gets its complexity from the invention of worlds rather than the definition of

character.'[19] Although she presents it as a description of the genre, Turkle is really describing a particular reading of that genre, one which is dominant not only within the Hacker culture she studied but the MIT community at large. MIT students are drawn to science fiction as a genre which centres on concepts rather than characters, hardware rather than 'wetware' (human factors) and science over sentimentality and these priorities may determine their preference for hard science fiction over some of the more socially centred variants. Yet, it is also the case that the students construct these value hierarchies both through their selection of appropriate and inappropriate forms of science fiction and through the ways they make sense of any given science fiction narrative. Much like Turkle, MIT students evoke a rigid and often troubling split between mind and body, intellect and emotion in discussing themselves and their relationship to the series. Such categories have a special relevance to the discussion of *Star Trek* because of the way such characters as Spock and Data pose questions about what constitutes an appropriate balance between logic and affect. Consider, for example, how John discusses Data's programming:

> One of the things about Data – he can't have emotions – he can have logic but emotions are higher order things. I tend to feel now that it's the other way around. When we build robots, the first thing they're going to have is emotions and then they eventually will develop logic. Intellect is a higher order than emotions. We don't understand emotions which is mainly why they seem so mysterious. My theory is that animals don't have a lot of higher reasoning abilities but they have emotions. Take some stupid animal. You can scare some stupid animal or make it react to various things at a very gut level the same way a person would but they can't think or talk or build a computer.

John, thus, employs the character of Data to talk about the relative importance of emotion and intellect within his own life and to justify his own decision to spend more time building computers than exploring his feelings. Emotion becomes the lower, more debased term within a discussion which maintains an absolute separation between intellect and affect.

What Turkle calls a 'computational aesthetic' can be recognized within the community's preoccupation with special effects. The MIT students constantly evoke special effects as a criteria for evaluating media science fiction. Many of the students said that they had little interest in *Doctor Who*, for example, because of their inability to look past its limited special effects budget. Richard was particularly sharp in his criticism of the programme, even though he admitted to having seen most of the episodes:

> *Doctor Who* was an extremely low quality series. They didn't make

any pretence to highbrow science fiction. They didn't give a shit about special effects. . . . These things were actually made in the early 1980s. The technology *was* there for them to be a better job. . . . After a while, I started to say 'My God! The acting isn't even any good! The stories are bad. Hell, this is just a stupid show so why am I watching it?'

Many of the interview participants suggested that while they had grown up watching the original *Star Trek* series, they now found the early episodes almost unwatchable when compared to the high-tech polish of the *Next Generation*.

The community's insistence on quality special effects works on several levels. First, the students link special effects with their general concern for scientific accuracy and technical rigour. Good special effects make the fictional worlds seem more credible, more 'realistic' and more immediate. As Scott explained:

I don't have to work as hard to pretend the rock isn't made of styro-foam. I can be swept away. When I see the old *Star Trek* ship fly by and almost see the string, I have to close my eyes to it. But, on the *Next Generation*, when the ship comes up and the little guy walks past the window, you can see it. You can almost touch it. It really makes my heart race.

Second, special effects are understood as remarkable technical accomplishments. The students often display a detailed knowledge of how the special effects were done, how much different types of effects cost to produce, and the relative strengths and weaknesses of different designers. Such insider knowledge is acquired, either directly from fan-oriented publications such as *Starlog* and *Cinefantastique*, or indirectly from general discussions on the computer nets. Several students described the pleasure they took in 'framestepping' through special effects scenes, watching them frame by frame to enjoy the precision of their design and execution. Their respect for such technical virtuosity extends to other aspects of the production process as well – to the craftsmanship of set and costume designers, to the challenges faced by performers such as Brent Spiner who plays the android Data. The restraint of Spiner's performance was singled out by several students in contrast to the hamminess they associate with William Shatner.

Third, the students seem to take a sensual pleasure in elements of visual spectacle and aural stimulation ('eye candy'). Many MIT students own videotapes of computer graphics and animations which they saw as remarkable achievements in the form. One net discussion group held a detailed debate about the emerging aesthetics of computer 'screen save' programmes. Often, however, the students are more hesitant to acknow-ledge the pleasure they take in mere spectacle, giving precedence to the

narrative function of special effects over their 'gratuitous' visual appeal. Consider, for example, this exchange with two graduate students:

Henry: 'How important are special effects in your evaluation of media science fiction?'

Wade: 'Sad to say, I think they are probably really important.'

Henry: 'Why's that sad?'

Wade: 'Because it's really the story that should be important.'

Amy: 'You are throwing these "shoulds" around with careless abandon.'

Wade: 'I think the point of science fiction is to explore the issues raised by science and technology. You don't need . . .'

Amy: 'What's wrong with . . .'

Wade: 'You don't need special effects to do that because literature allows you to do that for yourself.'

Amy: 'Wade, you've got to relax. Listen. I don't see what's wrong with taking pleasure in the purely sensual, taking pleasure in the purely visual, saying "Wow! That Robot in *Terminator 2* is cool" and enjoy it. Rather than just saying "content, content, content". We can't be goal-directed people twenty-four hours a day. Sometimes we just need to have fun. You do love the special effects and I don't think it's something you have to feel bad about. You don't have to be an intellectual twenty-four hours a day. You can say it's visual and sensual and I'm going to stop being a grad student for five minutes. . . .'

Many of the students insisted on the centrality of ideas and plots over spectacle in their appreciation of the programme, yet without much prodding confessed to taking real enjoyment in special effects regardless of their narrative context. Many expressed frustration with special effects which fall short of their exacting standards. One student told of a friend who had edited together a tape of nothing but the special effects sequences from *Star Trek: The Next Generation*, which was played in the background at parties. What often makes such activities a 'guilty secret' may be an anxiety that the sensuality of special effects runs against utilitarian logic. Often, as in Wade's comments, dependence on special effects is posed as a threat to intellectual rigour, since such explicit attention to detail does not provide sufficient space for the viewers' exercise of their own imaginations ('I think our generation has been spoiled by all of the great special effects and we don't work our mind as much'). Amy, however, insists on the importance of 'taking a break' from such regimentation, for creating a space for play rather than work.

As Amy's challenge to her friend suggests, the pleasure of special effects depends as much on affective stimulation as on notions of realism, and this may be difficult to admit within MIT's functionalist culture. Amy,

herself, pulled back from a pure embrace of form over content just a few minutes later:

> On alternate Wednesdays, I wake up in the morning and think about all of the people working in Hollywood and all the time they spend doing what they do. I wonder what would happen if we sent all of these people to build a bridge. Let them feed the hungry or something.

At such moments, Amy sees her 'sensual' pleasure in special effects as irresponsible, a form of conspicuous consumption which is difficult to justify in the face of logical challenge or practical considerations. Though he had earlier dismissed *Doctor Who* for its 'deliberately silly' special effects, Wade calls here for an even more austere aesthetic, one which emphatically places content over form: 'If there was some way of getting across the ideas *Star Trek* is about without drawing on the techniques of the advertising–mass media–entertainment world . . . I would find them much more satisfying.'

The students' conflicting feelings about special effects fit within a more general pattern of discomfort with the affective dimensions of the programme. One computer-net contributor complained about a character-centred moment in 'Future Imperfect' as 'the touchy-feeley part of this week's episode'. Another defended 'The Final Mission' from charges that it was too sentimental by suggesting 'I *believed* all the emotional gibberish being spewed by Wesley and Picard at each other.' Another episode, 'Data's Day', was described on the nets as 'a little bit boring and definitely much more mushy than was necessary'.

These same categories surfaced in the formal interview sessions. Richard, for example, said that the old series was 'particularly bad when they try to have a touching moment between men and women or between friends or something on the old episodes, whenever Nurse Chapel takes Spock's hand and Spock starts crying'. He accompanied his description with a loud imitation of Spock's sobbing, which was soon joined by the other discussion participants before all four men broke down laughing. One discussion centred around the difference between the 'childlike' qualities which they admired in Data and the 'childishness' they disliked in Wesley:

> I think the calculating and reasoning aspect of Data seems more mature to us. The emotionality has been repressed. . . . Wesley seems to be more emotional and immature. Wesley gets caught up in childish joys. He displays all the emotionality that Data doesn't have.

Another student referred to Wesley as 'Wellsley', a reference to a local women's college which figures heavily in the misogynist humour of MIT men. The empath, Deanna Troi, is particularly a focus of ridicule for these viewers since her entire role on the programme centres around her

ability to read emotions; she was variously described as 'whining', 'useless' and 'clueless' by the MIT students interviewed.

The acerbic comments that are directed against such characters and situations reflect the group members' often explicitly expressed desire to separate themselves from the 'Trekkies', who are seen as having an overly emotional preoccupation with the series. MIT students, particularly in more informal settings, use sophomoric humour and biting remarks to embrace a more distanced (and, they would insist, more coldly rational) stance, with much of the laughter aimed either against *Star Trek*'s sentimentality or its dependence upon transparent 'plot devices'. Richard suggests at one point that Riker's function in the series could be reduced to his sexual prowess: 'He's the captain's dick. They split Kirk into two parts. One part, the cool captain Picard, the other part, the captain's dick. Kirk's libido revisited. He even looks like him.'

After more than an hour of similar comments about the 'dorkiness' of *Star Trek*, Richard remarked with self-conscious irony, 'Yet we still watch it. Who is more foolish – the fool or the fool who follows the fool?' And this is precisely the issue. MIT students display intricate knowledge of the programme universe, quote line after line, identify the episode titles, and yet adopt a stance that pretends not to take it all very seriously. Such jokes are often a transparent effort to mask any signs of emotional engagement behind a public façade of cynical reason. Where enthusiasm surfaces, it must be muted, for fear that it will be crushed altogether as the group monitors its own ranks for signs of too much emotional involvement. At one point during that same discussion, Fletch displayed uncharacteristic excitement about a particular television line-up: 'I'd watch *Alien Nation* and then I'd watch *Star Trek: The Next Generation*. My schedule was great! I'd make sure my work was done by nine and then I'd kick back and watch a couple hours of science fiction.' Confronted by suspicious looks from his friends, Fletch quickly revised his assessment, 'Well, one hour of science fiction and one hour of drivel.'

AUTONOMOUS ANDROIDS

When the characters are discussed in more sympathetic terms, it is most often in terms of their competent performance of their duties within the *Enterprise* chain of command. John emphasized the 'problem-solving abilities' of the characters on the old series as a sharp contrast to the indecisiveness that bothers him about *Next Generation*: 'I like to see them get into trouble and think their way out of it.' In the course of the discussion, John praised Data because 'he seems to solve all the problems', suggested that Troi has 'great potential for solving things' and complained that Wesley 'just doesn't have the capacity to do anything when compared to a trained crewmember'.

Similar criteria surfaced in other discussions. Scott explained why he admires Data:

> He's one of those people who is striving the hardest to be all that he can be and more and I really respect that. The other characters do their best but they never try to be more than human. Data tries to do more than his limitations dictate.... We can visibly see him work towards his goal. His tools for achieving his goal are the crew, all of the humans he interacts with.[20]

Wesley Crusher, on the other hand, earns their disrespect because 'he can't handle critical situations. He chokes in the clutch.' The ability to act alone, to set and satisfy goals, to solve problems through swift mental calculations represent the admired traits in this discourse. These criteria are, not coincidentally, the same terms by which the students assess their own performance in and outside the classroom. What makes a good *Star Trek* character would seem to be what makes a good MIT student, though the students have particularly strong feelings (either positive or negative) towards characters which allow them to explore conflicts they face in their own lives. John, for example, explained his own long-time fascination and identification with Spock:

> I always wanted to be like Spock. I suppose I was like him – an outsider. He was an alien in the ship and I was an outsider in my town. I grew up there but I didn't belong. He was in science and things like that. He would go to investigate things. He would solve all the problems. He was someone I looked up to at the time.... I think that being in internal conflict with yourself about being outwardly emotional is something that is common to many people in science and technology and especially something I have experienced.

For the younger students, Data plays a similar role, allowing them to think about the difficult balance which they hope to achieve between their affective needs and their commitment to scientific rationalism.

DWEEBS, NERDS AND BRATS

Sherry Turkle neglects this dimension of the students' relationship to science fiction, ascribing the genre's appeal to its simplification of human experience: 'Mr. Spock will always be logical; Captain Kirk will always be smug and philosophical, the engineer Scotty will always be plodding and loyal. All of this is reassuring if you have a strong taste for consistency.'[21] Turkle notes the movement within computer-net discourse from the technological to the metaphysical, as in discussions of the transporter system that bleed into more ontological questions about the nature of human identity. However, these same discussions also pose questions

about human emotion and social identity. For these students, what makes the characters such 'evocative objects' (to borrow a term from Turkle's book) is the fact that they *do* face internal conflicts which mirror those the students confront in their daily lives – Spock's struggle to regulate his emotions, Data's distanced observation of human feelings, Worf's attempts to maintain a Klingon identity in human society, Beverley Crusher's need to balance her professionalism with her femininity, and Deanna Troi's difficulty in maintaining her autonomy from an overbearing mother.[22] That these conflicts are treated in bolder relief than in more realist fiction may be an asset, since they allow more space for the students to assert their own interests in the process of 'fleshing out' the characters; the students, thus, build not only on what the programme tells us about these figures but also draw on their own experience to explain the motivations for their on-screen actions. The students rely on the fictional experiences of these characters not to avoid the emotional complexities of social interaction but as resources to use for discussing their personal feelings without exposing too much of themselves. For all their attempts to display contempt and distance from these characters, their conversation often betrays their close identification with them and their problems.

Nowhere is this tension more fully visible than in their discussions of Wesley Crusher, a character who was introduced to the series in a conscious appeal to their demographic group but who has met nearly universal disapproval. Throughout the interviews, MIT students referred to Wesley as 'a brat', 'the kid', a 'computer dweeb', a 'nerd', a 'boy wonder' and a 'whiz-kid', all terms which are also used in their conversations to refer with varying degrees of self-parody to themselves and their friends. The students are clearly uncomfortable with this character, yet they can never fully dismiss him; he intrudes upon their self-image. Consider, for example, this discussion with several MIT undergraduates:

Val: 'It was a good idea to get someone our age but . . .

Dave: 'You would think that here at MIT more people would identify with this child prodigy and OK, something has failed somewhere down the line. As you've noticed, people don't identify with him, people almost hate him. I've seen child prodigies in real life and I've been really rubbed the wrong way by them. I think they are a fair approximation of what I was like at that age. I don't know whether we don't like child prodigies, not even ourself or . . .'

Scott: 'You just don't like people like that.'

Tom: 'Maybe we see him as like the worst-case scenario for a child prodigy. No humbleness. No sense of perspective. You are a

kid, no matter how brilliant you are. No sense of the proper channels you can direct your ideas towards.'

Val: 'I think we already identify with the rest of the characters and Wesley is just in the way. . . .'

Philip: 'I don't think I've ever seen Wesley behave competently in a non-emergency situation. You look at that situation with the Nanites. That's pure carelessness. That's a mistake even people here don't make.' (all laugh) 'It's a basic error in lab safety. Even now, you can recognize that's not a good idea. If you are really really tired, you shouldn't be doing lab work at all.'

Scott: 'I wouldn't say that MIT students are beyond that level of incompetency. My roommate talks about the reason why the 2.70 [mechanical engineering] lab isn't open at night is because people would be pulling all nighters on those dangerous machines and they would hurt themselves. He's incompetent but let's not put ourselves beyond that.'

Each attempt to define themselves as different from Wesley pulls him back into their orbit. Wesley makes these MIT students uncomfortable because he embodies aspects of themselves which they would rather forget, because he suggests the gaps between their idealized self-images and their day-to-day interactions. Other fans complain that Wesley is too competent or too intelligent, and that writers too often depend upon him to 'save the day'. These students downplay the character's intelligence and emphasize instead his emotional immaturity and his technical incompetence.

CONCLUSION

Talking about Wesley brings us full circle as we try to understand the discursive resources and interpretive strategies of what Klein calls the 'scientifically and technologically-oriented middle class'. Their identification with Wesley allows them to imagine a space for themselves within the future which *Star Trek* represents, even as their dislike for the character allows them to distance themselves from cultural stereotypes about MIT technical 'wonks' and 'nerds'. We have seen that this group's reading of *Star Trek* is preoccupied with issues of technology and science as they interpret the series through a discursive competency in both real-world science and hard science fiction. Their reading pulls to the surface the series' roots in technological utopianism. Their reading places primary importance on scientific accuracy and technical precision, issues which surface both in their attention to the narrative developments and their particular fascination with special effects. Such an approach allows them to exercise their growing mastery over the rules and contents of scientific

knowledge and reconfirms their professional ideology at the time when they are developing their identity as members of the scientific community. Moreover, these MIT students come to know the personal and the social through their exploration of the technological. The series characters are explored primarily in terms of their professional competency, problem-solving abilities and command authority; characters like Spock and Data or actors like Brent Spiner, Leonard Nimoy or Patrick Stewart attract particular attention because of their ability to achieve a proper balance of the emotional and the rational while characters like Troi and Wesley Crusher and actors like William Shatner draw particular fire for their lack of emotional control. Through this process, *Star Trek* is made to speak to MIT students about the pressures they experience and problems they face. What allows them to resolve their personal anxieties and to confront their professional doubts is the optimistic vision *Star Trek* offers them of a future perfected through advanced technology. Here, hard science fiction and space opera become the vehicles for exploring and resolving the 'crisis in faith' which Klein insists led to the formation of a dystopian strand of American science fiction.

Chapter 12

'Out of the closet and into the universe'
Queers and *Star Trek*

Henry Jenkins

Star Trek celebrates its 25th anniversary in 1991. In that quarter century, one of the most important aspects of the series ... has been the vision that humanity will one day put aside its differences to work and live in peace together. *Star Trek*, in its various television and motion picture forms, has presented us with Africans, Asians, Americans and Andorians, Russians and Romulans, French and Ferengi, Hispanics and Hortas, human and non-human men and women. In 25 years, it has also never shown an openly gay character.

(Franklin Hummel, *Gaylactic Gazette*)[1]

Perhaps someday our ability to love won't be so limited.
(Dr Beverley Crusher, 'The Host', *Star Trek: The Next Generation*)

'2, 4, 6, 8, how do you know Kirk is straight?' the Gaylaxians chanted as they marched down the streets of Boston on Gay Pride day. '3, 5, 7, 9, he and Spock have a real fine time!' The chant encapsulates central issues of concern to the group: How do texts determine the sexual orientation of their characters and how might queer spectators gain a foothold for self-representation within dominant media narratives? How has *Star Trek* written gays and lesbians out of its future, and why do the characters and their fans so steadfastly refuse to stay in the closet? The chant captures the play between visibility and invisibility which is the central theme of this chapter and has, indeed, been a central theme in the struggle against homophobia in contemporary society.

The Boston Area Gaylaxians is a local chapter of the international Gaylactic Network Inc., an organization for gay, lesbian and bisexual science fiction fans and their friends.[2] Founded in 1987, the group has chapters in many cities in the United States and Canada. Adopting the slogan, 'Out of the closet and into the universe', the group has sought to increase gay visibility within the science fiction fan community and 'to help gay fans contact and develop friendships with each other'.[3] The group hosts a national convention, Gaylaxicon, which brings together fans and writers interested in sexuality and science fiction. Although only

recently given official recognition from the Network, group members have organized a national letter-writing campaign to urge Paramount to acknowledge a queer presence in the twenty-fourth-century future represented on *Star Trek: The Next Generation*. Their efforts have so far attracted national attention from both the gay and mainstream press and have provoked responses from production spokespeople and several cast members. Gene Roddenberry publicly committed himself to incorporate gay characters into the series in the final months before his death, but the producers never delivered on that promise. The series *has* featured two episodes which can loosely be read as presenting images of alternative sexuality, 'The Host', and 'The Outcast'. Although the producers have promoted these stories as responsive to the gay and lesbian community's concerns, both treat queer lifestyles as alien rather than familiar aspects of the Federation culture and have sparked further controversy and dissatisfaction among the Gaylaxians.

The fans' requests are relatively straightforward – perhaps showing two male crew members holding hands in the ship's bar, perhaps a passing reference to a lesbian lover, some evidence that gays, bisexuals and lesbians exist in the twenty-fourth century represented on the programme. Others want more – an explicitly gay or lesbian character, a regular presence on the series, even if in a relatively minor capacity. As far as the producers are concerned, homosexuality and homophobia are so tightly interwoven that there is no way to represent the first without simultaneously reintroducing the second, while for the fans, what is desired is precisely a future which offers homosexuality without homophobia.

What is at stake for these viewers is the credibility of Gene Roddenberry's oft-repeated claims about the utopian social vision of *Star Trek*. Roddenberry's reluctance to include queer characters in *Star Trek*, they argue, points to the failure of liberal pluralism to respond to the identity politics of sexual preference. As one fan wrote, 'What kind of a future are we offered when there is no evidence that we exist?'[4]

INTERVENTION ANALYSIS AND FAN CULTURE

This chapter, thus, documents the Gaylaxians' struggles with Paramount over the issue of queer visibility on *Star Trek*, their efforts to gain a public acknowledgement that gay, lesbian and bisexual people belong within the programme's utopian community. I write from a partisan position within this debate – as a *Star Trek* fan and a member of the Gaylaxians. John Hartley has called upon media scholars to engage in what he calls intervention analysis: 'Intervention analysis seeks not only to describe and explain existing dispositions of knowledge, but also to change them.'[5] Hartley advocates that media scholars write from the position(s) of media audiences, recognizing and articulating the interpret-

ive work which viewers perform, documenting their creative engagement with the media content. Hartley continues:

> Intervention analysis certainly needs to take popular television more or less as it finds it, without high-culture fastidiousness or right-on political squeamishness, but it needs to intervene *in* the media and in the production of popular knowledges *about* them.[6]

Intervention analysis, Hartley argues, speaks from, about and for the margins of popular culture.

My goal is thus to intervene in the debates about queer visibility on *Star Trek*, to trace the discursive logic by which producers have sought to exclude and fans have sought to include queer characters, to situate this issue within a larger social and cultural context of queer reception of science fiction and network representation of alternative sexuality. My goal is not to instruct or politicize audience response, since I believe that fans already exercise a form of grassroots cultural politics which powerfully reflects their interests in the media and their own ideological stakes. We need to create a context where fan politics may be acknowledged and accepted as a valid contribution to the debates about mass culture.

Such an approach may provide one way of reconciling critical work on texts, institutional analysis of the production process, and audience research on reception contexts within television studies. Rather than reading the audience from the text, an approach characteristic of ideological criticism, we would rather move to read the text from the specific perspective of particular audiences, creating our analysis in dialogue with those reception communities and in furtherance of our common interests. Such an approach need not displace but rather should supplement other modes of ethnographic research, such as those employed in earlier chapters, which continue to be appropriate for addressing other questions and issues surrounding the circulation and reception of popular texts. Such an approach will make clearer the need to contextualize work on audience resistance in relation to the conditions blocking media access and determining television content and may help us to better understand both the strengths and limitations of subcultural appropriations and resistant reading as means of reworking the dominant ideological assumptions of television science fiction.

CHILDREN OF URANUS[7]

> During the course of our production, there have been many special interest groups who have lobbied for their particular cause. It is Gene Roddenberry's policy to present *Star Trek* as he sees it and not to be governed by outside influences.
>
> (Susan Sackett, executive assistant to Gene Roddenberry)[8]

We had been the target of a concerted, organized movement by gay activists to put a gay character on the show.

(Michael Piller, *Star Trek* writing staff supervisor)[9]

In the late 1960's, a 'special interest group' lobbied a national television network to renew a series for a third season. If those networks had not listened to those with a special interest, *Star Trek* would not have returned and today *Star Trek* might very likely not be all of what it has become. You, Mr. Roddenberry, and *Star Trek* owe much to a special interest group: *Star Trek* fans. Perhaps you should consider listening to some of those same fans who are speaking to you now.

(Franklin Hummel)[10]

The people who organized the national letter-writing campaign to get a queer character included on *Star Trek: The Next Generation* were not 'outside influences', 'special interest groups' or 'gay activists'. They saw themselves as vitally involved with the life of the series and firmly committed to its survival. As Hummel asserts, 'we are *part* of *Star Trek*'. They saw their goals not as antagonistic to Roddenberry's artistic vision but rather as logically consistent with the utopian politics he had articulated in *The Making of Star Trek* and elsewhere. As we saw in Chapter 9, fans had long drawn upon Roddenberry's own comments about the programme and its ideology as criteria by which to evaluate the series texts' ideological consistency. If fan writers often sought to deflect anxieties about ideological inconsistencies from producer (Roddenberry) to character (Kirk), the Gaylaxians had no such option. What was at stake was Roddenberry's refusal to act *as a producer* to reinforce the values he had asserted through extra-textual discourse. The fans reminded Roddenberry that he had said:

To be different is not necessarily to be ugly; to have a different idea is not necessarily wrong. The worst possible thing that can happen to humanity is for all of us to begin to look and act and think alike.[11]

When, they asked, was *Star Trek* going to acknowledge and accept sexual 'difference' as part of the pluralistic vision it had so consistently evoked? They cited his successful fight to get a black woman on the *Enterprise* bridge and his unsuccessful one to have a female second-in-command, and wondered aloud 'why can't *Star Trek* be as controversial in educating people about our movement as they were for the black civil rights movement?' (James).[12]

The people who organized the letter-writing campaign were *Star Trek* fans and, as such, they claimed a special relationship to the series, at once protective and possessive, celebratory and critical. Frank Hummel, one of the key organizers of the campaign, described his decision to take on Roddenberry:

We expected more of *Star Trek*. A lot of the letters came from a simple, basic confusion. We didn't understand why *Star Trek* hadn't dealt with it. Here was *The Next Generation*. Here was a new series. Here was the late 1980s–1990s. Why didn't *Star Trek* deal with this? Why didn't they approach it the same way they approached casting an inter-racial crew? It was a puzzle.

Frank, like many of the others I interviewed, had started watching *Star Trek* as a child, had grown up with its characters and its concepts. *Star Trek* provided him with a way of linking his contemporary struggle for gay rights with successful campaigns in the 1960s on behalf of women's rights and black civil rights. The producers' refusal to represent gay and lesbian characters cut deeply:

> They betrayed everything *Star Trek* was – the vision of humanity I have held for over 25 years. They betrayed Gene Roddenberry and his vision and all the fans. They didn't have the guts to live up to what *Star Trek* was for.

Even here, we see evidence of a desire to deflect criticism from Roddenberry onto those (the unidentified 'they') who 'betrayed' his 'vision'.

Others might point to a series of compromises Roddenberry had made in the programme ideology as evidence of a certain duplicity, or, more globally, as a failure of liberal pluralism to adequately confront issues of sexual identity:

> Todd: 'I think Gene Roddenberry was this prototypical liberal – and I am not saying that in the most flattering terms. Just like the characters on *Star Trek*, he wanted to convince himself he was open minded and thoughtful and growing so he would do things to present that image and make superficial changes but when it came to something that really counted, really mattered, that wasn't going to go at all.'

In both versions, Roddenberry as *Star Trek*'s 'author' embodies certain myths about 1960s' activism and its relationship to contemporary social struggle.

To understand the intensity of the Gaylaxians' responses, we need to consider more closely what science fiction as a genre has offered these gay, lesbian and bisexual fans. David, a member of the Boston group, described his early experiences with the genre:

> I wasn't very happy with my world as it was and found that by reading science fiction or fantasy, it took me to places where things were possible, things that couldn't happen in my normal, everyday life. It would make it possible to go out and change things that I hated about my life, the world in general, into something that was more comfortable for me, something that would allow me to become what I really wanted

to be. . . . Being able to work out prejudices in different ways. Dealing with man's inhumanity to man. To have a vision for a future or to escape and revel in glory and deeds that have no real mundane purpose. To be what you are and greater than the world around you lets you be.

Lynne, another Gaylaxian, tells a similar story:

I wasn't very happy with my life as a kid and I liked the idea that there might be someplace else where things were different. I didn't look for it on this planet. I figured it was elsewhere. I used to sit there in the Bronx, looking up at the stars, hoping that a UFO would come and get me. Of course, it would never land in the Bronx but I still had my hopes.

What these fans describe is something more than an abstract notion of escapism – the persistent queer fantasy of a space beyond the closet doorway. Such utopian fantasies can provide an important first step towards political awareness, since utopianism allows us to envision an alternative social order which we must work to realize ('something positive to look forward to') and to recognize the limitations of our current situation (the dystopian present against which the utopian alternative can be read). Richard Dyer has stressed the significant role which utopian entertainment plays within queer culture, be it the eroticism and romanticism of disco, the passion of Judy Garland, the sensuousness of ballet and opera or the plenitude of gay pornography.[13] Utopianism, Dyer writes, offers 'passion and intensity' that 'negates the dreariness of the mundane . . . and gives us a glimpse of what it means to live at the height of our emotional and experiential capacities'.[14] The Gaylaxians describe their pleasure in science fiction both in terms of what utopia feels like (an abstract conception of community, acceptance, difference, fun) and what utopia looks like (a realist representation of alternative possibilities for sexual expression within futuristic or alien societies).

Science fiction represents a potential resource for groups which have had very limited stakes in the status quo, for whom the possibility of profound social change would be a desirable fantasy. Many of the Gaylaxians argue that science fiction is a particularly important genre for gay and lesbian readers:

James: 'To me the purpose of fantasy and science fiction is to go where no one has gone before, to open our minds and to expand our intellect. The future is wider, bigger, larger and therefore that is a fertile ground for opening up possibilities that are now closed. I think it's the perfect genre to find a place where you can have your freedom because anything can happen here and anything is visible here.'

Science fiction offered these readers not one but many versions of utopia, sometimes contradictory or exclusive of each other, but that was part of the pleasure. Confronted with a world which seemed all too narrow in its acceptance of a range of sexualities, they retreated into a genre which offered many different worlds, many different realities, many different futures.

Dana: 'Science fiction allows us the flexibility to be ourselves.'

The historic relations between science fiction and gay culture are complex and varied. Eric Garber and Lyn Paleo's *Uranian Worlds* lists more than 935 science fiction stories or novels which deal with gay and lesbian themes and characters, starting with Lucian's *True History* (AD 200) and ending in the late 1980s.[15] Some of the stories they cite adopt homophobic stereotypes, yet they also see science fiction as a genre which was historically open to gay, bisexual and lesbian writers who could express their sexuality in a disguised but potent form. As Garber and Paleo note, science fiction fandom in the 1950s was closely linked to the emergence of homophile organizations, with fanzines, such as Lisa Ben's *Vice Versa* and Jim Kepner's *Toward Tomorrow*, among the first gay community publications in the United States. Writers like Marion Zimmer Bradley, Joanna Russ and Samuel R. Delany were writing science fiction novels in the 1960s which dealt in complex ways with issues of sexual orientation and envisioned futures which held almost unlimited possibilities for gays and lesbians.[16] These writers' efforts opened possibilities for a new generation of queer authors, working in all subgenres, to introduce gay, bisexual and lesbian characters within otherwise mainstream science fiction stories. A key shift has been the movement from early science fiction stories that treated homosexuality as a profoundly alien sexuality towards stories that deal with queer characters as a normal part of the narrative universe and that treat sexuality as simply one aspect of their characterization.[17]

Many of these new writers, such as J. F. Rifkin, Melissa Scott, Susanna L. Sturgis and Ellen Kushner, have been actively involved with the Gaylaxians and have been featured guests at their national convention. The Boston group holds regular meetings where professional science fiction writers do readings or where struggling amateurs share their writings and receive feedback. Reviews of new books by queer writers appear regularly in the groups' newsletters, helping to alert members to new developments in the field.

For many of the Gaylaxians, fandom represented an immediate taste of what science fiction's utopian future might feel like. Fandom was a place of acceptance and tolerance. Asked to describe what science fiction offered queers, their answers focused as much on fandom as on any features of science fiction as a literary genre. The gay men contrasted belonging to fandom to the alienation of the gay bar scene and particularly to their

inability to express their intellectual and cultural interests there. The female members contrasted fandom with the 'political correctness' of the lesbian community, which they felt regarded their cultural interests as trivial since science fiction was not directly linked to social and political change. Belonging to the Gaylaxians, thus, allowed them a means of expressing their cultural identity (as fans), their sexual identity (as queers) and, for some at least, their political identity (as activists).

The conception of science fiction which emerges in such a context is highly fluid as a result of the group's efforts to provide community acceptance for all those who shared a common interest in science fiction, fantasy or horror. If the MIT students offered a fairly precise and exclusive conception of the genre, one which preserved their professional status and expertise, the Gaylaxians struggle to find inclusive definitions:

> Betty: 'Science fiction is almost impossible to define. . . . Everyone you ask has a different definition.'
> Lynne: 'It can be anything from hard science to fantasy.'
> Dana: 'The author can do all kinds of things as long as the work is stable within its own universe. It can be close to present Earth reality or it can be as far-fetched as an intergalactic war from Doc Smith.'
> David: 'It's all out there! No matter what your vision of the future is, it's out there in science fiction and fantasy. It's all available to us.'

Push harder and one finds that science fiction, for these fans, is defined less through its relationship to traditional science than through its openness to alternative perspectives and its ability to offer a fresh vantage point from which to understand contemporary social experience:

> John: 'Science fiction doesn't limit its possibilities. You can constantly throw in something new, something exciting. . . . Science fiction can be as outlandish as someone's imagination.'
> James: 'My definition of science fiction would be something alien, either the future, the past, different cultures, different worlds, different realities. It would have to be different from our perspective.'

Many of these fans had been drawn to science fiction through *Star Trek* and saw its universe as fully embodying these principles. Nobody had expected the original *Star Trek* series, released in a pre-Stonewall society, to address directly the concerns of gay, lesbian and bisexual fans. They had taken it on faith that its vision of a United Federation of Planets, of intergalactic cooperation and acceptance, included them as vital partners. Yet, when *Star Trek: The Next Generation* appeared, at a time when queer characters had appeared on many American series, they hoped for

something more, to be there on the screen, an explicit presence in its twenty-fourth century. 'Everybody had a place in his [Roddenberry's] future,' explained one fan. 'It didn't matter if you were a man or a woman, white, black, yellow or green. If they can't take it one step further and include sexual orientation! God, if they don't have it under control in the twenty-fourth century, then it will never happen!' (James). Underlying this discussion lies a more basic concern: if *Star Trek* isn't willing to represent gay and lesbian characters in the 1990s, when would it be able to do so? As they watched a series of dramatic shifts in American attitudes towards gay and lesbian politics in the late 1980s and early 1990s, discussion of *Star Trek* provided them with one focal point for the group's discussion and comprehension of those changes, for talking about issues such as scientific research into the biological basis of sexual desire or efforts to abolish the ban on gays and lesbians serving in the United States military or the successes and setbacks of the Religious Right's campaign against Gay Rights legislation. Discussing *Star Trek* could provide a common ground for thinking through their conflicting feelings about this process of social transformation.

WHERE NO [GAY] MAN HAS GONE BEFORE

Mr. Roddenberry has always stated that he would be happy to include a character of *any* special interest group if such a character is relevant to the story.

(Susan Sackett)[18]

Were Uhura and LeForge included because the fact they were black was relevant to a story? Was Sulu included because the fact he was Asian was important to the plot? Were Crusher and Troi and Yar included because the fact they were female was relevant to an episode? I do not think so. These characters were included because they were important to the *spirit* of *Star Trek*.

(Franklin Hummel)[19]

'We expected *Star Trek* to do it because we expected more of *Star Trek* than other series,' one fan explained. They looked around them and saw other series – *LA Law, Heartbeat, Thirtysomething, Quantum Leap, Northern Exposure, Days of Our Lives, Roseanne* – opening up new possibilities for queer characters on network television, while their programme could only hint around the possibility that there might be some form of sexuality out there, somewhere beyond the known universe, which did not look like heterosexuality. *Star Trek* was no longer setting the standards for other programmes.

'Sooner or later, we'll have to address the issue,' Roddenberry had told

a group of Boston fans in November 1986, while *Star Trek: The Next Generation* was still on the drawing boards: 'We should probably have a gay character on *Star Trek*.'[20] 'For your information, the possibility that several members of the Enterprise crew might be gay has been discussed in a very positive light. It is very much an area that a show like *Star Trek* **should** address,' acknowledged David Gerrold, the man assigned to prepare the programme Bible for *Star Trek: The Next Generation*.[21]

What were the Gaylaxians to make of the absence of gays and lesbians in the programme universe, of Roddenberry's silence on the subject, as season after season came and went? Steve K., writing in *The Lavender Dragon*, a fan newsletter, saw only two possibilities consistent with the fan community's realist reading of the series:

> As a U.S. Navy veteran, I have had firsthand experience with the military's discrimination against gays and lesbians. It could be that the United Federation of Planets also bans homosexuals from serving in Starfleet. . . . That would explain the large number of never-married officers on board the Enterprise. Except for Dr. Crusher, none of the regular officers have been married (chiefs, e.g. Chief O'Brian, are non-commissioned officers like sergeants). Does Starfleet have a huge closet? Still, this does leave the problem of civilian homosexuals. Since many of the episodes involve interaction with non-Starfleet characters, you would think that occasionally a gay or lesbian character would be somewhere in the 24th century. Has the Federation found a 'cure' for homosexuality?[22]

Invisibility meant either that gays were closeted or that they had ceased to exist. Neither was an attractive alternative to a group, whose motto, after all, is 'Out of the closet and into the universe'.

If they had listened more carefully, the fans might have recognized the slippage in Roddenberry's original comments, from including gay people as *characters* to dealing with homosexuality as an *issue*. What the Gaylaxians wanted was to be visible without being an 'issue' or a 'problem' which the script writers needed to confront and resolve. What they wanted was to see gays and lesbians treated as any other character would be treated within the programme narrative, defined in terms larger than their sexuality while acknowledging a broader range of possible identities than would be acceptable within the contemporary social climate. As Theresa M. wrote:

> I want to see men holding hands and kissing in Ten-Forward. I want to see a smile of joy on Picard's face as he, as captain, joins two women together in a holy union, or pain across his face when he tells a man that his same-sex mate has been killed in battle. I want to hear Troi assure a crew member, questioning their mixed emotions, that bisexuality is a way to enjoy the best of what both sexes have to offer. I want to see crew members going about their business and acting

appropriately no matter what their sexual orientation in every situation.[23]

Such moments of public affection, community ritual or psychological therapy were common aspects of the programme text; the only difference would be that in this case, the characters involved would be recognizably queer. The fans wanted to be visible participants within a future which had long since resolved the problem of homophobia. They felt this utopian acceptance to be more consistent with the programme's ideology than a more dystopian representation of the social problems they confronted as gays, lesbians and bisexuals living in a still largely homophobic society.

The programme's producers would seem to agree, since their public responses to the letter-writing campaign often presuppose that queers would have gained tolerance and acceptance within *Star Trek*'s future, yet they evaded attempts to make this commitment visible on the screen. Curiously, the producers never acknowledged the economic risks in representing homosexuality on contemporary television, risks that might, arguably, involve alienating potential segments of their viewing public, but rather, like the fans, sought to justify their actions on the basis of appeals to the programme's liberal ideology. Perhaps a public recognition of the political and economic context of the programme's production would too directly undercut the authorial myth of Roddenberry as a crusading producer, which, for their own reasons, they saw as essential to *Star Trek*'s public image. The issue of gay identity on *Star Trek* was thus constructed by producers as a problem of representation rather than one of media access.[24] One can identify a series of basic assumptions about the representation of gay identities which underlie the producers' responses to the letter-writing campaign:

(1) The explicit representation of homosexuality within the programme text would require some form of labelling while a general climate of tolerance had made the entire issue disappear. As Roddenberry explained in a statement released to the gay newspaper, *The Advocate*, 'I've never found it necessary to do a special homosexual-theme story because people in the time line of *The Next Generation*, the 24th century, will not be labeled.'[25]

(2) The representation of homosexuality on *Star Trek* would necessarily become the site of some form of dramatic conflict. As Richard Arnold, the man appointed to serve as *Star Trek*'s liaison with the fan community, explained:

In Gene Roddenberry's 24th century *Star Trek* universe, homosexuality will not be an issue as it is today. How do you, then, address a non-issue? No one aboard the starship could care less what anyone else's sexual preference would be. . . . Do not ask us to show conflict aboard

the Enterprise when it comes to people's choices over their sex, politics or religion. By that time, all choices will be respected equally.[26]

The producers, in a curious bit of circular logic, were insisting that the absence of gays and lesbians in the *Star Trek* universe was evidence of their acceptance within the Federation, while their visibility could only be read as signs of conflict, a renewed eruption of homophobia.

(3) Representation of homosexuality on *Star Trek* would make their sexuality 'obvious' and therefore risk offence. As Arnold explained,

> Although we have no problem with any of our characters being gay, it would not be appropriate to portray them as such. A person's (or being's) sexual preference should not be obvious, just as we can't tell anyone's religious or political affiliations by looking at them.[27]

The signs of homosexuality, if they are there to be seen at all, automatically become too 'obvious' in a homophobic society while the marks of heterosexuality are naturalized, rendered invisible, because they are too pervasive to even be noticed.

(4) Representation could only occur through reliance on easily recognizable stereotypes of contemporary gay identities. With a twist, the group which the producers didn't dare to offend turns out to be not the religious right (which has often put pressure on producers to exclude gay or lesbian characters) but the gay fans who are demanding representation within the programme: 'Do you expect us to show stereotypical behavior that would be more insulting to the gay community than supportive?'[28] Arnold asked a room of 1,200 *Star Trek* fans at Boston's Sheraton Hotel: 'What would you have us do, put pink triangles on them? Have them sashay down the corridors?'[29]

(5) Representation of gay characters would require the explicit representation of their sexual practice. Arnold asked, 'Would you have us show two men in bed together?'[30] Since a heterosexist society has reduced homosexuals to their sexuality, then the only way to represent them would be to show them engaged in sexual activity.

(6) Representation of gay characters and their relationships would be a violation of genre expectations. Adopting a suggestively feminine metaphor, Arnold asked, 'Would you have us turn this [*Star Trek*] into a soap opera?' To deal with homosexuality as part of the character's lifestyle would be to transform (and perhaps, emasculate) *Star Trek* while to deal with heterosexuality as part of the character's lifestyle would be to leave its status as a male-targeted action-adventure programme unchanged. Any sort of concerted effort to respond to this logic requires an attempt to make heterosexuality rather than homosexuality visible, to show how its marks can be seen on the characters, the plots, and the entire environment:

Frank: 'How do we know any of the characters are heterosexual? How do you know? Because you see them interact with other people, especially in their intimate relations. *Star Trek* has done that over and over and over again. You know Picard is heterosexual. You know Riker is heterosexual. Why? Because they've had constant relationships with people of the opposite sex. This has been done systematically as character development. Why not this same development of a gay character?'

(7) As a last resort, having failed to convince the Gaylaxians with their other arguments, the producers sought to deny their own agency in the production of the programme and their own control over its ideological vision. 'Should a *good* script come along that allows us to address the problems that the gay and lesbian community face on the planet today, then it will very likely be produced.'[31] But, in fact, there had been a script, called 'Blood and Fire', written by David Gerrold, in the very first season of *Star Trek: The Next Generation* at a time when producers were desperately looking for material to keep the fledgling series on the air. Gerrold's script used Regalian Blood Worms as a metaphor to deal with the issue of Aids and included a gay couple as secondary characters. David Gerrold explained:

All I had was a medical technician working with the doctor and a security guy. At no point do they do anything overt. But someone turns to them and says, 'How long have you two been together?' The other guy says, 'Since the academy.' That lets you know that they're gay, but if you don't know about gay people, like if you're under the age of 13, they're just good friends.[32]

Gerrold's script went through multiple revisions before being scuttled. The producers have consistently insisted that their decision not to produce 'Blood and Fire' was based on its merits, not its inclusion of gay themes and characters. Gerrold, who parted company with Roddenberry shortly after this incident, has repeatedly challenged this account, charging that the episode was never filmed because the producers were uncomfortable with his attempts to introduce the issue of homosexuality into the *Star Trek* universe: 'People complained the script had blatantly homosexual characters. Rick Berman said we can't do this in an afternoon market in some places. We'll have parents writing letters.'[33]

Gerrold told his story at science fiction conventions, on the computer nets, and to lots and lots of reporters. Copies of the script have circulated informally among Gaylaxians and other fans. 'Blood and Fire' became part of the fan community's understanding of the programme history and was a key factor in motivating the Gaylaxians to adopt more aggressive strategies in lobbying for their cause. 'Good scripts are accepted, and this

script was deemed not to be a good script,' said Ernest Over, an assistant to the executive producer.[34]

The producers had said, repeatedly, in so many different ways, that the only ways that queers could become visible within *Star Trek* was by becoming a problem, and so, gay, lesbian and bisexual *Star Trek* fans became a problem for the producers. They organized a national letter-writing campaign; they posted notices on the computer nets; they went to the queer press and made their dissatisfaction with the producers' responses a public issue. Ernest Over, himself a gay community activist, told *The Advocate* that the *Star Trek* office had received 'more letters on this than we'd had on anything else'.[35]

In the midst of the publicity, just a few months before his death, Gene Roddenberry issued a statement: 'In the fifth season of *Star Trek: The Next Generation*, viewers will see more of shipboard life in some episodes, which will, among other things, include gay crew members in day-to-day circumstances.'[36] An editorialist in the *Los Angeles Times* reported,

> This season, gays and lesbians will appear unobtrusively aboard the Enterprise. . . . They weren't 'outed' and they won't be outcasts; apparently they'll be neither objects of pity nor melodramatic attention. Their sexual orientation will be a matter of indifference to the rest of the crew.[37]

Leonard Nimoy, the actor who played Spock on the original *Star Trek*, responded that Roddenberry's decision was 'entirely fitting' with the spirit and tradition of the series.[38]

When the Gaylaxians sought confirmation of Roddenberry's statements, they received no response. When reporters from the *Washington Blade* called, they received only a tape recorded message from executive producer Rick Berman: 'The writers and producers of *Star Trek: The Next Generation* are actively exploring a number of possible approaches that would address the issue of sexual orientation.'[39] Once again, 'the issue of sexual orientation' had substituted for the promise of queer characters. And, as the new season premièred, queer fans learned that they would become 'outcasts', after all.

A HUMAN FAILING

> [Roddenberry] had discussed with us before his death the possibility of having two men hold hands in some scene, which was totally irrelevant to the issue of homosexuality. . . . So we decided to tell a story that was about sexual intolerance.
>
> (Writing Staff Supervisor Michael Piller)[40]

Big Deal! The alien was oppressed for being hetero! Now that's science fiction!!

<div align="right">(*The Advocate*)[41]</div>

There is a curious footnote in Gene Roddenberry's novelization of *Star Trek: The Motion Picture*, one which members of the female fan writing community have long read as the producer's wink towards Kirk/Spock fiction. 'Because *t'hy'la* [a term Spock used to refer to Kirk] can be used to mean *lover*, and since Kirk's and Spock's friendship was unusually close, this has led some to speculate over whether they had actually indeed become lovers,' Roddenberry explained, acknowledging for the first and only time within a canonical *Star Trek* story that the concept, at least, of homosexuality still existed within his twenty-fourth-century universe.[42] Homosexuality is still the subject of 'speculations', 'rumors', perhaps of blackmail. Yet, Roddenberry allows Kirk to set the record 'straight':

> I was never aware of this *lovers* rumor, although I have been told that Spock encountered it several times. Apparently he had always dismissed it with his characteristic lifting of his right eyebrow which usually connoted some combination of surprise, disbelief, and/or annoyance. As for myself, although I have no moral or other objections to physical love in any of its many Earthly, alien and mixed forms, I have always found my best gratification in that creature *woman*. Also, I would dislike being thought of as so foolish that I would select a love partner who came into sexual heat only once every seven years.[43]

So, just as quickly as he makes it appear, Roddenberry begins to make homosexuality disappear again. Yet Roddenberry doesn't totally close the door here. With an extra bit of effort, we can peek into Kirk's closet and find hints of something perverse. What exactly does Kirk, this man of multiple worlds, mean when he says that his '**best** gratification' came through heterosexuality? How has he come to be in a position to make such an evaluation? He doesn't, after all, say that it was his only gratification. What experiences had Kirk had with 'physical love in any of its many Earthly, alien and mixed forms'? And, so, Roddenberry, at one and the same time, authorizes a space for fan speculation and explicitly, directly, denies the possibility that homosexual desire might run between Kirk and Spock.

In an important contribution to queer media theory, D. A. Miller has traced the ways that Alfred Hitchcock's *Rope* makes its characters' homosexuality a matter of connotation rather than denotation, something which is suggested but never said. 'Connotation will always manifest a certain semiotic insufficiency,' Miller notes, allowing 'homosexual meaning to be elided even as it is also being elaborated.'[44] While the homosexuality of *Rope*'s major characters has been taken for granted by almost all

critics writing about the film, their sexual preference is never explicitly stated and thus remains a matter of interpretation. The truth of denotation (i.e. the explicit representation or statement of homosexuality) is self-evident while the truth of connotation (i.e. suggestion or implication) remains open to debate and re-interpretation. Connotation has, as Miller suggests, 'an abiding deniability'. A play with connotation is often a way to work around censorship, but by its very nature, it denies the queer visibility the Gaylaxians sought from *Star Trek*'s producers. Rather, the play with connotation, as Miller suggests, teaches only the importance of remaining silent.

'The Host' and 'The Outcast', the two *Star Trek: The Next Generation* episodes which brush across the issue of sexual preference can be seen as similar plays with connotation, often threatened with being swamped by some larger, more 'universal' concern. Here, for example, is director Marvin Rush describing the *Star Trek* episode, 'The Host':

> Male/female male/male, female/female relationships exist in life in various forms and they're fair game for drama. I think 'The Host' was about an aspect of that. But to me it was more about the nature of love, and [whether] the packages makes a difference.[45]

Writing staff supervisor Michael Piller acknowledges that 'The Outcast' was a conscious response to the letter-writing campaign but it was, in truth, a 'story that addressed the issue of sexual intolerance. . . . that was really the broader issue'.[46]

In 'The Host', the *Enterprise*'s doctor, Beverley Crusher, falls in love – with a man. Odan, an alien ambassador, beams aboard, charms the pants off her, and the two become romantically, and, it is strongly suggested, sexually, involved. Only then, after the fact, does Crusher learn that the body she has been sleeping with is actually simply the host while the 'man' with whom she has fallen in love is an extraterrestrial symbiont. The host body is dying. The symbiont is temporarily transplanted into Riker's body, the body of a man she considers as a 'brother'. After much soul-searching, Crusher again falls in love with Odan and it is again suggested that she goes to bed with him. In the final scene, Odan's new host, a woman, arrives to receive the transplant. Odan, in this body as in all of his previous bodies, still desires 'Doctor Beverley', but Beverley backs away from embracing him in his female form. 'Perhaps it is a human failing but we are not accustomed to those kinds of changes,' Dr. Beverley says with a cold stare and a distant voice. 'I can't keep up. . . . I can't live with that kind of uncertainty. Perhaps someday our ability to love won't be so limited.' Odan kisses her on the wrist and then walks away, before the camera fades away on a cold, expressionless close-up of the good doctor contemplating, no doubt, the 'nature of love'. 'Perhaps it was a human failing', she confessed, safe in the knowledge that on *Star*

Trek, human failings like compassion, friendship, emotion, altruism, love, have long been validated in the face of alien challenge. It is, after all, in our failings that we are most decidedly human.

The Gaylaxians were sharply divided about 'The Host'. Christine, president of the Boston chapter, wrote a letter praising the episode: 'The story was powerful, sensitive, well-acted and intelligent, and clearly illustrates *Trek*'s continuing commitment to explore and present important issues regardless of how controversial they might be.'[47] Her praise was tempered by her recognition of what could be expected to be said on television rather than what it might be desirable for the programme to actually say. *Star Trek*, she suggested, had found a way to explore alternative sexuality without running the 'risk that the entire midwest would immediately switch off their TVs'. Christine's acceptance of 'The Host' thus balances multiple reading formations: one which interprets the programme's ideology in relation to Roddenberry's activist image and the other which recognizes the fans as a 'powerless elite' which must reconcile its desires with what is practical in reaching a larger viewing public. Similarly, she negotiates between the appreciation of allegory as a form of social commentary and the fans' desire for recognition in terms acceptable within fandom's realist aesthetic. At several different discussions, other members of the group also expressed some sympathy for the allegorical aspects of the episode: 'It was an interesting idea. You find you like not the physical person but the personality, the way they interact with you' (Betty); 'I think they set out to get their viewers to think about – do you fall in love with the person – the spirit – or is it the shell they are housed in?' (Dana).

Not surprisingly, however, given the precarious balance she achieves between these differing reading formations, other group members did not share Christine's endorsement of the episode. The ambiguities of the closing scene particularly provoked discomfort and debate. Why does Crusher pull back from Odan when he appears to her as a woman, yet she was able to sleep with him when he took the form of her 'brother'? Is it, as she says, because she can't keep up with the changes or because, as is strongly implied, she can't deal with the possibility of lesbian desire? What is it that the people of the Federation have not yet learned to accept, parasites in host bodies or queer visibility? And, is homosexuality even what's on offer here, given the programme's careful efforts to situate Odan as quite literally a man's mind trapped inside a woman's body? Consider, for example, this exchange during one of the interview sessions, a debate which recurred in a similar form each time I discussed this episode with group members:

Betty: 'I liked it but I wanted it to go on for another half hour. If the third body – the woman – had come in fifteen or twenty

minutes before the end of the show and Beverley had to deal with her.

Lynne: 'But they don't have the guts to do that yet. . . .'

Betty: 'If Beverley had to deal with the person she loved in the body of a woman, the whole gay issue would have been raised and you would have lost sight of the issue you raised – is it the shell or the personality that you love?'

Even here, heterosexuality is seen as universal, abstract, while homosexuality is too particular and concrete to carry the weight of such a global concern as 'the nature of love'. Straights can stand for all lovers, while lesbians are more specialized signifiers.

Dana: 'It was done in a way that typically reflects our present social climate. You take a person who as far as they know has never met a gay person in their life, never thought about homosexuality or hardly at all except as us versus them. They have been raised with the myth that's been handed down through your parents, your neighbours, your school.'

Lynne: 'Of course, that's the twentieth century being imposed on the twenty-fourth century.'

Dana: 'That's true but you've got twentieth-century writers writing a show about the twenty-fourth century. Of course, their perceptions change everything. I think Beverley responded by saying, "I'm just not ready. I need more time." I see that with people who are trying to come out of the closet to their friends or their family. If they don't downright reject them, it's often, "just take it slower. I need more time to think about it." They have to override all the myths that they have been taught. They have to go out and absorb this whole new set of information, to learn about this other alternative which they never knew about really.'

Allegorical reading practices would require an acknowledgement of the story's status as a fiction addressed to a contemporary audience. Dana's response represents an attempt to pull the discussion back into the realist framework of fan discourse as Beverley's response is compared to how real people respond to the disclosure of homosexuality rather than read as a fictional construct within an allegorical story.

Lynne: 'I think Beverley would have responded almost similarly if Odan came back as a young blond male but a total stranger. "I can't do this again." That's the feeling I got. But on top of it all, it's a woman and she's not usually inclined that way. I can't deal with you changing bodies on me. You don't look like you did before. First she had to deal with Riker. My God!

Riker's body! Blech! She dealt with that but it took her a good twenty minutes of the episode. She would have needed another twenty minutes of episode to deal with this female body. But I saw the little smile on her face at the end and that's what clued me in that the writer's left it open-ended.'

Homosexuality survives as a 'little smile', an ambiguous gesture, which is readable as homophobic, foreclosing all future possibilities or as tolerant, 'open-ended' and subject to multiple interpretations. So much weight to put on a 'little smile' but sometimes that's all you have.

The following season, *Star Trek* tried again to confront and resolve the 'problem' of homosexuality. If 'The Host' wasn't really about homosexuality, even if it visually represented the possibility, however fleetingly, on the screen, 'The Outcast' was to be '*The* gay episode'. Supervising producer Jeri Taylor explains, ' "The Host" was really more about the nature of what is the basis of a love relationship. "The Outcast", though, is a gay rights story. It absolutely, specifically and outspokenly dealt with gay issues.'[48] 'The Outcast' would put the issue behind them once and for all, carefully containing its implications within a single story set on an alien world which had no previous contact with the Federation and, under the circumstances, probably wouldn't want to get into communication again.

The J'naii are an androgynous race who have outlawed the very concept of gender. (The J'naii, predictably enough, were played entirely by women.)[49] Riker meets Soren, a J'naii technician, while working together to rescue a space ship which has been lost in 'null space'. The appearance of a woman without gender invites a constant investigation of the wonders of heterosexuality. 'What kind of a woman do you find attractive?' she asks Riker. 'Tell me, is that the kind of woman all human males prefer?' she asks again. 'It is up to the woman to attract the man?' Soren inquires of Dr Crusher. Repairing a disabled shuttle craft, Riker and Soren discuss their feelings towards each other. 'What is involved with two sexes? Mating?' she wants to know, and each time, both her questions and their responses assume that heterosexuality is the only possibility. After all, in a world with two sexes, why settle for only one? 'Perhaps it is that complexity which makes the differences in the sexes so interesting,' she exclaims, amid Riker's knowing talk about 'snips and snails and puppy dog tales' and 'sugar and spice and everything nice'. Soren confesses that she has, in fact, come to think of herself as female and to have an 'unnatural' preference for men, even though such a sexual identity is outlawed in her culture:

I am taking a terrible risk telling you that. . . . Some have strong inclinations for maleness. Some have urges to be female. I am one of the latter. . . . In our world, these feelings are forbidden. Those who

are discovered are shamed and ridiculed.... Those of us who have these urges lead secret and guarded lives. We seek each other out. Always hiding, always terrified of being discovered.

The two disobey the laws of her culture and dare to express their 'deviant' heterosexual desires for each other, but Soren is made to defend her heterosexuality before the council of Androgynies: 'What we do is not different from what you do.... What makes you think you can dictate how people love each other?' After much soul-searching, Riker and Worf decide to disobey Star Fleet's Prime Directive and attempt to rescue Soren from the therapy which will 'cure' her of her outcast sexuality. For once, on a programme famous for its split-second escapes from certain doom, they arrive too late. Soren, who has been cured, rejects Riker's advances and so he flies away aboard the *Enterprise*, leaving her behind.

'Is our business with the J'naii finished?' Picard asks.

'Finished, sir,' Riker responds, before putting a lot of space between them and that queer little world.

If allegory depends upon the readers' abilities to fill its silences with their own voices, to complete the statements the text has left unfinished, the fans saw only the gaps and the evasions. Nowhere do any of the characters make explicit reference to the possibility of homosexuality nor do they directly confront homophobia. Homosexuality remains a connotative ghost, still that form of sexual desire that dares not speak its name.

The Gaylaxians recognized that what made this episode particularly dangerous was its insubstantiability, its refusal to state directly and explicitly what its message was intended to be:

The depiction of Soren's society seemed to be something taken right from Rush Limbaugh's show or Pat Buchanan's campaign literature. If you listen to those people, you'll hear them talking about how the feminist and homosexual political agendas want to destroy the traditional family and make society into a sexless, genderless collection of politically correct clones, and if you don't toe the line, you'll be censored. Soren's society was a depiction of those people's worst nightmares. It seems to me that if you were of that mindset to begin with, this show did nothing but confirm those unfounded fears, and nothing to challenge them.... It was so ambiguous, so valueless and empty, as to leave it open for this interpretation.[50]

The denotative dimensions of the story – the literal level of the narrative – had such force, they feared, that it would completely swamp the connotative meanings of the allegory. What appears on screen, at the most basic denotative level, is an 'outspoken' defence of heterosexuality, including that daring moment when Riker and Soren, Jonathan Frakes and

Melinda Culea, break all social taboos and kiss each other on the lips, right there on television. What we see, denotatively, is a man and a woman thumbing their noses at a conformist, sexless society of androgynes (or, perhaps, given the all-female cast that populates the planet, lesbians) who want to restrict the expression of straight sexuality.

But, pull back from the denotative, take the allegory on its own connotative terms, and what do you have?

> If I were a gay teenager trying to come out, this episode would have done nothing for me. I would have left with exactly what I came in with. Yeah – I suppose there are gay people out there. I don't know how or why I'm going to find them and I don't have any kind of sense that things are going to be okay.
>
> (Gaylaxian group discussion)

What does the episode tell us about the experience of being gay in a straight society?

Man 1: 'This show would have told me to shut up or – '

Woman 1: 'This will happen to you if you try to come out of the closet.'

Man 1: 'Shut up or we will change you. Beware. You are not the mainstream of society. I would have been terrified.'

Man 2: 'In her talk with Riker, Soren catalogued all of the different ways they identified each other. It's the same things we had to learn to figure out if someone else was gay. Specific words you say, specific mannerisms. . . . If there's an advice column in the episode at all, it may be that if you are young and gay, you need to start looking for ways to identify each other.'

Homophobia speaks loudly here, while homosexuality whispers, never quite naming itself, offering a glimpse of how to survive as an outlaw in a heterosexual society.

But then again, given the instability of this allegory, perhaps some people missed the point altogether, perhaps some straight people didn't even realize that the episode was supposed to be about 'gay rights'. This story was oft-repeated:

> There was a discussion where I work in an almost completely straight environment and a lot of people who watched it didn't connect it to the gay issue at all. . . . The thing that was interesting, they were still outraged by what was done to Soren. They felt it was a generic freedom of choice issue. She wasn't allowed to live the life she wanted regardless of what that was. That this might be treated as a gay-related issue was quite a surprise to them.
>
> (Gaylaxian group discussion)

What happened when you pointed it out to them? 'They argued with it. They still felt that it was more a human rights issue.' And they did not perceive that a gay rights issue might also be a human rights issue? 'Well, I couldn't really go into it because I'm only out to half of the group I was talking with and so it wasn't something I could pursue.'

And, so, maybe, all the episode said was that heterosexuality ought to exist everywhere in the galaxy, hardly a ground-breaking statement. As staff writer Brannon Braga said, 'We were advocating tolerance. What's so risky about making a statement that intolerance is bad?'[51] The allegorical nature of the story allowed the producers to place the risk of 'coming out' onto the backs of viewers rather than taking on that responsibility for themselves. 'It was a very special episode. There are no subject[s] taboo for this show,' Braga brags.[52] Gay fans noted that this was not the same way the series had tackled civil rights issues in the 1960s:

> Frank: ' "Let That Be The Last Battlefield" was a statement against racial discrimination. There was no need to make that statement. *Star Trek* had been making a statement against prejudice from the first episode when they had a multi-racial crew. If they had done "Battlefield" exactly as they did it as a statement against racial prejudice and every person on the ship was white, it would have been insulting – hypocrisy. But that's exactly what "The Outcast" did. They said basically, "we should be accepting and tolerant of people who have different sexual preferences but we aren't going to show any on our show. We aren't going to include any on the crew." '

Q FOR QUEER?

> What about non-human species homosexuality? A Klingon male in drag would surely be a highlight of the TV season. Or maybe a lesbian Vulcan, who logically decided that sex with men was unnecessary. Or even a Betazoid chicken hawk after the virginal Wesley Crusher. The *ST:NG* Enterprise has been the home of some homosexual stereotypes. Tasha Yar was at times the ultimate in butch female, not afraid of any man. Data is more anally retentive than even the *Odd Couple*'s Felix Unger. And Worf sometimes wears more leather than an entire issue of *Drummer*.
>
> (Steve K., *The Lavender Dragon*)[53]

> I'm sure we're just as strange to them.
>
> (Deanna Troi, 'The Outcast')

If Paramount and Berman thought that 'The Outcast' would safely contain the spectre of homosexuality on the far-strung planet of the J'Naii, then they misunderstood the power of connotation to grow, like ivy, all over

a text once it has been planted there. As D. A. Miller writes, queer connotation has the

> inconvenience of tending to raise this ghost all over the place. For once received in all its uncertainty, the connotation instigates a project of confirmation. . . . Connotation thus tends to light everywhere, to put all signifiers to a test of their hospitality.[54]

The constant promise and deferral of a gay character coloured the Gaylaxians' relationship to the series and invited them to constantly read a gay subtext into the episodes. *Star Trek* seemed always on the verge of confessing its characters' sexual preferences, only to back away yet again.

If the producers have trouble thinking of ways to make homosexuality visible within *Star Trek*, if they couldn't seem to find a 'good script' to tell that particular story, the Gaylaxians have no trouble locating possibilities. Watch any episode with them and they will show you the spot, the right moment, for a confession of previously repressed desire to come out from hiding:

> Lynne: 'Geordi realizes that the reason he can't seem to work things out with women is that he's gay. . . . Picard goes on shore leave and meets this great woman. Why can't he go on shore leave and meet this great man? It doesn't mean he always prefers men. He can mix it up a little. . . . And it [bisexuality] would probably flourish on board the *Enterprise*. They're real open minded there.'

Soon the entire group is participating within this carnival of outlaw signifiers, partaking of what Miller calls 'the dream (impossible to realize, but impossible not to entertain) that connotation would quit its dusky existence for fluorescent literality, *would become denotation*'.[55]

For these fans, the text's silences about characters' sexuality or motives can be filled with homosexual desire, since, after all, in our society, such desire must often go unspoken. Straight fans, on the other hand, are apt to demand conclusive evidence that a character is homosexual and otherwise, read all unmarked characters as straight by default. What's at stake is the burden of proof and the nature of evidence within a culture where homosexuality most often appears within connotation rather than denotation. Such speculations cannot sustain direct challenge and often are not taken literally by those who advance them, but open up a fleeting possibility of imagining a different text existing in the margins of that which Paramount delivers.

Sometimes, the possibilities seem to cohere around a particular character, who appears to embody the richest potential for queer visibility, who builds upon the iconography and stereotypes of queer identity. Here, bids for character sexuality can be more strongly maintained since the text

offers precisely the type of evidence that is most commonly presented within popular culture to indicate a character's potential homosexuality. Rumours surrounded the arrival of Tasha Yar as a character in *The Next Generation*'s first season. Maybe this is the queer character Roddenberry had promised: 'Tasha Yar – an obvious bisexual character. . . . Considering what she went through as a child, she should be a lesbian' (Betty). Tasha Yar – tough, independent, security chief with short-cropped hair, from a planet where she was repeatedly gang-raped by men, able to fight against any and all adversaries, was the classic Amazon: 'She could easily be conceived as being a lesbian' (David). But, as the fans are quick to note, she goes to bed with Data in the programme's second episode, 'The Naked Now': 'When they decided to straighten her, they used an android. So we ended up heterosexualizing two perfectly wonderful characters. . . . Even if they had left the character alone and not heterosexualized Tasha Yar, we would have been farther ahead than we are now' (David).

The marks of heterosexuality, normally invisible, are made 'obvious' by this interpretation, an act of violence committed against otherwise potentially queer characters, a reaction of homosexual panic which seeks to stabilize (or even to deny) their sexuality. Characters' sexualities do not remain unmarked for long within the world of *Star Trek* or, for that matter, the world of popular culture, which insists that characters be undeniably heterosexual even if their sexual preference is totally irrelevant to their narrative actions.[56] 'Data has been assigned a sexual orientation, basically' (James). Data has been 'heterosexualized'. Yar has been 'straightened'.

Yet, again, how stable is that orientation? 'Data is someone where bisexuality can be explored' (James). And, soon, the speculations are all open again:

James: 'Data is a scientist.'

David: 'Not only is he a scientist, he is an android and literally he could not have any qualms in the persona they have cast him. If he is fully functional, he's fully functional and would be able to function with another male.'

John: 'One of the primary roles of the Data character is to explore humanity, to learn about humanity. It would not only be plausible. It would be probable that he would want to explore all aspects of humanity including – '

All: 'A homosexual relationship.'

John: 'Having had a heterosexual relationship, he must be curious. He has this underlying curiosity about all aspects of humanity. He wanted to witness the marriage between O'Brian and his bride. He wanted to understand that institution. He must surely be interested in a homosexual relationship. Even

interested in why prejudices – if they don't exist in the future – once existed against this type of relationship.'

Here, in a subversion of the producers' logic, a character can prove his interest in homosexuality by the insistence with which he investigates heterosexuality.

But there are more possibilities still:

John: 'I don't think they've ever approached Geordi's sexuality.'

Lars: 'Yes, they have.'

James: 'They've approached everyone's sexuality. . . .'

Lars: 'If they had an episode where Wesley seriously questioned and explored his sexuality –'

James: ' – With Data.'

John: ' – With Worf. What about the Klingons? Can't they conceivably be a homosexual race?'

James: 'I can't picture a gay Klingon.'

John: 'Historically, there have been many times when you've had extremely masculine warrior groups and there was a lot of homosexuality among them. The Greeks. The Romans. Ancient Japan. Ancient China.'

John moves beyond the terms of the text's own construction of character to evoke the discourse of gay history, itself just gaining a foothold within popular debates about sexuality but a powerful tool for challenging a straight society's ability to naturalize its own sexual categories.

And what about Q? That campy adventurer appears in Picard's bed in one episode and speaks enviously of that woman Picard is chasing: 'If I had known this was a way I could get at you, I would have taken that form a long time ago.' Could Q, who minces and swishes his way through every episode, be a Queen? Was Q, the outrageous shape shifter, Queer?

Dana: 'He's a flaming fag. He is and I love him. I think he's wonderful.'

Lynne: 'I think he's got a thing for Picard. I really do.'

The one point on which almost all of the Gaylaxians seemed to agree was that Q was possibly, though you can't be certain, queer, with the evidence residing as much in his evocation of subcultural codes of camp performance as in anything specifically said about his character within the series.

And that was precisely the problem which *Star Trek*'s producers hadn't foreseen. In refusing to demarcate a certain denotative space for homosexuality within the text, they left *Star Trek* open to wholesale reclamation. 'They could have introduced a character a long time ago and it just comes out, two, three years later, that he's gay' (John). Soon, all of the characters are potentially queer – at least on the level of connotation:

David: 'A large percentage of the people who settled the west – the cowboys, the frontiersmen – pushed a path away from civilization because they were gay.'

James: 'Using that same analogy, it is not theoretically impossible that once we will start migrating into outer space, gay people will form their own outer space societies and colonies. I don't think that's far-fetched at all.'

Yes, it is 'not theoretically impossible' that any or all of these characters could be bisexual. But, the double negative here is suggestive of the fans' insecurity about their own interpretive moves. The speculations can crumple almost as fast as they appear. At most, you can claim, we don't know for sure whether he or she is straight:

James: 'Q can be campy, campy to the campiest, but he would not be *the* homosexual character.'

Lars: 'No, No, No, No.'

David: 'I don't get any feelings of homosexuality from Q. Not at all. I don't get any feelings of heterosexuality from Q either. The best I could do would be to describe the character as asexual.'

John: 'It's more just plain fun, just the writers having fun.'

For a split second, the screen seemed open to all kinds of possibilities and there appeared to be gays and lesbians everywhere in *Star Trek*. Look again and all you see is 'the writers having fun'.

And so, for many, the experience has been one of tremendous frustration and disillusionment. Some hardcore members continue to write letters, hoping to make their case once again at a time when the production staff on *Star Trek* is undergoing another transition in the wake of Roddenberry's death or hoping that their concerns may surface and be better met within *Star Trek: Deep Space 9*. For many others, the myth of *Star Trek* as a progressive alternative to commercial television seems to have dissolved into a new recognition of the ideological constraints on the representation of gay identities within mainstream entertainment. 'After "The Outcast", there isn't much hope anymore' (Todd). Sometimes, resistant reading isn't enough.

RECONSIDERING RESISTANT READING

Resistance is futile. You will be assimilated.

(Science Fiction)[57]

Cultural studies' embrace of the model of resistant reading is a logical response to theoretical traditions which spoke of readers only in terms of textually constructed subject positions. Resistant reading, as a model, addresses many important questions about the ideological power of the

mass media and the relationship between 'the viewer and the viewed'. Resistant reading, however, only describes one axis of a more complex relationship between readers and texts. The reading practices character- istic of fandom are never purely and rarely openly resistant to the mean- ings and categories advanced by programme producers. Often, as we have seen, the fans' resistant reading occurs within rather than outside the ideological framework provided by the programme and is fought in the name of fidelity to the programme concepts. The consummate nego- tiating readers, fan critics work to repair gaps or contradictions in the programme ideology, to make it cohere into a satisfying whole which satisfies their needs for continuity and emotional realism. Fandom is characterized by a contradictory and often highly fluid series of attitudes towards the primary text, marked by fascination as well as frustration, proximity as well as distance, acceptance of programme ideology as well as rejection. The fans feel a strong identification with the programmes, the characters, the producers and their ideological conceptions, even when they feel strong frustration with the failure of the producers to create stories they would like to see told.

As I have discussed the Gaylaxians with non-fan friends, they often demand to know why these fans don't simply walk away from *Star Trek*, shift their attention to some other text which more perfectly responds to their political agendas or gratifies their desires. Leaving aside the prob- lems which all gay, lesbian and bisexual viewers face in finding *any* commercially available text which explicitly acknowledges their sexual identities, this question fails to grasp the particular character of their relationship to the programme. *Star Trek* has been a consistent presence in their lives for more than twenty-five years, a text which has offered them endless amounts of pleasure and fascination, even if it has not always delivered all they wanted from it. *Star Trek* continues to be import- ant as a utopian space for their fantasies, still offering them a taste of 'what utopia feels like' even if it refuses to show them what (*their*) utopia might look like.

A model of resistant reading cannot, therefore, accurately describe the group's relationship to such a series, nor can their engagement with *Star Trek* be reduced to the politics of the letter-writing campaign itself. Indeed, many group members were reluctant to engage in the letter- writing campaign for fear that it might tarnish their long-term relationship to the series and might politicize their relationship to fandom, a space they had sought out specifically to escape the more doctrinaire corners of the gay and lesbian community. Bob, for example, objected that the letter-writing campaign had 'forced the issue' and, as a result, the episodes which had been produced were equally 'forced'. Resistant reading describes only one side of the ebb and flow of desire which links these viewers to the texts of television science fiction.

Moreover, we need to identify ways in which resistant reading is not necessarily a sufficient response to dissatisfaction with the images currently in circulation. As many writers have noted, resistant reading risks becoming a catch-all solution for all the problems within popular culture, a way of escaping the need for ideological criticism or research into the political economy of media institutions. A model of resistant reading quickly becomes profoundly patronizing if it amounts to telling already socially marginalized audiences that they should be satisfied with their ability to produce their own interpretations and should not worry too much about their lack of representation within the media itself. Resistant reading can sustain the Gaylaxians' own activism, can become a source of collective identity and mutual support, but precisely because it is a subcultural activity which is denied public visibility, resistant reading cannot change the political agenda, cannot challenge other constructions of gay identity and cannot have an impact on the ways people outside of the group think about the issues which matter to the Gaylaxians. Slash, or K/S fiction, represents a long-standing tradition in the women's fan-writing community which poses ways of constructing homo-erotic fantasies employing the series characters. Slash, as many writers have now noted, represents a powerful form of resistant reading, an active appropriation and transformation of dominant media content into forms of cultural production and circulation that speak to the female fan community's needs and interests. Slash has proven empowering to its female fan readers and writers, helping them to articulate and explore their sexual fantasies, bringing them together into a community across various barriers which isolate them. Slash, by translating politics into the personal, gave them a way to speak about their experiences and commitments. Some members of the Gaylaxians have embraced slash as a form which can also express their fantasies about the series and their desires for its future development. *Science Friction*, a *Star Trek: The Next Generation* slash zine distributed at the 1992 Gaylaxicon, specifically presented itself as a response to the failure of the letter-writing campaign: 'Our motto is: If Paramount can't give us that queer episode, just make it so!'[58]

For many group members, however, slash does not represent the appropriate response to this issue. The fantasy of slash is not their fantasy, does not speak to their desire for visibility and recognition. The circulation of slash within their subcultural community cannot adequately substitute for their lack of access to the media, since the aired episodes, even within fandom, enjoy an authority which cannot be matched by any subcultural production and since, as they often stress, their push for a gay character on the aired episodes is intended as much for the consumption of closeted gay teenagers or straight parents, friends and co-workers as for the group itself.

Cultural studies' embrace of the model of resistant reading, then, only

makes sense in a context which recognizes the centrality of issues of media access and media ownership. Resistant reading is an important survival skill in a hostile atmosphere where most of us can do little to alter social conditions and where many of the important stories that matter to us can't be told on network television. It is, however, no substitute for other forms of media criticism and activism. The Gaylaxians' reception of *Star Trek* points to the importance of linking ethnographic research on resistant readers or subcultural appropriations with a political economy of media ownership and control and with the ideological analysis of programme content. If earlier forms of ideological analysis worked from the assumption that texts constructed reading subjects, this new mixture would assume that readers play an active role in defining the texts which they consume but: (a) they do so within a social, historical and cultural context that shapes their relative access to different discourses and generic models for making sense of the programme materials; (b) they do so in relation to institutional power that may satisfy or defer audience desires; and (c) they do so in regard to texts whose properties may facilitate or resist the readers' interpretive activities. The relationship between readers, institutions and texts is not fixed but fluid. That relationship changes over time, constantly shifting in relation to the ever-changing balance of power between these competing forces.

Notes

1 BEYOND THE *STAR TREK* PHENOMENON: RECONCEPTUALIZING THE SCIENCE FICTION AUDIENCE

1 Much of the information in this paragraph comes from Benjamin Svetkey, 'The Enterprise Turns 25', *Entertainment Weekly*, 27 September 1991, pp. 20–8. See also Mark A. Altman, '*Star Trek: The Next Generation*', *Cinefantastique*, October 1991, pp. 16–51.

2 Susan R. Gibberman, *Star Trek: An Annotated Guide to Resources on the Development, the Phenomenon, the People, the Television Series, the Films, the Novels and the Recordings* (Jefferson, NC: McFarland, 1991).

3 Svetkey (1991), p. 20.

4 For a more detailed discussion of these stereotypes and their history, see Henry Jenkins, *Textual Poachers: Television Fans and Participatory Culture* (New York: Routledge, Chapman and Hall, 1992).

5 So pervasive is the term, 'Trekkie', that it appears without much attention in the promotion for two recent Routledge, Chapman and Hall books dealing with fan cultures, Lisa Lewis's *The Adoring Audience* and Henry Jenkins's *Textual Poachers: Television Fans and Participatory Culture*, even though the books' contents specifically reject the use of this term.

6 Sunny Bains, '*Star Trek*: The Nerd's Charter', *New Scientist*, December 1991, pp. 45–7. The article's title reflects an ongoing effort within the science community to reclaim and redefine the 'nerd' label and should not be read as reflecting negatively on fans within this context.

7 See, for example, Constance Penley, 'Brownian Motion: Women, Tactics and Technology', in Constance Penley and Andrew Ross (Eds), *Technoculture* (Minneapolis: University of Minnesota Press, 1991); Constance Penley, 'Feminism, Psychoanalysis and the Study of Popular Culture', in Lawrence Grossberg, Cary Nelson and Paula Treichler (Eds), *Cultural Studies* (New York: Routledge, Chapman and Hall, 1991); John Fiske, 'The Cultural Economy of Fandom', in Lisa Lewis (Ed.), *The Adoring Audience: Fan Culture and Popular Media* (New York: Routledge, Chapman and Hall, 1992); Camille Bacon-Smith, *Enterprising Women: Television Fandom and the Creation of Popular Myth* (Philadelphia: University of Pennsylvania Press, 1992); Henry Jenkins, '*Star Trek* Rerun, Reread, Rewritten: Fan Writing as Textual Poaching', in Constance Penley, Elisabeth Lyon, Lynn Spigel and Janet Bergstrom (Eds), *Close Encounters: Film, Feminism and Science Fiction* (Minneapolis: University of Minnesota Press, 1991), pp. 171–204; Henry Jenkins, *Textual*

Poachers: Television Fans and Participatory Culture (New York: Routledge, Chapman and Hall, 1992).

8 For a more detailed history of *Doctor Who*, see John Tulloch and Manuel Alvarado, *Doctor Who: The Unfolding Text* (London: Routledge, 1983).

9 Gene Roddenberry, 'Foreword', in Jacqueline Lichtenberg, Sondra Marshak and Joan Winston, *Star Trek Lives!: Personal Notes and Anecdotes* (New York: Bantam, 1975), unnumbered page.

10 Stephen E. Whitfield and Gene Roddenberry, *The Making of Star Trek* (New York: Ballantine, 1968), p. 21. For a more detailed discussion of the construction of Roddenberry as the programme author, see Chapter 9.

11 Whitfield and Roddenberry (1968), pp. 23–30.

12 Whitfield and Roddenberry (1968), p. 112.

13 Whitfield and Roddenberry (1968), p. 2.

14 Gene Roddenberry, 'Supplementary Pages, Writer-Director Information', 1966.

15 Roddenberry (1966), p. 3.

16 Vance Kepley, Jr., 'From "Frontal Lobes" to the "Bob-and-Bob" Show: NBC Management and Programming Strategies, 1949–65', in Tino Balio (Ed.), *Hollywood in the Age of Television* (Boston: Unwin Hyman, 1990), p. 41.

17 Gene Roddenberry, in Susan Sackett, *Letters to Star Trek* (New York: Ballantine, 1977), p. 1.

18 Whitfield and Roddenberry (1968), p. 393.

19 Whitfield and Roddenberry (1968), p. 395.

20 Bjo Trimble, *On the Good Ship Enterprise: My 15 Years with Star Trek* (Norfolk/Virginia Beach: Donning Company, 1982), p. 36.

21 Eileen R. Meehan, 'Why We Don't Count: The Commodity Audience', in Patricia Mellencamp (Ed.), *The Logics of Television: Essays in Cultural Criticism* (Bloomington: Indiana University Press, 1990), p. 115.

22 Newton Minnow, 'The Vast Wasteland' (Address to the 39th Annual Convention of the National Association of Broadcasters, Washington DC: 9 May 1961).

23 On *Cagney and Lacey*, see Julie D'Acci, 'Defining Women: The Case of *Cagney and Lacey*', in Lynn Spigel and Denise Mann (Eds), *Private Screenings: Television and the Female Consumer* (Minneapolis: University of Minnesota Press, 1992). On *Beauty and the Beast* and *Twin Peaks*, see Henry Jenkins, *Textual Poachers: Television Fans and Participatory Culture* (New York: Routledge, Chapman and Hall, 1992). On Viewers for Quality Television, see Sue Brower, 'Fans as Tastemakers: Viewers for Quality Television', in Lisa Lewis (Ed.), *The Adoring Audience* (New York: Routledge, Chapman and Hall, 1991).

24 Lichtenberg, Marshak and Winston (1975), book jacket blurb.

25 This paragraph based in part on information provided in Lichtenberg, Marshak and Winston (1975), pp. 1–8.

26 David Gerrold, *The World of Star Trek* (New York: Ballantine, 1973), p. 181.

27 Gerrold (1973), p. 194.

28 Gerrold (1973), p. 182.

29 Marion Zimmer Bradley, 'Fandom: Its Value to the Professional', in Chorine Jarvis (Ed.), *Inside Outer Space: Science Fiction Professionals Look at Their Craft* (New York: Frederick Ungar, 1985), pp. 69–86. Bradley specifically identifies Jacqueline Lichtenberg, Jean Lorrah, Ruth Berman and Shirley Maiewski as *Trek* fan-writers who have since turned professional; she might

also have listed Leslie Fish, Julia Ecklar, Roberta Rogow and Della Van Hise.
30 Lichtenberg, Marshak and Winston (1975), p. 2.
31 Lichtenberg, Marshak and Winston (1975), p. 4.
32 Lichtenberg, Marshak and Winston (1975), p. 222.
33 Sondra Marshak and Myrna Culbreath (Eds), *Star Trek: The New Voyages* (New York: Bantam, 1976); Sondra Marshak and Myrna Culbreath (Eds), *Star Trek: The New Voyages II* (New York: Bantam, 1977).
34 Gerrold (1973), cover blurb.
35 Trimble (1982), p. 36.
36 Speculations and negotiations about *Star Trek*'s return as a television series or feature film had begun well before the release of *Star Wars*, but the studio began production only in the wake of Lucas's success.
37 Trimble (1982), p. 73. Trimble's denial of 'passion' stands in stark contrast to the more public celebration of such passions by more recent fans.
38 William Marsano, 'Grokking Mr. Spock or May You Never Find a Tribble in Your Chicken Soup', *TV Guide*, 25–31 March 1972, pp. 15–19.
39 Charles Leershen, '*Star Trek*'s Nine Lives', *Newsweek*, 22 December 1986, p. 66.
40 David Hartwell, *Age of Wonders: Exploring the World of Science Fiction* (New York: McGraw-Hill, 1984), pp. 7–8.
41 Robert Jewett and John S. Lawrence, *The American Monomyth* (Garden City, NY: Anchor Press, 1977).
42 Harvey Greenberg, 'In Search of Spock: A Psychoanalytic Inquiry', *Journal of Popular Film and Television*, 12, 1984, pp. 53–65.
43 See Chapter 2 for a summary of those critical accounts of the programme.
44 For a fuller discussion of the gap between fan interpretations and critical evaluations of the series, see Chapter 9.
45 Teresa Ebert, 'The Convergence of Postmodern Innovative Fiction and Science Fiction', *Poetics Today*, 1: 4, 1980, p. 93.
46 Ibid.
47 Ibid., p. 92.
48 Ibid.
49 Lester Del Rey, *The World of Science Fiction: The History of a Subculture, 1926–1976* (New York: Ballantine, 1979), pp. 304–15; Brian W. Aldiss, *Trillion Year Spree: The History of Science Fiction* (New York: Avon, 1986), see especially pp. 271–84; Hartwell, op. cit.
50 Hartwell (1984), p. 8.
51 Bernard Sharratt, 'The Politics of the Popular? From Melodrama to Television', in David Bradby, Louis James and Bernard Sharratt (Eds), *Performance and Politics in Popular Drama* (Cambridge: Cambridge University Press, 1980), p. 284.
52 Ibid., p. 285.
53 Ibid., p. 283.
54 Ibid., p. 285.
55 Anthony Giddens, *The Constitution of Society* (Cambridge, MA: Polity, 1984), p. 284.
56 Ibid., p. 336.
57 Tania Modleski (Ed.), *Studies in Entertainment: Critical Approaches to Mass Culture* (Bloomington: Indiana University Press, 1986), p. xi.
58 Renato Rosaldo, *Culture and Truth: The Remaking of Social Analysis* (Boston: Beacon, 1989), p. 21.

2 POSITIONING THE SF AUDIENCE: *STAR TREK, DOCTOR WHO* AND THE TEXTS OF SCIENCE FICTION

1 C. Elkins (1977) 'An Approach to the Social Functions of American SF', *Science Fiction Studies*, 4 (November), pp. 228–9.
2 D. Buxton (1990) *From The Avengers to Miami Vice: Form and Ideology in Television Series*. Manchester: Manchester University Press, p. 2.
3 Ibid., p. 3.
4 Ibid., p. 2.
5 See J. McGuigan (1992) *Cultural Populism*. London: Routledge; also W. R. Seaman (1992) 'Active Audience Theory: Pointless Populism', *Media, Culture and Society*, 14, pp. 301–11.
6 J. Goulding, (1985) *Empire, Aliens and Conquest*. Toronto: Sisyphus, p. 3.
7 Ibid., p. 9.
8 Ibid., pp. 78–9.
9 Ibid., p. 79.
10 Ibid., p. 41.
11 Ibid., pp. 16–17.
12 Ibid., p. 35.
13 Ibid., p. 86.
14 Ibid., p. 87.
15 Ibid., p. 77.
16 Ibid., pp. 79–80.
17 Ibid., p. 80.
18 Ibid., pp. 80–1.
19 Ibid., p. 81.
20 Ibid., p. 43.
21 Ibid., p. 18.
22 Ibid., pp. 19–20.
23 W. Wright (1975) *Sixguns and Society: A Structural Study of the Western*. Berkeley: University of California, pp. 17, 191.
24 J. Fiske (1983) '*Dr Who*: Ideology and the Reading of a Popular Narrative Text', *Australian Journal of Screen Theory*, 13/14, p. 75.
25 Buxton (1990), p. 71.
26 Discussion with Masters Communication students, Macquarie University, July 1990.
27 Elkins (1977), p. 230.
28 C. Taylor (1988) 'The Master Text and the Jeddi Doctrine', *Screen*, 29 (4), p. 97.
29 Buxton (1990), p. 68.
30 Fiske (1983), p. 74.
31 Ibid., p. 75.
32 Ibid., p. 84.
33 Ibid., p. 82.
34 Ibid., p. 73.
35 R. Dunn (1979) 'Science, Technology and Bureaucratic Domination: Television and the Ideology of Scientism', *Media, Culture and Society*, 1, p. 343.
36 Ibid., p. 344.
37 Wright (1975), p. 177.
38 Dunn (1979), p. 345.
39 Ibid., p. 346.
40 Ibid., pp. 351–2.
41 Ibid., p. 352.

42 Ibid., p. 352.
43 Ibid., pp. 352–3.
44 J. Russ (1978) 'SF and Technology as Mystification', *Science Fiction Studies*, 5, p. 254.
45 Ibid., p. 254.
46 R. Roberts, (1993) *A New Species: Gender and Science in Science Fiction*. Urbana, University of Illinois Press, pp. 4, 6.
47 Ibid., p. 98.
48 Ibid., p. 69.
49 Cited in Roberts (1993), p. 67.
50 Russ (1978), p. 254.
51 Ibid., p. 253.
52 N. Fairclough (1989) *Language and Power*. London: Longman, p. 211.
53 Russ (1978), p. 252.
54 H. Jenkins, (1992) *Textual Poachers: Television Fans and Participatory Culture*. New York: Routledge, Chapman and Hall, p. 282.
55 Ibid., pp. 266–7.
56 Ibid., p. 201.
57 Ibid., p. 175.
58 Ibid., pp. 175–6.
59 Ibid., p. 176.
60 Ibid., p. 177.
61 Buxton (1990), p. 3.
62 Ibid., p. 3.
63 Russ (1978), p. 252.
64 T. Lovell (1981) 'Ideology and Coronation Street', in R. Dyer *et al.*, *Coronation Street*. London: British Film Institute, p. 49.
65 Buxton (1990), p. 17.
66 Ibid., p. 19.
67 Ibid., p. 17.
68 Ibid., pp. 13,17.
69 Ibid., p. 15.
70 Ibid., p. 62.
71 Ibid., p. 65.
72 Ibid., p. 65.
73 Ibid., p. 66.
74 Ibid., p. 97.
75 Ibid., p. 62.
76 Ibid., p. 62.
77 Goulding (1985), p. 69.
78 Buxton (1990), p. 4.
79 Goulding (1985), p. 88.
80 Buxton (1990), p. 7.
81 A. Cranny-Francis (1990) *Feminist Fiction: Feminist Uses of Generic Fiction*. Cambridge: Polity, pp. 9–10.
82 Ibid., p. 25.
83 Ibid.
84 Ibid., p. 36.
85 Fiske (1983), pp. 86–7.
86 Cranny-Francis (1990), p. 20.
87 Ibid., pp. 20–1.
88 Roberts (1993), p. 90.

89 Ibid., p. 91.
90 Cranny-Francis (1990), p. 20.
91 Roberts (1993), p. 62.
92 Ibid., p. 64.
93 Cranny-Francis (1990), p. 74.
94 Roberts (1993), p. 141.
95 Ibid., p. 145.
96 Ibid., p. 150.
97 Ibid., p. 153.
98 Cranny-Francis (1990), p. 60.
99 Ibid., pp. 63, 64.
100 H. Jenkins (1991) '*Star Trek* Rerun, Reread, Rewritten: Fan Writing as Tex-
 tual Poaching', in Constance Penley, Lynn Spigal and Janet Bergstrom (Eds),
 Close Encounters: Film, Feminism and Science Fiction. (Minneapolis, Univer-
 sity of Minnesota Press, pp. 171–204.
101 J. Tulloch and M. Alvarado (1983) *Doctor Who: The Unfolding Text.* London:
 Routledge, ch. 6.

3 THE CHANGING AUDIENCES OF SCIENCE FICTION

1 T. Ebert (1980) 'The Convergence of Postmodern Innovative Fiction and
 Science Fiction', *Poetics Today*, 1: 4, p. 92.
2 C. Priest (1979) 'British Science Fiction', in P. Parrinder (Ed.), *Science Fiction:
 A Critical Guide.* London: Longman, p. 187.
3 Ibid., p. 192.
4 Ibid., p. 187.
5 Ibid., p. 192.
6 For example, Frederik Pohl, quoted in P. A. Carter (1977), *The Creation of
 Tomorrow: Fifty Years of Magazine Science Fiction.* New York: Columbia
 University Press, p. 14.
7 T. D. Clareson (1971) *SF: The Other Side of Realism*, quoted in Carter (1977),
 p. 212.
8 G. Klein (1977) 'Discontent in American Science Fiction', *Science Fiction
 Studies*, 4 (March), p. 6.
9 Ibid., p. 6.
10 A. L. Berger (1977) 'Science Fiction Fans in Socio-Economic Perspective:
 Factors in the Social Consciousness of a Genre', *Science Fiction Studies*, 4
 (November), p. 242.
11 H. Jenkins (1992) *Textual Poachers: Television Fans and Participatory Culture.*
 New York: Routledge, Chapman and Hall, pp. 266–8.
12 Klein (1977), pp. 4–5.
13 Ibid., p. 7.
14 Jenkins (1992), p. 267.
15 Interview with Christopher Bailey, August 1981.
16 A. Mellor (1984) 'SF and the Crisis of the Educated Middle Class', in
 C. Pawling (Ed.), *Popular Fiction and Social Change.* London: Macmillan,
 pp. 39–40.
17 Ibid., pp. 37–8.
18 Ibid., p. 38.
19 Ibid., p. 39.
20 Klein (1977), p. 7.
21 Mellor (1984), p. 40.

22 Ibid., p. 43.
23 C. Elkins (1977) 'An Approach to the Social Functions of American SF', *Science Fiction Studies*, 4 (November), p. 230.
24 Ibid., pp. 230–1.
25 Ibid., p. 231.
26 Ibid., p. 231.
27 Ibid., p. 230.
28 M. Angenot and D. Suvin (1979) 'Not Only But Also: Reflections on Cognition and Ideology in Science Fiction and SF Criticism', *Science Fiction Studies*, 6: 2, p. 169.
29 Interview with Eric Saward, September 1981.
30 Interview with Graham Williams, November 1981.
31 Jenkins (1992), p. 97.
32 Ibid., p. 98.
33 See J. Tulloch and M. Alvarado (1983) *Doctor Who: The Unfolding Text*. London: Routledge, pp. 159–73.
34 Focus group interview with seventeen members of the Nucon Science Fiction group, 11 May 1981, conducted by Elizabeth Christopher.
35 Focus group interview with seven members of the Telmar Science Fiction group, Macquarie University, Sydney, 4 September 1982, conducted by Elizabeth Christopher.

4 'THROWING A LITTLE BIT OF POISON INTO FUTURE GENERATIONS': *DOCTOR WHO* AUDIENCES AND IDEOLOGY

1 D. Morley (1980) *The 'Nationwide' Audience*. London: British Film Institute, p. 162.
2 J. Lewis (1991) *The Ideological Octopus: An Exploration of Television and its Audience*. New York: Routledge, Chapman and Hall, p. 34.
3 S. Moores (1990) *Media, Culture and Society*. New York: Routledge, Chapman and Hall.
4 D. Morley (1992) *Television Audiences and Cultural Studies*. London: Routledge, p. 31.
5 I. Ang (1990) 'Culture and Communication', *European Journal of Communications*, 5 (2–3), p. 247.
6 The *Doctor Who* audience project was conducted over a twelve-year period, primarily between 1979 and 1984, with follow-up interviews with fans continuing until about 1990. In that period thirty-eight focus group interviews were conducted by John Tulloch, Elizabeth Christopher and Anne Davies with fans and followers of the series: these included groups differentiated by age (e.g. infant and primary school students; secondary students; tertiary students; post-school unemployed); groups differentiated by 'professional' orientation to the programme (e.g. TV producers; academics; young mothers, actors, artists); groups differentiated by field of study (e.g. social science, mechanical engineering and general studies students); groups differentiated by gender (e.g. male and female sociology students); and groups differentiated by degree of liking for the programme (e.g. fans, followers and non-followers of the series). Altogether, in this period over 300 subjects discussed the series. Although all of these interviews were transcribed and analysed, there is only space to examine a few in this book. In 1990/1, the *Doctor Who* audience project entered a new stage, as part of the 'TV Violence' Australian Research Council project conducted by John and Marian Tulloch, in which over 1,000

students in years 4, 7 and 10 in state schools in Sydney were surveyed by qualitative and quantitative methods.

7 Focus group interview with five third-year sociology students, University of New South Wales, March 1981, conducted by John Tulloch.

8 Focus group interview with seven undergraduate, postgraduate and staff, School of Mechanical Engineering, University of New South Wales, 3 June 1981, conducted by Elizabeth Christopher.

9 G. Klein (1977) 'Discontent in American Science Fiction', *Science Fiction Studies*, 4 (March), p. 6.

5 'IT'S MEANT TO BE FANTASY': TEENAGE AUDIENCES AND GENRE

1 D. Morley (1981) 'The Nationwide Audience: A Critical Postscript', *Screen Education*, 39, p. 5.

2 Ibid., p. 10.

3 Ibid., p. 10.

4 Ibid., p. 10.

5 Ibid., pp. 10–11.

6 Ibid., p. 11.

7 Ibid., p. 11.

8 Ibid., p. 12.

9 Ibid., p. 13.

10 We did not look for an all-male Year 10 class because the demographics of *Doctor Who* audiences indicate that this group is insignificant; and any fans found in such a group would have found it hard to respond in a probable atmosphere of derision and hostility. A mixed class of Year 10 boys and girls was as far as we felt we could successfully go.

11 See P. Willis (1977) *Learning to Labour*. Farnborough: Saxon House.

12 Interview conducted by Elizabeth Christopher with twenty-seven Year 10 students at a North Shore (professional, middle-class area of Sydney) high school, 18 August 1982.

13 Focus group interview conducted by John Tulloch with five 14/15-year-old boys from a highly selective boys' high school in Sydney, July 1981.

14 Interview with Dicks and Letts, August 1981.

15 P. Gilbert and S. Taylor (1991) *Fashioning the Feminine: Girls, Popular Culture and Schooling*. Sydney: Allen and Unwin, pp. 68, 52.

16 Interview conducted by Elizabeth Christopher with twenty-seven Year 10 students at a mixed North Shore high school, Sydney, July 1981.

17 J. Goulding (1985) *Empire, Aliens and Conquest*. Toronto: Sisyphus, p. 68.

18 Morley (1981), p. 10.

19 R. Roberts (1993) *A New Species: Gender and Science in Science Fiction*. Urbana: University of Illinois Press, p. 117.

20 D. Morley (1992) *Television Audiences and Cultural Studies*. London: Routledge, p. 31.

21 Morley (1992), p. 30.

22 Morley (1992), p. 181.

23 C. Geertz (1973) 'Thick Description', in C. Geertz, *The Interpretation of Cultures*. New York: Basic Books, p. 26.

24 K. B. Jensen (1991), 'Introduction: The Qualitative Turn', in K. B. Jensen and N. W. Jankowski, *A Handbook of Qualitative Methodologies for Mass Communication Research*. London: Routledge, pp. 4ff.

25 K. B. Jensen (1991) 'Media Audiences. Reception Analysis: Mass Communication as the Social Production of Meaning', in K. B. Jensen and N. W. Jankowski, *A Handbook of Qualitative Methodologies for Mass Communication Research*: London: Routledge, p. 141.
26 M. Tulloch and J. Tulloch, 'Children's Understanding of TV Violence', Australian Research Council funded research project. The study into children's understanding of television violence explored over 1,000 school students' narrative accounts and structured responses to institutionalized violence in four fictional genres (science fiction, soap opera, police and war series) and two non-fictional genres (sport and talkback/documentary). Patterns of responses cut across the fiction/non-fiction distinction.
27 K. Schroder (1987) 'Convergence of Antagonistic Traditions', *European Journal of Communications*, 2, p. 27.
28 Cited in Morley (1992), p. 30.
29 T. van Dijk (1977) *Text and Context*. London: Longman; T. van Dijk and W. Kintsch (1983) *Strategies of Discourse Comprehension*. New York: Academic Press; J. Tulloch and M. Tulloch (1992) 'Discourses about Violence: Critical Theory and the "TV Violence" Debate', *Text*, 12 (2), pp. 183–231.
30 Canonical correlation 0.52, p > 0.001.
31 Canonical correlation 0.31, p > 0.001.
32 R. Hodge and D. Tripp (1986) *Children and Television: A Semiotic Approach*. Cambridge: Polity.
33 B. Gunter (1985) *Dimensions of Television Violence*. Aldershot: Gower.
34 Australian Broadcasting Tribunal (1990) *TV Violence in Australia*. Sydney: ABT.
35 D. Docherty (1990) *Violence in Television Fiction*. Broadcasting Standards Council Annual Review. Public Opinion and Broadcasting Standards: 1. London: Libbey & Co., ch. 4.

6 'BUT WHY IS *DOCTOR WHO* SO ATTRACTIVE?': NEGOTIATING IDEOLOGY AND PLEASURE

1 J. Fiske (1983) '*Dr Who*: Ideology and the Reading of a Popular Narrative Text', *Australian Journal of Screen Theory*, 13/14, p. 86.
2 D. Morley (1981) 'The Nationwide Audience: A Critical Postscript', *Screen Education*, 39, pp. 9ff.
3 J. Lewis (1983), 'The Encoding/Decoding Model: Criticisms and Redevelopments for Research on Decoding', *Media, Culture and Society*, 5, 195.
4 Interview by Elizabeth Christopher with seven ABC and commercial TV producers and executives, 13 October 1982.
5 Interview by Elizabeth Christopher with six mothers of pre-school children, 25 August 1982.
6 Interview by Elizabeth Christopher with six theatre performers and set designers, Sydney, 10 October 1982.
7 Interview by Elizabeth Christopher with seven fans of *Doctor Who* from academic, teaching, medical and visual arts professions, 23 June 1981.
8 T. Bennett and J. Woollacott (1987) *Bond and Beyond: The Political Career of a Popular Hero*. London: Macmillan, ch. 2.

7 'BUT HE'S A TIME LORD! HE'S A TIME LORD!': READING FORMATIONS, FOLLOWERS AND FANS

1 T. Bennett and Woollacott (1987) *Bond and Beyond: The Political Career of a Popular Hero*. London: Macmillan, pp. 59–60.
2 D. Morley (1981) 'The Nationwide Audience: A Critical Postscript', *Screen Education*, 39, p. 6.
3 J. Fiske (1983) '*Dr Who*: Ideology and the Reading of a Popular Narrative Text', *Australian Journal of Screen Theory*, 13/14, p. 86.
4 D. Morley (1992) *Television Audiences and Cultural Studies*. London: Routledge, p. 86.
5 Bennett and Woollacott (1987) pp. 64–5.
6 N. Fairclough (1989) *Language and Power*. London: Longman, p. 151.
7 Interview conducted by John Tulloch in a General Studies Sociology of Mass Communication class (fifteen students), University of New South Wales, 17 March 1982.
8 Cf. Fairclough (1989) on police reports and instrumental language, pp. 18–19.
9 Fairclough (1989), p. 152.
10 Ibid.
11 Interview with Liverpool (England) *Doctor Who* Appreciation Society fans, December 1981; conducted by DWAS president David Saunders.
12 J. Tulloch and M. Alvarado (1983) *Doctor Who: The Unfolding Text*. London: Routledge, pp. 270ff.
13 H. Jenkins (1992) *Textual Poachers: Television Fans and Participatory Culture*. New York: Routledge, Chapman and Hall, p. 71.

8 'WE'RE ONLY A SPECK IN THE OCEAN': THE FANS AS POWERLESS ELITE

1 H. Jenkins (1992) *Textual Poachers: Television Fans and Participatory Culture*. New York: Routledge, Chapman and Hall, p. 86.
2 The particular period covered here is from the late 1970s to the end of the 1980s, particularly in Australia and Britain. As current ADWFC president Kate Orman notes, the current period of *Doctor Who* fandom in Australia is marked by a less abrasive attitude to the producers of the series, and a less hegemonic and 'didactic' approach to PC (programme correctness) by the fan executive (K. Orman, 'The Changing Face of *Doctor Who* Fandom', personal communication, after reading the manuscript of this book). But, of course, the series has not been produced since the late 1980s; many of the battles that Tony Howe and his colleagues were fighting are over (or lost?), and fans are forced to become more eclectic in their tastes (turning to *Star Trek*, for instance, at some conventions).
3 A. Giddens (1984) *The Constitution of Society*. Cambridge, MA: Polity, pp. 284ff.
4 Interview with Ian Levine, November 1981.
5 Interview with Jeremy Bentham, November 1981.
6 P. Fenech (1985) *Zerinza*, 33/4, Supplement, p. 2.
7 Interview with David Saunders, Garry Russell and Deanne Holding, January 1982.
8 S. Collins (1982) 'Regeneration: A Time Lord Mystery', *Zerinza*, 23, p. 7.
9 Ibid., p. 7.
10 Ibid., p. 10.
11 Interview with Ian Levine, November 1981.

12 Interview with Graham Williams, November 1981.
13 T. Howe (1982) *Zerinza*, 25/26, Supplement, p. 2.
14 Focus group interview with Sydney *Doctor Who* fan club members, November 1982.
15 J. Tulloch and M. Alvarado (1983) *Doctor Who: The Unfolding Text*. London: Routledge, ch. 6.
16 S. Collins (1982) *Zerinza* 24, Supplement, pp. 3–4.
17 H. Jenkins (1991), 'Star Trek Rerun, Reread, Rewritten: Fanwriting as Textual Poaching', in C. Penley, E. Lyon, and J. Bergstrom, *Close Encounters: Film, Feminism and Science Fiction*. Minneapolis: University of Minnesota Press, p. 192.
18 Ibid.
19 Interview with Dallas Jones and Tony Howe, 23 November 1989.
20 I. Levine (1987) 'JN-T Must Go Now', *DW Bulletin*, 49, p. 1.
21 Ibid., p. 1.
22 T. Howe (1985) *Doctor Who Newsletter*, December, p.2.
23 Interview with Tony Howe and Dallas Jones.
24 Tony Howe emphasized some years later that he had changed his views on this issue of cultural decline: his earlier views are only used here to indicate a particular reading in the early Thatcher period, not to represent any timeless and 'authentic' picture of a particular fan.
25 B. Sharratt (1981) 'The Politics of the Popular – From Melodrama to Television', in D. Bradby, L. James, and B. Sharratt, *Performance and Politics in Popular Drama*. Cambridge: Cambridge University Press, pp. 275–95.
26 Interview with Ian Levine and Jeremy Bentham, 1981.
27 R. Williams (1975) *The Country and the City*. St Albans: Paladin, p. 60.
28 Ibid.
29 Ibid., pp. 59, 58.
30 Jenkins (1992) p. 35.
31 Ibid., p. 283.
32 Ibid., p. 84.
33 Ibid., p. 84.
34 Ibid., p. 85.
35 Ibid., p. 85.

9 'INFINITE DIVERSITY IN INFINITE COMBINATIONS': GENRE AND AUTHORSHIP IN *STAR TREK*

1 Judith and Garfield Reeves-Stevens, *Prime Directive* (New York: Pocket Books, 1990), p. 2.
2 Jacqueline Lichtenberg, 'Federation Centennial', in *Kraith Collected, Volume 2* (Detroit: Ceiling Press, 1976), p. 14.
3 Jacqueline Lichtenberg, Sondra Marshak and Joan Winston, *Star Trek Lives!: Personal Notes and Anecdotes* (New York: Bantam, 1975), p. 15.
4 Ibid.
5 Ibid., p. 17.
6 Ibid., pp. 43–4.
7 John Tulloch and Manuel Alvarado, *Doctor Who: The Unfolding Text* (New York: St Martin's Press, 1983), p. 2.
8 Gene Roddenberry, Writer's Guide, *Star Trek*, 1966, p. 4.
9 This list of generic traditions embodied within the series is far from complete. The female fan-writing community, for example, would stress the ties between

the series and other male-bonding programmes, such as *Starsky and Hutch* or *The Man from UNCLE*.

10 Roddenberry, Writer's Guide, p. 11.

11 Howard P. Segal, 'The Technological Utopians', in Joseph E. Corn (Ed.), *Imagining Tomorrow* (Cambridge, MA: MIT Press, 1984).

12 Segal (1984), p. 119.

13 Gene Roddenberry, 'Supplementary Pages, Writer-Director Information', 1966, p. 3.

14 Lester Del Rey, *The World of Science Fiction: The History of a Subculture* (New York: Ballantine, 1979). Del Rey divides the history of science fiction into five phases: The Age of Wonder, 1926–1937; The Golden Age, 1938–1949; The Age of Acceptance, 1950–1961; The Age of Rebellion, 1962–1973; The Fifth Age, 1974–present. His periodization has been widely adopted by science fiction insiders and literary fans. Many of the works in 'The Age of Acceptance' reflected a shift towards softer science fiction and a greater focus on characterization. Richard Matheson, Jerome Bixby and Theodore Sturgeon are closely associated with that period. 'The Age of Rebellion' represented a more radical break with the hard science fiction tradition, reflecting the influence of the British 'New Wave' writers and the American counter-culture. Norman Spinrad and Harlan Ellison are closely related to that shift.

15 '*Star Trek* is *not* pure science fiction. . . . It was never meant to be. . . . What *Star Trek* is, is a set of fables – morality plays, entertainments, and diversions about contemporary man but set against a science fiction background. *The background is subordinate to the fable. . . . True* science fiction requires that the background be logical, consistent and the overall shaper of the story. The world in which a character moves determines the kind of actions he can make, and hence the plot of the tale. In true science fiction, the background is never subordinate to the plot.' David Gerrold, *The World of Star Trek* (New York: Ballantine, 1973), p. 48.

16 Roddenberry, 'Supplementary Pages, Writer-Director Information', 1966, p. 3.

17 Peter Fitting, ' "So We All Became Mothers": New Roles for Men in Recent Utopian Fiction', *Science Fiction Studies*, 12, 1985, pp. 156–83.

18 Stephen E. Whitfield and Gene Roddenberry, *The Making of Star Trek* (New York: Ballantine, 1968), p. 26.

19 Whitfield and Roddenberry (1968), p. 205.

20 Roddenberry, 'Supplementary Pages', pp. 3–4.

21 Whitfield and Roddenberry (1968), p. 23.

22 Roddenberry, 'Writer's Guide', p. 5.

23 Paul A. Carter, *The Creation of Tomorrow: Fifty Years of Magazine Science Fiction* (New York: Columbia University Press, 1978).

24 Brian Aldiss, *Trillion Year Spree: The History of Science Fiction* (New York: Avon, 1986), p. 273.

25 *Star Trek: The Next Generation*, Writer's Guide, 8 September 1987, p. 11.

26 Ibid., p. 12.

27 Ibid., p. 4. The fact that 'sisters' is something of an afterthought here points to the continuation of *Star Trek*'s marginalization of women, a tendency discussed more fully in Chapter 10.

28 Ibid., p. 38.

29 David McDonald, 'Gene Roddenberry', *Star Trek 25th Anniversary Special*, p. 6.

30 Lichtenberg, Marshak and Winston (1975), p. 116.

31 The myth Roddenberry constructs of himself as the liberal producer has started to backfire in the years since *Star Trek: The Next Generation* first appeared. *The Making of Star Trek*, for example, blamed NBC for his decision to pull back from on-screen representations of sexual equality. Roddenberry, as the creative producer with much greater control over *Next Generation*, was held by many fans to be personally responsible for the programme's failure to deal with its new female characters in a more progressive fashion. Roddenberry has started to fall victim to the expectations he created. A similar backlash against Roddenberry can be seen in the responses of some gay, lesbian or bisexual fans (Chapter 12) to the series' failure to expand its progressive vision to include issues of sexual orientation and queer visibility.

32 Michael Logan, 'Deep Dish: The Inside Scoop on *Star Trek*'s Next Stop', *TV Guide*, 2–8 January 1993, p.15.

33 Michel Foucault, 'What is an Author?', *Screen*, XX (1), Spring 1979.

34 Walter Irwin and G. B. Love (Eds), *The Best of the Best of Trek II* (New York: Roc, 1992).

35 Tom Lalli, 'Same Sexism, Different Generation', in Walter Irwin and G. B. Love (Eds), *The Best of the Best of Trek II* (New York: Roc, 1992), p. 302.

36 Lichtenberg, Marshak and Winston, (1975), p. 37.

37 G. B. Love, 'The Second *Star Trek* Fan Poll Results', in Walter Irwin and G. B. Love (Eds), *The Best of Trek 10* (New York: Signet, 1986), pp. 183–98.

38 My goal in citing this particular survey is not to claim that it represents the full range of fan opinion nor even that its methodology is statistically reliable; nor would I suggest that these evaluations can be reduced to purely ideological concerns. Fan praise for 'The Trouble with Tribbles' and their distaste for 'Spock's Brain' probably have more to do with aesthetic than ideological evaluations. But the survey, which conforms closely to my own sense of the fan canon, indicates the problematic status of critiques which assume that all of the episodes can be weighed equally in understanding the programme's appeal or dissecting its ideological assumptions.

39 Jenny L. Nelson, 'The Dislocation of Time: A Phenomenology of Television Reruns', *Quarterly Review of Film and Video*, 12, 3, pp. 79–92.

40 Gail Schnirch, 'Reflections on *Star Trek*: Past, Present and Future', in Walter Irwin and G. B. Love (Eds), *The Best of the Best of Trek II* (New York: Roc, 1992), p. 235.

41 On 'Popular Memory', see Lynn Spigel, 'Communicating with the Dead: Elvis as Medium', *Camera Obscura*, pp. 176–204; Lynn Spigel and Henry Jenkins, 'Same Bat Channel, Different Bat Times: Mass Culture and Popular Memory', in Roberta Pearson and William Urrichio (Eds), *The Many Lives of the Batman* (New York: Routledge, Chapman and Hall, 1991).

42 Judy Klass, 'Ask Not What Your Federation Can Do For You: Kirk as Kennedy Figure', in Walter Irwin and G. B. Love (Eds), *The Best of Trek 16* (New York: Roc, 1991), pp. 172–7.

43 John F. Kennedy, as quoted in Arthur M. Schlesinger Jr, *A Thousand Days: John F. Kennedy in the White House* (New York: Houghton Mifflin, 1965), p. 64.

44 Ibid.

45 David Gerrold, *The World of Star Trek* (New York: Ballantine, 1971), p. 251.

46 For an academic analysis of the series which takes essentially this same position, see Rick Worland, 'Captain Kirk, Cold Warrior', *Journal of Popular Film and Television*, 16, 3 (Fall 1988), pp. 109–17.

10 'AT OTHER TIMES, LIKE FEMALES': GENDER AND *STAR TREK* FAN FICTION

1 Gene Roddenberry, Writer's Guide, *Star Trek*, 1966.
2 Majel Barrett, Gene Roddenberry's wife and the actress who played Number One, Christine Chapel, and Lwaxania Troi, in a *People* magazine interview (16 March 1987), as quoted in Tom Lalli, 'Same Sexism, Different Generation', in Walter Irwin and G. B. Love (Eds), *The Best of the Best of Trek II* (New York: Roc, 1992), p. 313.
3 A sense of the shifting intensity of *Star Trek* fan publishing can be gained from the following statistics, derived from information published by the Star Trek Welcommittee and provided to me by Joan Marie Verba.

Year	No. of Fanzines	No. of Fan Clubs
1973	88	110
1974	143	193
1975	176	264
1976	ND	ND
1977	431	ND
1978	431	ND
1979	400	300
1980	406	276
1981	292	203
1982	331	240
1983	343	250
1984	274	163
1985	195	122
1986	277	189
1987	289	281

Such figures should be taken as merely an approximation, since no organization can be expected to maintain complete records of an underground publishing activity as dispersed and decentred as the fanzine community. Such figures also do not reflect multi-media zines which may include *Star Trek* as one of several different programmes represented. Increasingly, fandom has shifted from exclusive commitments to individual programmes towards a more 'nomadic' exploration of a cluster of related series.

4 For a fuller discussion of the range of themes and approaches taken by fan writers, see Henry Jenkins, *Textual Poachers: Television Fans and Participatory Culture* (New York: Routledge, Chapman and Hall, 1992), especially chapters five and six. See also Camille Bacon-Smith, *Enterprising Women: Television Fandom and the Creation of Popular Myth* (Philadelphia: University of Pennsylvania Press, 1992) for a slightly different treatment of the conventions of fan writing. A growing body of academic writing has focused on slash, a subgenre of fan fiction dealing with homo-erotic relations between series characters. See Patricia Frazer Lamb and Dianna L. Veith, 'Romantic Myth, Transcendence and *Star Trek* Zines', in Donald Palumbo (Ed.), *Erotic Universe: Sexuality and Fantastic Literature* (New York: Greenwood, 1986); Constance Penley, 'Brownian Motion: Women, Tactics and Technology' in Constance Penley and Andrew Ross (Eds), *Technoculture* (Minneapolis: University of Minnesota Press, 1991); Constance Penley, 'Feminism, Psychoanalysis and the Study of Popular Culture', in Lawrence Grossberg, Cary Nelson and Paula Treichler (Eds), *Cultural Studies* (New York: Routledge, Chapman and Hall, 1991); Joanna Russ, *Magic Mommas, Trembling Sisters,*

Puritans and Perverts: Feminist Essays (Trumansberg, NY: Crossing, 1985). The bulk of fan writing focuses, like the series itself, on the primary male characters. My focus here on female-centred writing is intended to explore one specific subgenre of fan writing, rather than to represent the full range of works produced. Sections from this chapter previously appeared in Henry Jenkins, '*Star Trek* Rerun, Reread, Rewritten: Fan Writing as Poaching', in Constance Penley, Elisabeth Lyon, Lynn Spigel and Janet Bergstrom (Eds), *Close Encounters: Film, Feminism and Science Fiction* (Minneapolis: University of Minnesota Press, 1991) and in Henry Jenkins, 'Strangers No More, We Sing: Filking and the Social Construction of the Science Fiction Fan Community', in Lisa Lewis (Ed.), *The Adoring Audience: Fan Culture and Popular Media* (New York: Routledge, Chapman and Hall, 1992). This material has been considerably revised for the current chapter.

5 Jacquelin Lichtenberg, Sondra Marshak and Joan Winston, *Star Trek Lives!: Personal Notes and Anecdotes* (New York: Bantam, 1975), p. 112.

6 Lalli (1992), p. 301.

7 Toni Lay, letter to *Comlink*, 28, 1986, p. 15.

8 Nichols and Arnold, as quoted in Lalli (1992), p. 321.

9 Stephen E. Whitfield and Gene Roddenberry, *The Making of Star Trek* (New York: Ballantine, 1968), p. 128.

10 Lalli (1992), p. 305.

11 Lalli (1992), p. 302.

12 Catherine A. Siebert, 'Journey's End at Lover's Meeting', *Slaysu* 1 (1980), p. 33.

13 Leslie Fish, *The Weight* (Lansing, MI: T'Kuhtian Press, 1977), pp. 443–4

14 Jean Lorrah, *Full Moon Rising* (Bronx, NY: Author, 1976), pp. 9–10.

15 Lorrah (1976), p. 2.

16 Karen Bates, *Starweaver Two* (Missouri Valley, IA: Ankar Press, 1982), p. 10.

17 Janice Radway, *Reading the Romance: Women, Patriarchy and Popular Literature* (Chapel Hill: University of North Carolina, 1991), p. 214.

18 Camille Bacon-Smith, *Enterprising Women: Television Fandom and the Creation of Popular Myth* (Philadelphia: University of Pennsylvania Press, 1992).

19 Jane Land, *Demeter* (Larchmont, NY: Self-published, 1987), p. 1.

20 Elizabeth Rigel, 'The Neglected Whole, or "Never Heard of You"': Part I', in Walter Irwin and G. B. Love (Eds), *The Best of the Best of Trek II* (New York: Roc, 1992), p. 40.

21 Jane Land, *Kista* (Larchmont, NY: Author), p. 1.

22 Jane Land, *Kista* (Larchmont, NY: Self-Published, 1986), p. ii.

23 Land, *Kista*, p. 238.

24 Land, *Kista*, p. 16.

25 Jean Auel, *Clan of the Cave Bear* (New York: Crown, 1980).

26 Land, *Kista*, p. 60.

27 Land, *Kista*, p. 87.

28 Land, *Kista*, p. 116.

29 Land, *Kista*, p. 128.

30 Land, *Kista*, p. 142.

31 Radway (1991), p. 214.

32 Radway (1991), p. 215.

33 Radway (1991), p. 215.

34 Land, *Kista*, p. 198.

35 Land, *Kista*, p. 209.

36 Land, *Kista*, p. 210.
37 Land, *Demeter*, p. 27.
38 Land, *Demeter*, p. 25.
39 Land, *Demeter*, p. 57.
40 Land, *Demeter*, p. 58.
41 Land, *Demeter*, pp. 75–6.
42 Land, *Demeter*, p. i.

11 'HOW MANY STARFLEET OFFICERS DOES IT TAKE TO CHANGE A LIGHTBULB?': *STAR TREK* AT MIT

1 Gerard Klein, 'Discontent in American Science Fiction', *Science Fiction Studies*, March 1977, pp. 3–13. For a fuller discussion of Klein's account of the science fiction audience, see Chapter 3.
2 Adrian Mellor, 'Science Fiction and the Crisis of the Educated Middle Class', in C. Pawling, (Ed.), *Popular Fiction and Social Change* (London: Macmillan, 1984), p. 39.
3 This chapter builds upon a series of interviews with MIT undergraduate and graduate students in spring term, 1992, during *Star Trek: The Next Generation*'s fifth season and shortly after the release of the sixth feature film. The interviews were conducted under a variety of conditions – formal discussions in a seminar room on the MIT campus, one-on-one focus interviews to gain a better sense of some of the students' personal viewing histories, and, in one case, an informal chat between my undergraduate research assistant Greg Dancer and a group of close friends in their dormroom. The formally structured interviews produced a more reflective response, one proceeding according to academically recognized styles of argumentation; the informal dormroom session was much looser, interrupted by visits from hallmates, broken by spontaneous replays of favourite *Star Trek* clips and punctuated by boisterous laughter and scatological jokes. What emerged from this approach was the stark contrast between classroom discourse and dormroom discourse, yet also certain continuities in the ways that MIT students talk about their relationship to the series. In each case, we asked an initial contact to recruit other close friends to participate in our group interviews. We were thus able to create a relatively relaxed and comfortable context for the sessions. Discussions, which typically lasted from ninety minutes to two hours, were informal, with minimal intervention, and drifted onto a broad range of topics relating to *Star Trek*, science fiction, and MIT. The core of our participants came from engineering and the hard sciences, though, as a result of our recruitment practices, some more humanistically inclined students were also included. Only two women participated in our study, reflecting the 'gender gap' within MIT's current student body. Most of the students had watched the original *Star Trek* series as children and still caught the occasional episode in reruns; they were, however, much more devoted to *Star Trek: The Next Generation*, which premiered when they were in high school or late elementary school. Most said they watched the series every week, though few explicitly identified themselves as *Star Trek* fans. Although many now read a broader range of science fiction, most cited *Star Trek* as one of their earliest introductions to the genre and admitted that it set the terms by which they read and evaluated other works.
 In addition, Dancer and I closely monitored the interactions of two computer discussion groups, one a campus-based bulletin board, the other

the national Usenet group (Rec.arts.startrek). The computer nets prove a
particularly important resource in this project for several reasons: monitoring
the nets allowed us to observe the regular interactions of community mem-
bers within a context that is neither created nor directed by the researcher;
that can be legitimately observed without any invasion of privacy or inter-
ference with its activity; that offers a dense cluster of information about the
group's interpretive categories and discursive resources; and that allows one
to trace the immediate reactions to aired episodes as well as to explore how
reception changes over time. Computer-net discussions must be understood
within the context of a specific interpretive community (the technologically
literate middle classes, particularly those based within research institutions
and computer-based industries). However, read within this context, the net
is an invaluable resource for audience research. For more discussion of the
potential uses of computer nets in audience research, see Henry Jenkins, 'Do
You Enjoy Making the Rest of Us Feel Stupid?: alt.tv.twinpeaks, The Trickster
Author and Viewer Mastery', in David Lavery, *'Full of Secrets': Critical
Approaches to Twin Peaks* (Detroit: Wayne State University Press,
Forthcoming.)
4 On cyberpunk, see Bruce Sterling (Ed.), *Mirrorshades: The Cyberpunk
Anthology* (New York: Ace, 1988); Larry McCaffery (Ed.), *Storming the
Reality Studio: A Casebook of Cyberpunk and Postmodern Science Fiction*
(Durham, NC: Duke University Press, 1991).
5 Allucquere Rosanne Stone, 'Will the Real Body Please Stand Up?: Boundary
Stories about Virtual Cultures', in Michael Benedict (Ed.), *Cyberspace: First
Steps* (Cambridge, MA: MIT Press, 1991).
6 It is suggestive of the cultural climate of MIT that Wade thinks the techno-
logical utopian versions of the genre dominate while seeing Gibson's more
dystopian work as marginal, an inversion of the model of the genre's develop-
ment provided by Klein and Mellor.
7 Paul A. Carter, *The Creation of Tomorrow: Fifty Years of Magazine Science
Fiction* (New York: Columbia University Press, 1978), p. 5.
8 Carter (1978), p. 11.
9 For a useful discussion which links Gernsbackian science fiction and the
emergence of fandom to larger discourses about technology and science
within American culture, see Andrew Ross, 'Getting out of the Gernsback
Continuum', *Critical Inquiry*, Winter 1991, pp. 411–33. For an insiders' history
of early science fiction fandom, see Sam Moskowitz, *The Immortal Storm: A
History of Science Fiction Fandom* (Atlanta: ASFO Press, 1954).
10 Stewart Brand, *The Media Lab: Inventing the Future at MIT* (New York:
Viking, 1987), p. 224.
11 Brand (1987), p. 263. See, also, Peregrine White, *The Idea Factory: Learning
to Think at MIT* (New York: Dutton, 1991).
12 Katie Joynt, 'Harassment Surrounds *Star Trek* Viewing', *The Tech*, 28 April
1992, p. 4.
13 Here, the 'powerless elite' discourse which John Tulloch identifies within
Doctor Who fans is redefined in terms of the opposition between a
scientifically informed minority and a scientifically 'illiterate' majority.
14 Myths of human perfectibility and progress surface even in their evaluations
of television science fiction with *Star Trek: The Next Generation* read by
almost all of the students as a 'definite improvement' over the older series.
As one of the students interviewed asserted, 'Most of the *Star Trek* viewers

these days are pretty intelligent. They are not as stupid as they were in the 1960s.'

15 Bernard Sharratt, 'The Politics of the Popular? From Melodrama to Television', in David Bardby, Louis James and Bernard Sharratt (Eds), *Performance and Politics in Popular Drama* (Cambridge: Cambridge University Press, 1980).

16 Writing requirement director Les Perelman has argued, for example, that students write with much greater passion, rigour and vividness discussing *Star Trek* on the nets than in the formal essays they write for their classes. He has sought ways to integrate that energy into the process of teaching writing.

17 Sherry Turkle, *The Second Self: Computers and the Human Spirit* (New York: Simon and Schuster, 1984), p. 223.

18 Turkle (1984), pp. 219–23.

19 Turkle (1984), p. 222.

20 Spock was seen by several students in essentially similar terms.

21 Turkle (1984), pp. 222–3.

22 Sherry Turkle argues that the computer is an evocative object, which, like a Rorschach test, becomes a focus for a variety of different interpretations and a tool by which people work through emotional and psychological issues of central concern to them: 'As with the Rorschach, what people make of the computer speaks of their larger concerns, speaks of who they are as individual personalities' (1984, p. 15). Turkle's account reads these different interpretations in individualistic terms, yet her treatment of subcultural interpretations of technology, as in her chapter on Hacker culture, points to the ways that this concept might be applied to larger social categories. An evocative object might be seen, then, as working both on a personal and idiosyncratic level and on a social and subcultural level. That cultural studies has chosen to focus on the collective and Turkle on the personal levels should not blind us to the fact that any given respondent's interpretation of an evocative object is a mix of the two.

12 'OUT OF THE CLOSET AND INTO THE UNIVERSE': QUEERS AND *STAR TREK*

1 Franklin Hummel, 'Where None Have Gone Before', *Gaylactic Gayzette*, May 1991, p. 2. I am indebted to John Campbell for his extensive assistance in recruiting members of the Gaylaxians to participate in the interviews for this chapter. Interviews were conducted both in informal settings (members' homes) as well as more formal ones (my office), depending on the size and the needs of the groups. As it evolved, the groups were segregated by gender.

2 For more information on the Gaylaxian Network, see Franklin Hummel, 'SF Comes to Boston: Gaylaxians at the World Science Fiction Convention', *New York Native*, 23 October 1989, p. 26.

3 Gaylaxians International, recruitment flier.

4 Theresa M., '*Star Trek: The Next Generation* Throws Us a Bone . . .', *The Lavender Dragon*, April 1992, 2: 2, p. 1.

5 John Hartley, *Studies in Television* (New York: Routledge, Chapman and Hall, 1992), p. 5.

6 Hartley 1992, p. 7.

7 The nineteenth-century word, Uranian, was coined by early German homosexual emancipationist Karl Ulrichs and used popularly through the First World War to refer to homosexuals. As Eric Garber and Lyn Paleo note, 'It

refers to Aphrodite Urania, whom Plato had identified as the patron Goddess of homosexuality in his Symposium.'

8 Susan Sackett, executive assistant to Gene Roddenberry, letter to Franklin Hummel, 12 March 1991.

9 Mark A. Altman, 'Tackling Gay Rights', *Cinefantastique*, October 1992, p. 74.

10 Franklin Hummel, Director, Gaylactic Network, letter to Gene Roddenberry, 1 May 1991.

11 Ibid.

12 The analogy John and other Gaylaxians draw between the black civil rights movement of the 1960s and the queer civil rights movement of the 1990s is a controversial one. But it is hardly unique to these fans. This analogy has been part of the discursive context surrounding Bill Clinton's efforts to end the American military's ban on gay and lesbian enlistment.

13 Many of Dyer's most important essays on this topic can be found in Richard Dyer, *Only Entertainment* (New York: Routledge, Chapman and Hall, 1992). On Judy Garland and gay audiences, see Richard Dyer, *Heavenly Bodies: Film Stars and Society* (New York: St Martin's Press, 1986). For another central text in arguments about the politics of utopian entertainment, see Frederic Jameson, 'Reification and Utopia in Mass Culture', *Social Text*, Winter 1979, pp. 130–48.

14 Richard Dyer, 'In Defence of Disco', *Only Entertainment* (London: Routledge, 1992), p. 156. What Dyer describes here as 'banality' is what fans refer to as 'the mundane', while making a similar argument about the pleasures of fandom as a repudiation or movement away from 'the mundane.'

15 Eric Garber and Lyn Paleo, *Uranian Worlds: A Guide to Alternative Sexuality in Science Fiction, Fantasy and Horror* (Boston: G. K. Hall, 1990).

16 Several of the writers associated with the original *Star Trek* series made important contributions to the development of gay and lesbian science fiction: Theodore Sturgeon, who wrote 'Amok Time' and 'Shore Leave', two of the best-loved episodes, had been dealing with issues of alien sexuality and homosexuality in his fiction as early as 1957; David Gerrold, who wrote 'Trouble with Tribbles' and was closely involved in the development of *Star Trek: The Next Generation*, was the author of a 1973 science fiction novel, *The Man Who Folded Himself*, which dealt with the auto-erotic and homo-erotic possibilities of time travel; Norman Spinrad, the author of 'The Doomsday Machine', wrote stories which dealt, not always sympathetically, with alternative sexualities and had included gay characters in his fiction prior to his involvement in *Star Trek*.

17 Clearly, these newer representations of gay characters, rather than the older representations of the problem or issue of gay sexuality, set expectations about how *Star Trek* might best address the concerns of its gay, lesbian and bisexual viewers.

18 Sackett, op. cit. Roddenberry has, at various times, acknowledged that he saw his inclusion of Uhura on the original series as a contribution to the civil rights movement, that he had added Chekhov in response to a *Pravda* editorial calling for an acknowledgement of Soviet accomplishments in space, and that he introduced the blind character, Geordi, on *Star Trek: The Next Generation* as a response to the many disabled fans he had encountered through the years. Given such a pattern, it was not unreasonable for the Gaylaxians to anticipate a similar gesture towards gay, lesbian and bisexual viewers.

19 Hummel, *Gaylactic Gayzette*, op. cit.

20 Edward Gross, *The Making of The Next Generation* (Las Vegas: Pioneer Books) as reprinted in *Gaylactic Gayzette*, May 1991.

21 David Gerrold, letter to Frank Hummel, 23 November 1986.

22 Steve K., 'Gays and Lesbians in the 24th Century: *Star Trek – The Next Generation*', *The Lavender Dragon*, August 1991, 1: 3, p. 1.

23 Theresa M., ibid.

24 The commercial success of programmes like *Northern Exposure, LA Law, In Living Color* or *Roseanne*, all of which had previously included gay, lesbian or bisexual recurring characters might have substantially decreased the risk of including similar characters on *Star Trek*, though the industry's understanding of audience acceptance of queer visibility was shifting at the time this debate occurred.

25 '*Star Trek:* The Next Genderation', *The Advocate*, 27 August 1991, p. 74.

26 Richard Arnold, letter to J. DeSort Jr, 10 March 1991.

27 Richard Arnold, letter to J. DeSort Jr, 10 September 1989.

28 Ibid.

29 Mark A. Perigard, 'Invisible, Again', *Bay Windows*, 7 February 1991, p. 8.

30 Richard Arnold, letter to J. DeSort Jr, 10 March 1991.

31 Ibid.

32 Clark, p. 74; see also Gross, op. cit.; Altman, (1992) pp. 72–3.

33 Altman (1992), p. 72. Note that Berman or the other producers have never made similar arguments in their public statements about the controversy, always suggesting other reasons for their failure to introduce gay, lesbian or bisexual characters into the series.

34 Clark, p. 74.

35 Ibid.

36 Ibid.

37 Ruth Rosen, '*Star Trek* Is On Another Bold Journey', *Los Angeles Times*, 30 October 1991.

38 Leonard Nimoy, 'Letters to the Times: Vision of *Star Trek*', *Los Angeles Times*, 6 November 1991.

39 John Perry, 'To Boldly Go ... These Are the Not-So-Gay Voyages of the Starship Enterprise', *The Washington Blade*, 20 September 1991, p. 36.

40 Altman (1992), p. 74.

41 Roy Williams, Cartoon, *The Advocate*, 21 April 1992.

42 Gene Roddenberry, *Star Trek: The Motion Picture* (New York: Pocket Books, 1979), p. 22.

43 Ibid.

44 D. A. Miller, 'Anal *Rope*', in Diana Fuss (Ed.), *Inside/Out: Lesbian Theories, Gay Theories* (New York: Routledge, Chapman and Hall, 1991), p. 124. For other useful discussions of this subject, see Danae Clarke, 'Commodity Lesbianism', *Camera Obscura*, 25–6, January–May 1991, pp. 181– 202; Eve Kosofsky Sedgwick, *Epistemology of the Closet* (Berkeley: University of California Press, 1990).

45 Altman (1992), p. 73.

46 Altman (1992), p. 74.

47 Christine M. Conran, letter to Gene Roddenberry, 23 May 1991.

48 Altman (1992), p. 74.

49 Jonathan Frakes: 'I don't think they were gutsy enough to take it where they should have. Soren should have been more obviously male.' Rick Berman: 'We were either going to cast with non-masculine men or non-feminine females. We knew we had to go one way or the other. We read both men

and women for the roles and decided to go with women. It might have been interesting to go with men, but that was the choice we made.' Brannon Braga: 'If it would have been a man playing the role would he have kissed him? I think Jonathan would have because he's a gutsy guy.' 'Episode Guide', *Cinefantastique*, October 1992, p. 78. Gays might find some solace in the fact that it clearly takes more 'guts' to be a homosexual than a heterosexual.

50 E-mail posting, name withheld.
51 Altman (1992), p. 74.
52 Ibid.
53 Steve K., *The Lavender Dragon*) p. 2.
54 Miller (1991), p. 125.
55 Miller (1991), p. 129.
56 The Gaylaxians note, for example, a similar pattern in the introduction and development of Ensign Ro in *Star Trek: The Next Generation*'s fifth season: Ro, like Yar, drew on iconography associated with butch lesbians, and appearing in the midst of the letter-writing campaign was read as the long-promised queer character. Within a few episodes of her introduction, however, the programme involved her in a plot where the *Enterprise* crew loses its memory and Riker and Ro become lovers. As one Gaylaxian explained during a panel discussion of the series at Gaylaxicon, 'Oops! I forgot I was a lesbian!'
57 *Science Friction* (Toronto, 1992).
58 'Editorial: Welcome to Science Friction', *Science Friction* (Toronto, 1992).

Index